PEOPLE OF THE BIG VOICE

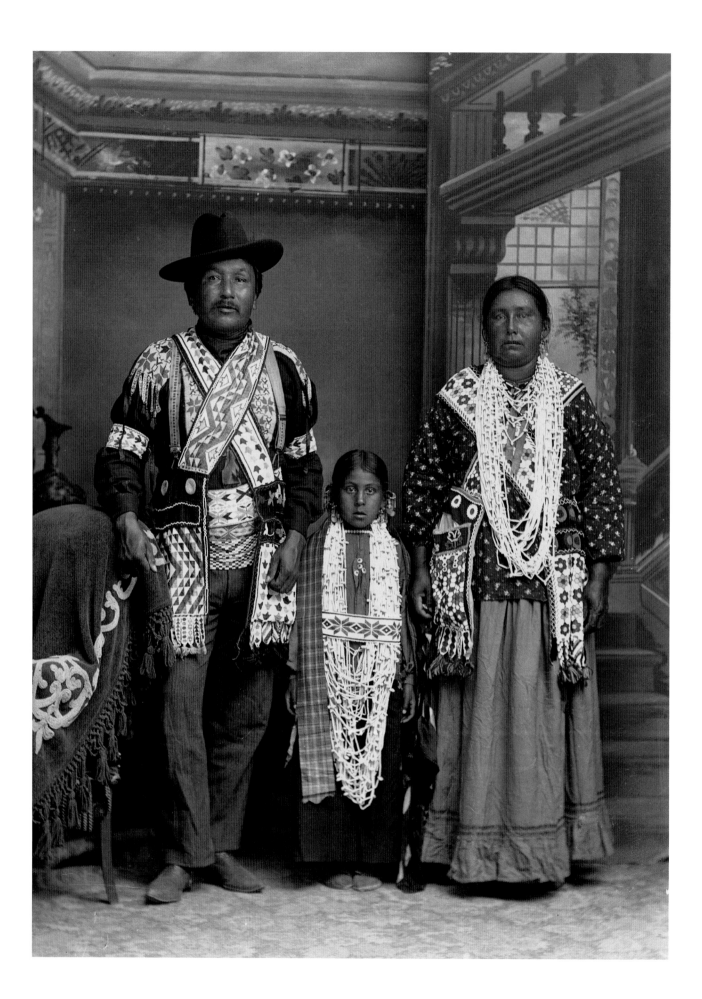

PEOPLE OF THE
BIG VOICE

PHOTOGRAPHS OF HO-CHUNK FAMILIES
BY CHARLES VAN SCHAICK, 1879–1942

Tom Jones, Michael Schmudlach, Matthew Daniel Mason,
Amy Lonetree, & George A. Greendeer

WISCONSIN HISTORICAL SOCIETY PRESS

*Publication of this book was made possible in part
by a gift in memory of Allen Van Schaick.*

Published by the Wisconsin Historical Society Press
Publishers since 1855

© 2011 by the State Historical Society of Wisconsin

wisconsinhistory**.org**

Printed in Wisconsin, U.S.A.
Designed by Percolator Graphic Design

15 14 13 12 11 1 2 3 4 5

Library of Congress Cataloging-in-Publication Data
Jones, Thomas L., 1964
 People of the big voice: photographs of Ho-Chunk families by Charles
Van Schaick, 1879–1942 / Tom Jones . . . [et al.].
 p. cm.
 Includes bibliographical references and index.
 ISBN 978-0-87020-476-0 (hardcover: alk. paper) 1. Ho Chunk
Indians—Portraits. 2. Ho Chunk Indians—Pictorial works. 3. Portrait
photography—Wisconsin—Black River Falls. 4. Black River Falls
(Wis.)—History—Pictorial works. 5. Van Schaick, Charles—Photog-
raphy collections. I. Title.
 E99.W7J66 2011
 305.897′526—dc22
 201100431

Front cover: Susie Kingswan (HeNuKah) and her son Fred Kingswan
(MaHeNoGinKah), ca. 1894. WHi Image ID 60862. The image appears
in full on page 72. *Frontispiece:* David Goodvillage (WauHeTonChoE-
Kah), Lucy Blackhawk Bighead Davis Goodvillage (NeAhTakEWinKah),
and Lucy's granddaughter Mabel Blackhawk St. Cyr, ca. 1897. WHi
Image ID 61508.

CONTENTS

FOREWORD

PEOPLE OF THE BIG VOICE documents a critical chapter in American—and Ho-Chunk—history. Despite numerous removals in the nineteenth century, some Ho-Chunk always returned to their beloved homeland in Wisconsin. The photographs taken by Charles Van Schaick and contained in this book document members of this community. They also record the Ho-Chunk Nation's deep connection to the land of this region. Above all, they demonstrate the resilience of a people.

This book is also important for the balanced, multidimensional history it provides. In the first essay, historian Matthew Daniel Mason sketches the life of Charles Van Schaick, adding little-known details about the Black River Falls studio photographer. In tracing Van Schaick's ties to the community he photographed, Mason offers a perspective on the region that is markedly different from the psycho-sociological presentation Michael Lesy advanced in his book *Wisconsin Death Trip* in 1973.

Ho-Chunk historian Amy Lonetree in her essay uses personal family history to delineate the devastating effects of federal Indian removal policies on one Native American community.

In the final essay in this collection, Ho-Chunk photographer Tom Jones interprets the structure and organization of Van Schaick's photographs and offers some observations on the perceived relationship between the photographer and his customers/subjects.

I feel a special connection to Van Schaick's photographs because they depict the place where I grew up and individuals whose children and grandchildren I know. I am especially pleased with the contributions by Lonetree and Jones because, in addition to the information they contain, they represent instances in which Ho-Chunk are looking at, interpreting, and writing our own histories.

People of the Big Voice is the collaboration of many

PEOPLE OF THE BIG VOICE jaagu ha'ehira, že'e Mąįxetera nąga Hoocąkra waaehi waakšąną. Mąįxetejąąne, Hoocąkra wawahas nąąį nųnįge, hąke'ųų ruxuruiknį. Hoocąkra mąąnegųs Hoocąk hoomąregi hakiri nąąžįre. Hokiwagax nąąkre, hižą Charles Van Schaickga ruusra, wąąkšik š'aakra wawaha wa'ųnąkšąną, anąga, Hoocąk hoomąrašge wahanąga, jaasge ciire šųnųra wawaha wa'ųnąąkšąną. Hoocąkra jaasge hitaje'ųųhanįhaire wa'ųirera, horak waakšąną.

People of the Big Voicera, hanąąc horak nąąį waakšąną. Hocekeja, Matthew Daniel Masonga nąga Charles Van Schaickga haehianąga, nįoxawanįeja hokiwagax ruusrera horak nąąį waakšąną. Hagaira wąžą hįjąhįšąną mąįxetera wagaxirera, te'e žige wąąkšik š'aakra jaasge hiihanįhairera horak nąąį waakšąną.

Amy Lonetreega hagaira, waagax hižą wagaxra, jaasge wąąkšikra wowahasirera, jaagu waišgąirera, wagax jįįphi.

Tom Jonesga, hokwagaxra waehi. Jaasge nįįsge wąąkšikra wookišgą wa'ųiregi, hija t'ųųpšąną.

Hokiwagax nąąkre, hacįįja xetewįįrera, eeja, hota waha wa'ųnąąkra, neexjį wawiyaaperesxjį wa'ųnąąkšąną. Hakogijąrą rooha yaaperessąną. Lonetreega nąga Jonesga wažą aairera wąįaginąpšąną. Hoocąk wiwewįra hikarak'ųire anąga hija t'ųųp wa'ųire.

People of the Big Voice, aakre, wąąkšikra roohą hikišere wa'ų. Wąąkšik š'aakra hąke hįwakikųnųnįkjawi hireanąga. Hokiwagax nąąkre, wąąkšik š'aakra haakja wooruǧoc pįį jįįphire wa'ųnąąkšąną. Hazohi wooruǧocgi, jaasge Hoocąkra Mąįxetetra wookišgą hajiirera horak waakšąną. Hoocąkra hoomąsįąra wawagiwaha wa'ųąkšąną.

individuals who are committed to preserving the history of the Ho-Chunk. These photographs bring forth memories like carefully wrapped, stored items. Only when unwrapped do they reveal the cultural fabric of Ho-Chunk life. Because it captures the intersection of two cultures at a particular moment in time, this book is certain to become a valuable resource. Most important, it provides evidence of the endurance of community.

Truman Lowe
WaKaJaHunkKah (King of Thunder)
Professor Emeritus of Art,
University of Wisconsin, Madison

A LONG VIEW

CHARLES J. VAN SCHAICK AND HIS PHOTOGRAPHS OF THE HO-CHUNK

Matthew Daniel Mason

For more than sixty years, professional photographer Charles Josiah Van Schaick (1852–1946) chronicled the lives of people in and around Black River Falls, Wisconsin. Beginning in 1879, he methodically captured images of his neighbors and friends who visited his gallery, as well as creating views of their homes and businesses. He also took informal snapshots that documented the changes and constancies in his community. His photographs provide especially rich visual documents of the Ho-Chunk. The studio portraits of tribal members depict them dressed in traditional regalia and contemporary fashions, as well as identifying themselves as indigenous peoples to the camera lens. Van Schaick did not systematically create portraits of Ho-Chunk. Instead, they patronized his business because he created fine images. His enduring role in the community allowed him to document generations of Native families.

Van Schaick left a rich photographic collection, but he did not leave any publicly accessible personal papers in the form of business records, journals, or correspondence. Consequently, much of his biographical and professional information derives chiefly from period newspaper accounts, as well as printed sources and the records of governmental and corporate bodies.[1]

The following briefly relates highlights from the professional life of Van Schaick and outlines the stewardship of his photographic collection by the Jackson County Historical Society in Black River Falls and the Wisconsin Historical Society in Madison. It also discusses some of the different photographic formats used by Van Schaick to market portraits to his Ho-Chunk clients and identifies several of his contemporaries who also photographed Native Americans in Wisconsin and throughout North America. It concludes with a discussion of the portrait photography and the meanings a viewer may derive from these images as documents of the past.

1

Biographical Sketch of a Photographer and Shutterbug Chronicler

Charles Josiah Van Schaick was born on June 18, 1852, in Manlius, New York. His parents were John B. Van Schaick (1818–1894), a farmer and butcher, and Sophronia Adams (1820–1877). Charles grew up a middle child with three older half sisters and an older brother, as well as a younger brother and sister. In 1855, his family moved to Springvale in Columbia County, Wisconsin, where Charles's paternal grandfather, Josiah Robbins Van Schaick (1790–1864) had established a farm five years earlier. Charles was educated in a one-room schoolhouse near his family's farm, and during his young adulthood he likely gained training as a schoolteacher.

In September 1872, his older brother, John Adams Van Schaick (1849–1875) married Florence L. Beedy (1856–1892), a sixteen-year-old schoolteacher from Albion, a small town west of Black River Falls in Jackson County, Wisconsin. Within two years, Charles moved to Albion and began courting Ida Adella Beedy (1858–1924), Florence's younger sister. Ida taught at the nearby Wrightsville School, which served the towns of Albion and Alma, while Charles worked as a teacher four miles away in Disco.[2]

During this time, Charles explored different careers. In February 1877, he traveled to the Black Hills of the Dakota Territory with Ida's father, Joseph S. Beedy (1841–1900) and local butcher Hiram B. Greenly (1841–1925) to sell smoked meat and dry goods for seven months in the mining camps. On returning from the Dakota Territory, Van Schaick temporarily returned to teaching. He then changed his career path from teaching to photography.

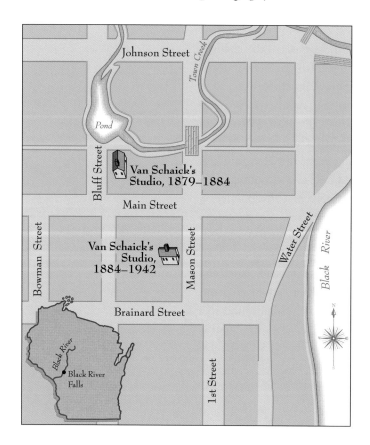

In June 1879, Van Schaick rented the photographic gallery formerly occupied by Edward P. Slater and began offering his services in Black River Falls. He probably received his training from Slater or from an "itinerant picture man," who had offered to train individuals the previous year. By November 1881, a local newspaper reported that Van Schaick surprised "his many friends in the proficiency he has made in this art and the amount of business he is doing." With the success of his gallery, Van Schaick married Ida on December 20, 1881. The next day they left for an extended honeymoon in Milwaukee, where he also took lessons in retouching photographs. Over the next forty years, they would raise three sons to adulthood.

In October 1882, Van Schaick hired an itinerant painter to paint backdrop scenes and build an ornamental stone balustrade; both appeared in nearly six decades of portraiture he created in his gallery. Painted backdrops were common fixtures in studio portraits. They typically consisted of an oversize painting on a heavy cotton weave or thin canvas with reinforced edges that included loops or ties to fasten the fabric tautly to a frame. Patrons posed sitting on the stone balustrade or

on chairs and stools, or standing in front of painted backdrops.[3] Other consistent features of Van Schaick's portraits included sections of a rustic wooden fence, as well as blankets, rugs, and other set pieces such as liquor bottles, despite Van Schaick being an ardent supporter of temperance.

In September 1884, Van Schaick moved to a gallery on the second floor of the newly constructed "Independent Building," located on Mason Street, later known as South First Street, in Black River Falls (see page 4). He remained at this location for the rest of his career. The skylight and sidelight for the gallery both faced north, which provided the studio with consistent light throughout the day. The waiting rooms offered a cooler space for customers during the summer despite its location on the second floor of the building. Nevertheless, the gallery was usually a jumble of frames and display cases filled with photographs.

In May 1885, Van Schaick's father-in-law served as a government agent to the Ho-Chunk. This may partially explain why many of Van Schaick's Ho-Chunk clientele had portraits created at his gallery. Studio portraits comprised a significant portion of his business; they encompass nearly sixty percent of his approximately 5,700 extant negatives, while portraits of Ho-Chunk people account for nearly one-third of the surviving studio work. Similar to other customers, Ho-Chunks bought portraits to place in their albums and to give to family and friends, as well as to mark events and occasions such as weddings and funerals.

Van Schaick also created informal photographs of powwows and tribal events of the Ho-Chunk, usually with a portable camera that he bought in May 1885 (see page 109, bottom). With this camera, Van Schaick captured candid images of everyday life in the city, which included informal portraits and extemporaneous townscapes. He created many

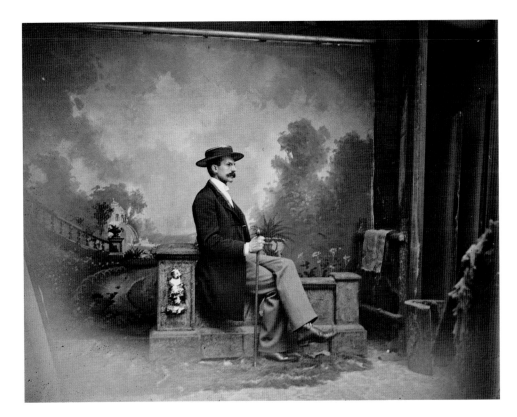

Charles J. Van Schaick sitting on a stone balustrade in front of a painted background, ca. 1882–1885. The photograph was probably taken by one of his assistants, Louis Sander, A. R. Cottrell, or S. Wohl.

The building that housed the gallery of Van Schaick and the dental offices of Edward F. Long, ca. 1890. Over the years, the building also accommodated a newspaper office and a telephone company.

street portraits of Ho-Chunk individuals and families that congregated on the streets of Black River Falls during the winter to collect their annuity payments from the federal government (see page 131, top).[4]

Skilled in his craft, Van Schaick generally adhered to the same methods throughout his career. This included using primarily glass plate negatives rather than film negatives. Glass plate negatives consist of glass with a coating of a light-sensitive emulsion, while film negatives of the period have emulsion coated on a transparent flexible plastic material, usually nitrocellulose. Widely available after 1890, film negatives weighed considerably less and occupied less space than glass plate negatives, and proved instrumental in the development of portable cameras for amateur photographers.[5] Van Schaick would routinely retouch the emulsion of glass plate negatives to remove facial flaws such as pock marks and wrinkles.

Though he did not make the switch to film negatives in his studio work, Van Schaick did not avoid all developments in photographic technology. He made some early experiments in stereoscopic photography, which uses two images captured simultaneously at slightly different positions to produce the appearance of three-dimensionality. He occasionally employed flashlight powder, a mixture of magnesium and other chemicals, which burned quickly to produce a bright white light to illuminate interior photographs. Around 1911, he began using a panoramic camera, which captured images encompassing a field of 140 degrees in 3½ × 12 inch exposures on a film negative (see page 112, top).

In addition to his photography business, Van Schaick participated in local politics. By June 1893, he became a court commissioner for Jackson County, and in April 1906, voters elected him as a justice of the peace. In this capacity, he served as a judge of a court that heard misdemeanor cases and other petty criminal infractions.

In his photographic work, Van Schaick documented major events in the region. For example, on October 6, 1911, following a month of intermittent rainfall and a continuous deluge the week before, the Black River flooded its banks. The floodwaters washed away eighty-five percent of the downtown district of Black River Falls and destroyed more than eighty buildings. The floodwaters spared his building, so Van Schaick had an advantage in creating photographs of the reconstruction of the downtown district from the vantage point of his gallery. Van Schaick demonstrated the scope of the destruction through photographs he created before and after the flood.[6]

Despite Van Schaick's success as a businessman, the role of the town photographer began to lessen around the turn of the twentieth century. Since the 1890s, the development of film negatives and relatively inexpensive cameras had allowed amateur photographers to create their own portraits and views. Despite this, in 1913 Van Schaick sold a group of twenty-seven photographic prints, comprising mostly studio portraits depicting Ho-Chunk, to the Wisconsin Historical Society for $2.20.[7] In November 1917, a local newspaper featured the oldest business owners in Black River Falls and stated, "C. J. Van Schaick was 'making faces' for the public and still stands by the camera." Years later, another newspaper article reported that Van Schaick kept an eye on the Black River and he "watched the various moods and tenses of the river as long, if not longer, than anybody else here."

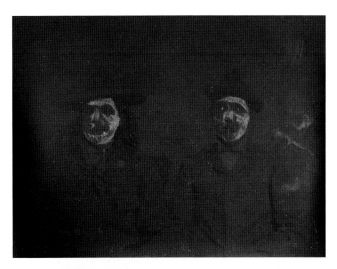

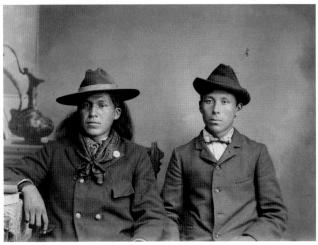

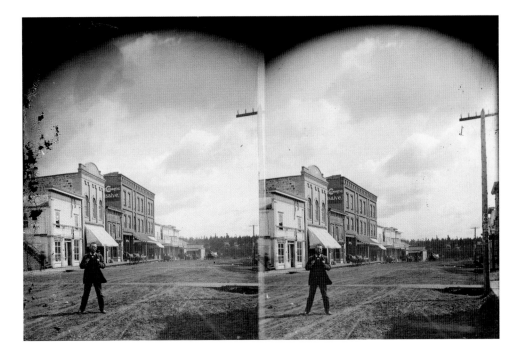

ABOVE: A glass plate negative and final studio portrait of Sam Carley Blowsnake (HoChunk-HaTeKah), pictured with long hair, and Martin Green (Snake) (KeeMeeNunkKah), ca. 1910. The negative shows retouching Van Schaick applied to the emulsion around their faces.

LEFT: Stereographic view of a man on Main Street in Black River Falls, ca. 1886, created by Van Schaick or his colleague Thomas T. McAdam.

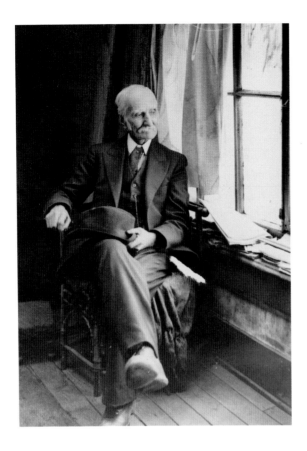

Informal portrait of Charles J. Van Schaick sitting by the window in his gallery, taken by his son Roy Van Schaick in 1942.

On December 13, 1924, Ida Van Schaick died as a result of liver disease. In the decade following her death, Van Schaick continued to take photographs, but with less regularity. Over the years, he often visited his sons and their families, but he always returned quickly to Black River Falls.[8]

On June 16, 1942, Van Schaick sold his interest in the building that held his gallery to the Community Telephone Company of Wisconsin. He also retired after sixty-three years as a professional photographer, and more than forty years as a justice of the peace. With its purchase of the building, the telephone company acquired the contents of the gallery, consisting of thousands of photographic prints and an estimated nine thousand glass plate negatives. The company immediately donated the collection to the Jackson County Historical Society, which stored it in the basement of the public library. Nearly four years later, Charles Van Schaick died, on May 25, 1946, twenty-four days short of his ninety-fourth birthday and after a long career of documenting his community.

RECOVERING THE PHOTOGRAPHY OF VAN SCHAICK

After his retirement, the negatives and photographic prints created by Charles J. Van Schaick remained in relative obscurity in the basement of the public library. In 1954, workers renovating the telephone company building found another group of negatives and donated them to the Jackson County Historical Society. Stimulated by this discovery, local librarian Frances R. Perry (1897–1996) took on the daunting task of organizing the collection. She sought advice from Paul Vanderbilt (1905–1992), the recently hired Curator of Iconography at the Wisconsin Historical Society, for the best approach to organize and care for the collection. Vanderbilt advocated that she retain images that could "transmit 'the feeling of its time,' transmit personal experience, [and] give one the feeling (in [the] case of a portrait) of being there, face to face with that person." Vanderbilt further suggested she discard duplicate or very similar images and suggested the Wisconsin Historical Society acquire superfluous material.

Over the next year, Perry worked with high school student volunteers to sort the photographs and negatives. She decided to discard broken glass plate negatives, as well as those with peeling emulsion, poor exposures, or scratches. They also discarded "uninteresting" negatives, which generally depicted people with no conspicuous features, probably including many unidentified studio portraits. The majority of these discarded negatives were taken to the town dump, while a smaller portion found their way into the personal collections of the volunteers and others. One volunteer recalls that they often made arbitrary choices. They also kept images that personally interested Perry: street scenes, women with children, and especially portraits of Ho-Chunk people, which reflected her personal interest in their language and culture. Perry also provided many of the identifications of Ho-Chunk in the images, often with her friend Flora Thundercloud Funmaker Bearheart. Many Ho-Chunk had a fondness and respect for Perry, and she was given a Ho-Chunk name, Blue Wing, by Adam Thundercloud.

Local photographer James Speltz (1923–1969) suggested the Jackson County Historical Society create 35mm copy slides from the original glass plate negatives, rather than photographic prints. He believed that creating modern photographic prints would require a large quantity of storage space, while constant handling would degrade their quality over time. More importantly, slides would allow the group to present slide shows for local groups. To ensure the best copies, Perry and the volunteers cleaned each negative. Speltz constructed a light box from a radio console and created over 2,200 individual 35mm slides from the glass plate negatives. The Jackson County Historical Society devoted portions of meetings to identifying locations and individuals in the images. For instance, at a meeting held at the Winnebago Indian Mission Church on November 30, 1961, fifty Ho-Chunk elders and their families identified many of the images of Native American people and activities. Other meetings took place over the ensuing years between elders and members of the historical society, as well as between Perry and individual Ho-Chunk people, to identify images.

In May 1957, Perry invited Vanderbilt to examine the negatives in the Van Schaick collection and select a portion for the Wisconsin Historical Society. He spent a week examining the collection and ultimately selected six boxes of glass plate negatives, making up nearly two thousand glass negatives. Since their acquisition, authors and publishers have used many of the images to illustrate publications throughout the world, ranging from textbooks to record album covers.

The most prominent use of the Van Schaick collection occurred when Michael Lesy used its imagery in his book, *Wisconsin Death Trip* (1973).[9] This work, which also represents his dissertation for a doctoral degree in history at Rutgers University, has become a cult classic. It ostensibly relates social conditions and events in western Wisconsin during the last decades of the nineteenth century. For its source material, it chiefly uses items from the *Badger State Banner* newspaper in Black River Falls, Wisconsin, from 1885 to 1886 and 1890 to 1900, positing them among images created by Van Schaick, but manipulated by Lesy. Throughout *Wisconsin Death Trip*, Lesy provides a limited historical view of the region by explicitly shaping textual and visual source material to fit his preconception that "something very strange was happening" at the turn of the twentieth century.[10] He particularly chafed at a nostalgic view of the period. For example, he argues in an early version of the work that the newspaper accounts "were considered neither sensational, nor exceptional when they were printed. If you will believe them, then at least you'll be free of the good old days."[11]

For his text in *Wisconsin Death Trip*, Lesy chose to highlight lurid excerpts from the *Badger State Banner*, medical records from a distant psychiatric asylum, and a hodgepodge of literary works by authors who did not live in the region. These works highlight the harsher features of rural life in the American Midwest on the precipice of the twentieth century, presenting a landscape run rampant with crime, disease, and insanity. Lesy manipulated sources, did not provide context for events, and infers a relationship between the photographs, newspaper accounts, and other sources.

Furthermore, Lesy selectively uses images created by Van Schaick in *Wisconsin Death Trip* in ways that the photographer and his customers would not have presented them. In a manner similar to the sensational newspaper accounts of his source material, Lesy manipulates original photographs through cropping, reversing, and creating montages that transmit his perception of insanity and death in a Wisconsin community. He

thereby influences the way the reader interprets the imagery in a manner much different from the photograph in its original context. Lesy only uses a few images of Ho-Chunk in the work. These portraits include Flora Thundercloud Funmaker Bearheart (see page 48), a portrait of George Blackhawk with an unnamed man, and Thomas Thunder with his wife, Addie Littlesoldier Lewis Thunder (see below). While Lesy accurately presents most of these images, he does create a cropped montage of a detail from the portrait of George Blackhawk and an unidentified man, which implies that the former is missing the forefinger on his left hand.[12] Overall, the text and images in *Wisconsin Death Trip* are a partial presentation of the past that encourages the reader to make misleading connections among unconnected material.

While the negatives at the Wisconsin Historical Society appeared in a variety of publications, the Jackson County Historical Society continued to care for its collection of negatives and photographic prints. In February 1968, it purchased the building that formerly held the photography gallery of Charles Van Schaick from the Community Telephone Company of Wisconsin. At that time a portion of the negatives and photographs made by Van Schaick returned to the place of their creation. During the winter of 1973 to 1974, likely stimulated by the publication of *Wisconsin Death Trip*, a team of volunteers supervised by Perry cleaned thousands of additional glass negatives.

Over the next two decades, the remaining glass negatives in the Van Schaick collections at the Jackson County Historical Society received relatively little attention from its members or researchers. After a series of discussions in 1994, the board members of the

LEFT: Studio portrait of George Blackhawk (WonkShiekCho-NeeKah), sitting, and an unidentified man wearing an otter-fur hat, ca. 1895.

RIGHT: Studio portrait of Thomas Thunder (HoonkHaGaKah) and his wife, Addie Littlesoldier Lewis Thunder (WauShinGa-SaGah), ca. 1915.

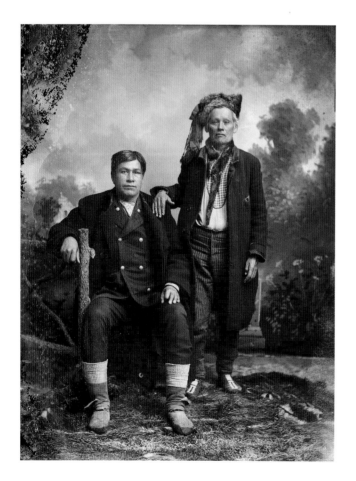

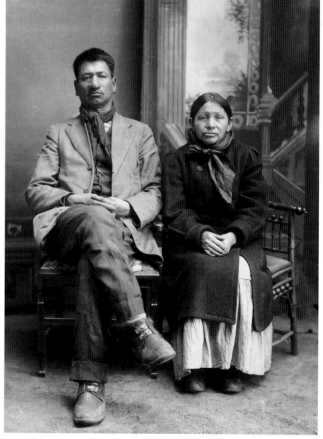

Jackson County Historical Society decided to donate nearly three thousand glass plate negatives to the Wisconsin Historical Society, which included the bulk of the portraits of Ho-Chunk. Nearly 115 years after Van Schaick began his career as a photographer and more than five decades after his retirement, most of the extant negatives reside in a single location and total around 5,700 negatives. The Jackson County Historical Society has retained a few glass plate negatives, which supplement its rich collection of photographic prints and copy slides of the negatives.

Beginning in April 1998, I volunteered to organize and describe the glass plate negatives in the Charles J. Van Schaick Collection at the Wisconsin Historical Society. Over six years, I individually inspected each negative, captured digital reference images, composed detailed descriptions of the images, and placed the negatives into photographically safe housing. In December 2008, I completed a dissertation enriched by my discoveries in the collection for a doctoral degree from the Department of History at the University of Memphis. Since then, the staff at the Wisconsin Historical Society continue to build on the work of Perry, Vanderbilt, and others to ensure that the work of Van Schaick will inform our view of his time and place.

MARKETING NATIVE PHOTOGRAPHS

Over the years, Van Schaick provided different photographic formats to his customers. These mostly consisted of photographic prints mounted on cardboard, known as card photographs. During the nineteenth century, card photographs were a popular way to present photographic prints, especially cartes-de-visite and cabinet photographs. The cardboard mounts of card photographs often have printed or embossed decorations or benchmarks that conveyed advertisements about the photographer or the studio and location, as well as any awards, areas of expertise, or prominent patrons (see page 10).

Cartes-de-visite derive their name from French calling cards and became a popular photograph format in the United States around 1860. They consisted of photographic prints that usually measure 2⅛ × 3½ inches mounted on cardboard measuring 2½ × 4½ inches. Carte-de-visite photographs remained a popular form in the United States into the early 1870s, when cabinet photographs eclipsed them. Cabinet photographs are larger than carte-de-visite photographs, usually 3½ × 5½ inches mounted on cardboard 4½ × 6¼ inches. Cabinet cards remained popular during the last two decades of the nineteenth century. Variants of card photographs continued into the twentieth century in a variety of dimensions.

During the early twentieth century, Van Schaick also offered his customers photographic postcards of their images. These consisted of a photographic print on postcard stock that generally measured approximately 3½ × 5½ inches. The Eastman Kodak Company first marketed this format to amateur photographers in 1903, and its competitors soon followed suit. The format remained popular until around 1930. Other photographers used the format to supplement their gallery business by creating postcards for sale to tourists. For example, a contemporary photographer of Van Schaick, Arthur Jerome Kingsbury (1875–1956), worked in Antigo, Wisconsin. He created a series of informal portraits on photographic postcards of Menominee on the Menominee Indian Reservation in northeastern Wisconsin, circa 1907–1909, which he marketed to tourists. Van Schaick apparently did not market postcards of Ho-Chunk or other images to tourists. Some busi-

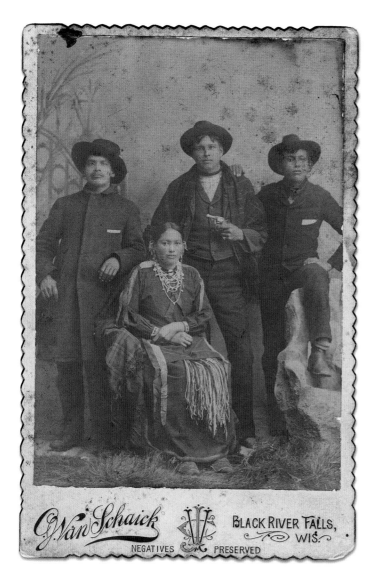

Cabinet photograph with a studio portrait of Emma Lookingglass Greengrass (ChayHeHooNooKah) sitting in front of, left to right, an unknown man, Howard Joseph McKee Sr. (CharWaShepInKaw) holding a small revolver, and Louis Johnson (HaNuKaw), ca. 1895. McKee and Johnson were on the rolls of the Nebraska Winnebago (Ho-Chunk).

nesses in Black River Falls and Jackson County did use images created by Van Schaick in mass-produced postcards as advertisements, but these were not generated by him for distribution. Still, Van Schaick did maintain a stock of photographic postcards for his Ho-Chunk customers tacked on a wall in his gallery for sale. Ho-Chunk patrons would then buy these postcard images of their family and friends. Many vintage prints in family collections have pinholes in them that reflect this marketing of images to Ho-Chunk clientele.[13]

Other professional photographers contemporary to Van Schaick created portraits of Ho-Chunk in Wisconsin, although they did not create portraits in a similar quantity. For example, Henry Hamilton Bennett (1843–1908) of Kilbourn City, later known as Wisconsin Dells, was a photographer active from 1866 until his death. He created several images of local Ho-Chunk to publicize the natural wonders in and around the Wisconsin Dells, but they only account for several dozen images. Another contemporary photographer in Wisconsin, David F. Barry (1854–1934), operated a gallery in Superior after he sold his gallery in Bismarck, Dakota Territory, in 1883, where he created iconic portraits of Sitting Bull and other Dakota Indians.[14]

Other photographers contemporary to Van Schaick explicitly sought to document the Native peoples across the continent. Most notably, Edward Sheriff Curtis (1868–1952) sought to record the traditional lives of Native peoples during the first three decades of the twentieth century. This led to the publication of his twenty-one-volume series, *The North American Indian* (1907–1930), in which Curtis presented images of Native culture and costume in the wake of the transcontinental expansion of the United States. Overall, the work presents Native peoples as historical features of a landscape and apart from contemporary society. Another midwestern photographer, Frank Albert Rinehart (1861–1928), collaborated with his assistant Adolph F. Muhr (circa 1860–1913) to document representatives from Native groups attending the Trans-Mississippi and International Exposition in Omaha, Nebraska, in 1898. Some Native peoples also operated galleries and documented their communities. For example, in Oklahoma, Kiowa photographer Horace Poolaw (1906–1984) documented changes in Native life from 1923 until sometime after 1955.[15]

Engaging Images of the Ho-Chunk

Like many of his contemporaries, Van Schaick clearly possessed a measure of respect and admiration for his Ho-Chunk customers and neighbors. This becomes particularly evident when viewing individual portraits and exploring the levels of meanings within them.

The moment between the portrait photographer and their subjects becomes salient in the image that develops from it. In front of the camera, the subject of a portrait usually suspends their naturalness and impulsiveness to present the best image of themselves to the photographer and the eventual recipient of their visage. By extension, the photographer becomes an inextricable part of the captured frame through framing, lighting, and exposure.

Portrait photographs allow the viewer to see individuals in the past through a frame and perspective they created with the photographer. With portraits of American Indians, common cultural knowledge provides some standard for interpreting images. Consider the portrait of Benjamin Raymond Thundercloud (born circa 1896) created around 1915 (see page 45). The young man wears a headdress of eagle feathers, a woodland floral breechcloth, beaded belt, rings, bracelets, and moccasins, and he holds a pipe bag. His physical features, clothing, and accoutrements embody an American Indian. Viewers read the image and create a probable context based on shared cultural perceptions.

Still, reflecting traditions of other indigenous peoples, Ho-Chunk individuals intermarried with other cultures and groups, as well as adopting some non-indigenous peoples into the nation. For example, Carrie Elk (born circa 1888) had a mixed racial heritage of African American and Ho-Chunk but wholeheartedly identified herself as Ho-Chunk—she was raised by her Ho-Chunk grandparents and spoke primarily Ho-Chunk. Her portraits with other women also attest to her self-identification as a Ho-Chunk (see pages 172 and 173).

In addition to common cultural knowledge, documentary evidence provides context for interpreting portrait photographs. This may include knowledge of the date, time, perspective, and subject captured in the image, as well as the equipment used in making photographs and the uses of the prints. This contextual knowledge becomes less necessary when viewing and appreciating photographic images on purely aesthetic merits, but the documentary context adds dimension to its depth or meaning. For example, in the portrait of two men on page 5, the man on the right is identified as Martin Green or Martin Snake, and the man on the left is Sam Carley Blowsnake (born circa 1876), also known as Crashing Thunder. Blowsnake was described as a well-known member of the Ho-Chunk Nation in "Autobiography of a Winnebago Indian," transcribed and edited by anthropologist Paul Radin (1883–1959) in the early twentieth century. This autobiography and other accounts provide much of the anthropological information known about the nation.[16] In this portrait, although dressed in modern clothing, the men distinguish themselves as Ho-Chunk by their physical characteristics. This is particularly the case with Blowsnake's long hair, which mirrored hairstyles of Native American men of the Great Plains. Long hair was not traditionally worn by Ho-Chunk men at that time, so Blowsnake probably grew it while working as a performer with Wild West shows to signify a Native American identity among the other performers.

Van Schaick and his contemporary photographers often positioned their subjects following the conventions of portraiture. This often delineated hierarchy, authority, and subordination in the arrangement of individuals in a frame, especially in family groups, arranging men, women, and children in positions and relationships to each other. Historian Alan Trachtenberg points out that "group portraits come laden with a surplus of information, but there's always something more we want to know—about the group's history, its inner dynamics."[17] For example, consider the portrait of five Ho-Chunk men—

four men posed sitting and one man standing—as well as a white man, circa 1905, from a photographic print by another photographer that Van Schaick copied for a customer (see page 111). All of the men wear traditional regalia, including beadwork clothing, necklaces, earrings, and feathers, while the white man additionally wears a hat. The portrait raises many questions: Who are these men? Why group them together? In fact, these men toured and performed in traveling Wild West shows organized by the white man in the photograph, Thomas R. Roddy (1860–1924), also known as White Buffalo, who traded extensively with the Ho-Chunk.[18]

Portrait photographs possess aesthetic qualities that can distinguish them. Images that depict frontal views possess a greater aura of authenticity. The eyes of the subject and the photographer—and by extension the viewer—meet and provide a forthright acknowledgment of the portrait process. In other examples, averted glances and expressions may create a sense of intimacy in the image. The two portraits of George Hindsley (1887–1967) on a single negative, circa 1900, express the different senses of this individual.

Developments in the technology of photography also reduced exposure times for negatives. This allowed amateur and professional photographers to capture spontaneous emotions and movements, which proved especially useful in photographing children, whose frequent movement often blurred their portraits. In a portrait of two Ho-Chunk girls, identified as Maude Browneagle and her sister, Liola, the instantaneous shutter captured a moment of their childhood (see page 250).

The images of Ho-Chunk captured by Charles J. Van Schaick document the different ways individuals identified themselves as indigenous peoples in front of the camera lens. The photographs show the relationships within families and between individuals. By providing contextual information, the following pages pay homage to the work of Van Schaick and the Ho-Chunk individuals in these images.

Dual studio portrait of George
Hindsley (AHoShipKah), ca. 1910.

VISUALIZING NATIVE SURVIVANCE

ENCOUNTERS WITH MY HO-CHUNK ANCESTORS IN THE FAMILY PHOTOGRAPHS OF CHARLES VAN SCHAICK

Amy Lonetree

M Y FIRST EXPERIENCE with the Ho-Chunk images by Charles Van Schaick happened in 1993, when I was an exhibit researcher at the Minnesota Historical Society. That summer, I had been hired to work on *A Common Ground*, an exhibit that highlighted six different communities from across Minnesota, including the Ho-Chunk Nation. As a Ho-Chunk citizen and museum scholar, my interest in the project was both professional and personal. The exhibit marked the first time that a Minnesota cultural institution had presented the Ho-Chunk Nation's story, and I wanted to participate in presenting this much-neglected part of state history. As the primary content specialist for the Ho-Chunk exhibit, I was responsible for researching Ho-Chunk tribal history, especially the tragic treaty and "removal" period of the nineteenth century. I was also in charge of locating objects and images to include in the gallery.

As the summer progressed, one of my colleagues—a designer on the project—told me about a treasure trove of historic images of Ho-Chunk families located at the Jackson County Historical Society in Black River Falls, Wisconsin.[1] These images were particularly compelling because of how and why they were made. Unlike the collections of Edward Curtis, who sought to capture images of a "vanishing race" for ethnographic and commercial purposes, these were photographs that Ho-Chunk families themselves commissioned for their own personal use.

So, off I went to Black River Falls. On a hot and sunny June day, Donn Holder, who was the president of the Jackson County Historical Society, greeted me and ushered me into a room with the images. Boxes upon boxes were brought to me. For the first time, I held images of long known but never seen relatives on both sides of my family. I was profoundly moved. The photos were loosely organized according to family, so I asked for both the Lonetree and Littlejohn boxes during my first visit. I will never forget the

moment when I found them—individuals whom I have heard about all of my life, people whose names I carry and who are the source of the fierce pride I hold within me. Here they were—in their regalia or the clothing of the day, inside the studio, on the streets of town, or at powwow grounds, smiling or looking stoic and strong. In many of their faces, I saw the faces of other relatives I love. I couldn't help but feel enormous pride in these ancestors, my Ho-Chunk family, captured in photographs almost a century ago. Seeing these images of my relatives led to a series of conversations with my grandparents, and through these conversations I came to know my own family history and tribal history in ways that strengthen me to this day.

As I examined the hundreds of images of Ho-Chunk families, my mind was heavy with the historical research I was immersed in that summer. The Ho-Chunk Nation suffered a series of forced removals during the nineteenth century, and a significant number of the images were taken just a few short years after the darkest, most devastating period for the Ho-Chunk. Invasion, diseases, warfare, forced assimilation, loss of land, and repeated forced removals from our beloved homelands left the Ho-Chunk people in a fight for their culture and their lives. We as a tribal nation—both those in Wisconsin and in Winnebago, Nebraska—have yet to come to terms fully with this history. Yet, in the wake of these devastating events, the Ho-Chunk people survived and managed to remain in Wisconsin.

Those survivors were staring back at me from photographs taken decades before, near the very spot where I sat in Van Schaick's studio, now home to the Jackson County Historical Society. They reminded me of the strength, resiliency, and survivance of my Ho-Chunk ancestors. Survivance is a concept defined by Anishinaabe scholar Gerald Vizenor as "more than survival, more than endurance or mere response; the stories of survivance are an active response. . . . [S]urvivance is an active repudiation of dominance, tragedy, and victimry."[2] The word "survival" does not sufficiently encompass the great strength, courage, and perseverance that it took for our people to remain intact as a tribal nation in the face of violence, colonial oppression, and policies of ethnic cleansing.

When examining photographs of Native Americans, Hulleah Tsinhnahjinnie reminds us that "one cannot understand the images until you understand the history."[3] What played continually through my mind as I looked at this powerful visual legacy were the words of my late Ho-Chunk father, Rawleigh Lonetree, who always reminded me that "we were the ones that they could not keep on the reservation." His words conveyed the strength and sheer determination of my Ho-Chunk ancestors to remain and persist in our ancestral homeland despite removals to faraway reservations—qualities that are central to my identity.

The Ho-Chunk individuals in the photographs have a historical context; they are not nameless faces but survivors of ethnic cleansing and ongoing colonization.[4] In the essay that follows, I will place these photographs in historical context by providing a brief overview of Ho-Chunk history. And I will focus particularly on the history of our nineteenth-century forced removals, which ended just a few short years before these images were taken. Just as these photographs have inspired me, I hope they will inspire other tribal citizens to conduct research on their families and tribal histories. Knowing our history through the lives of our ancestors opens a recovery process that is central to addressing the legacies of historical unresolved grief that persist in our communities. Through these journeys into our past, we can reclaim our history for current and future generations of Ho-Chunk people.

Understanding the Visual Legacy of the Photographs

The Ho-Chunk are indigenous to present-day Wisconsin and have lived on these lands since time immemorial. Formerly known as Winnebago, the name given to us by outsiders, in 1994 we officially changed the name of our tribal government to Ho-Chunk, our name for ourselves. It means People of the Big Voice. Ho-Chunk claims to this land are deep and long-standing; we originated near present-day Green Bay, Wisconsin, known as Mogašuuc in our language, or the Red Banks. For countless generations, we occupied the lands in Wisconsin extending down into northern Illinois, and these lands bear the marks of our lives and the graves of our ancestors. Before the invasion of our homelands and the multiple land cession treaties in the nineteenth century, the Ho-Chunk occupied more than ten million acres of land in what is now Wisconsin and northern Illinois.[5] After eventually acquiring almost all of that land, the U.S. government initiated a series of removals across four states that proved devastating for the Ho-Chunk, resulting in great misery and death. We are not sure how many of our people died during these removals or where they were buried.

The forced expulsions of tribal nations from their ancestral lands—at gunpoint and under the threat of extermination—during the nineteenth century to pave the way for westward expansion is typically referred to as the "removal period" in American history. Yet, this language obscures the devastation that this period brought. The invasion of our homelands, the heartbreak caused by the loss of lands that we as Indigenous people had occupied for hundreds of generations, and the killing of our people during these forced removals caused great suffering at the hands of the United States government.

These massive losses have never been fully acknowledged. Instead, much of the American public has chosen a willed ignorance of the devastating impact that this history has had on us. Using the more benign language of "removal period" to describe this history is but one example of this choice to minimize or erase the realities of this history. What truly happened—and what always should be remembered—is that deliberate acts of ethnic cleansing and genocide were committed against Indigenous people throughout the United States. It is difficult for Americans to accept that such brutality and inhumanity could happen in this country—more, that their privileged positions in our society today have everything to do with

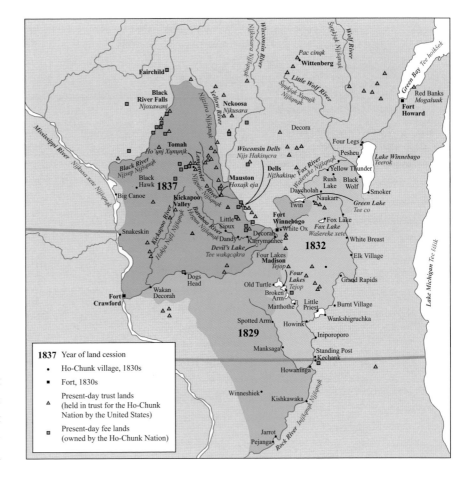

the attempted destruction of tribal nations. Difficult as it is, though, speaking the hard truths of this history is essential to moving forward in decolonizing the historical record and reclaiming Indigenous history.

It is also tragic that the specifics of the Ho-Chunk experience are not as well known or recognized as the experiences of other Native nations. We endured multiple land cession treaties and forced removals at the hands of the United States government, yet our history remains largely unacknowledged. I grew up hearing stories about my ancestors' steadfast determination to return to our ancestral lands in Wisconsin in the wake of multiple attempts to keep us on a reservation in Nebraska. However, until 1993 I was not aware of the multiple attempts to remove us to reservations in Iowa, Minnesota, and South Dakota in the nineteenth century.

The photographs taken by Charles Van Schaick shortly after the most devastating period ended are a powerful visual legacy of the resiliency and pride that my father expressed. In order to understand the photographs, as Hulleah Tsinhnahjinnie reminds us, we must understand the history. The very fact that we continued to exist as families and as a nation is testament to the strength and endurance of the people.

The loss of our beloved homelands began with the signing of the 1829 treaty. It was the first treaty that the Ho-Chunk Nation signed with the United States that included a major land cession. The land loss included our lead-rich lands in the southern part of Wisconsin and in northern Illinois. Before we even signed the treaty, waves of miners—close to 10,000 by the 1820s—began moving into our homelands, and neither the territorial or federal government did anything to stop the invasion. These early "settlers" and "miners" of Wisconsin committed depredations against Ho-Chunk people including theft and rape, leading government agent Thomas Forsyth to write in 1828, "[S]ome of the white people are insulting to the Indians and take liberties with their women, which the Indians do not like."[6] These early "settlers" also destroyed crops and reduced the hunting territory of the people, leading to extreme hardships and increasing hostilities between the invaders and the Ho-Chunk.[7]

A leader from the La Crosse band of Ho-Chunk, Red Bird, took a stand in 1827 against white encroachment onto Ho-Chunk lands. He initiated a series of raids against settlers and miners as they moved illegally into Ho-Chunk territories, but later surrendered to the Americans. Red Bird's acts of resistance were not sanctioned by the Ho-Chunk leadership as a whole, but the United States government would later hold the entire tribe responsible for his attacks in order to secure a future land cession.[8] While in Washington, D.C., Ho-Chunk leaders negotiated for his release. But the terms were devastating: the Ho-Chunk had to surrender their lands in the lead region. Tragically, Red Bird was never released from prison; he died of dysentery in 1828.

The Ho-Chunk were forced to give up their mineral-rich lands in the treaty of 1829. The Ho-Chunk "sold" 2.5 million mineral-rich acres in Wisconsin and Illinois to the U.S. government for the shockingly low sum of 29 cents an acre. Even by a conservative estimate, the land was valued at $1.25 an acre. Because of the sale, six hundred to seven hundred Ho-Chunk people were forced to move; most were members of the Rock River Band.[9] The loss of the lead-rich land weighed heavily in the hearts and minds of the Ho-Chunk as leader Spoon Decorah stated, "[W]e never saw any of our lead again, except what we paid dearly for; and we never will have any given to us, unless it be fired at us out of white men's guns, to kill us off."[10]

In 1832, the United States forced the Ho-Chunk to the treaty table once again because of their alleged involvement in the Black Hawk War. The charge gave the government the excuse it needed to force the Ho-Chunk to give up lands south of the Fox–Wisconsin River portage.[11] This treaty was the first signed after Congress's passage of the 1830 Removal Act, a federal law that allowed for the wholesale removal of Native Americans from one land to another. The 1832 treaty with the Ho-Chunk contained a removal order: the Ho-Chunk were to be removed to land in Iowa, called the Neutral Ground, designed to be a buffer zone between the Sac and Fox and the Dakota Nations. All that remained of the Ho-Chunk lands in Wisconsin were located north of the Wisconsin River. The government acquired these lands in 1837.

The treaty of 1837 was signed in Washington, D.C., by twenty Ho-Chunk leaders, none of whom were authorized to negotiate a land cession treaty. In Ho-Chunk culture, only Bear clan leaders could enter into land negotiations; there were not enough Bear clan members of sufficient age and authority present in the delegation. Steadfast in their determination to keep what remained of our aboriginal homeland, the Ho-Chunk leadership made this maneuver intentionally to show their opposition to ceding land.[12]

Many of the treaties negotiated between Indigenous nations and the United States government were signed under horrific circumstances, but the signing of this treaty seems particularly egregious. After a long period of negotiation, the Ho-Chunk representatives were forced to sign away all of our lands in Wisconsin. The first article of the treaty states, "The Winnebago nation of Indians cede to the United States all their land east of the Mississippi river."[13] In a powerful quote, Ho-Chunk leader Dandy described what compelled the men to relinquish control of our homelands after long, painful negotiations: "[T]heir [Indian] agent told them . . . if they did not sign the treaty, he would . . . kill them."[14] At the

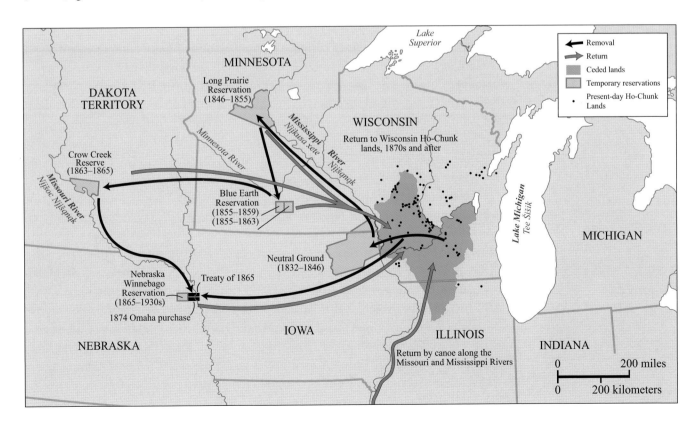

time of the treaty signing, the leaders were also told that the Ho-Chunk would have eight years to move to the Neutral Ground in Iowa, but the treaty actually stated that we had eight months. Our removal out of Wisconsin began.

The first official order to remove the Ho-Chunk Nation occurred in 1840; investigations into the 1837 treaty negotiations had delayed the process by several years.[15] A majority of the tribe was then forced from our homelands, and close to one thousand people died as a result of the horrific journey and poor living conditions on the Iowa reservation in the summer and fall of 1840.[16] Our removal from our ancestral lands was brutal and heartbreaking. I cannot even imagine the pain my ancestors felt as they faced leaving their beloved homelands. A witness to the removal, John T. De La Ronde, relayed the following about the great sorrow of the people: "Two old women, sisters of Black Wolf, and another one, came up, throwing themselves on their knees, crying and beseeching Captain Sumner to kill them, that they were old, and would rather die and be buried with their fathers, mothers, and children, than be taken away; and that they were ready to receive their death blows."[17] Later, he came upon another Ho-Chunk group "on their knees, kissing the ground, and crying very loud, where their relatives were buried."[18]

Our time on the Neutral Ground reservation proved to be short-lived. Fueled by their belief in manifest destiny and their "divine right" to settle the west, white settlers once again invaded our rich farming lands in Iowa. Following the signing of the treaty of 1846 that compelled us to relinquish the Iowa lands, the Ho-Chunk were removed to a reservation at Long Prairie in north-central Minnesota. Gull, a Ho-Chunk leader, expressed the ongoing heartbreak of the Ho-Chunk over these repeated removals: "We fear that our Great Father does not live in the fear of the Great Spirit or he would not ask us again to move from our lands. We have already given . . . a large and valuable portion of lands the Great Spirit gave us, and we greatly fear that his wrath will descend upon us if we move again."[19]

Dissatisfied with the poor farming conditions on the Long Prairie reservation and the lack of access to the Mississippi River, the Ho-Chunk negotiated for a new reservation beginning in 1853.[20] Ho-Chunk leader One Eyed Decora testified to the inadequacy of the Long Prairie reservation in 1855: "The brush is so thick we cannot get into it and if we could, the ground is so soft we could not stand upon it. There is no game in our country; it is fit for nothing but frogs, reptiles and mosquitoes."[21] In exchange for Long Prairie, the Ho-Chunk received land near the Blue Earth River in southern Minnesota following the signing of the treaty of 1855. This land proved more suitable for farming.

Almost as soon as we arrived on our reservation at Blue Earth, though, white citizenry began calling for our removal. The land at Blue Earth was fertile farmland and allowed us to have our crops and return to our seasonal agricultural activities. By all accounts, the Ho-Chunk at Blue Earth began to make a life on the reservation, following the preceding painful removals. For the most part, the Ho-Chunk were satisfied with the reservation, but our people faced serious attacks by the white citizens in the area.

One group in particular, the "Knights of the Forest," organized for the sole purpose of seeking our removal from the state. In an article published in the *Mankato Daily Review* in 1886, one of its members spoke about the organization, claiming that many of the leading men of the city had been involved in this group. He discussed how their members would "lie in ambush on the outskirts of the Winnebago Reservation, and shoot any Indian who might be observed outside the lines."[22]

Removal efforts only intensified after the U.S.–Dakota War of 1862, a war fought between the U.S. government and the Dakota Nation that left hundreds dead. Charles A. Chapman, one of the members of the Knights of the Forest, stated to the Mankato newspaper, "When the Sioux war was ended we saw that our safety from future massacres required the removal of all Indians from our neighborhood. Besides being a constant menace, they were occupying and rendering useless 234 square miles of the best farming land in Blue Earth county."[23] But the Mankato vigilante group was not alone in calling for our removal. A government agent at the time reflected the whites' desire to rid the state of both tribal nations: "While it may be true that a few Winnebagos were engaged in the atrocities of the Sioux . . . the exasperation of the people of Minnesota appears to be nearly as great toward the Winnebagos as toward the Sioux. They demand that the Winnebagos, as well, . . . be removed from the limits of the state."[24]

Although official government reports later confirmed that the Ho-Chunk remained on the reservation and had not participated in the U.S.–Dakota War of 1862, Minnesota's ethnic-cleansing policy called for the removal of both tribes from the southern part of the state. In 1863, both nations were sent to the Crow Creek Reservation in South Dakota. Close to 2,000 Ho-Chunk made the brutal journey, and more than 550 people died on our forced migration out of the state of Minnesota. John Blackhawk, grandson of Chief Coming Thunder Winneshiek, recounts the brutality of the removal:

> There are some few survivors of the band of that time still living, who went through those terrible days and shudder at the thought of them, when they were the helpless prey of the ruffian soldiers. Women and girls raped, men murdered, and all subjected to every insult and indignity that brutal men could invent. These outrageous things were inflicted upon the hapless victims for no other crime whatever except that they had been unfortunate enough to be born Indians.[25]

Crow Creek was a place of death far away from our ancestral lands—a place so horrible that my ancestors immediately began cutting down cottonwood trees to make dug-out canoes so they could flee. In 1865, the survivors moved to a new reservation in Nebraska near the Omaha Nation. This would become our last reservation. Tribal leader Baptiste Lasallieur recounted in 1863 the living conditions at Crow Creek that led to the mass exodus out of South Dakota: "We are not afraid to die, but we do not wish to die here. This country is unhealthy. All our people are becoming sick—our children and old people are dying every day. Father, never before have we had so many get sick and die. . . . If we stay here long, we think we will all die."[26]

Throughout these "removals" across four states, groups of our ancestors kept returning to Wisconsin, even though it meant living as "fugitives" in our homelands. Between 1840 and 1874, the government made various attempts to remove these determined ancestors to the Ho-Chunk reservation of the moment.[27] In 1874, the U.S. government's attempts at expelling us from our beloved homelands finally ended, and in 1881, legislation was passed that allowed the Ho-Chunk people to remain in Wisconsin.

That same year, the government created a census roll of Ho-Chunk living in the state. This roll has become the "base roll" according to which citizenship in the Ho-Chunk Nation of Wisconsin is determined today.[28] Many of the relatives listed on this "base roll"—survivors of the ethnic cleansing policies of the nineteenth century—are seen in

the photographs of Charles Van Schaick's collection, now housed at the Wisconsin Historical Society and reproduced in this volume.

BLOOD MEMORY AND PHOTOGRAPHIC IMAGES: THE LONETREE AND LITTLEJOHN FAMILIES

During the summer of 1993, I was immersed in researching this history while I was working on the *Common Ground* Ho-Chunk exhibit. Needless to say, this brutal, tragic past was foremost in my thoughts as I engaged with the photographs. These images are also of great personal importance, given the many conversations I had with my grandparents, Ann and Samuel Lonetree, and other family members in the summer of 1993. After I returned to Minnesota from Black River Falls, I shared with family members the photographs I found of our relatives (and in my grandmother's case, one of her). Photographs have the power to inspire conversations, clarify genealogical and historical information, recall anecdotes and humorous stories, discuss painful truths, and help us connect past and present.

One of the images that I discussed with my grandparents that summer was of my great-great grandfather Alex Lonetree. His Ho-Chunk name has become our family surname, and he is listed on the official tribal census roll of 1881. Alex is the son of Dave Tohee and Mary Hill, and he married Kate Winneshiek, daughter of John Winneshiek and granddaughter of Chief Coming Thunder Winneshiek. The Chief was the leader of the Ho-Chunk during the period of our forced removals in the nineteenth century. Repeatedly in the government documents, I came upon his words as he fought for our very survival as a nation. Alex and Kate's son is my great-grandfather, George Lonetree, who also had several portraits taken with friends and family at the Charles Van Schaick studio over the years. In all of these images George is shown wearing the clothing of the day, unlike his father, Alex, who had a majority of his photos taken in his regalia.

LEFT: My great-great-grandfather, Alec (Alex) Lonetree (NaENeeKeeKah), ca. 1910.

RIGHT: In this image, my great-grandfather, George Lonetree (HoonchXeDaGah), left, is seated next to Robert Greengrass (HoNutchNa-CooMeeKah), ca. 1920.

The portrait of Alex shows him in the center of the frame—a stocky man with a square wide face—wearing intertribal Native dress, including a floral bandolier bag across his shoulder. While others have identified his items of clothing as "Potawatomi leg bands, Chippewa bandoleers, and Arapaho moccasins,"[29] what stood out for me was having the opportunity to hold an image of the person whose name I carry and through whom my citizenship in the Ho-Chunk Nation is traced and recognized. The conversations with my grandparents clarified my genealogy that summer and reminded me how deeply and inextricably linked my personal family history is to the history of the Ho-Chunk Nation. I have heard repeatedly in Indigenous communities that family history is tribal history, and knowing exactly who you are and where your relatives come from is a source of strength and pride that no one can ever diminish.

One of the other images that I shared with my grandparents that summer—and one of my personal favorites—is of my grandmother, Ann Littlejohn Lonetree, standing with her sisters, Florence Littlejohn Lamere and Mary Littlejohn Fairbanks, around their mother, my great grandmother Rachel Whitedeer Littlejohn. I absolutely love this image. While other images of Rachel exist in the Van Schaick collection, this is the only one taken with her daughters. I remember fondly the look on my grandmother's face when she saw the photograph again many years after it was taken. Always a quiet, dignified woman, she smiled when she saw it, and her eyes lit up. She promptly told me who each of the individuals were in the frame, the proper spelling of their names, and what she recalled of the day when this photo was taken. While many people plan extensively for a studio portrait—deciding who should be included, what to wear, and how to style one's hair—my grandmother said that they had this portrait taken on the spur of the moment. They found themselves in Black Rivers Falls, decided to go into Van Schaick's studio, and then had the photo taken on the spot. I love the expressions on their faces and the contemporary feel of the photo. These are proud, attractive women, gazing straight into the camera and standing tall around their mother.

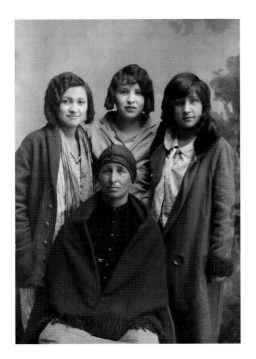 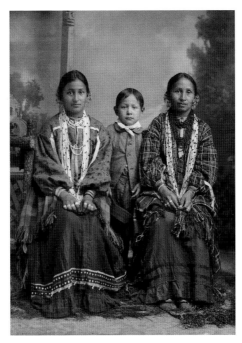

LEFT: My great-grandmother, Rachel Whitedeer Littlejohn (ENaKaHoNoKah), front, with daughters Florence Littlejohn Lamere (HoonchHeNooKah), left, Mary Littlejohn Fairbanks (WeHunKah), and Ann Littlejohn Lonetree (WakJa-XeNeWinKah), ca. 1930.

RIGHT: Several generations of the Lonetree and Littlejohn families are represented in the Van Schaick Collection. Seated from left to right are my great-aunt, Margaret Whitedeer Littlesam (NauChoPinWinKah), and my great-great-grandmother, Emma Stacy Whitedeer Lowery (HompInWinKah), sister and mother of Rachel Whitedeer Littlejohn. Standing between them is Lee Dick Littlesam (HaNotchANaCooNeeKah), ca. 1898.

For me, one of the most significant aspects of the Ho-Chunk photographs is that, while they were taken during the so-called dark ages of Native history, their existence provides visual proof of our presence. The images challenge the commonly held view that nothing of significance happened once Native people were confined to reservations in the nineteenth century, until the American Indian Movement's militant activism captured the public's imagination in the 1960s.[30] The photographs taken by Charles Van Schaick are an invaluable resource for Ho-Chunk people as we begin to document more fully our tribal history during the nineteenth and twentieth centuries. The images give us a sense of what life was like for our families and people during this period. The so-called dark ages of Native history are no longer as dark. This collection of photographic images powerfully conveys the importance of kinship, place, and memory, as well as ongoing colonialism—all central themes of the Ho-Chunk experience during the nineteenth and twentieth centuries. Every encounter with the images should begin with the recognition that you are not just looking at Indians; you are looking at survivors whose presence in the frame speaks to a larger story of Ho-Chunk survivance.

A Ho-Chunk Photographer Looks at Charles Van Schaick

Tom Jones

A s a member of the Ho-Chunk Nation and a photographer, I am honored to be part of this collaboration on Charles Van Schaick's photographs of the Ho-Chunk. This essay draws on visual records from the Charles Van Schaick collection housed at the Wisconsin Historical Society, combined with the oral histories of our elders. As I studied these photographs and shared them with family and tribal members, I discovered stories I had never known before. I began to understand that these photographs come with history, stories, and lives I could not fully know or experience. Even though I am culturally connected to the people represented in these photographs, I was uncertain at the outset whether I would be able to read these images truthfully or adeptly. Each photograph and each person comes with their own life history, and I was reading these photographs with twenty-first-century eyes. In the process of selecting images for the book, questions began to arise about viewership, my own and that of the general public: How do our ancestors shape our identities? When do we have to adapt our culture or our lives in order to survive? Is the physical home as important as the psychological home? How do non-Ho-Chunk perceive these photographs? To what extent does the viewer place falsehoods or misconceived histories onto an image?

When I look into the faces of the people within these photographs, I find that looking back are the faces of individual Ho-Chunk I see today. Anthropologists and historians who study and photograph particular ethnic groups have often used the word "typical," as in "a typical Ho-Chunk." This ethnographic code for describing a people as a tribe cannot be applied to the Ho-Chunk, because our history, like many American Indian peoples' histories, is so complex. As I showed the photographs to tribe members, many said, "That person looks like this family or that family." When a Ho-Chunk looks at these photographs, we distinguish each family differently. One has to understand that people came

into the tribe in many different ways. There were raids, intermarriages with other tribes or with non-Indians, and rapes of our women by United States soldiers during the forced Indian removals. My grandfather, Jim Funmaker, who was born in 1904 and lived to be 100 years old, shared with me that members of other tribes were adopted as Ho-Chunk. As a result, each family looks different. So, what is a "typical" Ho-Chunk? This cannot be answered visually, but I believe it can be answered culturally.

There is an unstated complexity in the way a photograph is read by individuals from different cultures and backgrounds. Each time a photograph is encountered, the viewer will decipher the image with constructed imagination or constructed knowledge. There are also the intentions of the photographer and subject. What has the photographer decided to show us and what has the sitter decided to reveal? I believe that in the end, Van Schaick's studio portraits become more about the sitter than the photographer or viewer. To understand the photographs more fully, it is our task as viewers to add the historical contexts back in. Whether we read these photographs through the lens of tribal history or through family stories, the interpretation we place on the image today comes from our understanding of what the people in the photographs have experienced.

Without stories or history, the photographs in this collection have little meaning. Take the copy photograph that Van Schaick made from an unknown photographer for the sitters, Henry Thunder and my great-grandfather George Funmaker Sr. Both men look directly at the camera, each firmly positioned for the long camera exposure. Henry holds a traditional pipe, while my great-grandfather nonchalantly holds a cigar. A Ho-Chunk finger-woven sash is draped over his shoulders. The two young men exhibit a casual comfort with the camera. Both wear a mixture of Ho-Chunk and Western clothing. Their long earrings graze their suitcoats. The viewer who takes this photograph at face value might think, "Look at the visual contrast of traditional and contemporary." In reality, only ten years before, my great-grandfather was ice-skating on a pond when the United States sol-

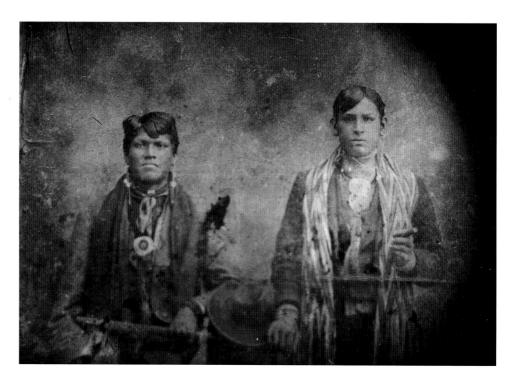

Henry Thunder (WahQua-HoPinKah), left, and George Funmaker Sr. (WojhTchaw-HeRayKah), ca. 1888.

diers rounded him up at gunpoint along with the rest of his village. He was twelve at the time. In the dead of winter, they herded them onto railroad boxcars to be sent west in one of the last forced Ho-Chunk removals in the 1870s. When they were relocated they were allowed to bring only what they could carry. Many families were separated, the villages were burned, and sacred objects were lost. Numerous Ho-Chunk lost their lives along the way. I marvel at the casualness of this image and the visual power that the two men evoke. Is this only because I bring the stories that I have heard to the photograph?

What the photographs in this collection cannot convey are the hardships and struggles of the removals of the Ho-Chunk, especially during the removal period of the 1830s to the 1870s. For many years my ancestors lived as refugees in Minnesota, North Dakota, South Dakota, Iowa, and Nebraska. Each time they were deprived of food and warmth. As many as eight hundred people died of starvation during these journeys. The Ho-Chunk were removed from their homeland at least eleven times over the course of more than forty years by the United States government. Dissatisfied with the conditions of the land in which they were placed, they returned again and again to their original territory. They would travel at night and hide during the day. I asked my mother, Jo Ann Jones, why our people continued to return to Wisconsin. Her reply was, "My father told me that the Great Spirit placed us here and we were to take care of our ways of life here."

When viewing these photographs one has to imagine the period of the 1870s, when many groups of Ho-Chunk returned to Wisconsin for the last time on foot, horseback, or canoe from Nebraska. They eventually settled in sixteen counties throughout Wisconsin where we originally resided. Around 1880, Charles Van Schaick began photographing the Ho-Chunk in Black River Falls as part of his work as a studio photographer. He continued until the early 1940s. By that time, Ho-Chunk were returning to the Nebraska reservation in cars to visit relatives and tribal members from whom they had been physically separated years before.

Despite the terrible history of the removals and the poor treatment of Native peoples by the U.S. government, Van Schaick's photography of the Ho-Chunk is not exploitative or intrusive. He worked as a commercial photographer and the Ho-Chunk were his clients. Photographers who were his contemporaries took different approaches when photographing the Indian; Edward Curtis used his photographs to depict what he saw as a vanishing race, and H. H. Bennett to promote tourism in the Wisconsin Dells. The photographs Van Schaick produced of the Ho-Chunk who settled in and around Black River Falls were not used as a commodity to be distributed to the public. The Ho-Chunk commissioned these postcard photographs for their homes and to be given as gifts to family and friends. They were shared with family members in Wisconsin, Iowa, Minnesota, and Nebraska. Van Schaick would often make multiples of the photographs so family members could come to his studio and buy them at a later date.

A man sleeping in a chair, possibly Thomas Thunder (HoonkHaGaKah). On the back wall of Van Schaick's studio are photographs he made available for purchase.

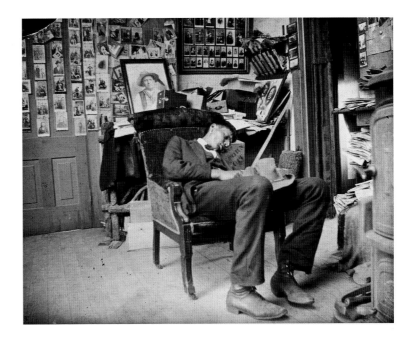

Because Van Schaick's photographs of Ho-Chunk were for personal rather than public consumption, their worth is unique. The Ho-Chunk were not visual props for the photographer. The Ho-Chunk presented themselves to the camera the way they wanted to be seen, often, especially in earlier years, in traditional Ho-Chunk regalia. In terms of technique, Van Schaick preferred to photograph his clients in a full-body style—from head to toe, rather than a head portrait or half-frame. He rarely did any type of close-up on the Ho-Chunk until later years. It is likely Van Schaick's Ho-Chunk clients wanted to show their complete outfits. In later years, as Ho-Chunk began to wear Western clothing, Van Schaick employed a close-up style that he was already using with white subjects. In the majority of photographs, early and late, the Ho-Chunk sitter looks directly at the viewer. The sitter is not stoically looking off in the distance as seen in the work of many of Van Schaick's contemporaries. This direct view is consistent with the way Van Schaick photographed white subjects and may simply have been Van Schaick's style for taking portraits (see below).

To the viewer with no cultural background in Ho-Chunk history, the stories behind the photographs are not easily accessible. Such stories give the background necessary to understand particular images. In an interview with Flora Thundercloud Funmaker Bearheart conducted by Frances Perry, the Black River Falls librarian and the town's un-official historian, Flora tells a story from her mother, Annie Blowsnake Thundercloud's youth. Annie came to the studio to have her picture taken wearing the new appliqué dress she had sewn for herself (see page 44). The photograph was not what she expected. Moments before it was taken, her mother draped several necklaces of white bugles and shells around Annie's neck. They completely covered the fine handwork of her appliqué. As viewers, would we ever be able to discern this in her expression? Further, would we guess that the picture was taken to send to relatives and friends in other settlements to notify eligible young men about her looks and her eligibility as a future wife?

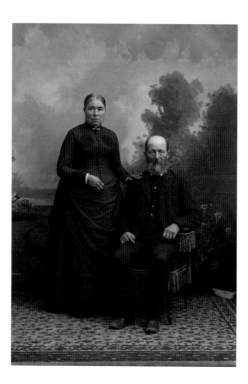 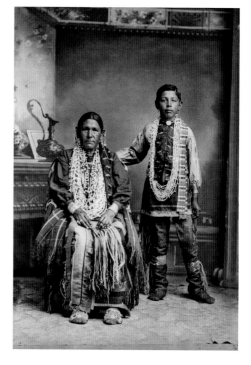

LEFT: An unidentified white man and woman.

RIGHT: Susie Kingswan (HeNuKah) and her son Fred Kingswan (MaHeNoGinKah), ca. 1894.

When I looked closely at another photograph of a group of beautifully dressed Ho-Chunk, I recognized a few of these people as members of the medicine lodge (see page 51). I was not sure why the seated woman, Lucy Emerson Brown, had the markings on her cheeks that are worn when a new member joins the medicine lodge. An elder, Delphine Swallow, explained to me that Lucy was trying to be pretty. This was the Ho-Chunk interpretation of white women wearing rouge, and it can be seen in other photographs of the time (see page 160). Amy Lonetree, whose great-great-grandfather, Alex Lonetree, stands directly behind Lucy, related another story about this image to me. Many non-Ho-Chunk would ask, "What kind of shirt is he wearing?" and "Is it traditional?" In fact, Alex was in downtown Black River Falls and saw the jester-like shirt in the store window. He liked the shirt and bought it.

Van Schaick did not limit his work to studio photography. Outside the studio, his photographs act as snapshots. They lose the formality of the studio and become loose and carefree. Starting around 1895, he used the 4 × 5 glass plate negative camera like a brownie camera; although it was not compact, it was mobile, and didn't require the long exposure times of the studio. With this camera Van Schaick chronicled what happened in real time at powwows, in home settings, and on the streets of Black River Falls (see pages 105, 124, bottom, and 129). He was not staging a romantic ideal of what was, or intruding where he was not welcome; like other whites, he was a spectator at powwows, which were not closed to outsiders. The Ho-Chunk were his neighbors, his fellow townspeople with whom he interacted outside the studio. His outdoor environmental photography shows us the everyday, the celebrations, the harvest, the sick, the homes, the religious, and the ceremonial.

On the surface it may seem that going to where one's subjects live is more authentic than having them come to the studio. Is this really so? Do our preconceptions play a part? Take the image of the home compared to the portrait in the studio (see pages 122, bottom, and 171). Some individuals who came to Van Schaick's studio to be photographed in their finery were living in canvas-covered tents or ciiporoke. Does this knowledge affect the viewer's interpretation? In a newspaper article for the *Chicago Daily Tribune* on December 22, 1931, Rev. Ben Stucki of Neillsville gives us a glimpse into the Ho-Chunk culture. He writes,

> The Indian knows no social inequality. A man is a man whether he is dressed in rags or beautiful robes, and the Indian always shares his food with those less fortunate. The Indian feels that all he has belongs to the Great Spirit and that it was sent for the needs of all. Indians are naturally honest and there is no thievery among them. They lock their tents by laying a stick in front of the door and no Indian would think of entering a tent marked in that way.

"In the forty years we lived with the Winnebagos in Jackson county," states Rev. Stucki, "Nothing was stolen from our home by the Indians, but I cannot say as much for the White people." An example of locking their ciiporoke in order to let people know they were not home can be seen in the image of a board leaning near the door (see page 124, top). My grandfather, Jim Funmaker, who was born near Trempeleau, Wisconsin, lived in a traditional ciiporoke with his family.

When my grandfather was ninety-eight years old, my mother asked him who his friends were when he was young. His reply was, "I didn't have any friends." Because our

George Funmaker Sr. (Wojh-TchawHeRayKah) is surrounded by his three youngest sons, ca. 1915. Standing left to right are George Funmaker Jr. (Hoonk-MeNukKah), Harold Jones (WaNaChaySheNaSheKah), and James (Jim) Funmaker (HaHayMonEKah).

elders are constantly joking I thought he was too, so I laughed. He paused and then continued to say that his father, George Funmaker Sr., kept his family and children away from others during times of sickness. Tuberculosis and influenza were going around at this time. It was a few years before my grandfather's birth in 1904 that smallpox was brought into the tribe again. These diseases killed many people within the tribe and also some of the individuals who are represented in these photographs.

Van Schaick's photographs preserve this difficult time in our history. When he photographed the smallpox epidemic of 1901, what was his original intent? Who was the audience for these images? Seeing the heartbreaking photographs of the children with smallpox was painful for me. I wanted to look away, but at the same time I also wanted it burned into my memory in order to never forget a disastrous part of our history. This is a tragic story that I have heard countless times, passed down from our elders, about the devastation of diseases like smallpox and influenza on the tribe's population. One of the earlier smallpox epidemics was purposely introduced through contaminated blankets from the United States government as a means of wiping out Native populations.

During the 1901 outbreak, government officials conjectured that Indians from Nebraska had brought the disease to Black River Falls. In a letter dated September 2, 1901, to Wisconsin Attorney General E. R. Hicks, State Board of Health Secretary Dr. U.O.B. Wingate requested that the Ho-Chunk pay for the expenses of his mandated quarantine by deducting the costs from their monthly allotment money.

These photographs, and that letter, are evidence of a devastating time in Ho-Chunk and American history and should never be silenced. It is through the photographs that we have been given a concrete image of this human suffering. Here is a visual record of why so many families were extinguished. Do these images affect a Native American dif-

Two unidentified young Ho-Chunk girls with smallpox are kneeling outside their lodge. Some of the Ho-Chunk suffering from smallpox were quarantined during the 1901 outbreak.

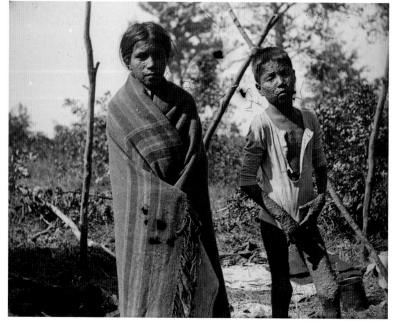

An unidentified young Ho-Chunk boy and girl with smallpox stand outside of their home.

ferently than they would a non-Indian? These horrific images place a new burden on all viewers of these photographs to learn more about the history of the American Indian and the devastating policies enacted by the American government.

It is important that there be no silencing of history or censoring of photographic images that Ho-Chunk and non-Ho-Chunk do not want to be seen. They are a part of our lives, our truths, and our history. Another burden of our history that can be seen in these photographs is the drinking of alcohol. A common photographic convention during Van Schaick's career was for sitters to be photographed with a glass or bottle of alcohol. These bottles were props that Van Schaick furnished for his sitters. A liquor bottle, shot glasses, and a round carafe can be seen in photographs of both white and Ho-Chunk sitters (see page 206). Here is a case that is ripe for censorship. Alcoholism is an issue that many Indians do not want to confront, but these photographs document this issue and should not be ignored. When we view these photographs we maybe able to laugh it off, but it is important to not turn away from this destructive problem.

One of Van Schaick's most iconic images of the Ho-Chunk is a photograph of two seated Ho-Chunk women, laughing with one's arm wrapped around the other's shoulder and their hands slightly raised. The viewer with an untrained eye is often drawn to this image because the women are joking, animated, and smiling. A closer look reveals that part of the photo has been retouched: in the women's hands, etched out, is the shape of a whiskey bottle. Who etched the bottle out? Was it Van Schaick, or one of his assistants? Was it etched out at a later date? Who decided to censor the evidence of alcohol, and why? Could it have been at the request of the sitters themselves?

Is the evidence of alcohol in the image a means of coping or are the Ho-Chunk in these images acting out in a humorous fashion? It is the Ho-Chunk humor that I believe has helped us cope with the tragedies we face and have faced as a people. The span of Van Schaick's career coincided with the turbulent transition in Ho-Chunk culture from being able to freely hunt for food to feed one's family to needing a permit to hunt or needing to rely on the government relief office for food. Decisions about permits and relief were often made on a whim by relief workers, who could take an individual's drivers' license or car keys away. Only then would they offer relief. As I read the *Banner Journal* articles of Ho-Chunk journalist Charles Low Cloud for inspiration, I came across this writing, "Shoes Don't Grow," from November 22, 1939, by a young girl that sums up the relationship with the government relief office and our Ho-Chunk humor (see page 209). Doris (Dolly) Stacy writes, "One day a mother went up to the relief lady and said, 'May I have some shoes for my girl?'

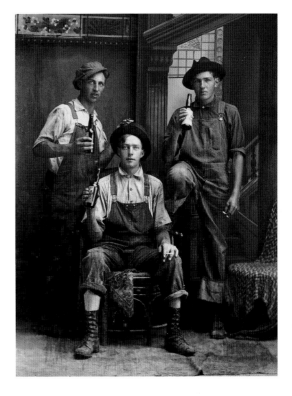

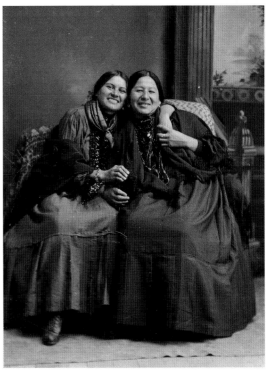

TOP: Three unidentified white men dressed in bib overalls holding cigarettes and beer bottles, ca. 1900.

ABOVE: Clara St. Cyr, a Nebraska Winnebago, left, and Lucy Davis (NukZeeKah), the sister of John Davis (KaRoJoSepSkaKah), ca. 1900.

The relief lady answered, 'I think not, as you had a big garden last summer.' The mother answered, 'But I did not grow shoes in the garden.'"

This Ho-Chunk humor does not always come through within the photographs of Van Schaick, but there are glimpses, such as Frisk Cloud riding a cow during a gathering for a powwow, or the quirky image of the man with an apple in his mouth.

Many visual codes make these images specifically Ho-Chunk. Take the example of a group of men standing outside at a powwow (see page 113, bottom). Standing shoulder to shoulder, each of the men holds what appears to be a walking stick. In actuality, this lets other Ho-Chunk know that these men are from the Bear clan, whose responsibility it is to police the people and keep order within the tribe. Another example is the man wrapped in a blanket leading a horse during winter. The man, who is identified as David Good-village, is shown in the process of moving his camp in order to hunt and trap at the Mississippi River near Marshland, Wisconsin. It was common for Ho-Chunk to have summer and winter camps during this period. One was for farming and the other for hunting and trapping. The horse carries on its back the cattail reed mats that would be used to cover David's home; snowshoes hang from the other side.

Throughout the history of photography the photographic image has simulated cultures, but there are times when members of a distinct culture also use photography to their own advantage. Does Van Schaick's photography show the evolution of culture or does it contribute to the misconception of culture? Visual cues can be misleading if we do not know the context. For instance, the dominant stereotype of the Indian man with long hair is rarely visible in these photographs. This was not the hairstyle of Ho-Chunk men during the time period that Van Schaick photographed. Only a few examples of long hair exist in the collection. These are men who traveled the world as performers in Wild West shows (see page 110). They were Indians playing Indian for the general public. Who perpetuated this myth? The Ho-Chunk who participated or the whites who attended the performances?

LEFT: Frisk Cloud (MauhHeTa-ChaEKah) riding a cow at a powwow, ca. 1905. Watching Frisk, left to right, are two unidentified men, likely Ho-Chunk, Albert Thunder (CheNunkEToKaRaKah), George Monegar (EwaOna-GinKah), Andrew Bigsoldier (WaConChaShootchKah), and an unidentified white man.

RIGHT: An unidentified man, seated with his family, with an apple in his mouth.

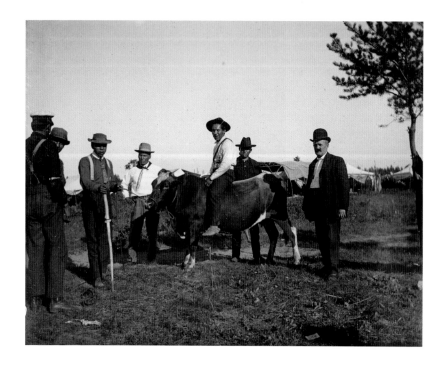

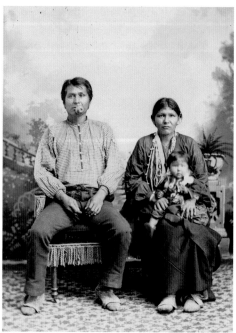

Ironically, Wild West shows did influence Ho-Chunk dress. The Plains Indian war bonnet was introduced at the turn of the nineteenth century, during Wild West shows in which many Ho-Chunk participated. Though it was used initially only when performing, it has become a part of the Ho-Chunk culture that continues today, a visual marker of those who have warrior or chief status. Thomas Thunder, pictured in full regalia with an elaborate war bonnet, was a powwow organizer and performer in Wisconsin Dells (see page 85). Benjamin Raymond Thundercloud was photographed in similar clothing in 1912 (see page 45). Traditionally, an eagle feather on a stick also signifies warrior status, as in the portrait of Civil War veteran John Johnson (see page 100). Today we see eagle staffs that are elaborate, with many feathers.

David Goodvillage (WauHe-TonChoEKah) with his horse loaded with supplies, including cattail mats, snowshoes, and canvases, for a hunting and trapping trip at Marshland near the Mississippi River.

Taken over a sixty-year span, these photographs show the visual evolution of Ho-Chunk culture. Van Schaick does not create a static fiction like Edward Curtis, who constructed his photographs in order to create a visual record and a way of life before white contact. Ours is not a stagnant culture. The Ho-Chunk were adapting to, not assimilating to, societal changes, just like any other persons of this time. Do we ask the German farmer why he no longer uses a horse and plow to till the earth? Why, then, does contemporary culture question the shift to modern dress and modern textiles? Originally, buckskin was the material used to make clothing, but with the introduction of European trade cloth, Ho-Chunk women adapted to this more readily available textile. While each woman has her own variation in style or design, they keep the basic design in this transformed traditional woman's dress (hinųkwaje). The Ho-Chunk women in these photographs continued to hold hard to their traditional dress style, just as Ho-Chunk women continue to do today, in turn keeping the Ho-Chunk heritage alive while adapting to the current culture.

The studio and environmental portraits created by Charles Van Schaick in collaboration with the Ho-Chunk are a valuable archive of a people. They do much to dispel the popular myth of a "typical Ho-Chunk." The Ho-Chunk came to the studio in control of how they wanted to be represented. Through these incredible photographs they preserved and passed on their identity as a people and a way of life. For me, the photographs have become a reminder and a memorial of a people who had a strength, determination, and resilience to survive and fight for their people, their land, and their culture.

GALLERIES

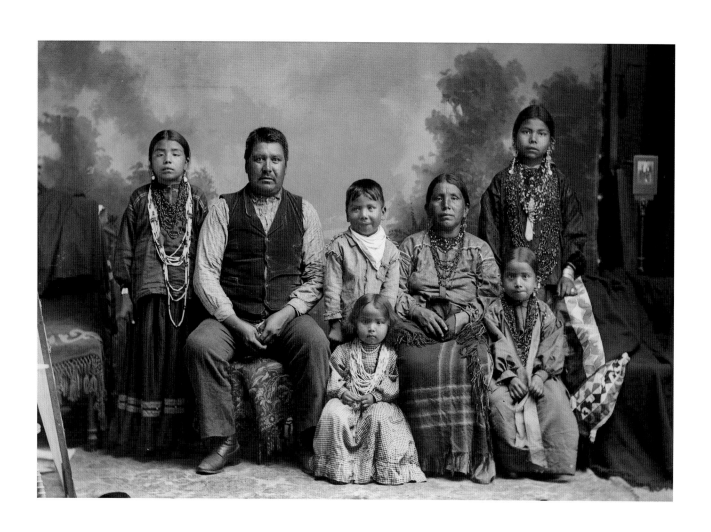

FAMILIES AND KINSHIP

THE HO-CHUNK FAMILY AND KINSHIP STRUCTURE is quite complicated when compared to European American families and extended families. In the Ho-Chunk language, there are over ninety male kinship terms of address. Many kinship terms, especially for one's immediate and extended family, are still in use today.

The terms of address for both men and women for the relatives of their parents and grandparents are the same. Maternal and paternal grandparents, great-grandparents, and all relatives from these generations are addressed as Cooka, translated as grandfather, and Gaaga, translated as grandmother.

One's father and his brothers are addressed by the same name, Jaaji, which translates as father, and one's paternal aunts are addressed as Cųųwį, which translates as aunt. One's mother and her sisters are addressed as Nąąnį, which translates as mother, and one's maternal uncles are called Teega, which translates as uncle. These male and female terms, Teega and Nąąnį, are also used for one's maternal uncle's children. These relatives are referred to in English as "little uncle" and "little mother."

Men and women use separate terms for the children of their maternal aunts, paternal uncles, and paternal aunts. Even though these cousins have different terms of address, they are considered to be brothers and sisters. Often when a Ho-Chunk speaks about a brother or sister, they are actually talking about what a European American would consider a cousin.

A man's brother's children are regarded as his sons and daughters and are addressed as Hinik (son) and Hinuk (daughter), while his sister's children are called Cuusge (nephew) and Cuuzak (niece). Similarly, a woman considers her sister's children as her own and addresses them as Hinik and Hinuk, and her brother's children as Cuusge and Cuuzak. Cuusge and Cuuzak are also used by older relatives and may be translated as grandson and granddaughter.

There is a special relationship between a maternal uncle (Teega) and his sister's children. A Teega is considered more closely related to his nephews and nieces than to his own children. A Teega will give his maternal nephews and nieces whatever they ask for, and in return they will do whatever he asks. They also have what is known as a "teasing" or "joking" relationship. This reciprocal relationship also exists between a paternal aunt (Cųųwį) and her nephews and nieces, and between a woman and her brothers-in-law and a man and his sisters-in-law. These kinship and joking relationships are still practiced among the Ho-Chunk.

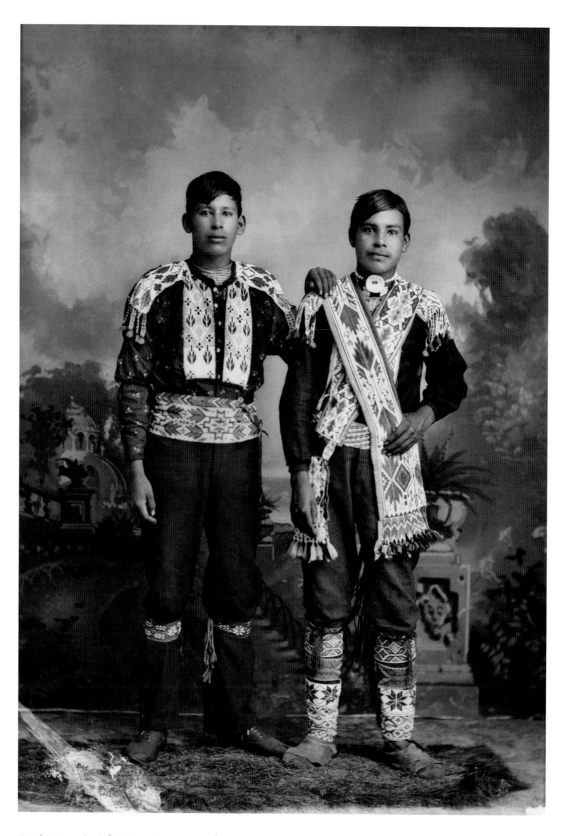

Frank Winneshiek (WaConChaHoNoKah), left, and Henry Winneshiek (WaConChaRooNayKah), ca. 1894. Both are wearing beaded shirts, belts, and garters. Henry is wearing Ho-Chunk moccasins, two bandolier bags, and a bone choker with a shell. Traditionally this choker was worn as armor to protect the throat during battle.

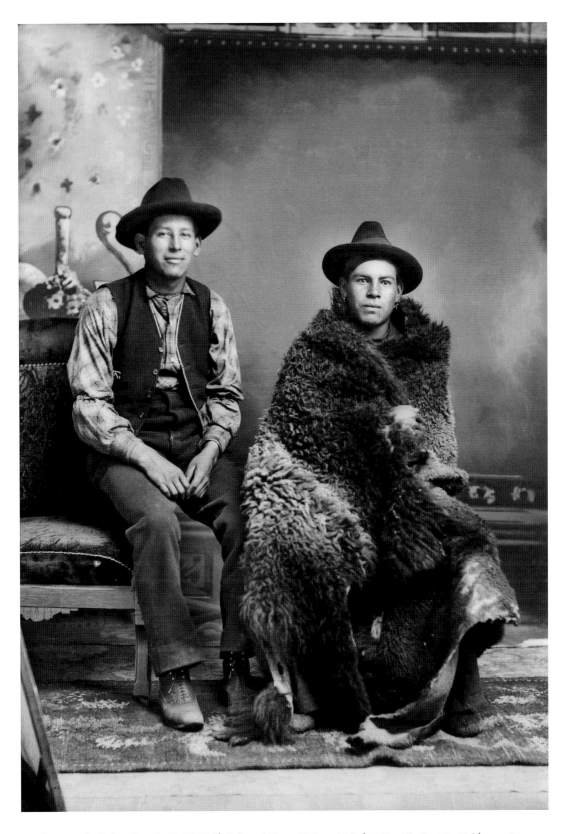

Frank Winneshiek (WaConChaHoNoKah), left, and Henry Winneshiek (WaConChaRooNayKah), wearing a buffalo robe (waį cexjį), ca. 1899.

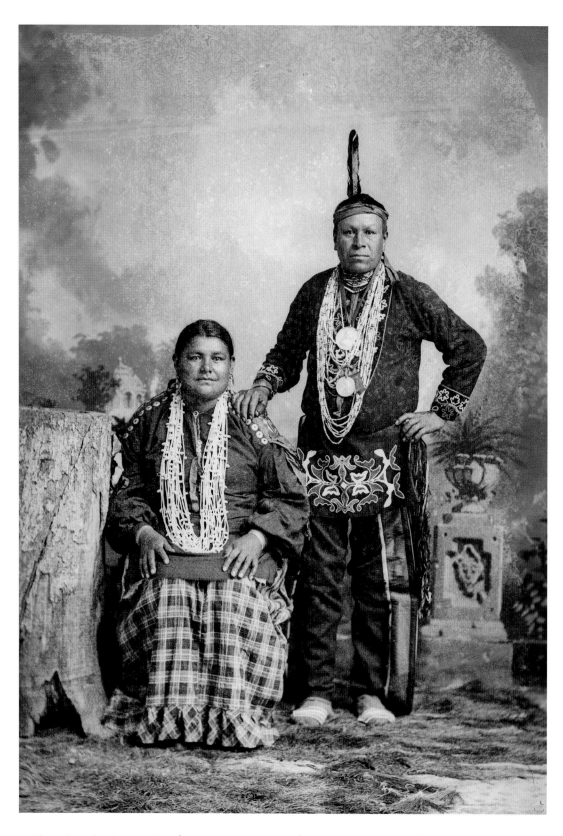

Liddy Walkingcloud Winneshiek (KsoonchEMonEWinKah) and her husband, Little (Nady) Winneshiek (NoGinKah), ca. 1895. Little Winneshiek wears a finger-woven sash and eagle feather on his head and two George Washington Indian Peace Medals around his neck.

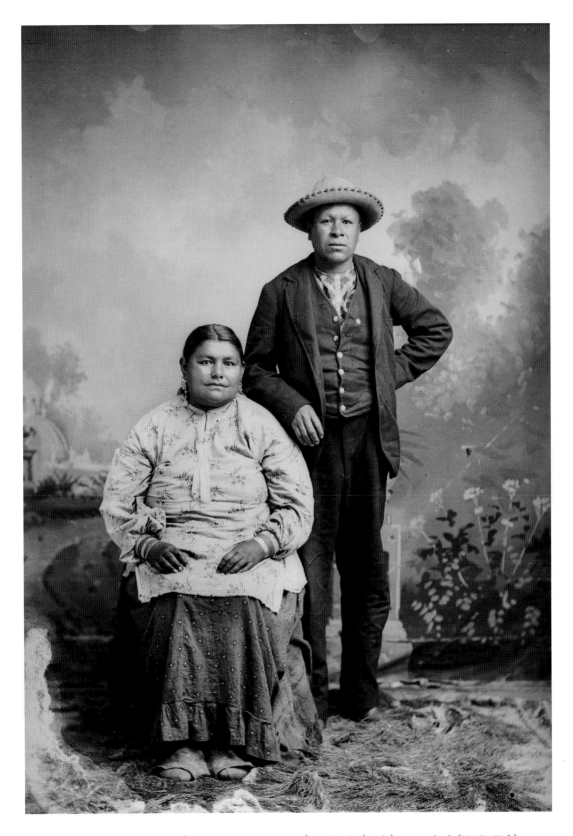

Liddy Walkingcloud Winneshiek (KsoonchEMonEWinKah) and Little (Nady) Winneshiek (NoGinKah), ca. 1895.

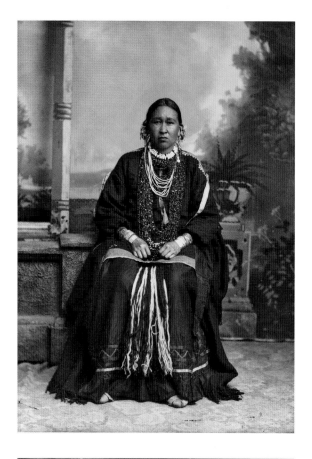

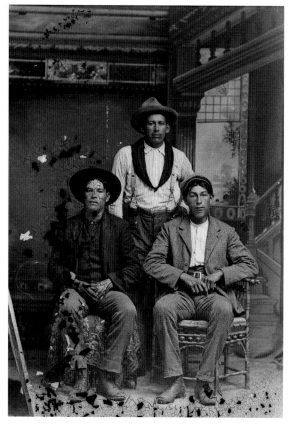

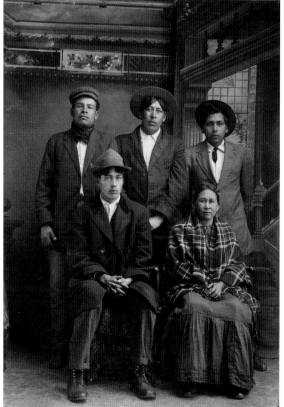

Clockwise from top left:

Lucy Long-Wolf Winneshiek (ShunkChunkAWinKah), ca. 1895.

From left to right, Henry Winneshiek (WaConChaRoo-NayKah), Frank Winneshiek (WaConChaHoNoKah), and Richard (Luther) Winneshiek (MaHeKeeZheeNaKah), ca. 1905.

John Blackhawk (NoJumpKah) is seated to the left of Lucy Long-Wolf Winneshiek (ShunkChunkAWinKah), ca. 1904. Standing left to right are Henry Winneshiek (WaConCha-RooNayKah), Edward Winneshiek (NaZhooMonEKah), and George Lonetree (HoonchXeDaGah).

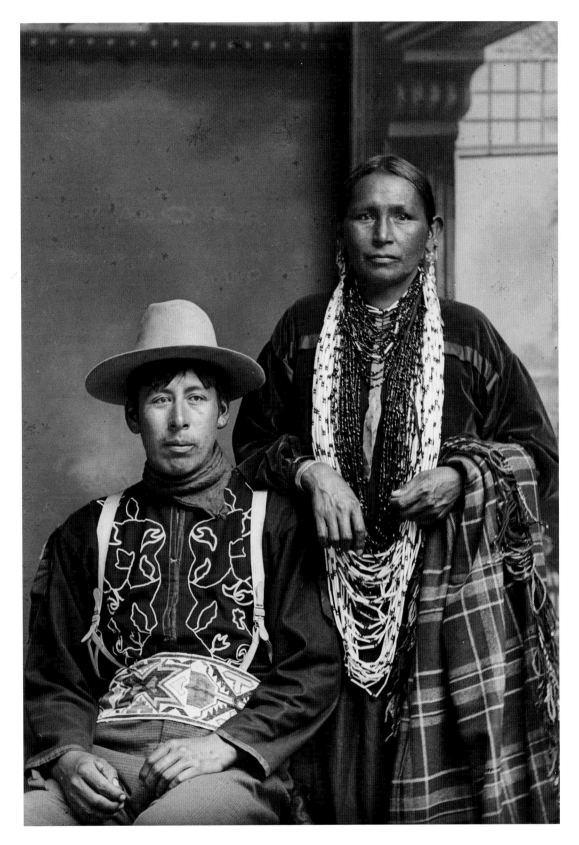

Edward Winneshiek (NaZhooMonEKah), left, wearing a rare floral hand-beaded Ho-Chunk shirt and loom-beaded belt, sits next to Annie Lucy Yankee Bill (HaTaHeMonEWinKah).

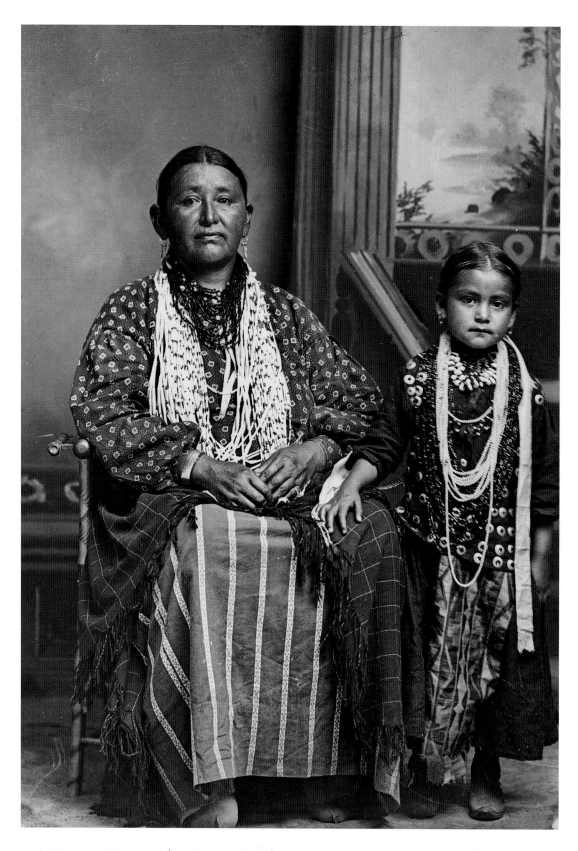

Rachel Funmaker Winneshiek (HockJawKooWinKah), left, is seated next to Fannie Winneshiek (HoChunkEHo-NoNeekKah), ca. 1904.

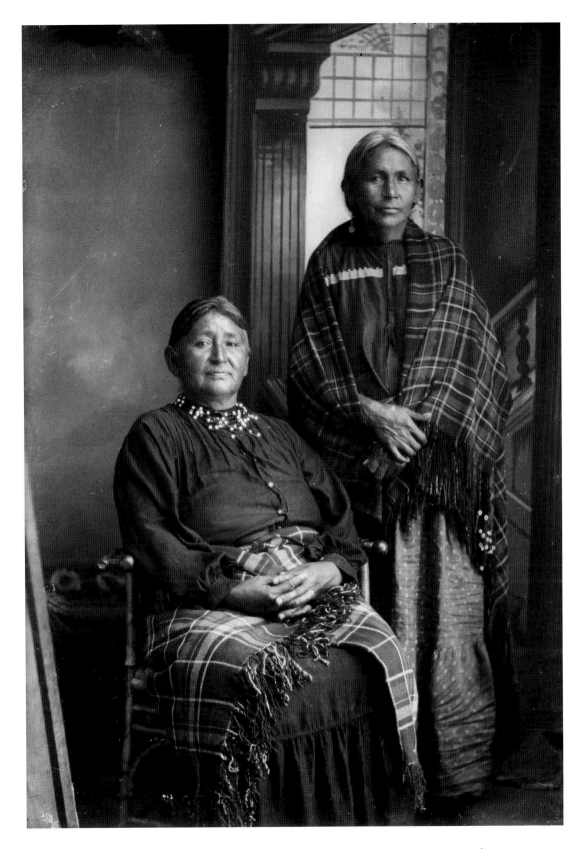

Rachel Funmaker Winneshiek (HockJawKooWinKah) sits next to Mary Thunderchief Snowball (WaSayMaKa-WinKah).

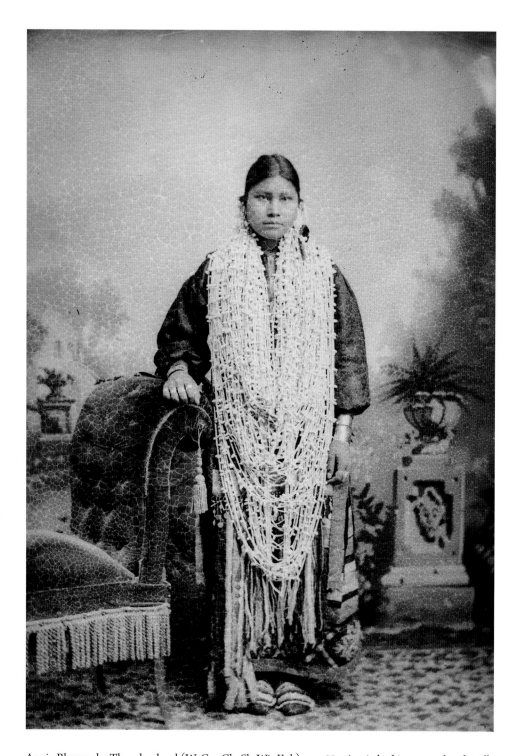

Annie Blowsnake Thundercloud (WaConChaSkaWinKah), ca. 1882. Annie had just completed a silk appliqué dress (wawaje) when she stopped in at Van Schaick's studio. Moments before the photograph was taken, Annie's mother draped several large necklaces of white bugles and shells around her neck, completely covering her appliqué. Annie's face registers her disappointment. Fine regalia complements the ensemble: silver bracelets (žuura sgaa aipa), earrings (woorušik), rings (nąąp hirusgic), and traditional Ho-Chunk moccasins (caahawaguje).

Photographs of this type were made into postcards and sent to relatives in other Ho-Chunk settlements to serve as notice to eligible young men of the young woman's appearance and dowry in wampum necklaces (wanąpį) and jewelry.

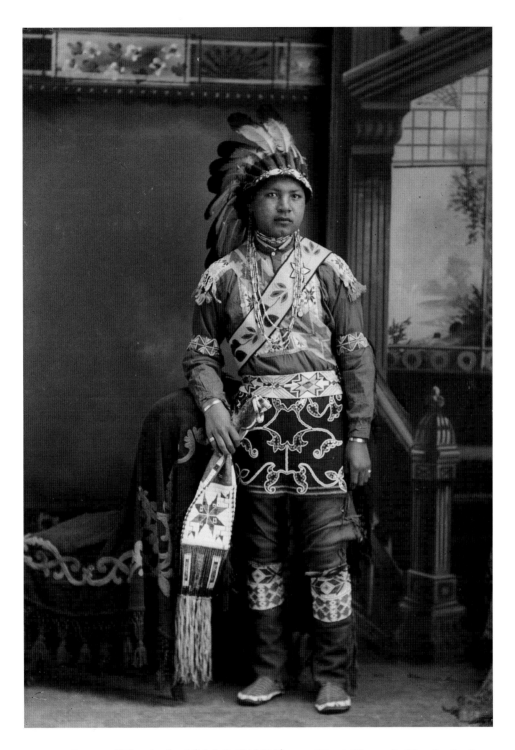

Benjamin Raymond Thundercloud (NySaGaShiskKah), son of Annie Blowsnake Thundercloud (WaConChaSkaWinKah) and Moheek Thundercloud (MaZheeWeeKah), wears a mix of Ho-Chunk regalia and items from other tribes, ca. 1912. The eagle feather bonnet, commonly referred to as a war bonnet (mąąšų wookąnąk), was not traditionally worn by the Ho-Chunk but was adopted from the Plains tribes after the Ho-Chunk participated in Wild West shows. His shirt (woonąžį) is a traditional Ho-Chunk beaded shirt with loom-beaded strips sewn on the shoulders and the upper front. The beaded armbands (aapara), beaded belt (ceehį), garters, and breechcloth (táanį wóroh'įc) are Ho-Chunk. The pipe bag and moccasins are a Plains Indian style.

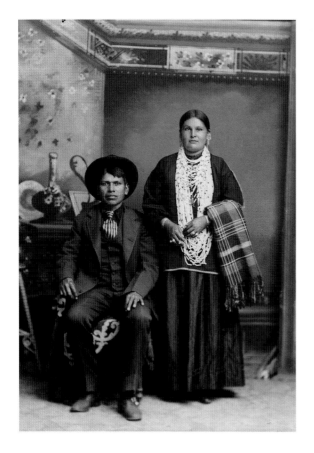

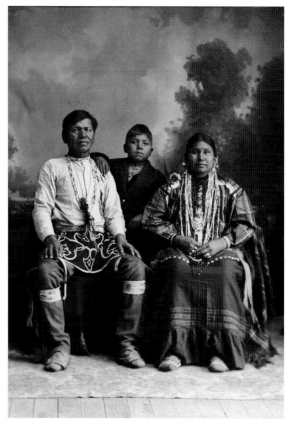

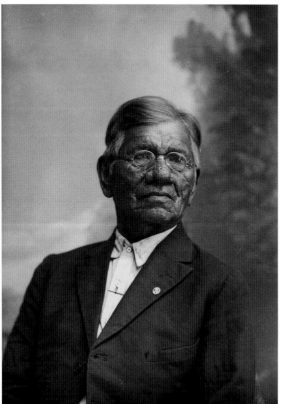

Clockwise from top left:

Henry Thunder (WahQuaHoPinKah) and Soldier Woman (MahNaPayWinKah), ca. 1905.

Moheek Thundercloud (MaZheeWeeKah) and Annie Blowsnake Thundercloud (WaConChaSkaWinKah), seated in front of their son, Benjamin Raymond Thundercloud (NySaGaShiskKah), ca. 1903.

Moheek Thundercloud (MaZheeWeeKah) as an older man, ca. 1925. It was very rare for Ho-Chunk to wear eyeglasses in Van Schaick's photographs.

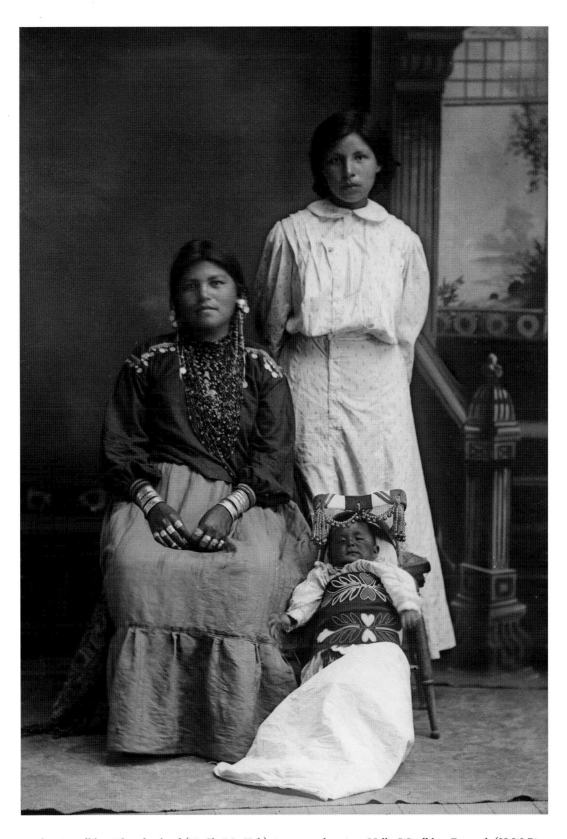

Sarah B. Windblow Thundercloud (HeChoWinKah) sits next to her sister Nellie Windblow Decorah (HaWePin-WinKah), who is dressed in a white school uniform, ca. 1909. Sarah's son Lawrence Leonard Thundercloud (CooNooKah) is resting in a Ho-Chunk cradleboard.

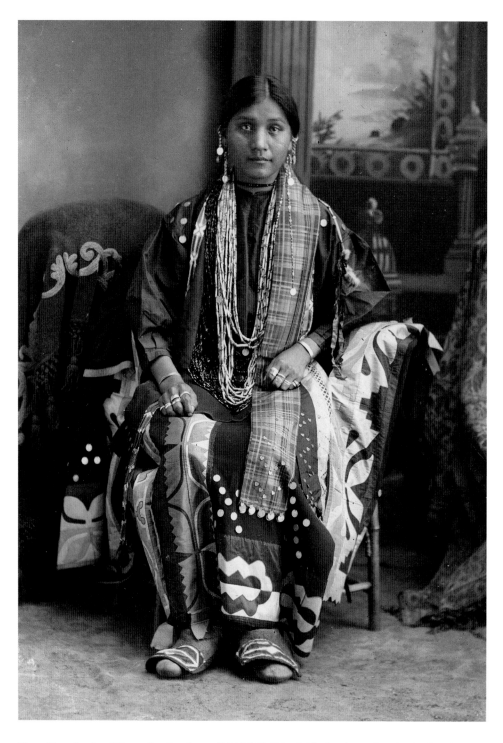

Flora Thundercloud Funmaker Bearheart (WaNekChaWinKah), daughter of Moheek Thundercloud (MaZheeWeeKah) and Annie Blowsnake Thundercloud (WaConChaSkaWinKah), ca. 1910. Flora is seated in a chair covered by a silk appliqué blanket (waį) and is dressed in a fine appliqué dress (wawaje) with silver dimes attached to the skirt. The plaid ribbon with silver coins hanging on her left side and the strip of side-stitch beadwork (paaxgeš) hanging over her right shoulder would have been worn down the back extending from her hair wrap, but they have been brought to the front for the photograph. Small silver coins accent her blouse. The flaps of Flora's moccasins (caahawaguje) are decorated in silk appliqué to match her dress. Many Ho-Chunk moccasins of this style have the top flaps decorated with beadwork.

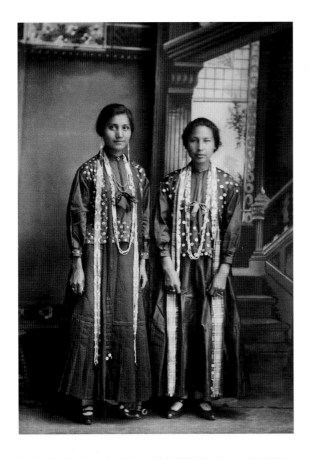

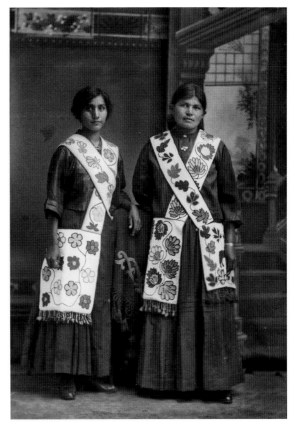

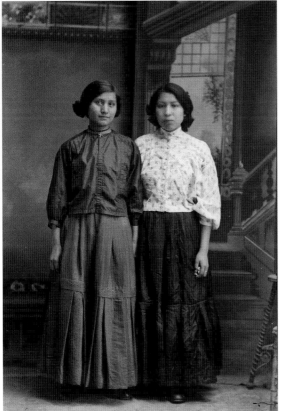

Clockwise from top left:

Flora Thundercloud Funmaker Bearheart (WaNekCha-WinKah), left, and Mary May Thundercloud Deer (WaNeekPiWinKah) wear blouses covered with small silver brooches (hiiwapox) and contemporary shoes, ca. 1920. Blouses covered with hiiwapox were sometimes referred to as "buckle blouses" because the brooches looked like miniature buckles.

Flora Thundercloud Funmaker Bearheart (WaNekCha-WinKah), left, and Sarah B. Windblow Thundercloud (HeChoWinKah), ca. 1920. Both wear floral beaded bandolier bags across their shoulders.

Flora Thundercloud Funmaker Bearheart (WaNekCha-WinKah), left, and Emma Annie Funmaker Lowe (ENooGreHeReKah) wearing basic women's dresses or hįnųkwaje, ca. 1920.

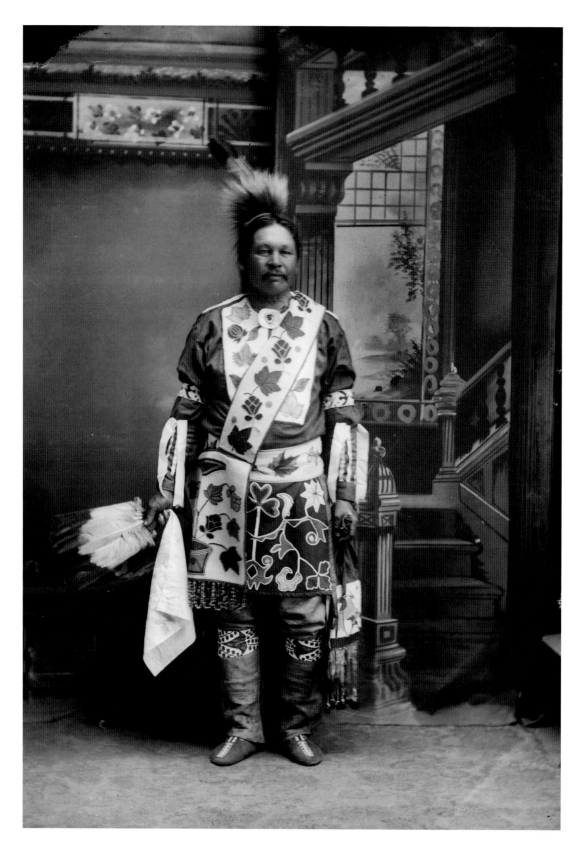

Alec (Alex) Lonetree (NaENeeKeeKah) is dressed in a mix of Ho-Chunk and non-Ho-Chunk regalia, ca. 1910. His moccasins and pipe bag are Plains Indian style.

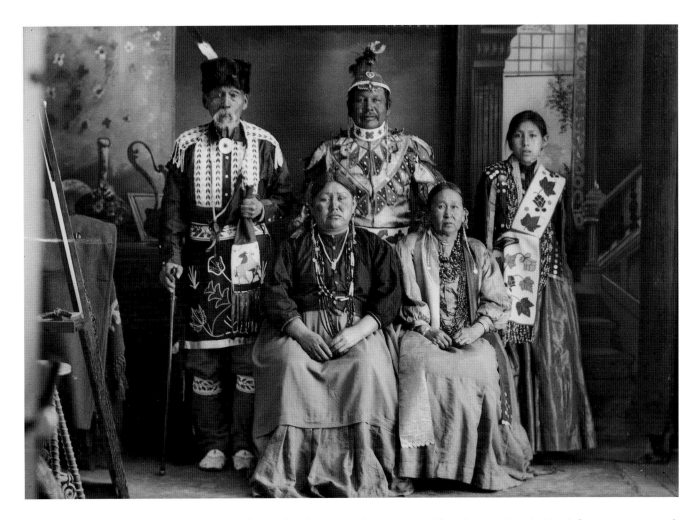

Standing are John Hazen Hill (XeTeNiShaRaKah), Alec (Alex) Lonetree (NaENeeKeeKah), and Mary Clara Blackhawk (WaHoPiNiWinKaw), daughter of Lucy Emerson Brown; sitting are Lucy Emerson Brown (HeNuKaw), left, and Lucy Long-Wolf Winneshiek (ShunkChunkA-WinKah), ca. 1900.

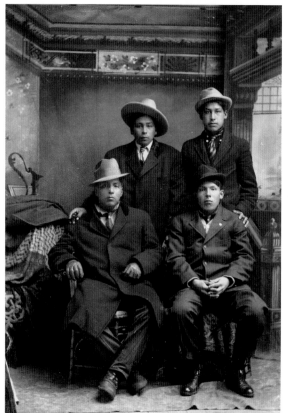

Clockwise from top left:

Standing are Hugh Lonetree (NoCheeKah), left, and George Lonetree (HoonchXeDaGah); seated are Alec (Alex) Lonetree (NaEneeKeeKah) and his wife, Lucy Emerson Brown (HeNuKaw), a Winnebago from Nebraska, ca. 1915.

From left to right, Hugh Lonetree (NoCheeKah), Jesse Stacy (CooNooKah), and Alliston Winnesheik (MoNaKaKah), ca. 1915.

Standing are George Lonetree (HoonchXeDaGah), left, and Harry Funmaker (HaGaChaCooKah); seated are Fred Peter Wildrice Bearchief (WaGeSeNa-PeKah), left, and Julius Whitedog (ChakShepWas-KaHeKah), ca. 1908.

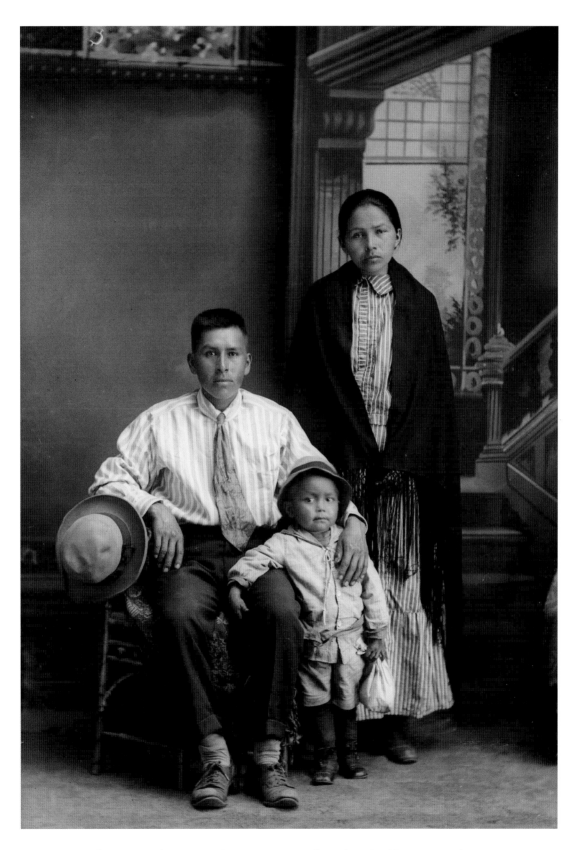

Hugh Lonetree (NoCheeKah) with his wife, Mary Lucy Sine (Trout) Littlesoldier Lonetree (WaHoPinNeeHaTa-Kah), and son Jacob Littlesoldier, ca. 1916.

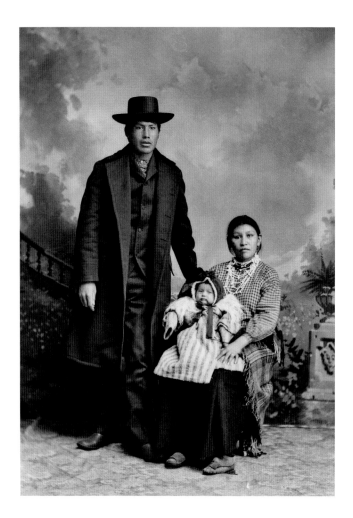

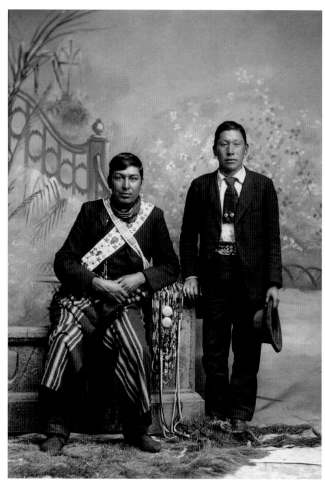

George (Lyons) Lowe (AhHaZheeKah) stands with his wife, Lena Nina Marie Decorah (Lyons) Lowe (AhHooSkaWinKah), and their infant son Martin (MaHisSkaKah), ca. 1895. The Lowes were first listed on the census as Lyons, taking the name of a farmer they had worked for. The last name was later changed to Lowe.

Joe Thunderking Lowe (King of Thunder) (WauKonJahHunkKah), seated, wears Ho-Chunk-style bandolier bags across his chest, an Indian trade blanket on his lap, and Ho-Chunk moccasins. He is leaning on a pedestal that is draped with bandoliers of beads, hair pipe bone, and silver conches. David Davis W. Decorra (NeZhoo-LaChaHeKah) is dressed in contemporary clothing that has been accented with a Ho-Chunk beaded belt and a tie decorated with German silver brooches (hiiwapox), ca. 1895.

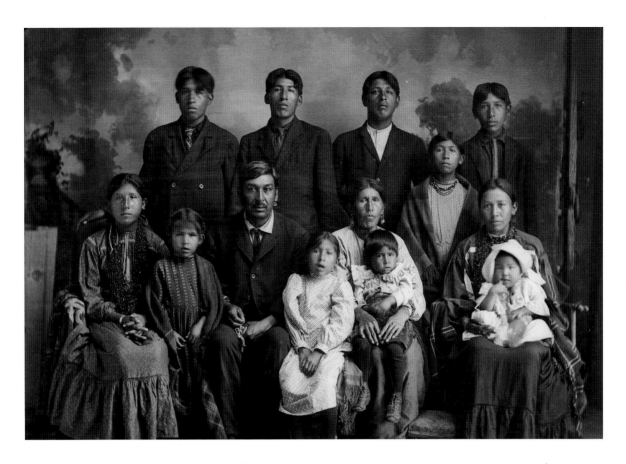

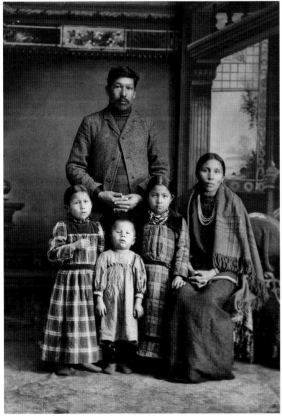

ABOVE: The family of Joe Thunderking Lowe (King of Thunder) (WauKonJahHunkKah), ca. 1904. Standing in back from left to right are Gilbert Thunderking Lowe (WaConChaHoNoNeeKah), Albert Thunderking Lowe (ChakShepSkaKah), Fred Kingswan (MaHeNoGinKah), Annie Thunderking Lowe (WaNukScotchEWinKah), and Sam Thunderking Lowe (HoChumpHoNikKah). In the front row from left to right are Lucy Thunderking Lowe Yellowbank (MaHiSkaWinKah), Minnie Thunderking Lowe (ENooKahHooNooKah), Joe Thunderking, Dora Thunderking Lowe (AkSeKahHoNoKah), Mary Decorah Thunderking (KaNooKayWinKah), Theodore Thunderking Lowe (WaConChaHoNoNikKah) sitting on his mother Mary's lap, and Alice Thunderking Lowe Kingswan (MaHayPaSayWinKah) holding Violet Kingswan (WeGoSeeDaWinKah).

LEFT: George (Lyons) Lowe (AhHaZheeKah) with his wife, Lena Nina Marie Decorah (Lyons) Lowe (AhHoo-SkaWinKah) and family, ca. 1903. Standing in front of George are their children, Lydia Lowe, Daniel Lowe, and Bessie Lowe.

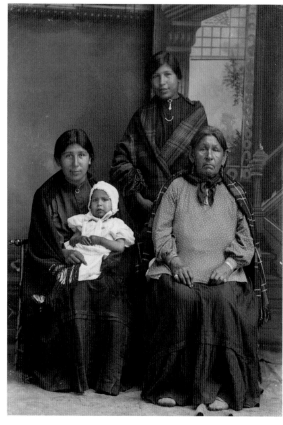

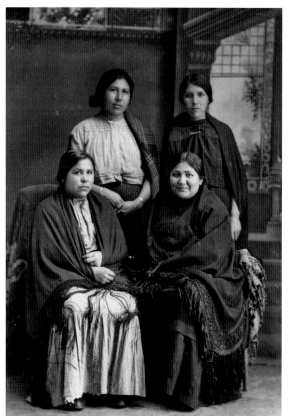

Clockwise from top left:

Dora Thunderking Lowe (AkSeKahHoNoKah), right, and Jennie Youngthunder Decorah (PetHakChaCooWinKah) in winter coats, ca. 1930.

Lucy Thunderking Lowe Yellowbank (MaHiSkaWinKah), sitting left, holds her nephew David Neil Lincoln Jr. (WaWaHasKah), with her sister and the mother of David, Annie Thunderking Lowe Lincoln (WaNukScotchE-WinKah), standing, and Sarah Half-a-Sack Longmarsh (NeeZhooJhotchKayWinKah) seated right, ca. 1915.

Standing are Lucy Thunderking Lowe Yellowbank (MaHiSkaWinKah), left, and Mamie (Minnie) Bearchief (HoHump-CheKaRaWinKah); seated are Hannah Whitefish, left, and Edna Grizzlybear, ca. 1920.

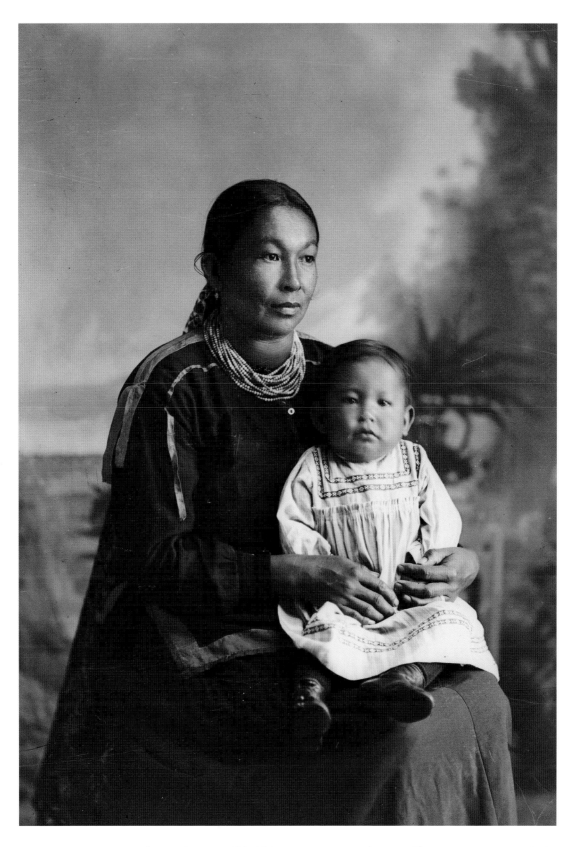

Martha Lyons-Lowe Stacy (KaRaChoWinKah) holds her son James Stacy (NaHeKah), ca. 1904. James, son of John Stacy (ChoNeKayHunKah), died at the age of two.

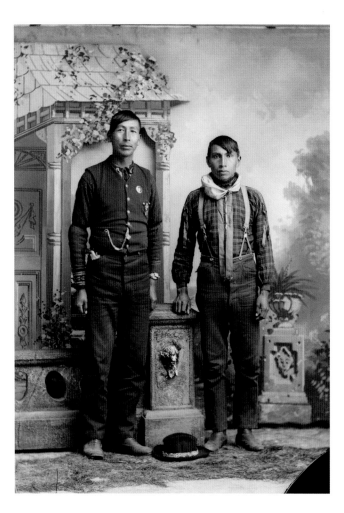 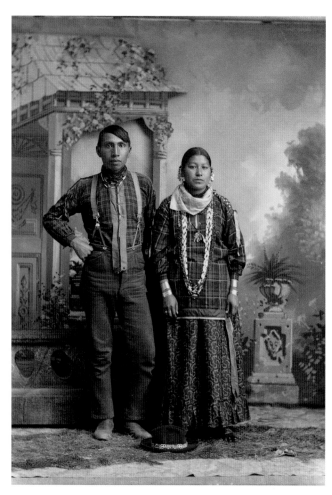

Albert Thunderking Lowe (ChakShepSkaKah), left, and Edward Funmaker (WaGeSeNaPeKah), ca. 1905. Edward wears a flannel shirt with two ribbons (zeenįba) sewn down the front.

Edward Funmaker (WaGeSeNaPeKah) and his wife, Mamie (Minnie) Bearchief Funmaker (HoHumpCheKaRaWinKah), ca. 1905.

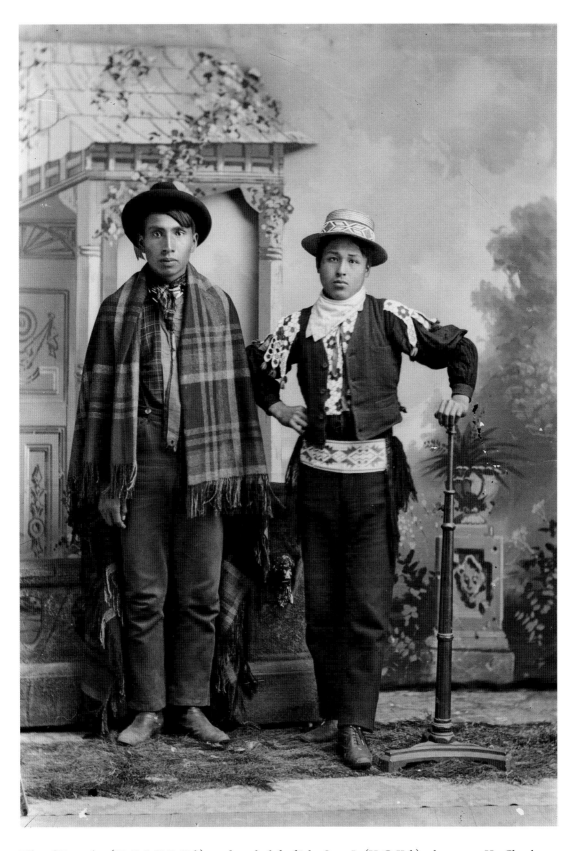

Edward Funmaker (WaGeSeNaPeKah) stands to the left of John Stacy Jr. (HaGaKah), who wears a Ho-Chunk beaded shirt, belt, and a beaded hat band, ca. 1905.

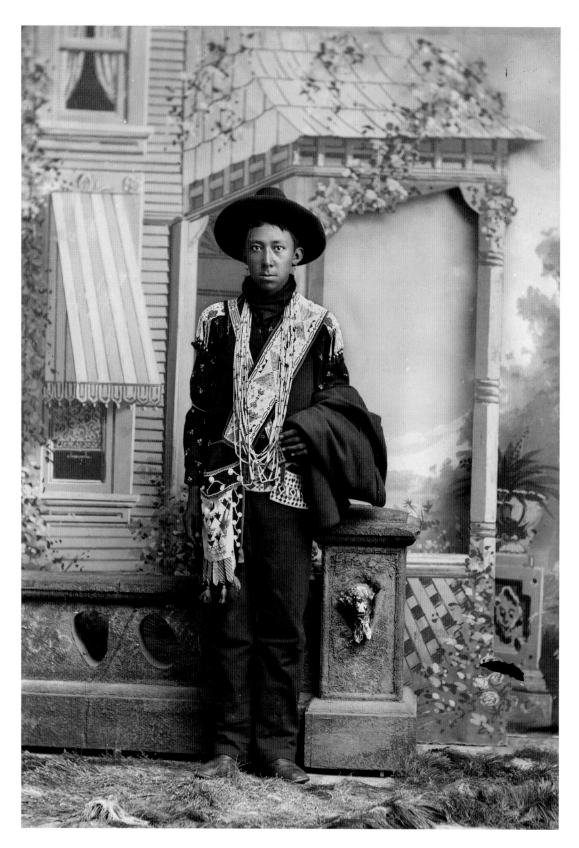

Frank Washington Lincoln (ChakShepKonNeKah), dressed in the style of a single man with crossed bandolier bags, ca. 1902.

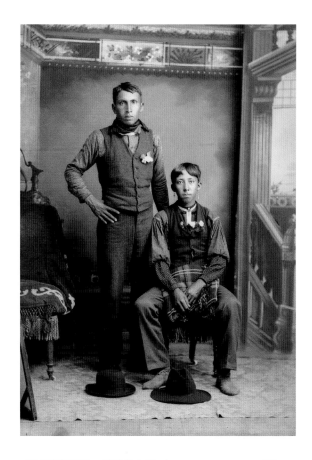

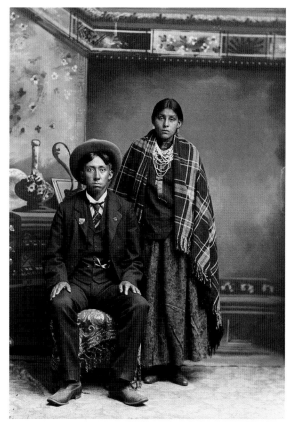

Clockwise from top left:

Edward Funmaker (WaGeSeNaPeKah), left, and Frank Washington Lincoln (ChakShepKonNeKah), seated, ca. 1900.

Frank Washington Lincoln (ChakShepKonNeKah) and his first wife, Betty Otter Lincoln (NaChoPinWinKah), ca. 1905.

Howard Joseph McKee Sr. (CharWaShepInKaw), a Nebraska Winnebago, seated next to Frank Washington Lincoln (ChakShepKonNeKah), ca. 1902. Howard wears old-style Ho-Chunk men's moccasins with a large top flap that could be pulled up over the ankle and tied on the leg, making it a boot.

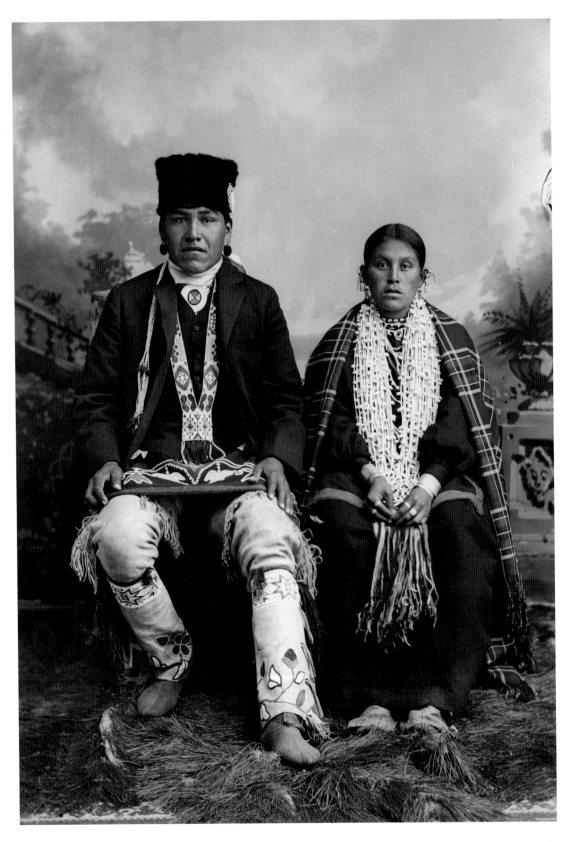

Ed Greengrass (CheWinCheKayRayHeKah) and his wife, Jennie (Johnnie) Blackhawk (CheNunkMonEWinKah).
Ed wears an otter-fur turban and floral appliqué beaded aprons and leggings, ca. 1895.

Green Grass (HaWinChoKah) wears floral beaded Ho-Chunk moccasins and holds a map of Jackson County that shows his forty-acre allotment, ca. 1910.

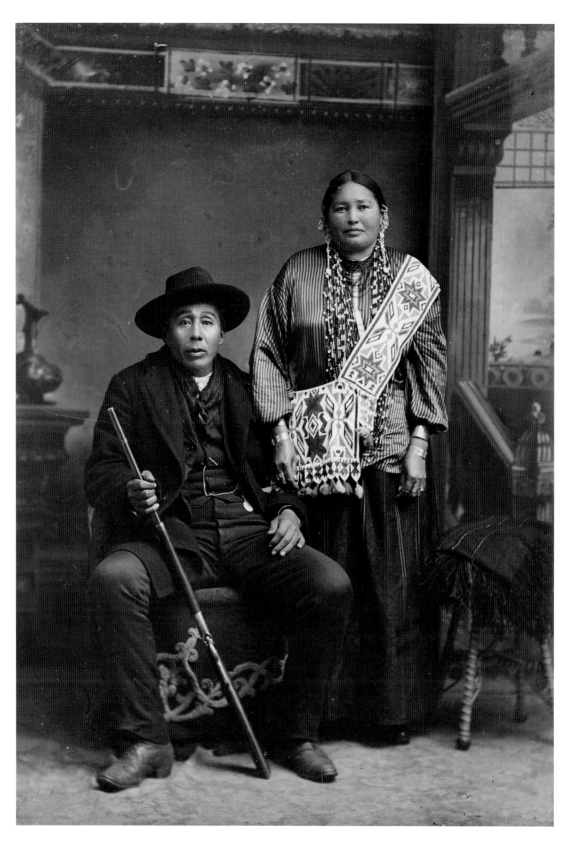

George Greengrass (WauKeCooPeRayHeKah) and Emma Lookingglass Greengrass (ChayHeHooNooKah),
ca. 1900. Emma is wearing a bandolier with an offset top strap, which was common to Ho-Chunk bandolier bags.

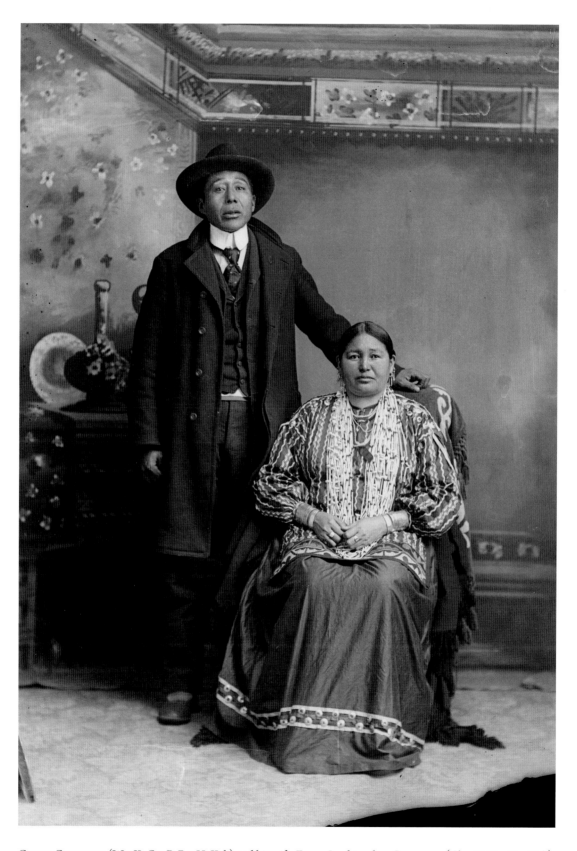

George Greengrass (WauKeCooPeRayHeKah) and his wife, Emma Lookingglass Greengrass (ChayHeHooNooKah), ca. 1900.

Green Grass (HaWinChoKah), ca. 1920.

Dorothy Greengrass, daughter of Robert Greengrass (HoNutchNa-CooMeeKah) and Dora Whitefeather Decorah (HoHaWinKah), ca. 1935.

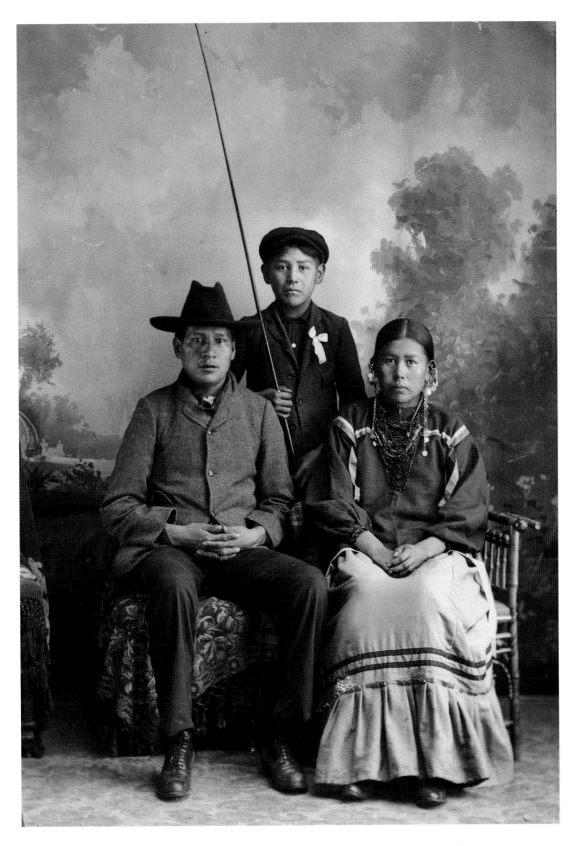

Harry Littlesnake (HaKaChoMonEKah) and Annie Youngswan Snake (WaKaChaMaNeeKah) seated in front of James or George Swan, ca. 1931.

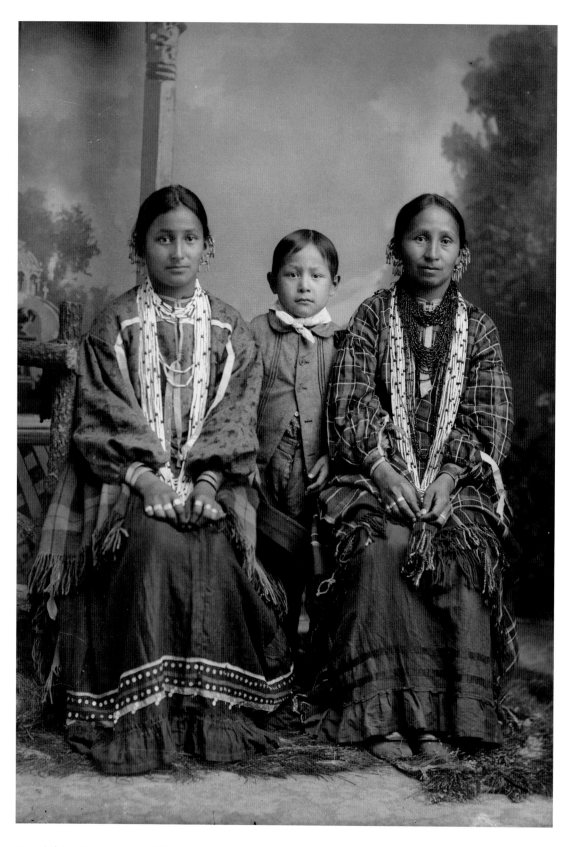

From left to right, Margaret Whitedeer Littlesam (NauChoPinWinKah), Lee Dick Littlesam (HaNotchANaCoo-NeeKah), and Emma Stacy Whitedeer Lowery (HompInWinKah), ca. 1898.

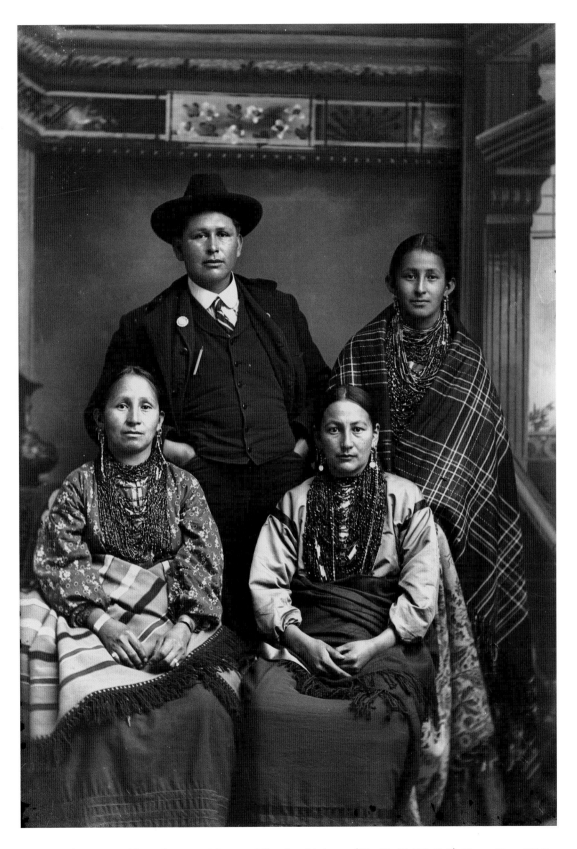

Little Sam (HePaHeKah) stands next to Margaret Whitedeer Littlesam (NauChoPinWinKah); Emma Stacy White-deer Lowery (HompInWinKah) is seated to the left of Sarah French (Ellen Davis) (AhHooChoWinKah), ca. 1900.

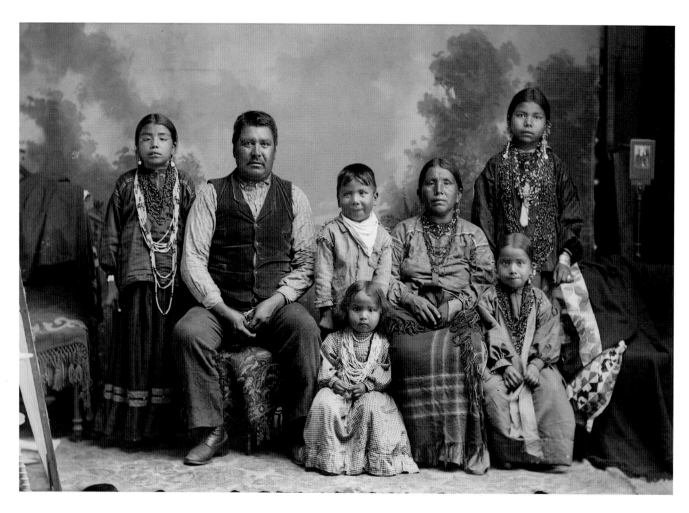

The Whitebear family was referred to in the census rolls with the last name of White, but they used the name Whitebear. From left to right are Ella Whitebear (MauNaPayWinKah), father Jim Whitebear (HoonchSkaKah), Dan Whitebear (HeNukKah), mother Kate Thundercloud Whitebear (MawHePauSayWinKah), and Daisy Whitebear (WeHunKah). Lucy Whitebear (HoDaHooKah) sits in front of Dan, and Viola Whitebear (UkSeUkKah) sits in front of Daisy, ca. 1906.

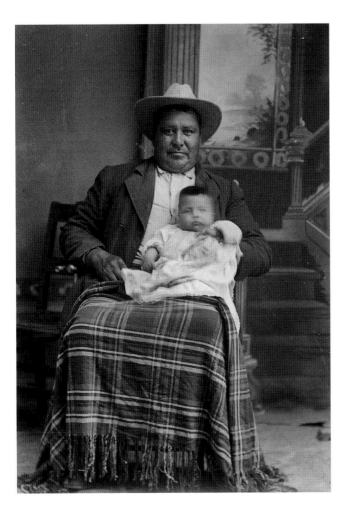

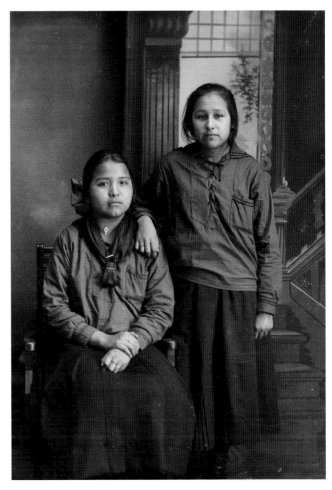

Jim Whitebear (HoonchSkaKah) holds a baby boy, possibly his son Dan Whitebear (HeNukKah), ca. 1901.

Lucy Whitebear (HoDaHooKah) seated next to Mary (Pinkah) Lewis (KeSaWinKah), ca. 1930.

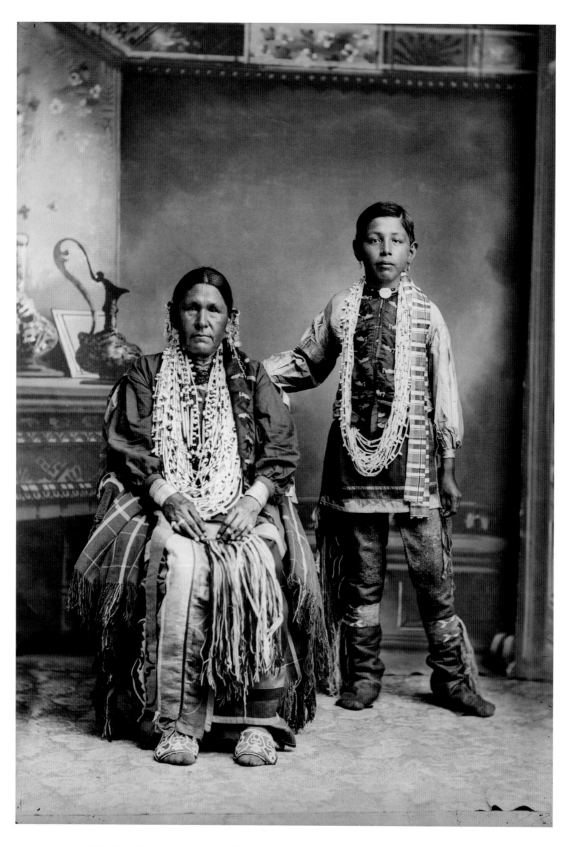

Susie Kingswan (HeNuKah) wears a fine pair of floral beaded Ho-Chunk moccasins, ca. 1894. Her son Fred Kingswan (MaHeNoGinKah) wears traditional leather leggings (wagucą) and beaded garters.

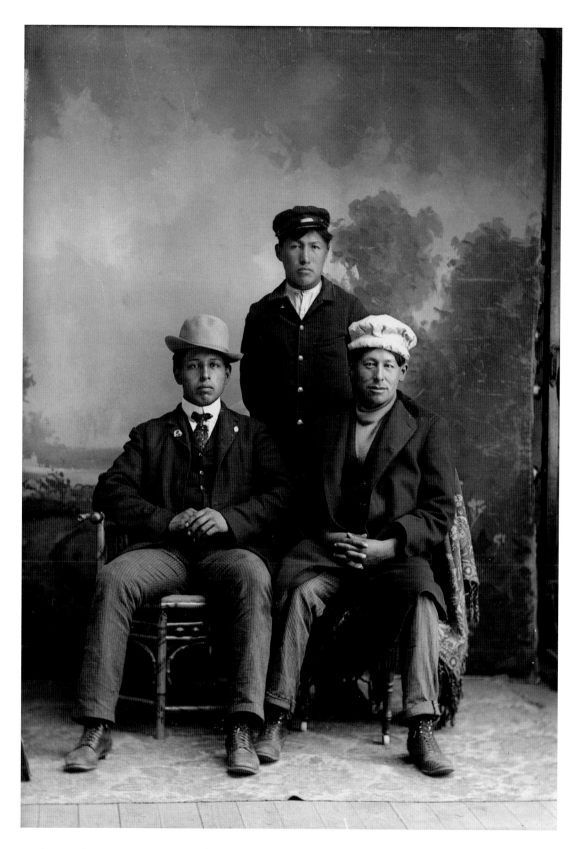

Frank Lewis (HaNaCheNaCooNeeKah) stands behind Fred Kingswan (MaHeNoGinKah), left, and John Swallow (MonKeSaKaHepKah), ca. 1904.

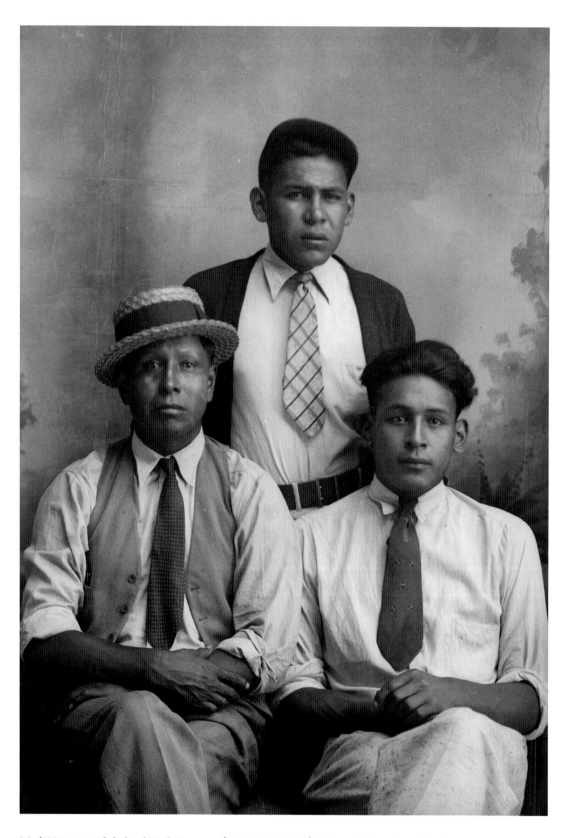

Mark Henry stands behind Fred Kingswan (MaHeNoGinKah), left, and his brother Elias Henry, ca. 1931.
The Henry boys were from Nebraska.

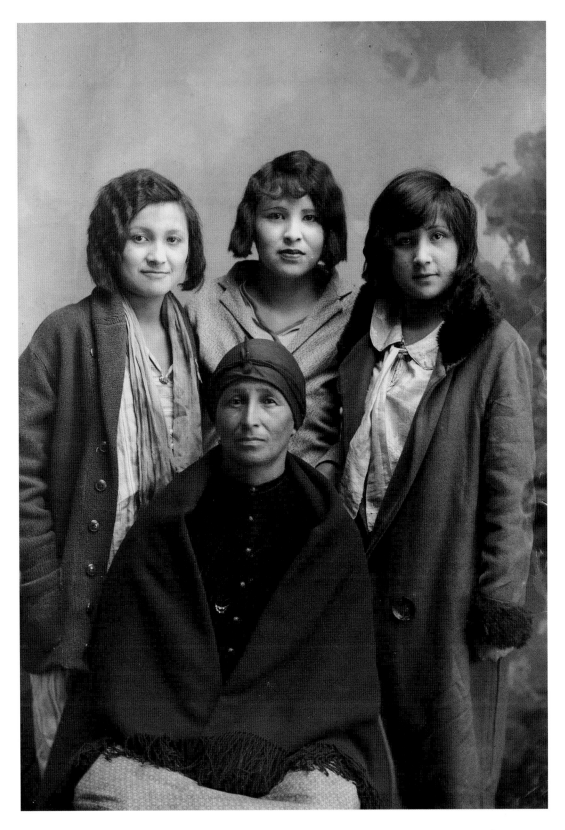

Rachel Whitedeer Littlejohn (ENaKaHoNoKah), front, with daughters Florence Littlejohn Lamere (Hoonch-HeNooKah), left, Mary Littlejohn Fairbanks (WeHunKah), and Ann Littlejohn Lonetree (WakJaXeNeWinKah), ca. 1930.

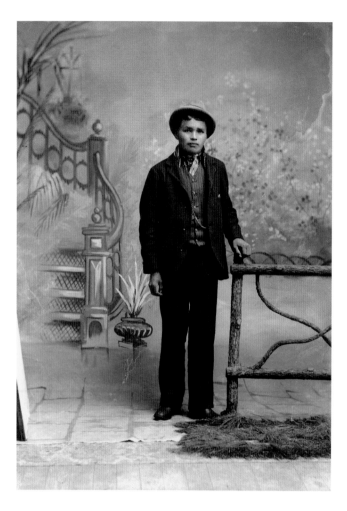

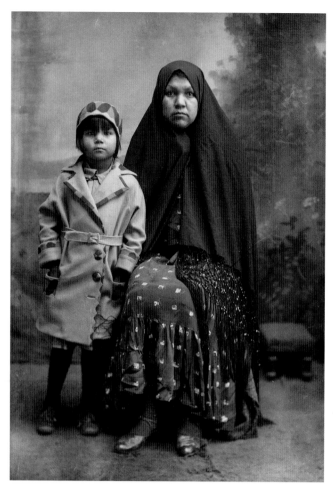

Frank Yellowfeather Climer (HawKahKah), ca. 1895. Frank and Emma E. Climer (ENooKaStaLaKah) were the parents of Susie and Bertha Climer.

Agnes Payer Climer, seated, and her daughter Juanita June Climer, ca. 1932.

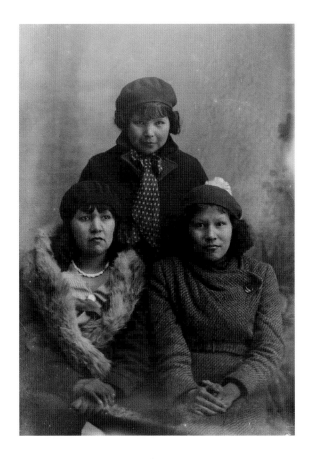

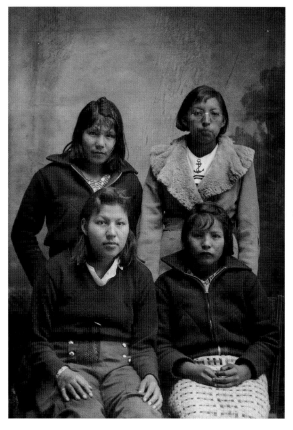

Clockwise from top left:

Bertha Climer stands behind her sister-in-law, Agnes Payer Climer, left, and sister, Susie Climer, ca. 1931. Agnes was married to Bertha and Susie's brother, Thor.

Seated are Dorothy Greengrass, left, and Edna Climer. Standing are Edna's twin Jennie Climer, left, and Ollie May Sine, ca. 1934.

Emma Climer, ca. 1930.

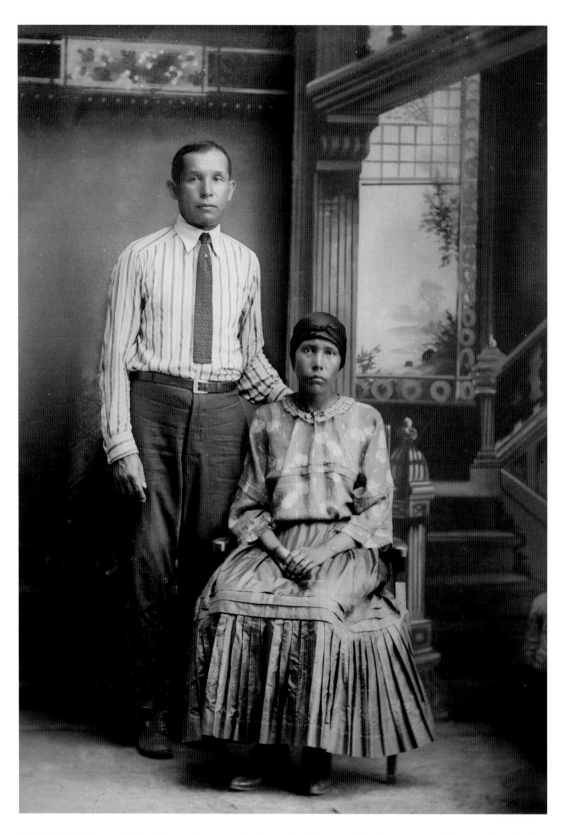

Felix White-Wilson of Nebraska stands next to his first wife, who is listed in the census as a "New York Indian," ca. 1925. This was a common listing for the Wisconsin Oneida, Brotherton, and Stockbridge-Muncee Indians. After his first wife passed away, Felix married Agnes Eagle (HaHumpAWinKah).

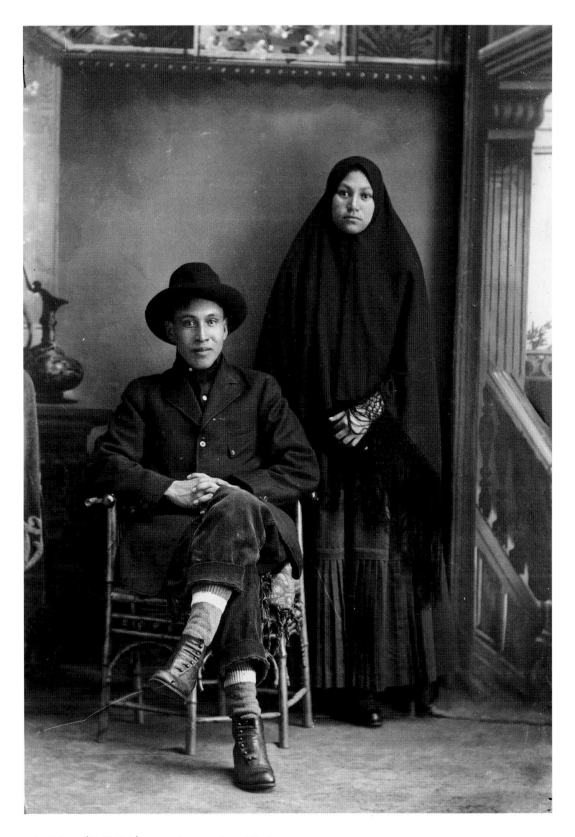

John Falcon (NaHeKah) is seated next to Lucy Waukon, ca. 1920.

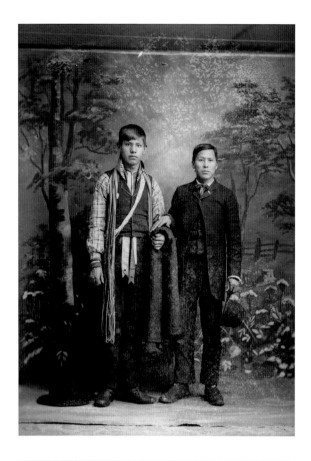

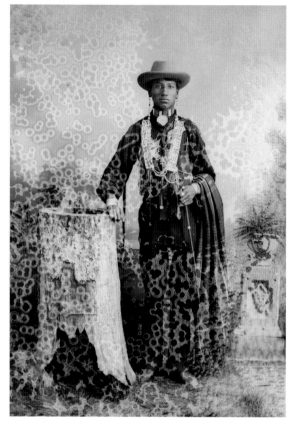

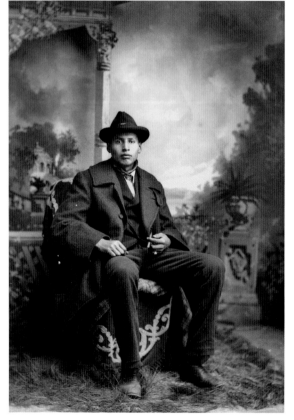

Clockwise from top left:

Frank C. Thunder (HoonkTaKaKah), left, and Ed Greengrass (CheWinCheKayRayHeKah), ca. 1892.

Thomas Thunder (HoonkHaGaKah) leans on a stump used as a prop in Van Schaick's studio, ca. 1886. He is adorned with earrings and a choker.

Will Thunder (NaNikSayWaHeKah) is seated on an embroidered blanket that appears in many of Van Schaick's photographs, ca. 1902. This blanket was not Ho-Chunk, but a studio prop.

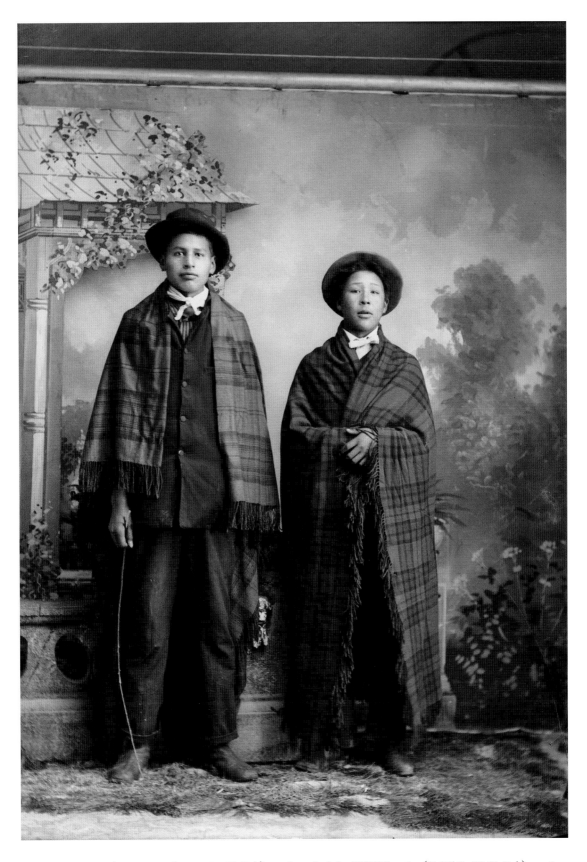

Charlie Greengrass (HoeHumpCheeKayRayHeKah) stands to the left of Will Thunder (NaNikSayWaHeKah), ca. 1899.

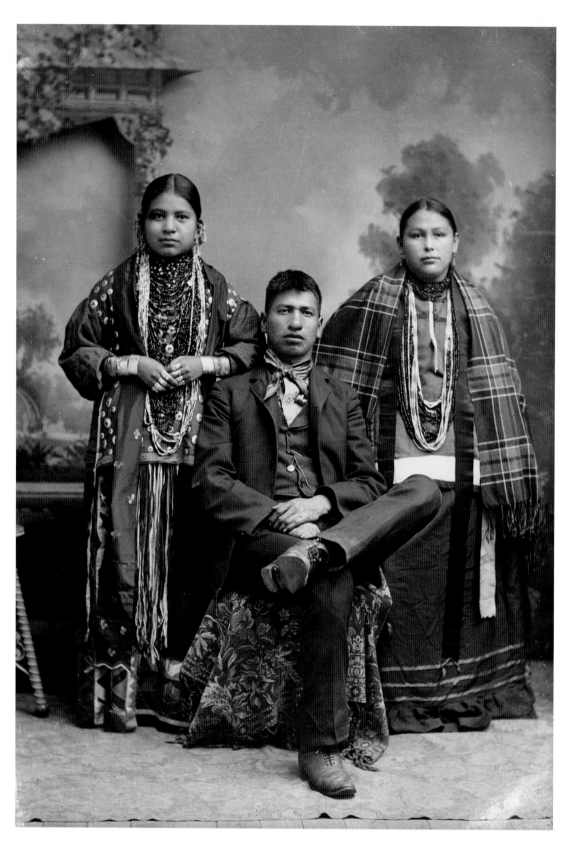

Thomas Thunder (HoonkHaGaKah) sits between Emma Thunder Littlesoldier (WePaMaKaRaWinKah), left, and his wife, Florence Littlesoldier Wallace Thunder (MauKonNeeWinKah), ca. 1905.

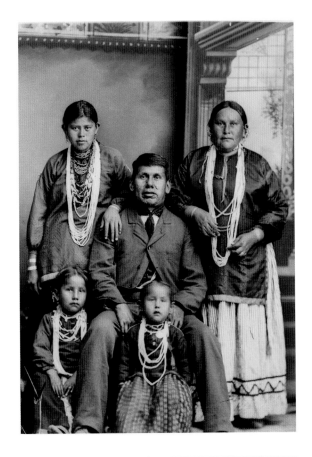

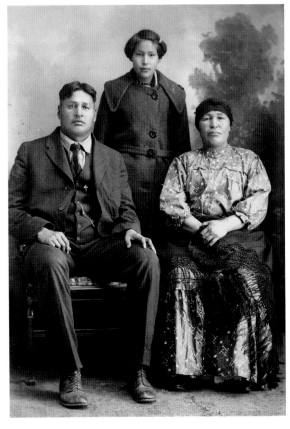

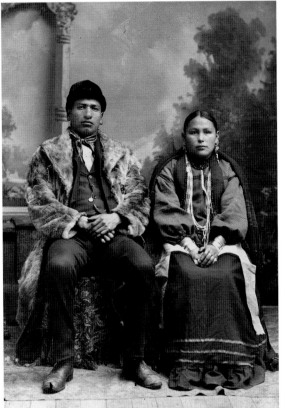

Clockwise from top left:

William Thunder (WaConChaHaTeKah) is seated to the left of his wife, Mary Mollie Prophet Thunder (HoWaChoNe-WinKah). Their children are seated in front of them: Kate Thunder (WaRoSheSepEWinKah), left, and Lucy Thunder (ENooKahKah). The young woman resting her hand on William's shoulder is unidentified.

Will Thunder (NaNikSayWaHeKah) and Emma Mary White Greencloud-Redcloud Thunder (JumpBroShunNupChun-TinWinKah), seated in front of their daughter, Ivy Thunder (Kate Greencloud), ca. 1918.

Thomas Thunder (HoonkHaGaKah) and his wife, Florence Littlesoldier Wallace Thunder (MauKonNeeWinKah), ca. 1895.

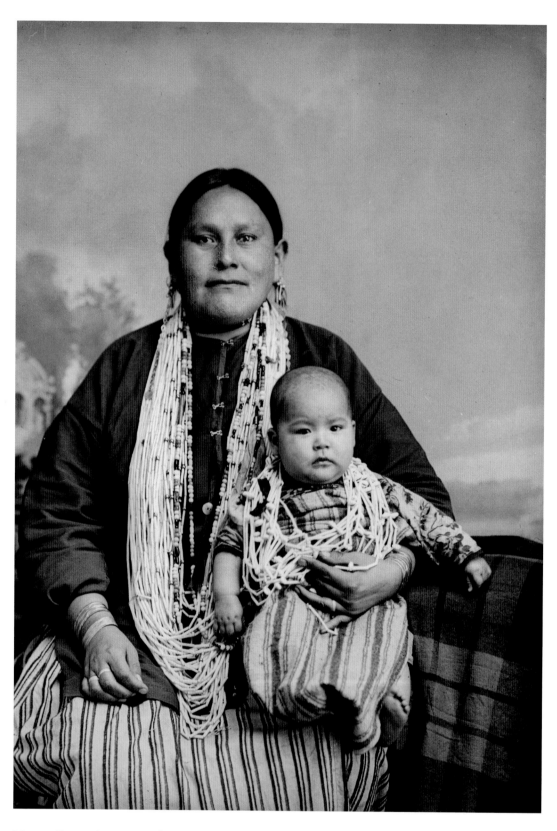

Mary Mollie Prophet Thunder (HoWaChoNeWinKah) holds her daughter Kate Thunder (WaRoSheSepEWinKah), ca. 1891.

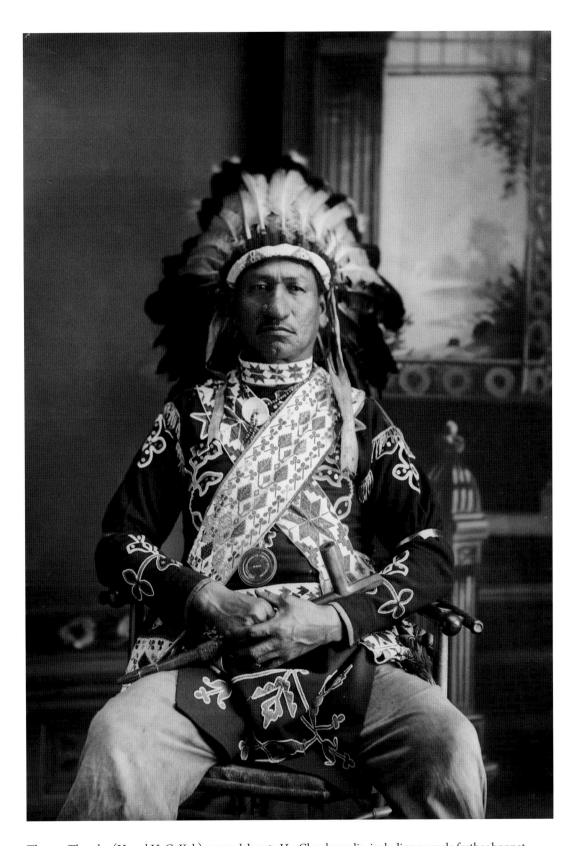

Thomas Thunder (HoonkHaGaKah) wears elaborate Ho-Chunk regalia, including an eagle feather bonnet, floral beaded shirt and breechcloth, loom-beaded bandolier bags, choker, and an Indian Peace Medal. He holds a calumet pipe, ca. 1910.

Fred Kingswan (MaHeNoGinKah), ca. 1904.

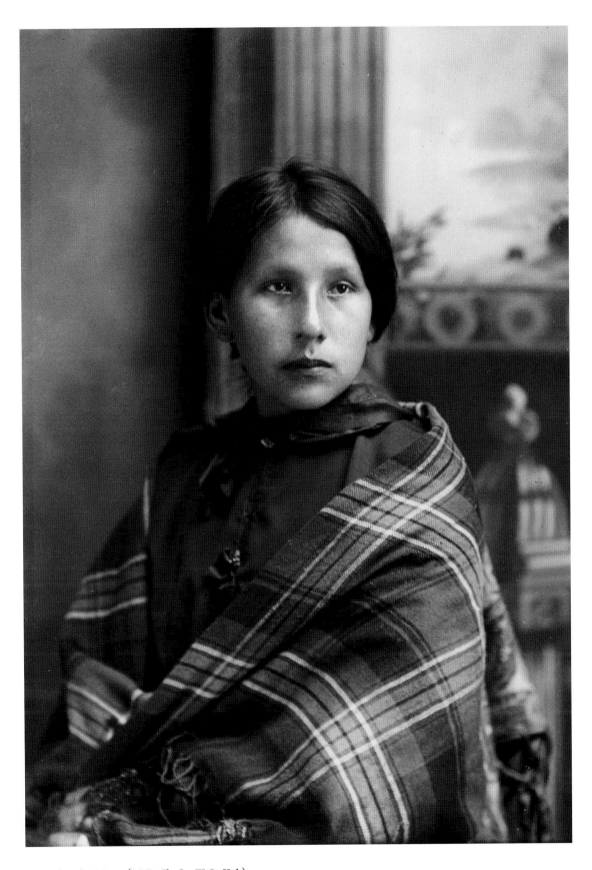

Kate Thunder Miner (WaRoSheSepEWinKah), ca. 1905.

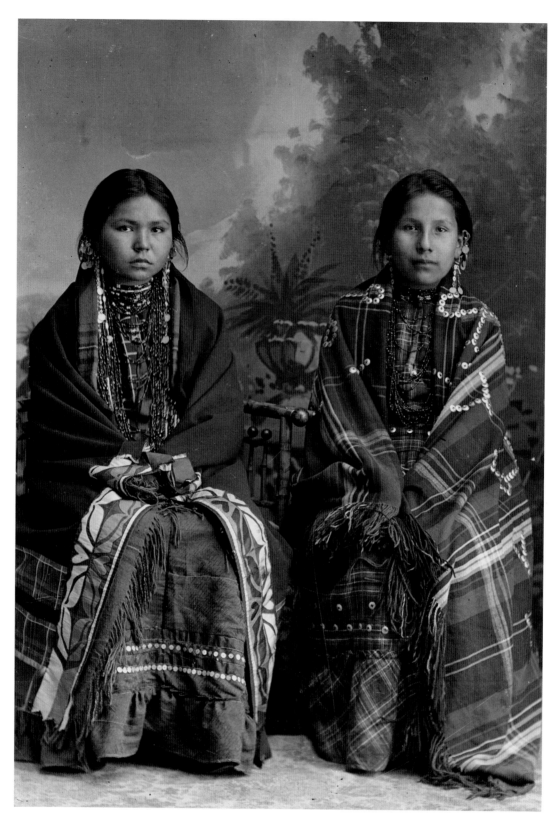

Caroline Mary Decorah Blackdeer (CheHeTeChaWinKah), left, wears a silk appliqué blanket (waį zeenįbawoore), and Kate Thunder Miner (WaRoSheSepEWinKah) wears a shawl (waį) embellished with silver brooches (hiiwapox), ca. 1906.

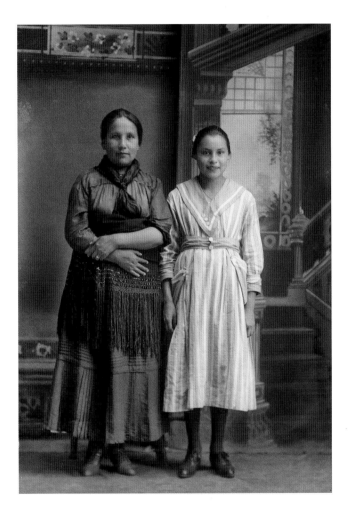

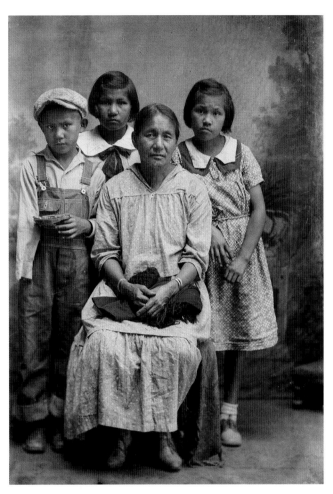

Kate Thunder Miner (WaRoSheSepEWinKah) stands next to Hilda Alice Stacy Funmaker (HoWaChoNeWinKah), ca. 1922.

Lucy Wilson Blackhawk (HoChunkEWinKah), seated, with Donald (Dun) Blackhawk, left, Margaret Blackhawk, and Virginia Blackhawk, ca. 1932.

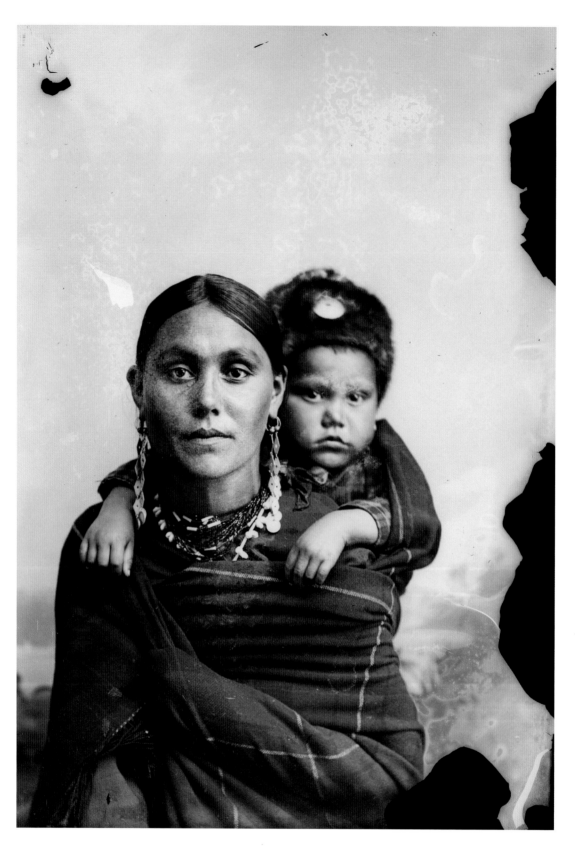

Clara Kingsley (Big) Blackhawk (KeesKawWinKah) carries her son Andrew John (Big) Blackhawk (WaConCha-HoNoKah) on her back, ca. 1887. Using a shawl as a back sling was a common way to carry infants in this period.

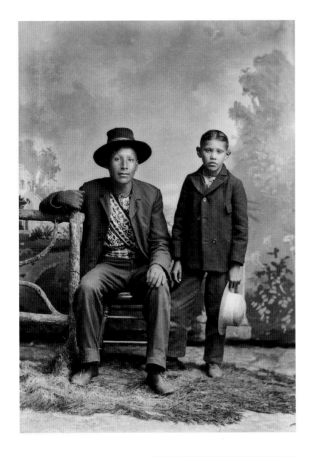

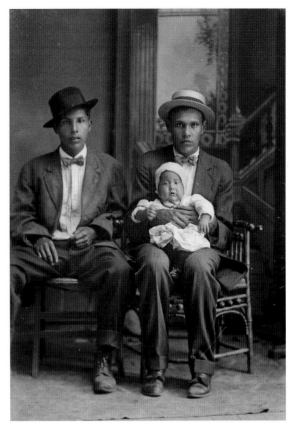

Clockwise from top left:

Will Stohegah Carriman (WonkShiekStoHeGah), seated next to Andrew John (Big) Blackhawk (WaConChaHo-NoKah), wears a beaded belt and bandoliers across his chest, ca. 1893.

Andrew John (Big) Blackhawk (WaConChaHoNoKah) holds his son Clarence Blackhawk (WaCheeWaHaKah) and is seated next to an unidentified man, ca. 1911.

Andrew John (Big) Blackhawk (WaConChaHoNoKah), a World War I veteran, is pictured here in 1926. The Ho-Chunk powwow grounds near Black River Falls, Wisconsin, were donated to the tribe in his honor. They were part of the original forty acres allotted to his family.

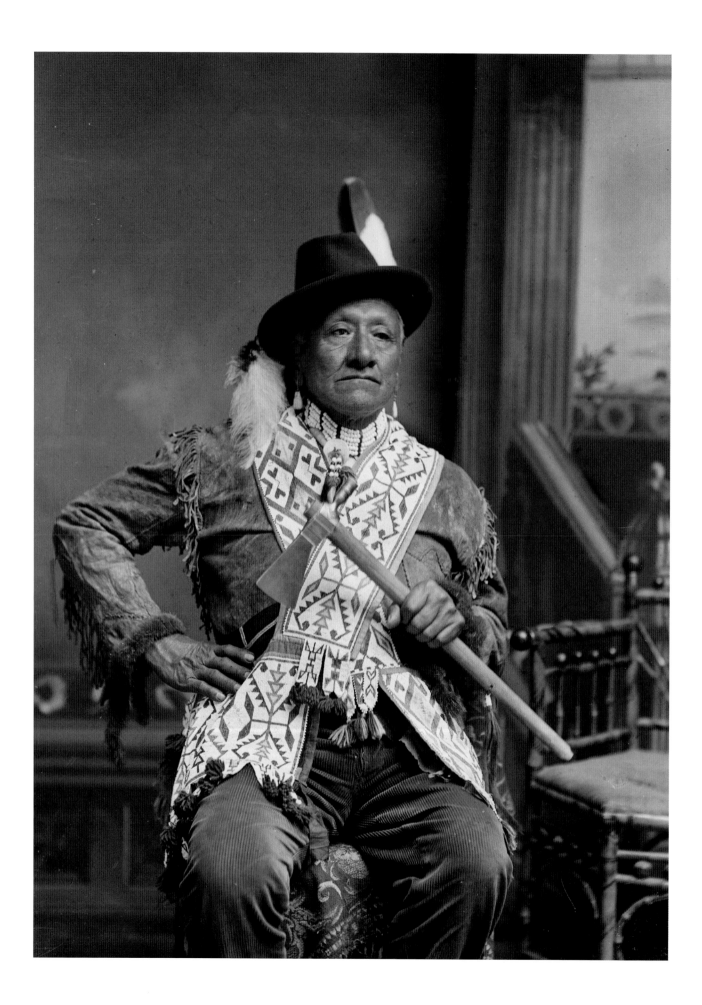

VETERANS

"Among the [Ho-Chunk] Indians there has been a systematic teaching of courage from infancy to the grave," wrote Henry Roe Cloud in the early twentieth century. "The old-time Indian had respect for the aged, developed art, and had a love for the beautiful. He developed thrift. He was always willing to work. We [as Ho-Chunk warriors] have all inherited these characteristics."[1] The words of Henry Roe Cloud hold true today. Even after the United States government removed the Ho-Chunk and other tribes to reservations and disrupted their traditional cultural practices, the Ho-Chunk maintained most of their warrior traditions and continue to hold their veterans in high esteem.

The Ho-Chunk have participated in many of the United States' wars. During the War of 1812 they sided with the British against the United States, and during the Civil War they fought for the Union. Seventy-two Ho-Chunk warriors joined the Omaha Scouts and saw action during the Civil War, patrolling the Indian frontier west of the Mississippi. Some individual Ho-Chunk fought with other units, including John Hazen Hill, who enlisted with the 14th Cavalry in Kansas, and John Greencloud "Green Thunder," who served in the army as a scout with the Comanches (see pages 97 and 98, top).

After the Civil War, the opportunity for Ho-Chunk to fight as warriors was limited, but they still maintained many of their traditional warrior practices. Warrior songs were handed down, and many of the clans still held war bundle feasts, as some still do today. When the United States entered into World War I in 1917, the opportunity for Ho-Chunk to become warriors and receive the honor and privileges associated with warrior status resulted in a large number of Ho-Chunk enlisting.

To ensure the warriors' success, each clan gave the warriors items from their war bundles to carry with them as they left for service. Many World War I veterans returned with trophies to show proof of their bravery. When the warriors returned home, victory dances were held and the veterans were honored in the warrior tradition. The Ho-Chunk again had warriors to carry on the traditions and tell their stories at wakes. New warrior songs were composed to add to the traditional repertoire, including songs for each branch of the military in which Ho-Chunk served. Today there are Ho-Chunk veterans from every branch of the armed services.

The warrior tradition was given new life after World War I and in the wars that followed, from World War II through the current conflicts in Iraq and Afghanistan. Today, the Ho-Chunk warrior tradition remains a vital part of the Ho-Chunk way of life—a fact evident to anyone attending the annual Ho-Chunk Memorial weekend powwow in Black River Falls, which pays honor to all veterans, Ho-Chunk and non-Ho-Chunk.

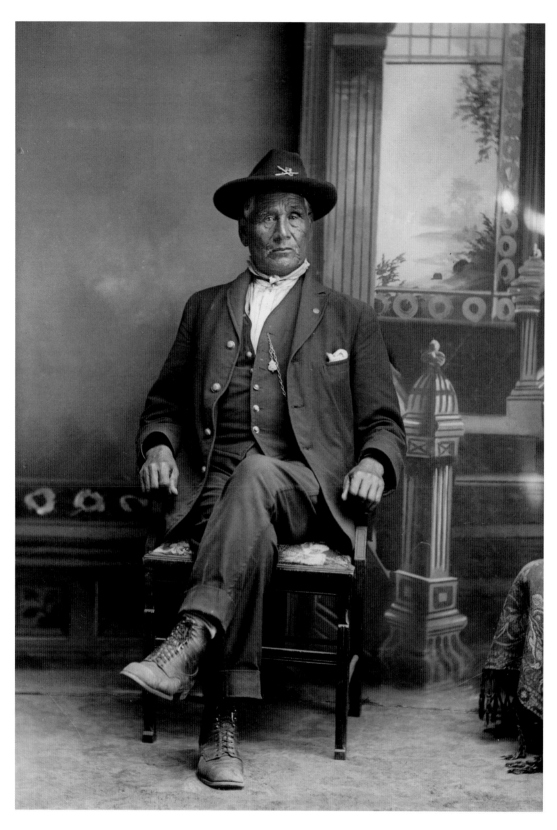

Civil War veteran James Bird (WeeJukeKah or MaKeSucheKaw), ca. 1900. The emblem on his hat is made of two crossed arrows, the insignia of a Civil War Indian scout. James Bird was a private with Company A of the Omaha Scouts, a Civil War outfit consisting of six white officers and seventy-two Ho-Chunk soldiers.

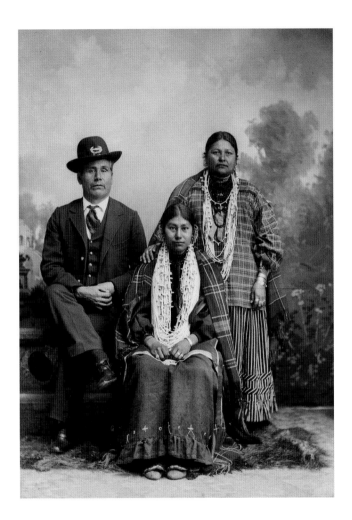

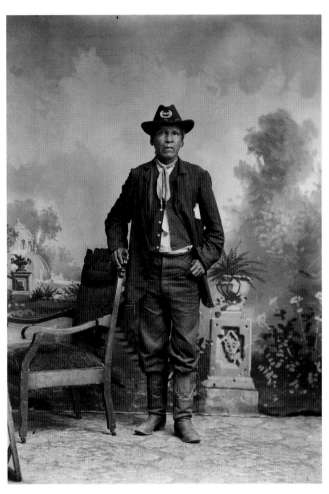

Non-Ho-Chunk Charlie Saunders with his Ho-Chunk wife, Mary Eagle (ChaUkShePaRooEWinKah), and her daughter, Annie Davis Bigsoldier White Rogue (KeeReeJayWinKah), ca. 1900. Saunders served in the Civil War as a private in Company B of the 1st Wisconsin Cavalry and was twice a prisoner of war. The first time, he was captured in Bloomfield, Missouri, and released in exchange for a Confederate prisoner. He was captured again on July 30, 1864, and held at the infamous Andersonville Prison. Saunders is wearing the GAR (Grand Army of the Republic) emblem on his hat. Saunders spoke the Ho-Chunk language and was close to the Ho-Chunk community, but it is not known whether he received Ho-Chunk warrior privileges.

Homer Snake wears a hat with a GAR emblem, signifying he is a Civil War veteran, ca. 1900. Snake served as a private with Company A of the Omaha Scouts.

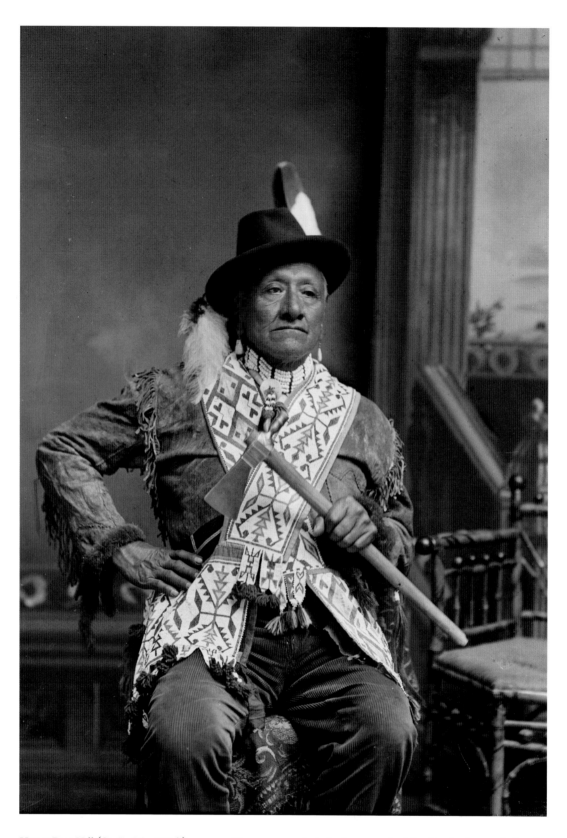

Henry Rice Hill (SanJanMonEKah), ca. 1900. Henry was a private in Company A of the Omaha Scouts during the Civil War. He is wearing a beaded choker around his neck and two Ho-Chunk bandolier bags across his chest, and he holds a pipe tomahawk. The golden eagle tail feather in his hat signifies warrior or veteran status.

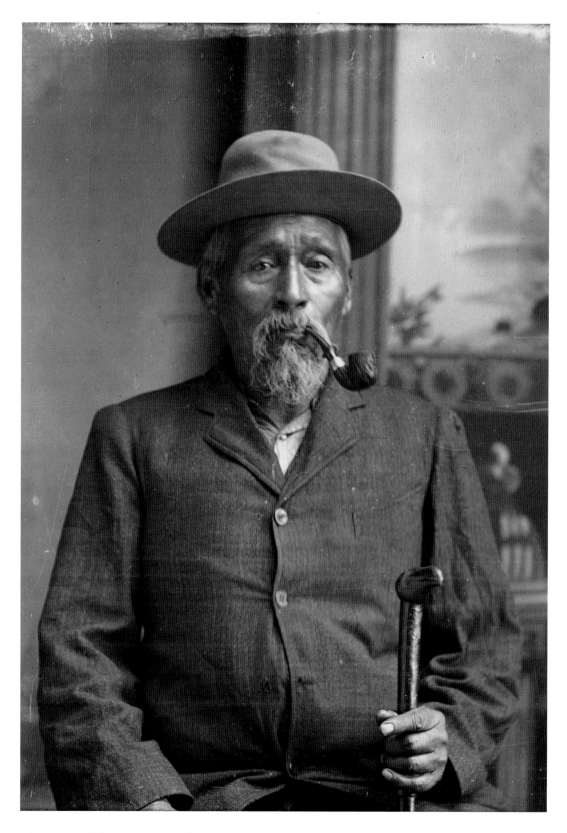

John Hazen Hill (XeTeNiShaRaKah), ca. 1910, served in the Civil War as a scout leader with the 14th Kansas Volunteer Cavalry Regiment.

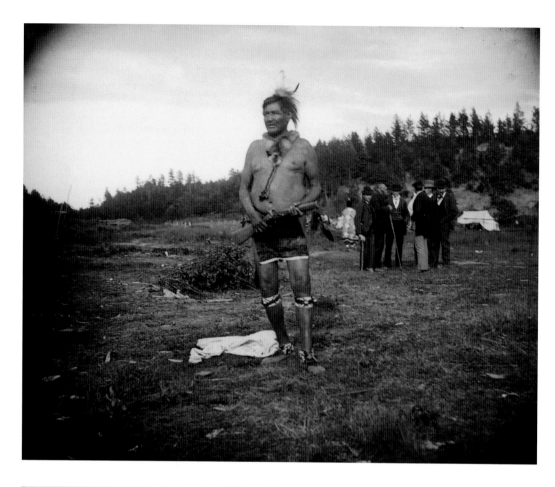

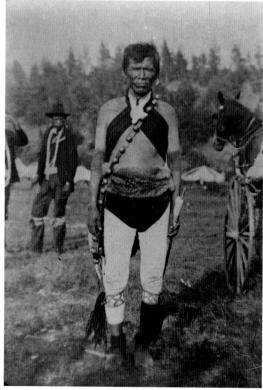

ABOVE: John Greencloud "Green Thunder" (WauKonChawChoKah), ca. 1906. John served in the Civil War as a scout for the U.S. Army with the Comanches.

LEFT: Army veteran George Standingwater (HaNaKah), ca. 1906.

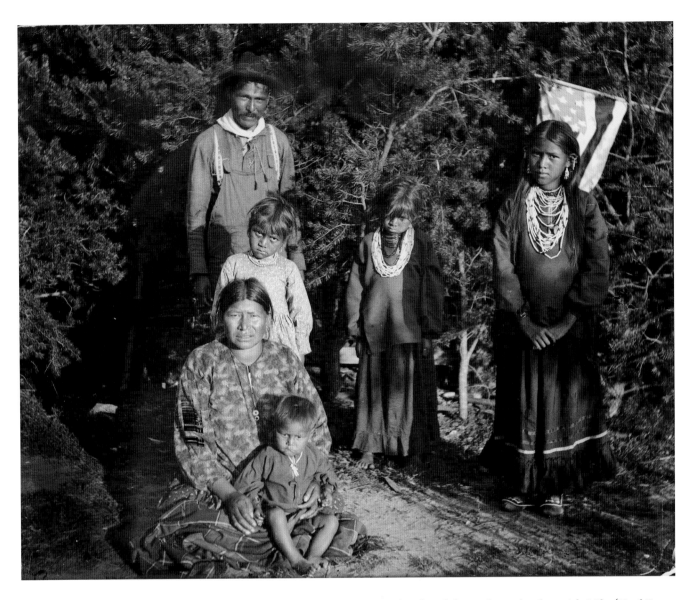

John Mike Jr. (HayShooKeekah), rear left, pictured with his family, ca. 1901. Standing from left to right are daughters Ada Mike (HunkE-WinKah), Lizzie Mike (WeHunKah), and Belle (Mattie) Mike (ENooKah). Wife Kate Mike (ENooKeeKah) is seated with son Dewey Mike (WaHoPinNeKeKah) in her lap. Dewey Mike, who became an army private, was killed in action on August 30, 1918, in France. A member of Company A, 128th Infantry, he was among the twelve thousand Native Americans on active duty during World War I. At the time, most Native Americans were not United States citizens and were not granted citizenship until the passage of the Indian Citizenship Act of 1924. Dewey was honored posthumously in May of 1933 when his mother visited his grave in France. Kate Mike was the only Native American Gold Star Mother to be invited by the government to France. She made the trip despite her limited ability to speak English, laying a wreath of pine boughs from the trees Dewey played beneath when he was a boy on his grave.

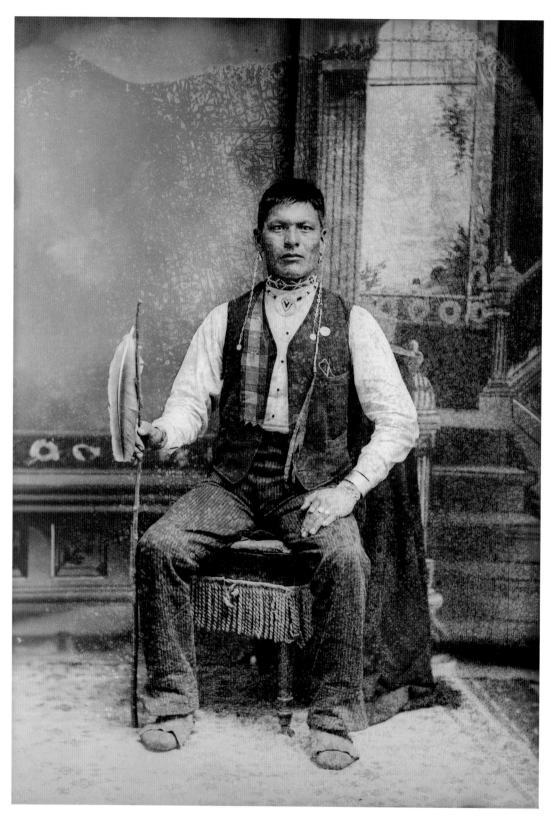

John Johnson, ca. 1885. John was a private with Company A of the Omaha Scouts. He is wearing traditional Ho-Chunk moccasins and earrings. In his hand is a staff with an eagle feather attached, indicating his warrior status.

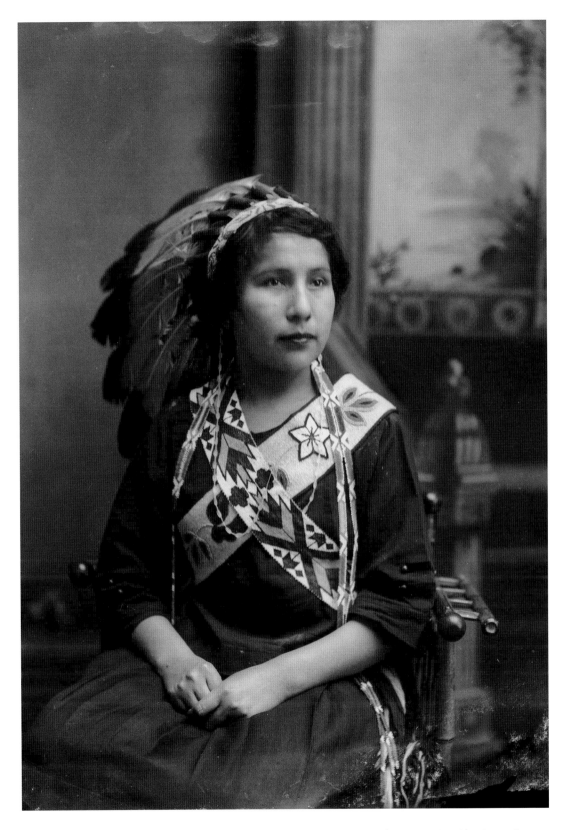

World War II veteran Ruby Whiterabbit is wearing an eagle feather war bonnet (mą́ąšų wooką́nąk). The war bonnet was not traditional among the Ho-Chunk but came to them from the Sioux (Lakota), with whom the Ho-Chunk participated in Wild West shows. The eagle feather bonnet is only worn by chiefs and warriors among the Ho-Chunk.

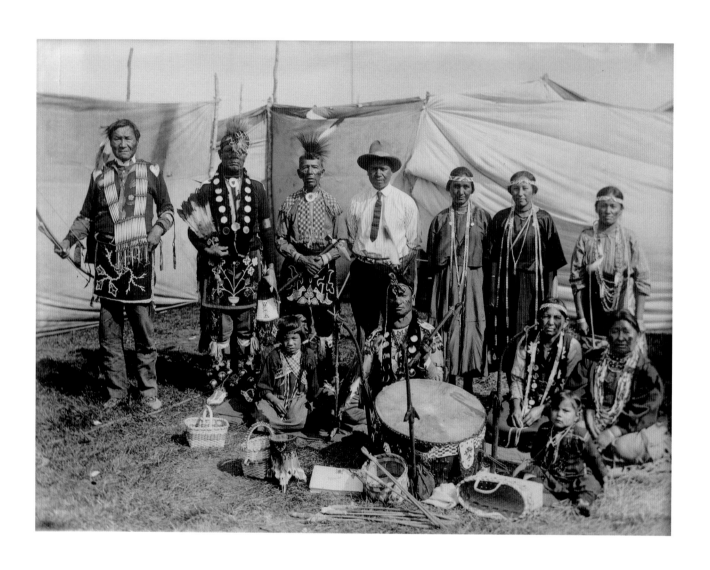

POWWOWS

I N JULY OF 1908, a weeklong "Homecoming Celebration" took place in Black River Falls to honor the *Badger State Banner*'s fifty years as the town newspaper. The celebration included an old soldiers program, band concerts, and speeches, as well as parades of bicycles, automobiles, carriages, and Indians on horseback. Besides taking part in the parades, the Ho-Chunk set up a small Indian village just below the Lutheran Church.

Chief George Winneshiek set up two different types of housing for the display: a wigwam (ciiporoke) covered in reed matting and a small teepee of the style used by the Ho-Chunk on short trips for berry picking and hunting. Tribal members also dressed in regalia to sing and dance for the townspeople. The 1908 Homecoming Celebration was not simply a nostalgic look back at the history of Black River Falls. It took its cue from the Ho-Chunk, whose own Homecoming Celebration, based on the tradition of the Haylushka and the powwow, had taken place a few years earlier on tribal land east of the town.

The powwow came to the Winnebago (Ho-Chunk) living in Nebraska from the Omaha Nation after the Civil War in the form of the Haylushka, a warrior honor society that originated with the Pawnee and promoted warrior traditions and values, in particular the selflessness of the true warrior. In 1866 the Omaha presented the Nebraska Winnebago with the ceremony, as well as a drum, roaches, and crow belts. The Nebraska Winnebago used the occasion to honor their veterans, especially those who fought in the Civil War. This ceremony evolved into the Nebraska Winnebago's Annual Homecoming Celebration Powwow, which has been held every year since 1866. It is recognized as the longest-running powwow in North America.

Like the Nebraska Winnebago, Ho-Chunk living in Wisconsin also used the Haylushka to honor their veterans. The Ho-Chunk hosted their first Haylushka near Black River Falls on July 12, 1888. The Ojibwa traveled from northern Wisconsin to participate and presented three Civil War veterans—John Bigsoldier, John Hazen Hill, and Jim Decorra—with eagle feathers. Mrs. Winneshiek, "Grey Eyes Lady," was also given a broken feather. The visiting Ojibwa followed the new "Drum Religion" or "Big Drum Religion," and they presented the Ho-Chunk with a series of ornately decorated Big Drums and introduced them to the teachings of the religion. In return for these gifts, the Ho-Chunk gave the Ojibwa feasts, horses, and other gifts. Ultimately, the Ho-Chunk chose not to follow this new religion, a choice evidenced by their use of a decorated Big Drum during a powwow at the 1908 Homecoming Celebration (see page 106, top).

The Wisconsin Haylushka later merged with the powwow and became a "Homecoming Celebration." The powwow, which was a social gathering for dancing Native dances, was never ceremonial, although ceremonial activities might take place. Similar to

the Haylushka, the powwow included giveaways to veterans and others to honor them for their sacrifices and good deeds. Gifts and prizes were also presented to the winners of the different games, races, and athletic competitions.

The first Ho-Chunk powwow was held at Frog Place on the first full moon in August 1902. At that powwow, the Omaha came to Wisconsin with four wagonloads of gifts to make amends for offending the Ho-Chunk; years earlier, they had refused to offer assistance during one of the government removals. After 1902, the powwow moved to Big Soldier Place near what was known as Dry Lake Place. In the days of horse and wagon, people traveled great distances to attend and would set up camp for the celebration, which might last between one and two weeks. The guests brought tents that they set up in a circle, with the Sky and Earth clans opposite each other in the traditional way.

The Ho-Chunk Black River Falls powwow is now held twice a year for four days on Memorial Day and Labor Day weekends. The Memorial Day weekend powwow honors all veterans, Ho-Chunk and non-Ho-Chunk, and the Labor Day powwow is usually a contest powwow. Until after World War II, a formal Haylushka dance continued as a separate dance from the powwow. In the 1990s Chief Michael Winneshiek and Kenneth Funmaker Sr. began to revive the Ho-Chunk Haylushka dance. Chief Winneshiek passed away before the first dance was held; his friends and relatives continued the work, and Kenneth Funmaker Sr. hosted the first dance. Just as in early Haylushkas, participants included the Ojibwa and many others from across Indian country.

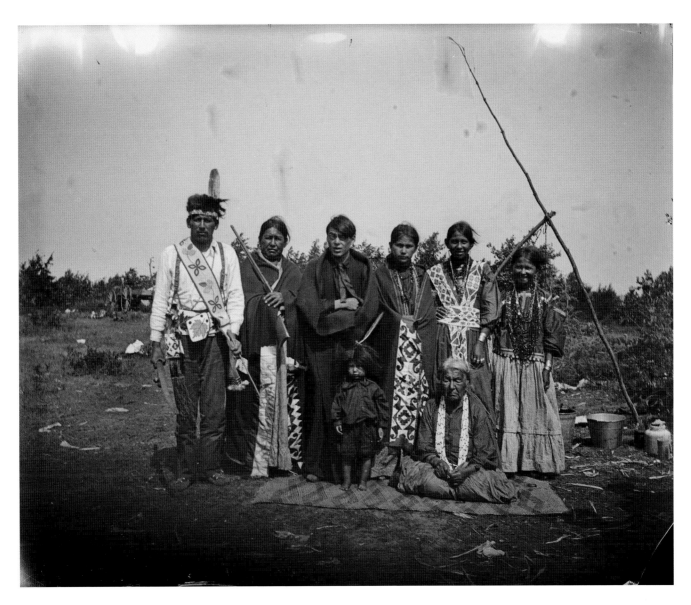

A group of Ho-Chunk dressed in regalia gather behind an elderly woman and child. The person with the rifle wears an appliqué blanket, as does the woman in the middle of the back row, fourth from left.

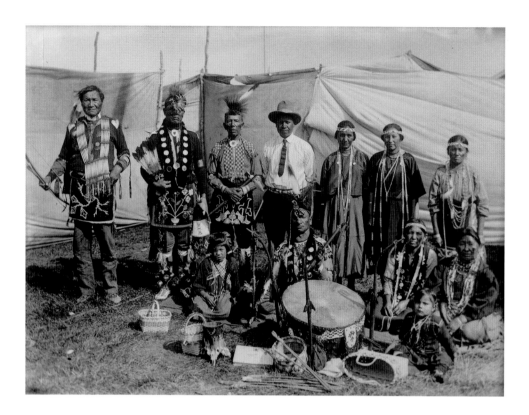

Ho-Chunk performers gather behind a drum and Winnebago baskets at the 1908 Homecoming in Black River Falls, Wisconsin. Standing from the left are Jim Swallow (MaPaZoeRayKeKah), William Massey (ChawRoCoo-ChayKah), George Eagle (WaNaKeeScotchKah), Benjamin Thundercloud (NySaGaShisk-Kah), and Flora Thundercloud Funmaker Bearheart (WaNek-ChaWinKah). The woman standing on the far right is Susie Lena Pettibone Johnson (ChoNukKaWinKah), and the woman seated to the left is Addie Littlesoldier Lewis Thunder (WauShinGaSaGah). Thomas Thunder (HoonkHaGaKah) is seated beside her behind the drum. Remaining names are unknown.

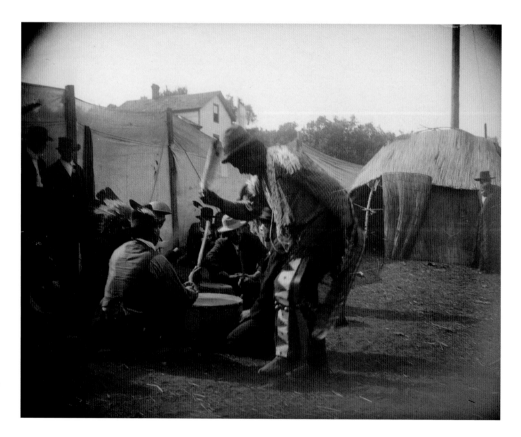

A Ho-Chunk man dressed in a mix of Native and contemporary clothing dances around singers seated around a drum, ca. 1908.

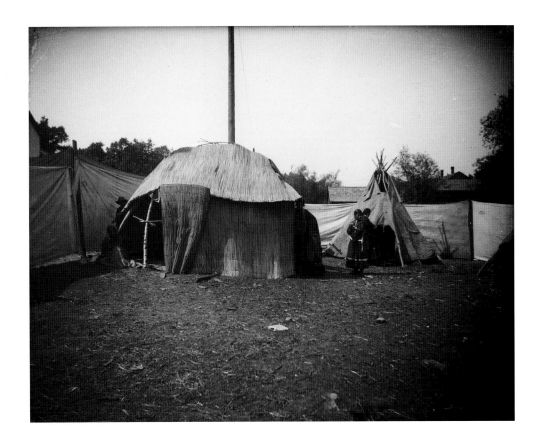

A cattail mat–covered wigwam (ciiporoke) and a small teepee were set up in a mock Ho-Chunk village for the 1908 Homecoming Celebration.

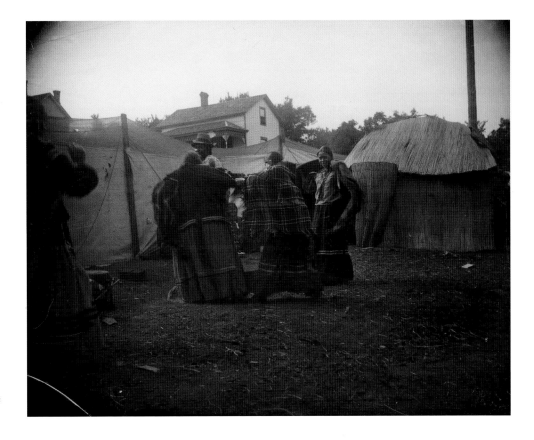

A group of Ho-Chunk women wrapped in shawls gather at the temporary Ho-Chunk village.

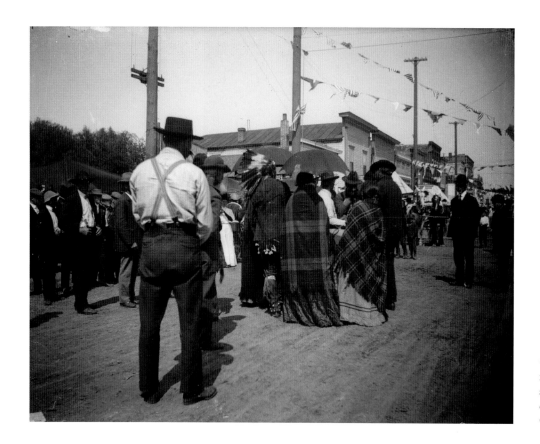

Groups of Ho-Chunk and non-Indians gather on the streets of Black River Falls during the 1908 Homecoming Celebration.

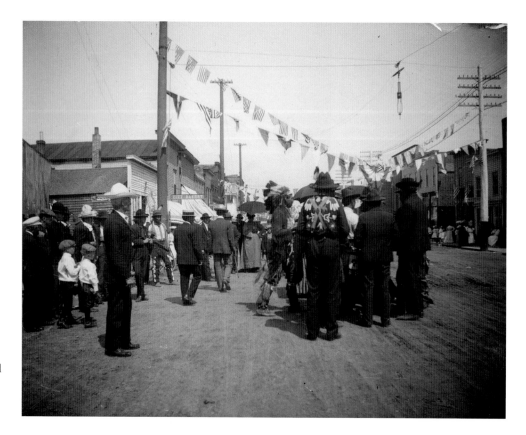

Tourists look on as a group of Ho-Chunk dressed in traditional regalia walks down the street during the Homecoming Celebration.

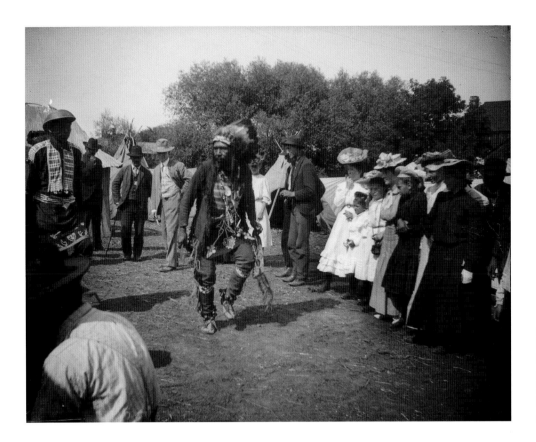

An unidentified man dances for a group of onlookers in Black River Falls during the 1908 Homecoming Celebration. He wears a Sioux-style eagle feather headdress and carries a Plains-style pipe bag.

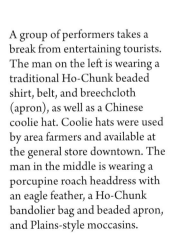

A group of performers takes a break from entertaining tourists. The man on the left is wearing a traditional Ho-Chunk beaded shirt, belt, and breechcloth (apron), as well as a Chinese coolie hat. Coolie hats were used by area farmers and available at the general store downtown. The man in the middle is wearing a porcupine roach headdress with an eagle feather, a Ho-Chunk bandolier bag and beaded apron, and Plains-style moccasins.

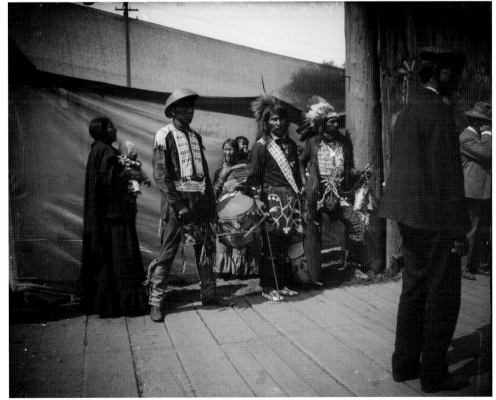

 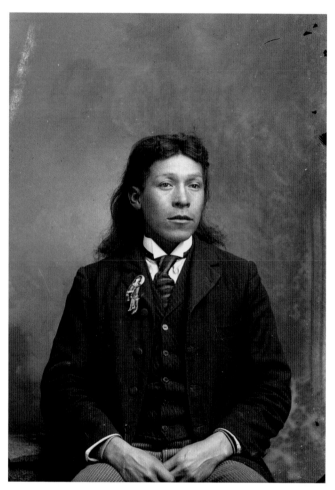

George Frank Buffalohead (WaChoZhoNoZheeKah), seated, and Sam Carley Blowsnake (HoChunkHaTeKah). Sam was the subject of Paul Radin's 1920 book, *Autobiography of a Winnebago Indian.*

Henry Greencrow (CooNooZeeKah), ca. 1900. Henry has a button on his lapel made from a photograph. Some of Van Schaick's photographs were made into buttons like this one.

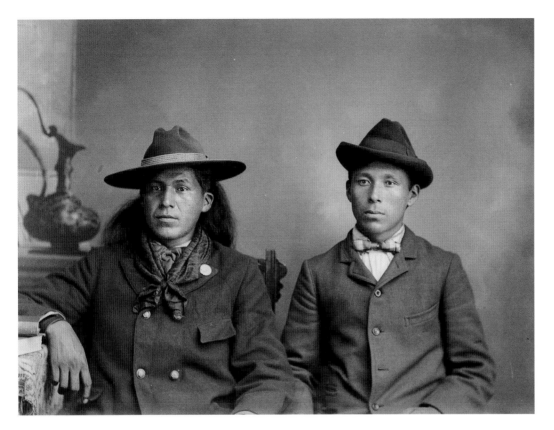

Sam Carley Blowsnake (HoChunkHaTeKah), wearing a hat and sporting long hair, is seated next to Martin Green (Snake) (KeeMeeNunkKah), ca. 1905. Long hair was not a common hairstyle for Ho-Chunk men during this time period but was adopted by some who performed in Wild West shows.

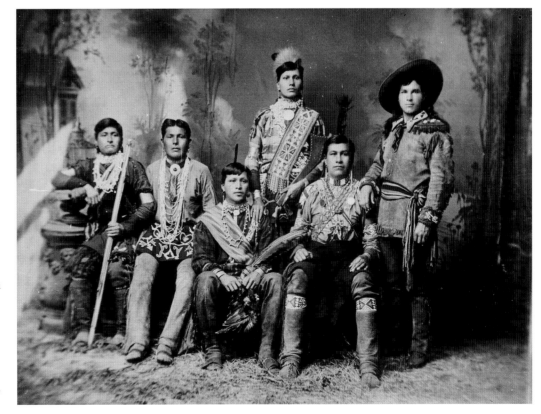

In this photograph, copied by Van Schaick from another photographer, Wild West show promoter Tom Roddy stands on the far right with his cast of performers. From left to right are Thomas Hunker (WaConChaKeeKah), John Whitedog (ChaShepSka-Kah), George Littlegeorge (KayRayChaSekSkaKah), Jake Decorra Whiterabbit (MuaHeRooZhooKah), and George Blackhawk (WonkShiekChoNeeKah), ca. 1885.

Ho-Chunk powwow participants. From left to right are an unidentified boy, John Hazen Hill (XeTeNiShaRaKah), William Hall (HunkKah), William Hindsley (Hensley) (CooNooChoNeeNikKah), John (Hoke) Highsnake (HaukSheNeeKah), Thomas Thunder (HoonkHaGa-Kah), Chief George Winneshiek (WaConChawNeeKah), George Greengrass (WauKeCooPeRayHeKah), John Davis (KaRoJoSepSkaKah), Luke (Duke) Snowball (NySaGaShiskKah), George Lonetree (HoonchXeDaKah), Henry Greencrow (CooNooZeeKah),William Hanson (HoonchHoNoNikKah), and David Goodvillage (WauHeTonChoEKah). Seated behind the drum is George Monegar (EwaOnaGinKah), with Frank Winneshiek (WaConChaHoNoKah) to his left.

A group of Ho-Chunk men are enjoying a game of cards at a powwow.

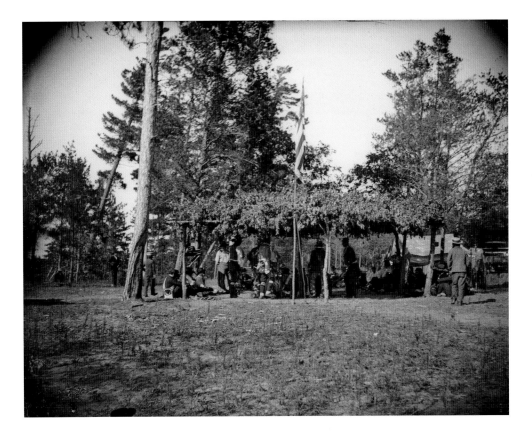

This arbor was erected for a celebration with the Ojibwe, who traveled from their reservation in northern Wisconsin to participate in the Winnebago-Chippewa Conference of 1895 and to present the Ho-Chunk with a ceremonial drum. Arbors were often used for powwows. Singers would sit around a drum in the center of the arbor, and the dancers would dance in a circle around the drum and singers. At a large powwow, only the drums and singers could fit under the arbor and the dancers would dance around the arbor. An American flag is visible at the front of the arbor.

Six Ho-Chunk men line up for a photograph at the powwow grounds, ca. 1910. The men with sticks in their hands are members of the Bear clan, who act as police for the tribe and handle security at tribal events. From left to right are Andrew Bigsoldier (WaConChaShootchKah), Henry Winneshiek (WaConChaRooNayKah), George Monegar (Ewa-OnaGinKah), Albert Thunder (CheNunk-EToKaRaKah), Frank Washington Lincoln (ChakShepKonNeKah), and Max Bearheart (MoNeKah).

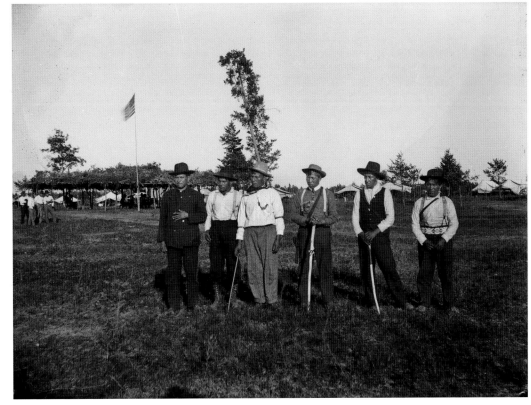

RELIGION AND CLANS

Ho-Chunk clans, or family groups, are divided into two distinct sets, or moieties: Those-who-are-above, and Those-who-are-on-earth. The Thunder (Wakąja), Warrior (Woonąǧire Wąąkšik), Eagle (Caaxšep), and Pigeon (Ruucge) clans belong to the upper moiety, while the Bear (Hųųc), Buffalo (Ceexjį), Deer (Caa), Wolf (Šųųkjąk), Elk (Hųųwą), Fish (Hoo), Water Spirit (Wakjexi), and Snake (Waką) clans belong to the lower moiety. Traditionally, men from the upper moiety married women from the lower moiety, and vice versa.

The clan, which was usually passed through the father's side, regulated social and political functions. Each clan had important duties to ensure that the tribe operated in an organized and efficient manner. These duties were divided up in much the same way that any organized society delegates responsibilities, and ranged from leadership, peace-making, discipline, and communication to hunting, war, and sanitation.

During this period, the Ho-Chunk had three principal religions: traditional, including war bundle feasts, wakes, and the Medicine Lodge; Christianity; and the Native American Church. The Medicine Lodge is a secret religious society of the Ho-Chunk. There are two ways in which a person may join. The first is to apply for admission to one of the leaders. The second and more common option is to take the place of a deceased relative. In the latter case, surviving relatives determine who will take the place of the deceased.

In the Black River Falls area, the first attempts to convert the Ho-Chunk to Christianity took place around 1878 when the Winnebago Indian Mission of the Evangelical Reformed Church began with land given by Jackson County. In 1882 a new chapel was built, and two years later Reverend Jacob Stucki replaced Jacob Hauser as the minister. Stucki and his family learned the Ho-Chunk language and with the help of John Stacy translated parts of the Bible. The first Ho-Chunk to convert were David Decorah, John Stacy, Joe Thunderking (King of Thunder), Martha Stacy, and George Lowe in 1898. The Mission Church still stands near the place it was first erected.

The Native American Church spread from Indian Territory (Oklahoma) to the Winnebago (Ho-Chunk) in Nebraska around 1890. In 1908 the Nebraska Winnebago sent a delegation of around one hundred Indians to Wisconsin to introduce their new religion, which combined elements of Native American religions and Christianity, to their relatives there. By 1915 the religion was being practiced by some of the Ho-Chunk living near Wittenberg, a town one hundred miles northeast of Black River Falls.

All of these Ho-Chunk religions are still practiced today.

A group of Ho-Chunk standing
in the rear of a Buffalo Dance
Lodge. The Buffalo Dance
would take place in the spring
when the grass was long enough
to tie in a knot.

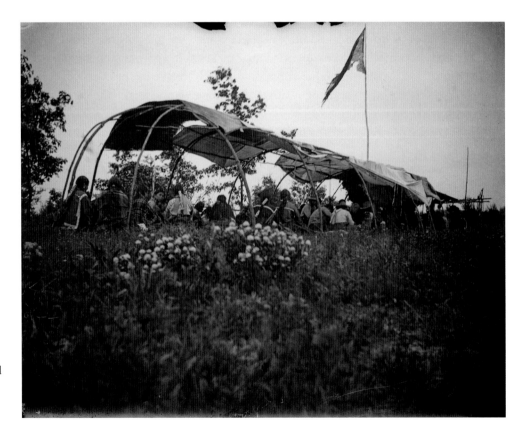

Thunder Clan Feast Lodge.
The flag is British and came to
the Ho-Chunk when they joined
forces with the British against
the United States during the
War of 1812.

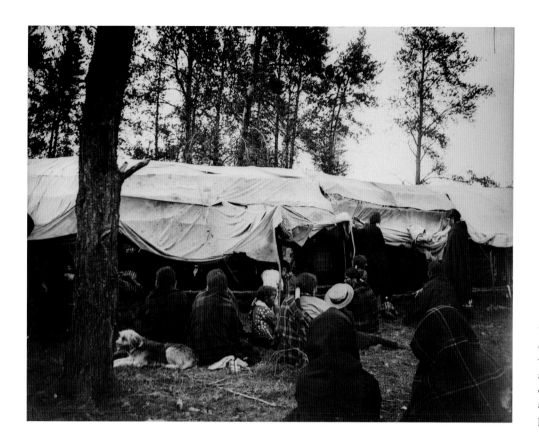

Unidentified Ho-Chunk sitting outside of a medicine lodge, whose sides are rolled up to allow airflow. Only members of the Medicine Lodge were allowed to enter the lodge and participate in the ceremonies.

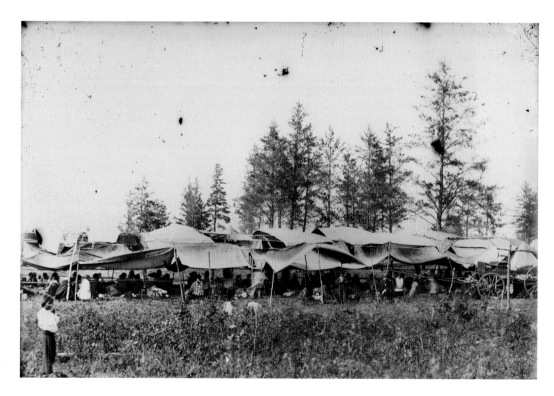

A Medicine Dance Lodge at Morrison Creek.

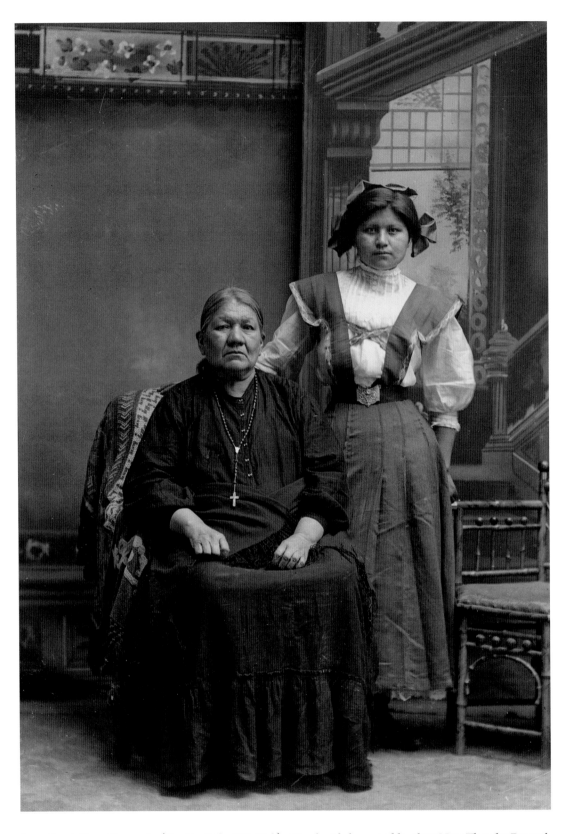

Lucy Goodvillage Blowsnake (NauNawZokeAWinKah) sitting beside her granddaughter Nina Thunder Decorah Green (AhHooGeNaWinKah), ca. 1915. Lucy wears a Christian cross around her neck.

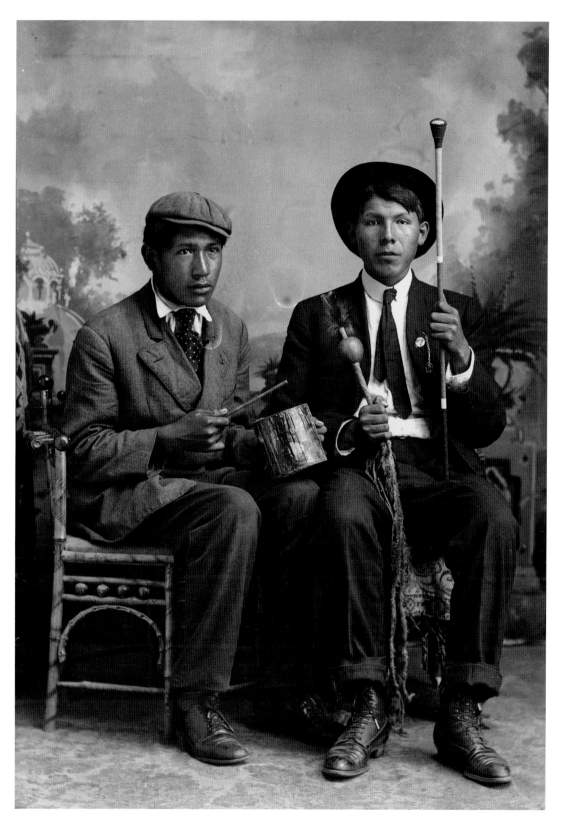

Sam Thunderking Lowe (HoChumpHoNikKah), seated on the left, and Julius Whitedog (ChakShepWasKaHe-Kah), ca. 1920. Both men are holding items used in the Native American Church. Sam holds a can used as a drum, and Julius has a staff and gourd rattle.

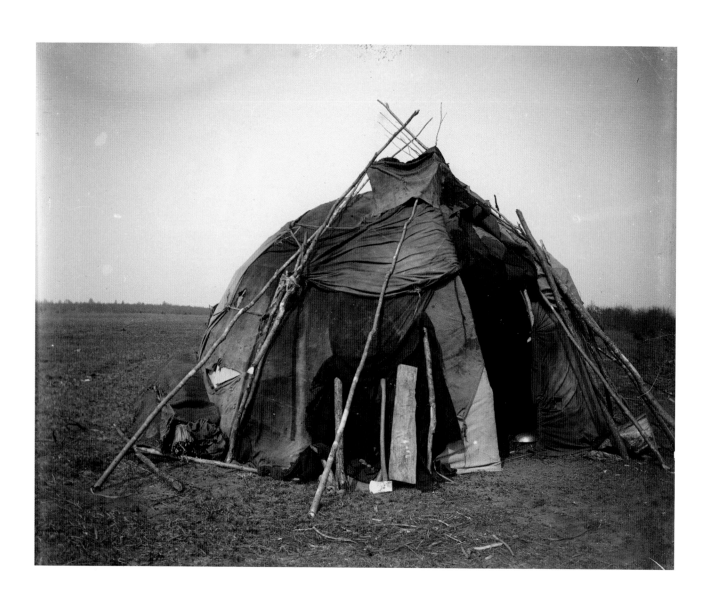

HOUSING AND WORK

TRADITIONALLY, THE HO-CHUNK built eight different types of lodges. In Van Schaick's outdoor photographs, the most common types are a long lodge (ciiserec) used for Medicine Lodge and clan feast ceremonies and the round house (ciiporoke), which served as housing. The Ho-Chunk women were responsible for building all lodges except ceremonial ones. Variations existed according to season: the structures were bark-covered in colder months and reed- or canvas-covered in the warmer months, with combinations of these according to weather and availability of materials.

Lodges were erected by driving ironwood poles (ciišu) into the ground, bending them into an arch, and lashing the poles together with basswood bark. The covering on the outside of the lodge would be tied to the poles with more strips of basswood bark. A hole was left in the roof to allow the smoke from the fire to exit. In the summer the Ho-Chunk who still lived in bark-covered lodges would cover them with reed mats, as the mats shed water better than the bark. After its introduction, canvas was used for tents in summer because it was lightweight and easy to roll up for ventilation.

Like housing, work was also seasonal. Before removal by the U.S. government, the Ho-Chunk had been accustomed to traveling to different areas of their territory to take advantage of the bounty of the different seasons. The summers were spent in areas with good soils in which to grow their traditional crops, and the fall and winter found them living in areas with good hunting and trapping. In 1874 Congress passed legislation allowing homesteads of up to eighty acres to those who had returned to Wisconsin. Finding only marginal land available to them, the best land of the original Ho-Chunk territory having been sold to settlers, the returning Ho-Chunk had no choice but to settle on these less desirable tracts of land.

It was difficult to live the old way and support and feed their families, so many Ho-Chunk hired themselves out as farm laborers to earn money. A common way to generate income was to work the various seasonal harvests, including the cherry and cranberry harvests. Local growers would place posters requesting Winnebago (Ho-Chunk) workers for the harvest in early fall. The Ho-Chunk would harvest the crops by hand, often alongside their white neighbors.

Three Ho-Chunk children pose for a photograph in a field known as Browneagle Bottoms. The children, from left to right, are Maude Browneagle (WeHunKah), Liola Browneagle (ENooKah), and Jesse Stacy (MoRoJaeHooKah).

Frank Browneagle (HeWaKaKayReKah) and his wife, Annie Snake (KhaWinKeeSinchHayWinKah), stand in front of their homes, ca. 1906. The wigwam (ciiporoke) on the left is covered with canvas and cattail mats. The stovepipe rising from the roof indicates that they have a wood-burning stove inside. The canvas tent on the right was used as a summer home or cooking house.

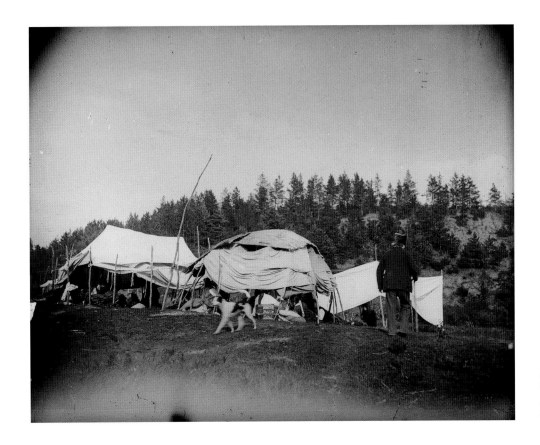

A Ho-Chunk man and a dog walking near their home and cooking tent. The sides rolled up to allow air to flow through.

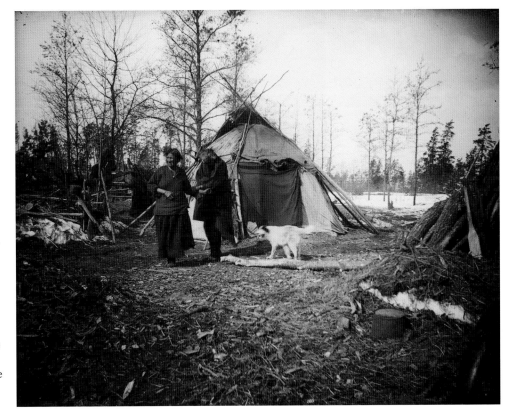

A Ho-Chunk couple and their dog outside of their winter home (ciiporoke), ca. 1890. A Hudson's Bay blanket hangs over the door opening. The long tree branches leaning against the canvas were used to open and close the smoke flaps on the top of the roof. On the right side of the image is a pile of wood that has been gathered for the winter.

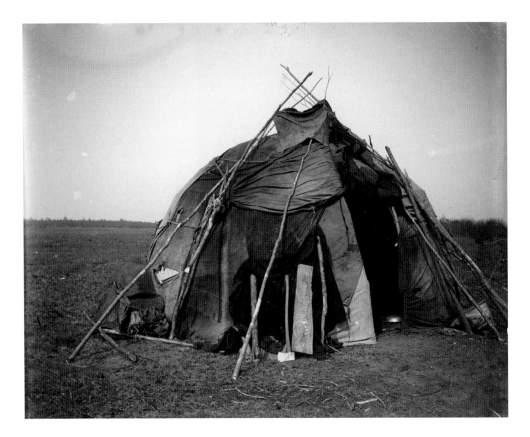

The Ho-Chunk used many different materials to cover their lodges. The earlier lodges had coverings made of cattail mats, deer hides, and sheets of bark. This one is covered with canvas, with a smoke hole visible at the top. When residents were not home, they would simply allow a blanket or mat to hang down over the door opening. A stick or board leaned against the door would indicate that no one was home.

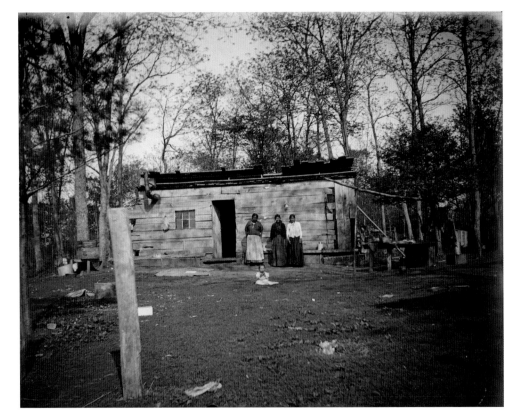

Three unidentified women pose in front of a log home located near Wittenberg, ca. 1910. It seemed strange to many Ho-Chunk to live in a house that was square. Very few Ho-Chunk lived in log or framed houses until the WPA built housing for the Ho-Chunk.

An unidentified person wrapped in a blanket walks across the snow. The wigwam poles (ciišu) of a ciiporoke are visible in the distance.

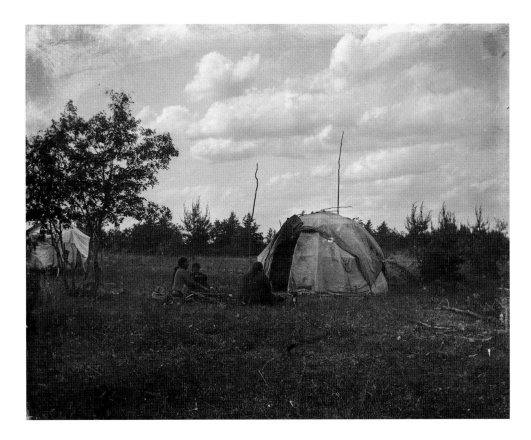

Three unidentified Ho-Chunk are seated outside of their canvas-covered ciiporoke. A summer house can be seen through the trees.

Two Ho-Chunk men wearing beaded shirts gather cranberries (hoocąke) alongside a Ho-Chunk woman and a white man and woman, ca. 1900. A large group of cranberry harvesters can be seen in the background. The men, who wear beaded shirts not usually worn for work, may have been told in advance that a photographer was coming to take pictures.

A large group of Ho-Chunk and whites harvest cranberries, ca. 1900. The wooden boxes lying in the field were filled with the fruit and then shipped by railroad to the processor.

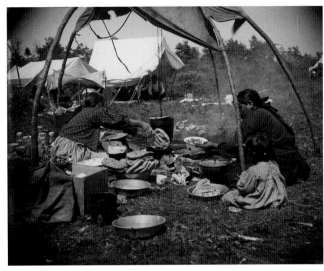

Clockwise from top left:

A group of Ho-Chunk men and boys stand in front of two canvas tents set up at a Ho-Chunk gathering, possibly a cranberry camp. The smiles on their faces and relaxed poses indicate how comfortable the Ho-Chunk were with Charles Van Schaick and his camera equipment.

Alice Cloud and Mrs. Mallory making frybread at a cranberry camp at Trow's Marsh. The marsh extends from south of Merrillan to north of Millston. Frybread (wasgaptaxere) became popular after the government began providing basic commodities to the tribes. One of the simplest foods to make with the flour was frybread, which has since become an iconic Indian dish.

Seven Ho-Chunk men stand in a cranberry bog holding the hand scoops used to harvest cranberries, ca. 1920. The long narrow slats at the front of the hand scoop were used to strip the berries off the vines. Standing third from left is George Garvin Sr. (WoShipKah); second from right is Jim Swallow (MaPaZoe-RayKeKah).

Van Schaick also photographed Ho-Chunk on the streets of Black River Falls. These occasional pictures offer a glimpse into the everyday life of the Ho-Chunk. Here, Harold Blackdeer (WeShipKah) waits with his wife, Nellie W. Blackdeer (CheHaCheWinKah), and their son Earl W. Blackdeer in the snow. This photograph, taken around 1915, was shot from the window of Van Schaick's studio. The Blackdeer family have their horses packed with goods for the winter.

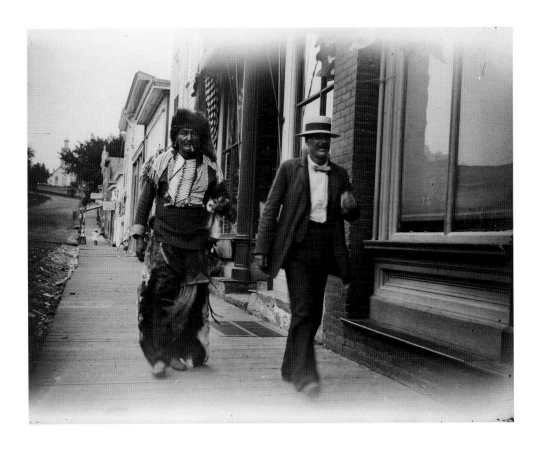

An unidentified Ho-Chunk man and a white man walk along a boardwalk in downtown Black River Falls, prior to the 1911 flood.

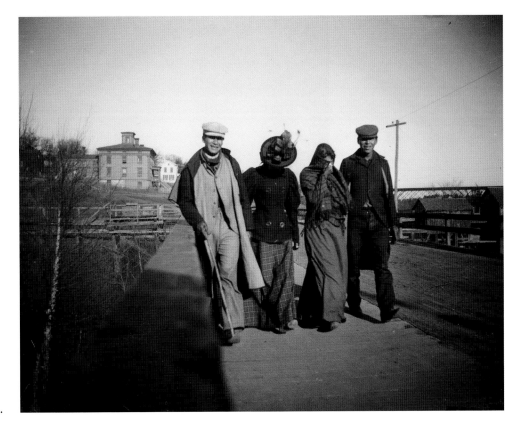

Four Ho-Chunk cross a bridge spanning the Black River. This photograph was taken before the flood of October 1911, when the bridge was completely destroyed.

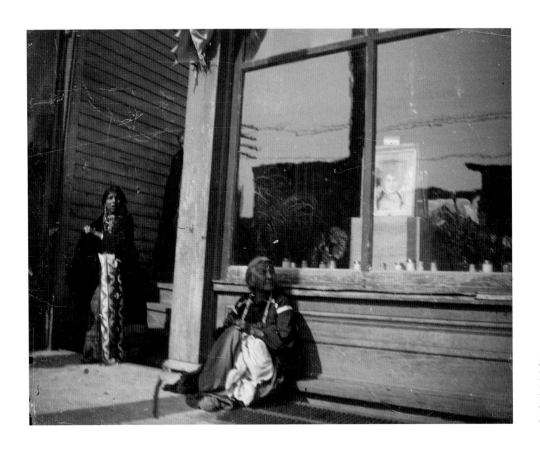

Annie Massey (KeKoRaSinch-Kah), left, and Hester Decorah Lowery (NoGinWinKah), ca. 1915. Hester lived to be well over one hundred years old.

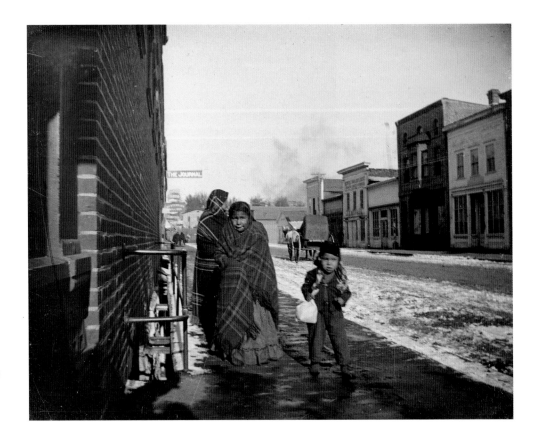

Two Ho-Chunk girls wrapped in Racine Woolen Mills shawls walk with a young boy down Water Street in downtown Black River Falls, ca. 1915.

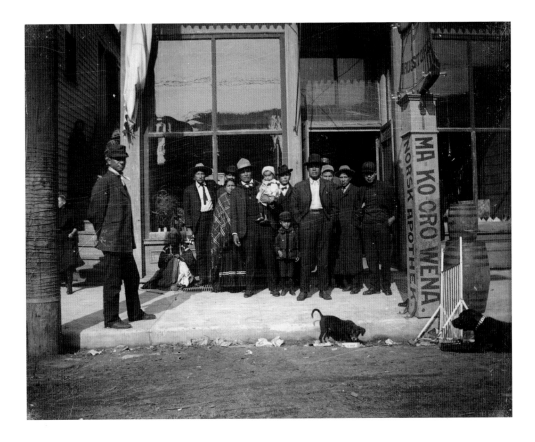

A group of Ho-Chunk gather in front of Werner Drugstore on Main Street in Black River Falls, ca. 1915. The signpost on the right side of the photo indicates that English was not the first language of many of the area's residents. One side of the post gives the Norwegian word for drug store, "APOTHEK." The front side reads "MA KO CRO WENA," which means "medicine sold here" in Ho-Chunk. Thomas Thunder (Hoonch-HaGaKah) is standing on the left, and Hester Decorah Lowery (NoGinWinKah) is seated next to the building.

Jim Swallow (MaPaZoeRayKe-Kah) and Pinkey Bigsolder (HoWaWinKah), as well as an unidentified child, cross at the corner of Main and South First Street in Black River Falls, ca. 1915. Jim Swallow was a tall man, at least six and a half feet in height, who lived between Sandy Plains and Shamrock. Early explorers who had contact with the Ho-Chunk often noted how tall they were.

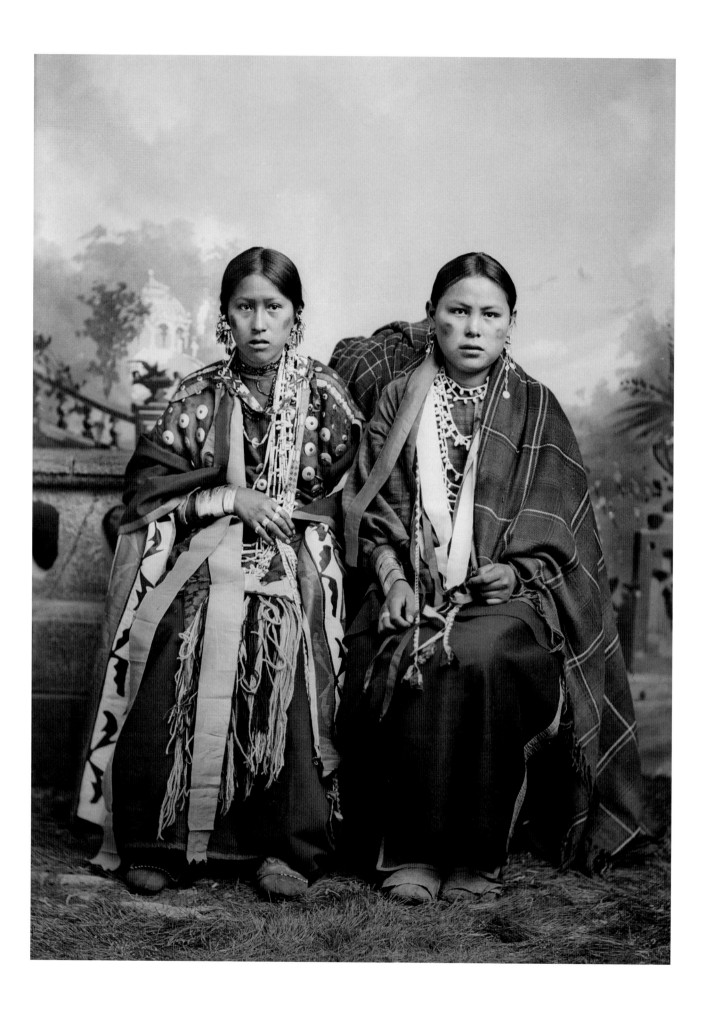

TRADITIONAL AND
CONTEMPORARY DRESS

As the viewer looks at these photographs of the Ho-Chunk by Charles Van Schaick, one thing should be apparent: the stereotypical view of Indians is missing. In only a few pictures are the Ho-Chunk dressed in traditional buckskin clothing or an eagle feather bonnet. With the introduction of trade cloth, silk ribbon, and trade beads, the Ho-Chunk were quick to adapt these items to their clothing. Trade cloth was much easier and less time consuming for the Ho-Chunk women to work with than buckskin.

The basic woman's outfit, or hinukwaje, consisted of a cloth skirt and blouse, which probably mimicked the style of the buckskin dress. The hinukwaje was sometimes accessorized with rings, earrings, bracelets, and necklaces with beads made of shell, glass, or bone. The plain hinukwaje is still worn by women today at traditional Ho-Chunk gatherings. Women's moccasins were made from one piece of leather with a top flap that was unique to the Ho-Chunk (see page 152). The top flap was left plain or decorated with silk appliqué or beadwork.

Women did not wear coats, so they would cover themselves with a wool shawl (waj). The plaid shawls seen in many of these photographs were produced by the Racine Woolen Mills Company (see page 88). The Ho-Chunk had an account at the Taylor and Jones store in downtown Black River Falls to purchase the shawls, which were always kept in stock.

Early cloth Ho-Chunk skirts were made from wool trade cloth and were worn wrapped around the waist, overlapping at the front. The skirt was held in place by a wool finger-woven sash that was tied around the waist, and the top portion of the skirt was turned over the sash. The early skirts were plain and did not have any embellishment. Women would sometimes wear an appliqué blanket around their waist, and this later became the appliqué skirt, or wawaje.

Like dresses, blouses varied according to the maker. Most blouses had three-quarter sleeves and a bottom that extended below the hips to cover the top of the skirt and the finger-woven sash. Some of the later-style blouses worn with a hinukwaje-style skirt only extended to the waist (see pages 49, bottom, and 231). Some Nebraska women wore a style of blouse that had a slit in the front with a ribbon sewn on each side (see page 139).

The regalia worn by these Ho-Chunk women ranges from a basic unadorned hinukwaje to intricate hand-cut and hand-sewn silk ribbon appliqué skirts, necklaces,

German silver jewelry, and beadwork (see page 44). In the photograph of Flora and Mary May Thundercloud (see page 49, top left), side-stitch beaded paques and long ribbons are tied to their hair with a hair wrap. These would usually hang down the back but are brought forward for the photograph. The German silver brooches on both girls' blouses were made by Flora's father, Moheek Thundercloud, using small wooden molds. Flora's wawaje outfit is completed with silver rings, bracelets, and earrings made by Ho-Chunk silversmiths (see page 48). Photographs like this were occasionally made into postcards by Van Schaick and sold to the family to be sent to relatives in other Ho-Chunk settlements in the hope that they would be shown to other families, letting them know of an eligible young woman.

As time passed, Ho-Chunk women started to wear more contemporary clothing due to the influence of boarding schools and the Winnebago Mission Church, which supplied donated clothing from area churches to the Ho-Chunk.

Ho-Chunk men began wearing a mix of contemporary and Ho-Chunk clothing much earlier than the women. In only a few instances are the men dressed in full Indian regalia (see pages 38, 106, top, and 111, bottom). In many photographs clothing is complemented with items from other tribes that the Ho-Chunk obtained through trade, gift, or purchase (see pages 45, 50, 85, and 188).

In the photograph on page 36, Frank and Henry Winneshiek are both dressed in a typical young man's outfit of the time, consisting of a cotton shirt with loom-beaded strips on the shoulders and down the front of the shirt, a loom-beaded belt, and beaded garters. Henry is also wearing traditional Ho-Chunk moccasins and has bandolier bags crossed over his chest, indicating that he was a bachelor. Crossed bandoliers were also worn by the Ho-Chunk in honor of the French and represent the crossed straps holding the swords in French military regalia. The French and the Ho-Chunk had mutual respect for each other and both benefited from their relationship during the fur trade era. The bandolier bags worn by young men tended to be smaller in size than those worn by women and older men (see pages 49, top right, and 50). Some of the photographs of young men were made into postcards and sent to relatives in other communities to serve as notice of an eligible bachelor.

The regalia that the Ho-Chunk men are wearing in the Van Schaick collection represent different styles of traditional dress. In most of the photographs the men have adopted the hat of the time period as their head covering, but traditionally they would have worn an otter-fur turban, a finger-woven sash, a porcupine-and-deer-tail hair roach, or an eagle feather bonnet (see pages 50, 62, and 167).

The shirt would be plain or covered with appliqué beading or loom-beaded strips (see page 41). The breechcloth or apron would be decorated with beaded appliqué or silk appliqué. The leather leggings would be made of buckskin and would extend over the moccasins to the ground. These old-style men's moccasins, which are rarely seen today, had a large flap on the top similar to the women's style and could be pulled up over the leggings and tied to keep out snow. Loom-beaded garters would be tied just below the knee and also worn above the elbow.

Many of the men and some of the young boys can be seen wearing earrings made of shells or German silver. The privilege for a man or boy to pierce his ears was reserved for those who had fasted. The men usually had fewer piercings in each ear than the women, who would have up to seven. Multiple piercing was not common to other tribes.

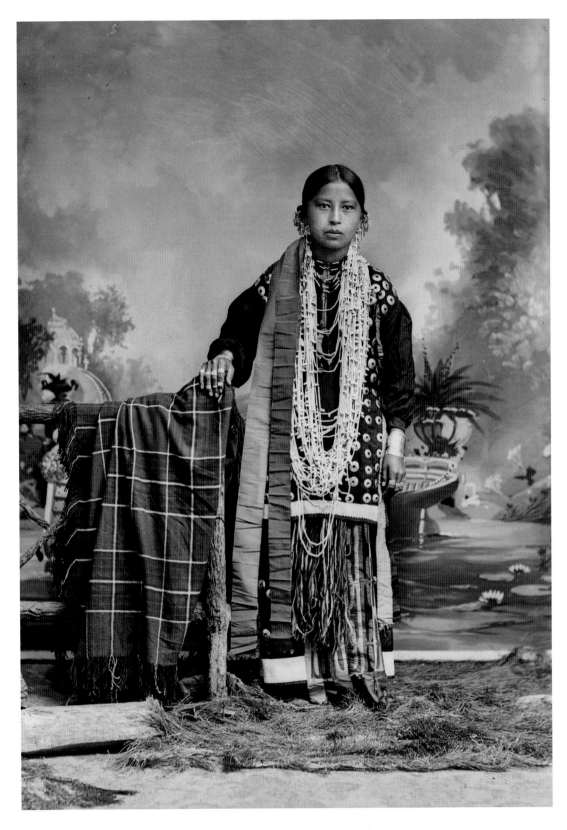

Sally Dora Redbird Goodvillage Whitewater (WauNeekShootchWinKah), ca. 1904. The braided ends of her finger-woven sash hang down from her waist, covering up the appliqué on her skirt. The appliqué on the skirt was traditionally worn to the side but was sometimes brought to the center so that it could be seen in photographs.

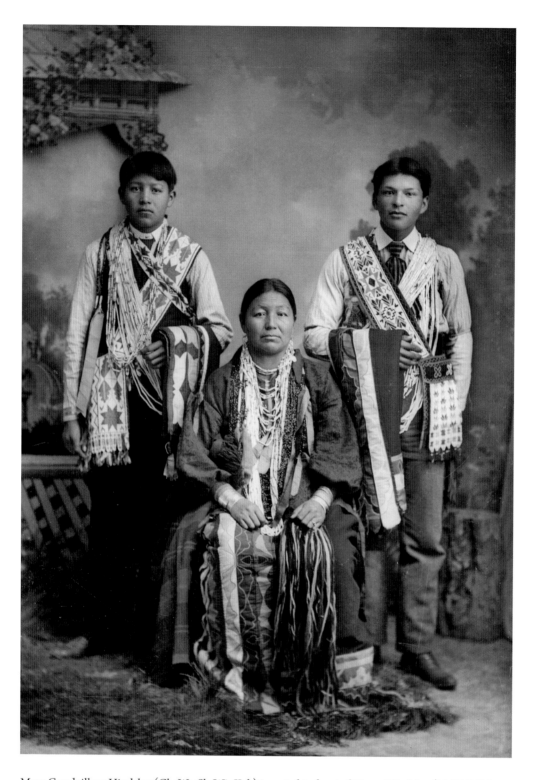

Mary Goodvillage Hindsley (ChoWasSkaWinKah) is seated in front of Henry Hindsley (MaHePeWin-Kah), left, and Henry Badsoldier Stacy (MonNawPaeSheSheckKaw), ca. 1910. Mary is dressed in tradi-tional Ho-Chunk clothing, including a silk appliqué skirt (wawajé), necklaces (wanąpį), German silver bracelets (žuura sgaa aipa), and a finger-woven wool sash. Both young men wear beaded Ho-Chunk bandolier bags and bone and shell bandoliers and hold silk appliqué blankets. These bandolier bags are of Ho-Chunk design. The Ho-Chunk traded for bandolier bags with the Ojibwa, a common practice at this time. It is said that the price for a bandolier bag was one good horse.

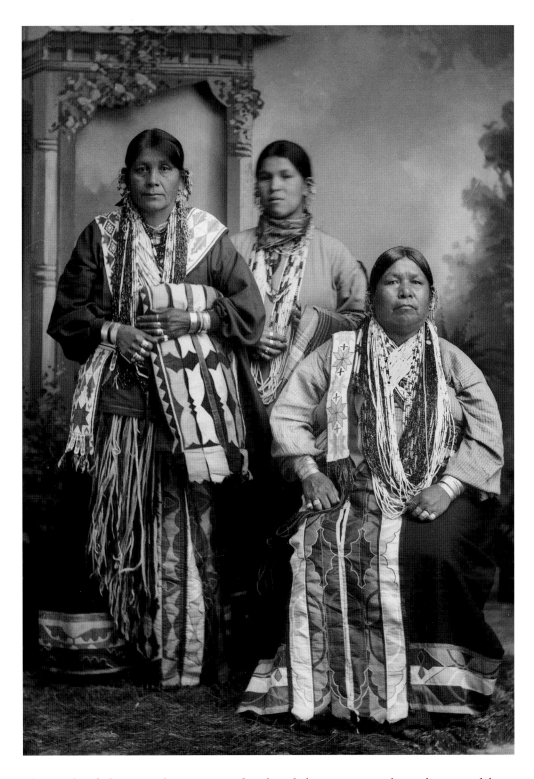

Three unidentified women. The woman seated on the right has contrasting color stitching around the floral designs on her appliqué skirt. The woman on the left is wearing two Ho-Chunk beaded bandolier bags and holds a silk appliqué blanket.

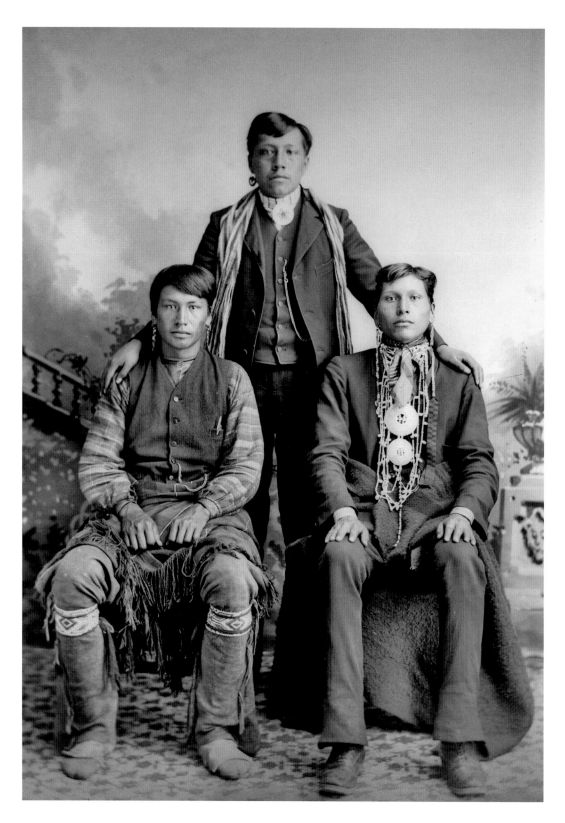

Three unidentified men in a mix of contemporary and Ho-Chunk clothing, ca. 1880. The man seated on the right is wearing beads and a necklace made of large German silver medallions. The Ho-Chunk have always been metal workers, having made ornaments, armor, and functional objects from the lead and copper they mined and later using trade metals.

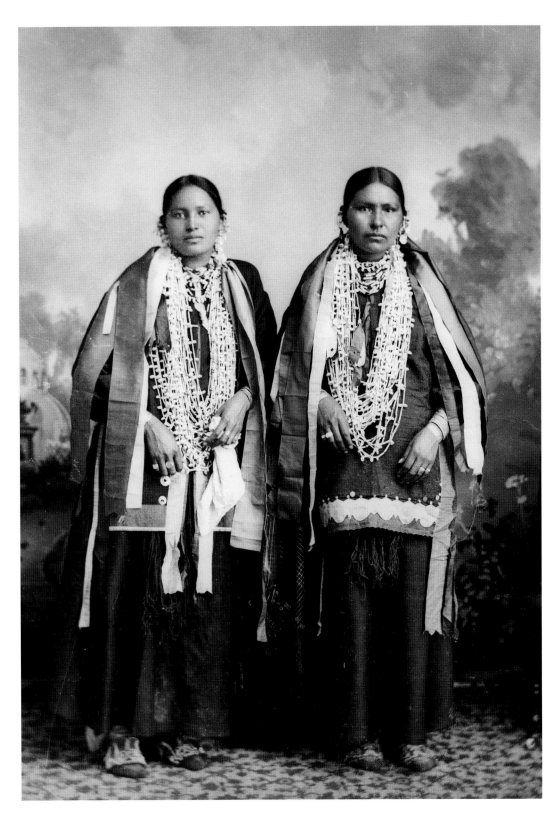

Two unidentified women in traditional clothing with traditional necklaces and strips of silk ribbon over their shoulders. Both have ribbon work on the bottom edge of their blouses. The woman on the left has a slit on the front of her blouse with ribbons sewn on both sides. This is a style used by some of the women from Nebraska.

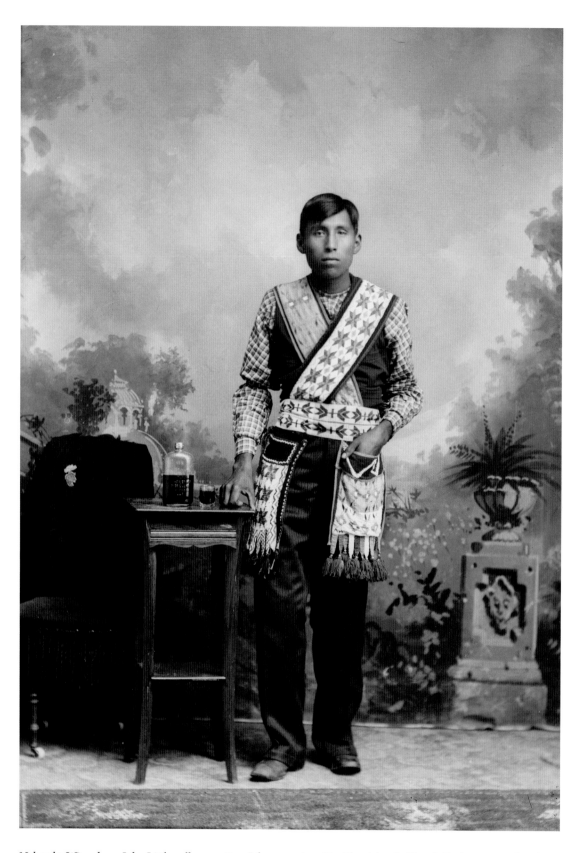

Nebraska Winnebago John Littlewalker, ca. 1890. John wears two Ho-Chunk beaded bandolier bags across his chest, indicating his wealth and his status as an eligible bachelor. He later married Lucy Longtail of Nebraska.

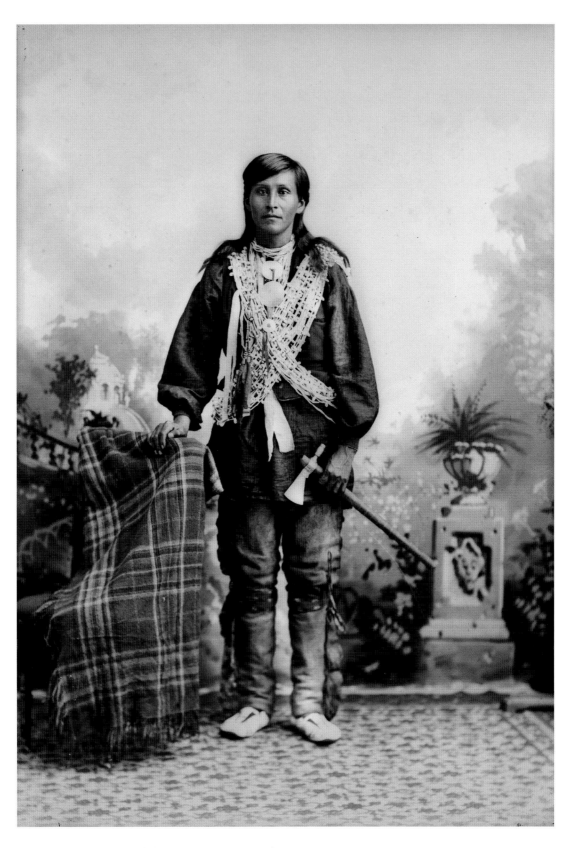

William Hindsley (Hensley) (CooNooChoNeeNikKah) holds a pipe tomahawk and wears bandoliers of bugle beads across his chest, ca. 1880.

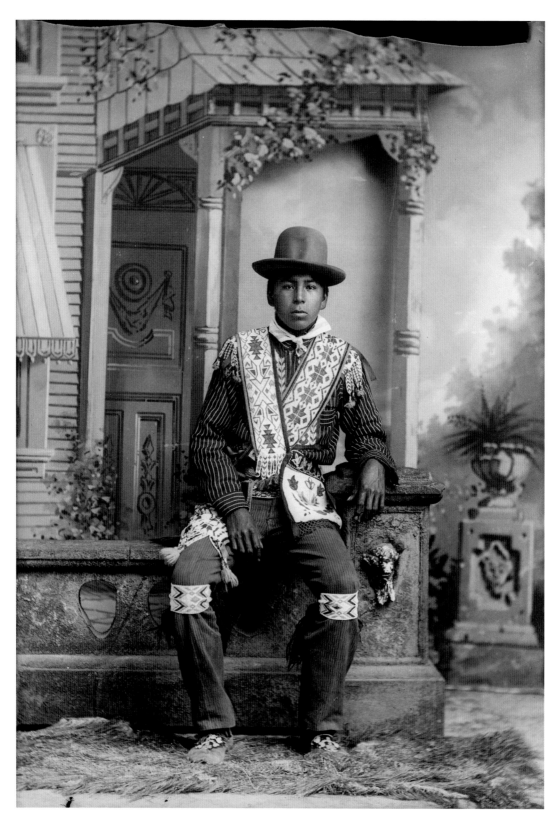

David Bow Littlesoldier (MauJchayMauNeeKah) poses in front of a backdrop that appears in many of Van Schaick's photographs, ca. 1895. He wears a hat (wookąnąk), a beaded shirt (woonążį), two bandolier bags crossed over his chest, loom-beaded garters, and traditional Ho-Chunk moccasins (caahawaguje).

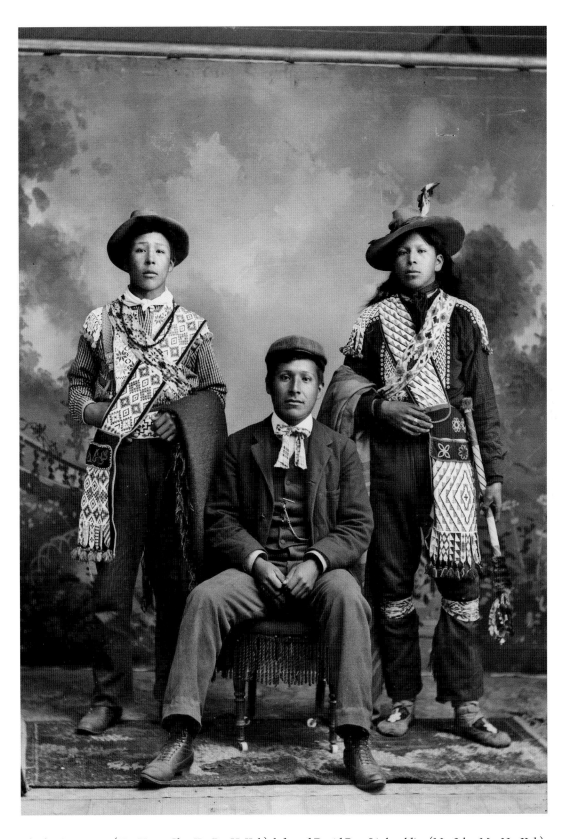

Charlie Greengrass (HoeHumpCheeKayRayHeKah), left, and David Bow Littlesoldier (MauJchayMauNeeKah) stand behind Will Stohegah Carriman (WonkShiekStoHeGah), ca. 1890. Will is dressed in contemporary 1890s clothing, while the others wear traditional regalia.

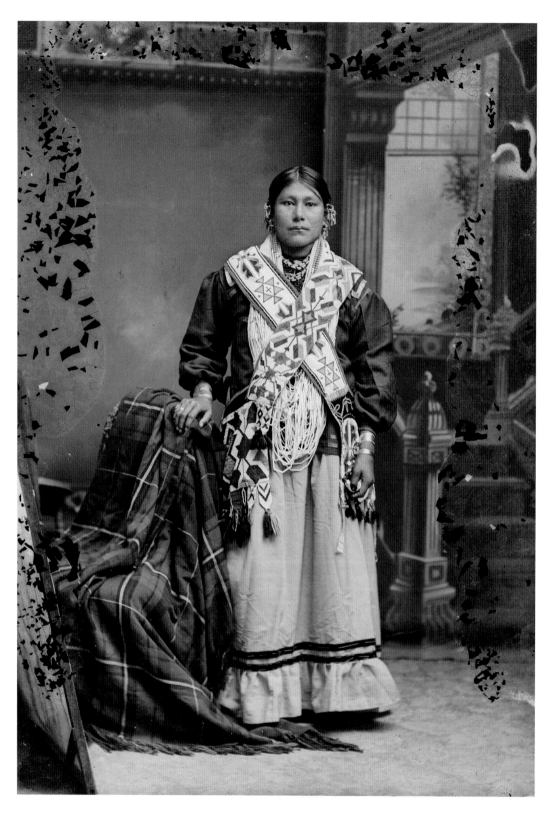

Blanche Blackhawk (Hopinkah) (ENookSkaGaKah) stands next to a chair covered in a Racine Woolen Mills shawl (waį). These shawls were marketed exclusively to Native Americans. She is wearing a woman's dress (hįnųkwaje) and traditional earrings (nąącawa hocpok), rings (nąąp hirusgic), and bracelets (žuurá sgáa áipa). She wears a necklace made of long strands of shell and beads and two Ho-Chunk bandolier bags.

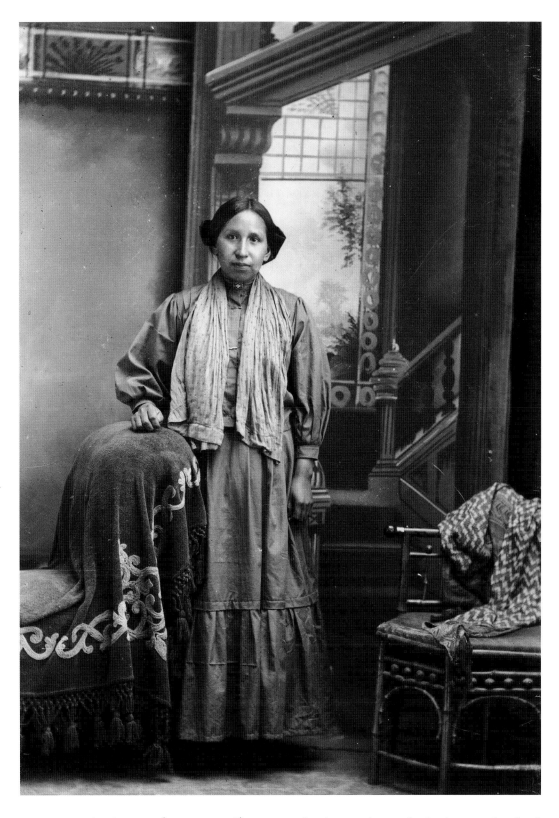

Mae Mary Smith Whitewater (WaRaKaKaKah) is wearing a hịnųkwaje and resting her hand on an embroidered blanket that was a prop in Van Schaick's studio, ca. 1930. This blanket shows up in many photographs throughout Van Schaick's career.

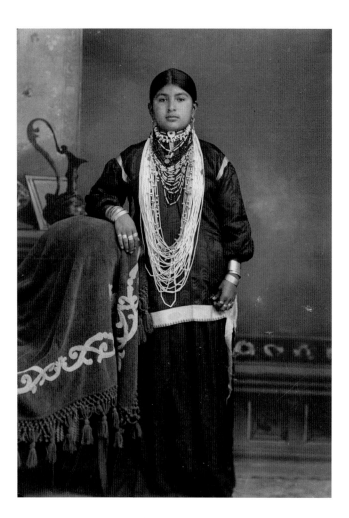

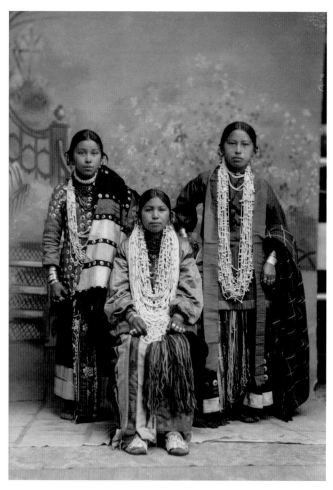

Lucy Dot Redbird Brown (WakJaHeWinKah), ca. 1909.

Addie Littlesoldier (KzunchJeKahRayWinKah) is seated between Queen Redbird Yellowbank, left, and Sally Dora Redbird Goodvillage Whitewater (WauNeekShootchWinKah), ca. 1905. The two girls that are standing are cousins; their mothers are sisters.

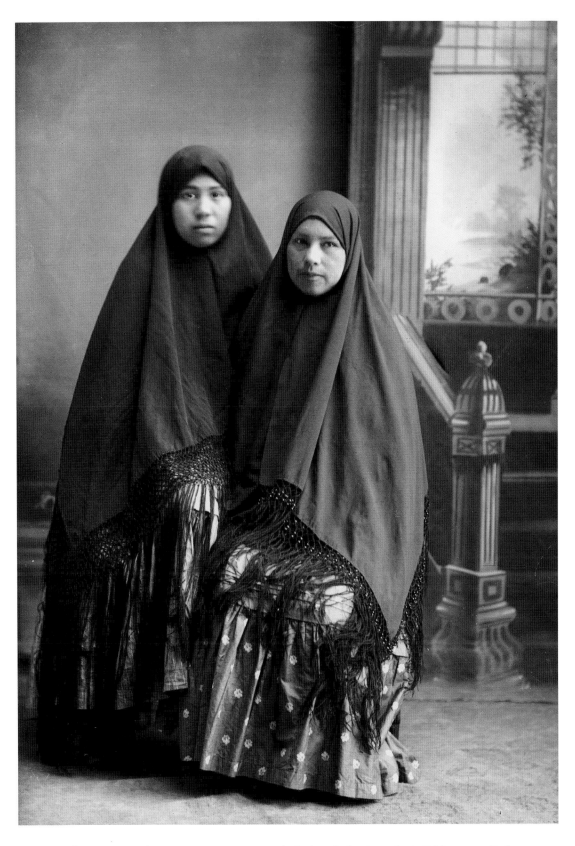

Kate Eagle (WoJayWinKah), left, and her sister Minnie (Edna) Eagle (DaScootchWinKah), ca. 1910. Both women wear fringed shawls over their heads.

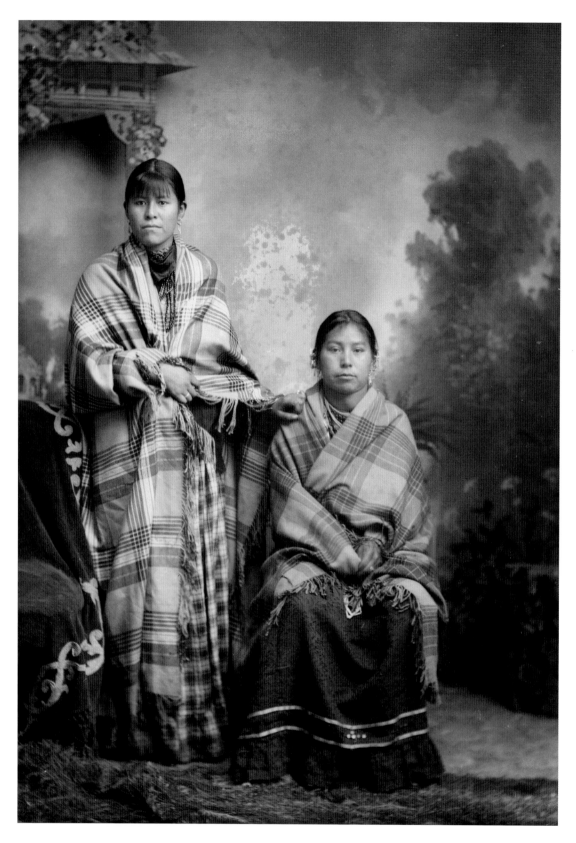

Annie (Katie) W. Blowsnake (MaHeHaNaSheWinKah) seated next to a woman identified as her mother, ca. 1910. Both women wear Racine Woolen Mills shawls.

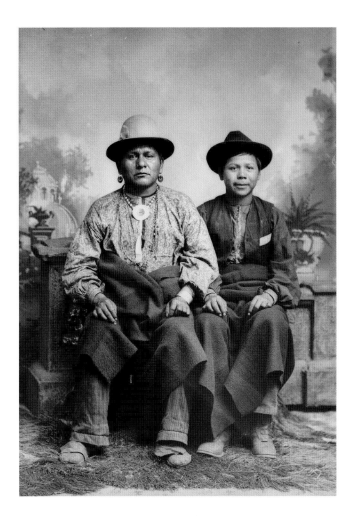

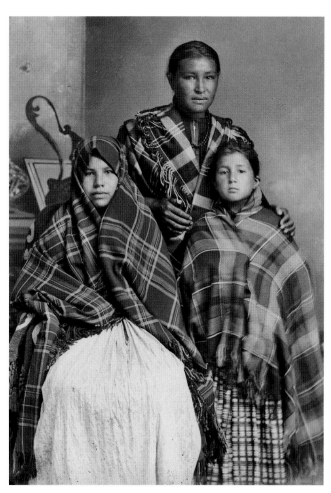

Two unidentified men. The man on the left wears earrings, a shell and metal bead necklace, and traditional Ho-Chunk-style moccasins.

Flora Miner Goodbear (WaNikPeWinKah) stands behind her sister, Grace Miner Littlebear (WeHunKah), left, and Nellie Windblow (HaWePinWinKah). The women are wearing plaid Racine Woolen Mills shawls.

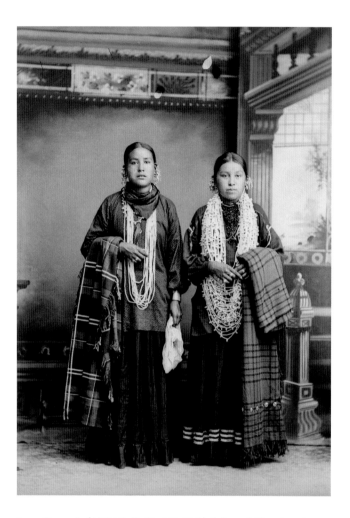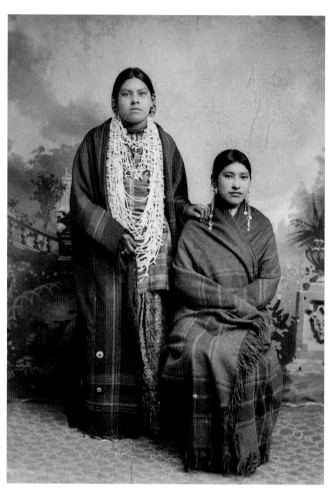

Lucy Decorah (AhHoRaPaNeeWinKah), left, and Alice Stand-straight Blowsnake Littlewolf (HeChoWinKah), ca. 1910.

Two unidentified women, ca. 1896.

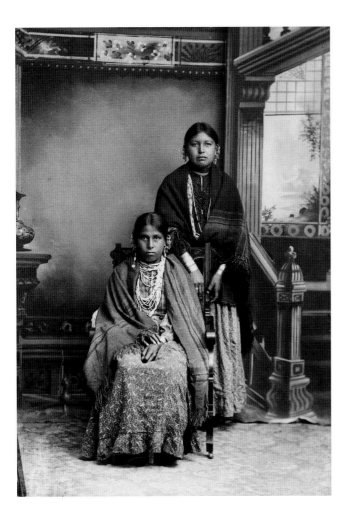

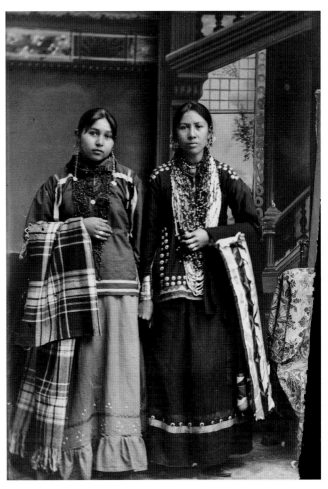

Mabel White Blackhawk St. Cyr, left, and Louisa Lowcloud
Thunderchief Redbird (WaQuaWaZinWinKah), ca. 1905.

Lena Ora Longthunder (UkSeKaHoNoKah), left, and Alice
Thunderking Lowe Kingswan (MaHayPaSayWinKah), ca. 1908.

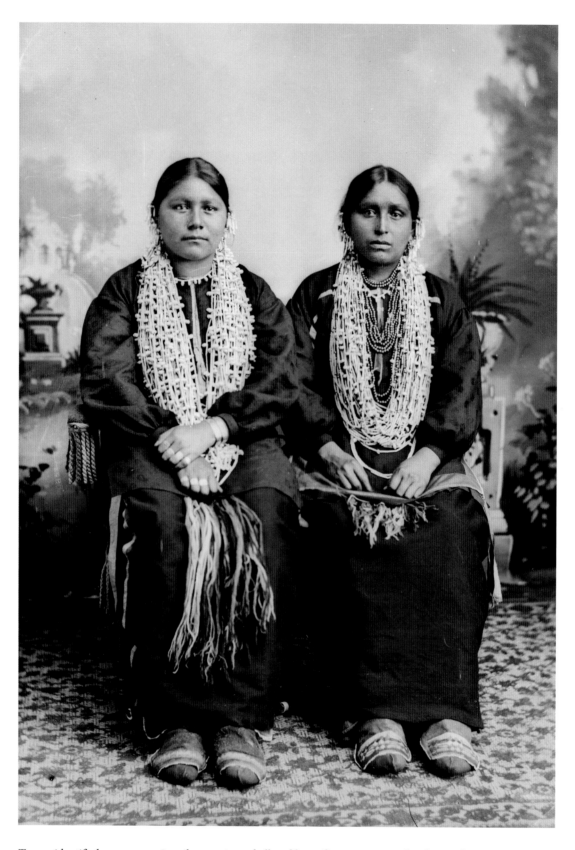

Two unidentified women wearing silver earrings, shell necklaces, finger-woven wool sashes, and moccasins with beaded top flaps, ca. 1890.

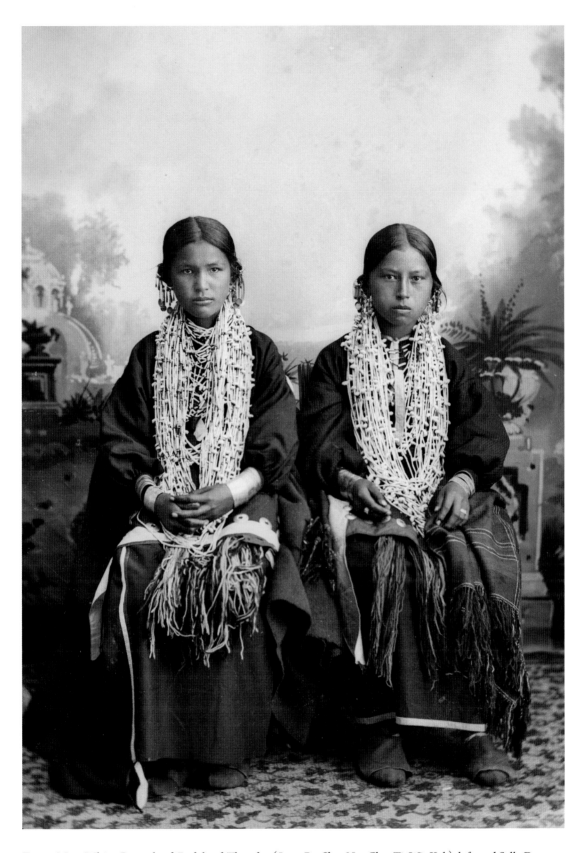

Emma Mary White Greencloud-Redcloud Thunder (JumpBroShunNupChunTinWinKah), left, and Sally Dora Redbird Goodvillage Whitewater (WauNeekShootchWinKah), ca. 1905.

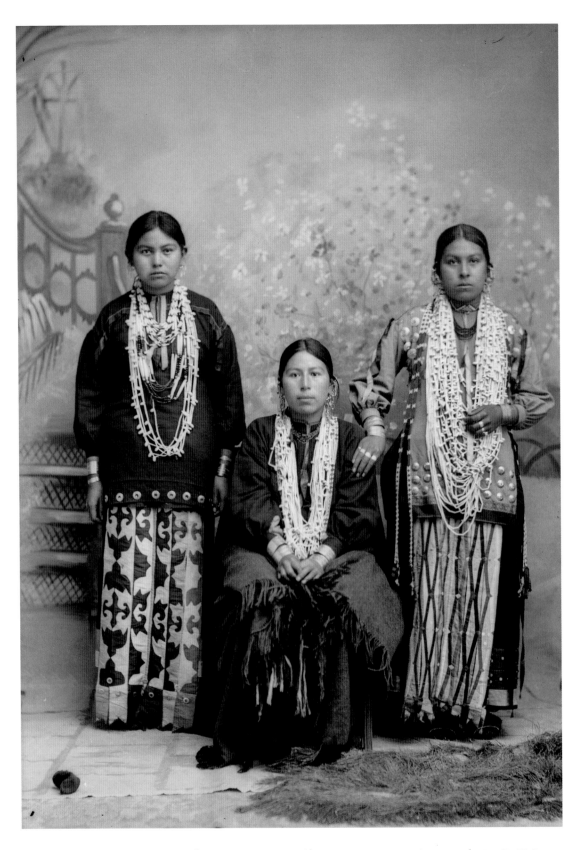

From left to right are Emma Bigbear (WaConChaZeeWinKah), Emma Annie Funmaker Lowe (ENooGreHeRe-Kah), and Lillie Winneshiek (WaConChaWinKah), ca. 1895.

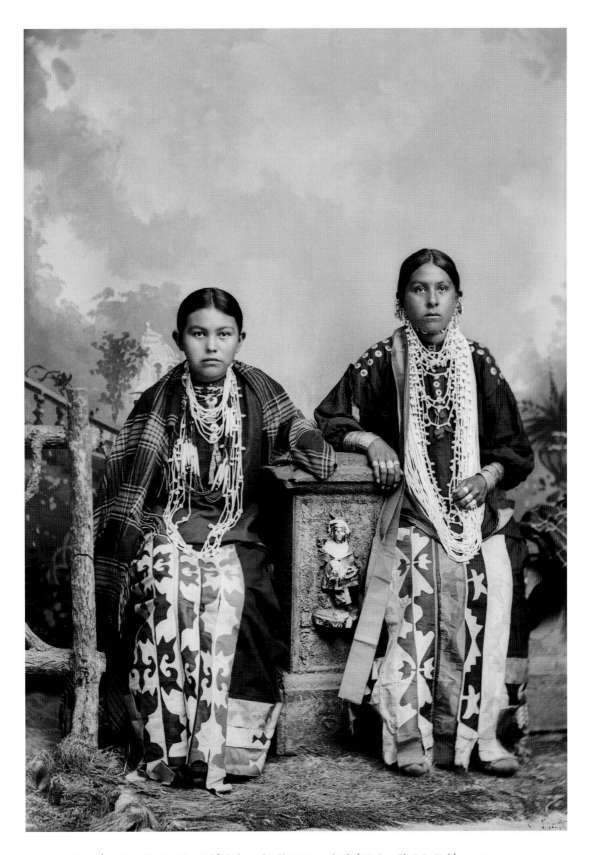

Emma Bigbear (WaConChaZeeWinKah), left, and Lillie Winneshiek (WaConChaWinKah), ca. 1892.

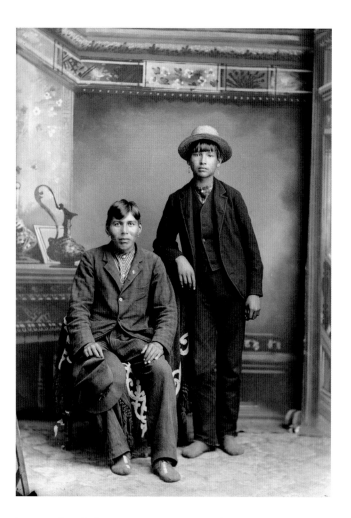

Two unidentified young men pose in period clothing, with the exception of moccasins and earrings, ca. 1900.

An unidentified boy holds a hat with a wide ribbon band, ca. 1890.

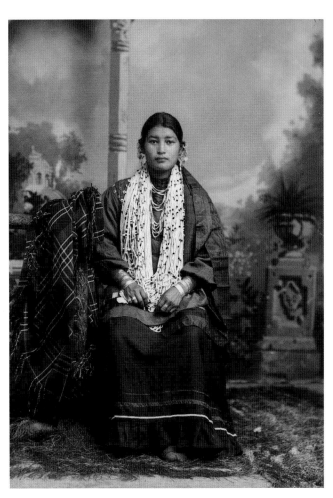

Early carte-de-visite of a Ho-Chunk man identified as Moccasin, ca. 1885. The backdrop indicates the photograph came from Charles Van Schaick's studio, but it may have been produced by an earlier photographer.

A young woman displays her shell necklace, silver bracelets, and earrings, ca. 1885.

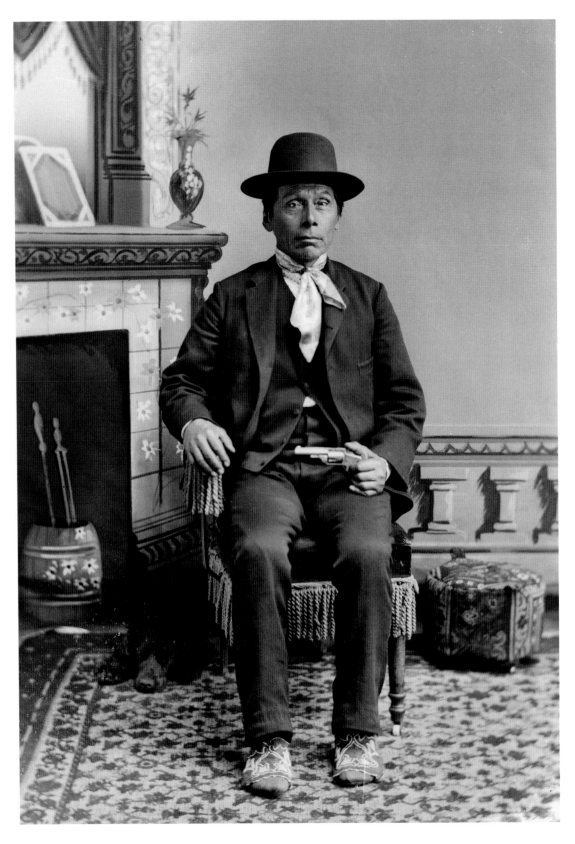

Green Grass (HaWinChoKah), ca. 1880, in period dress with the exception of his Ho-Chunk moccasins. He is holding a pistol, and his dog is lying next to his chair.

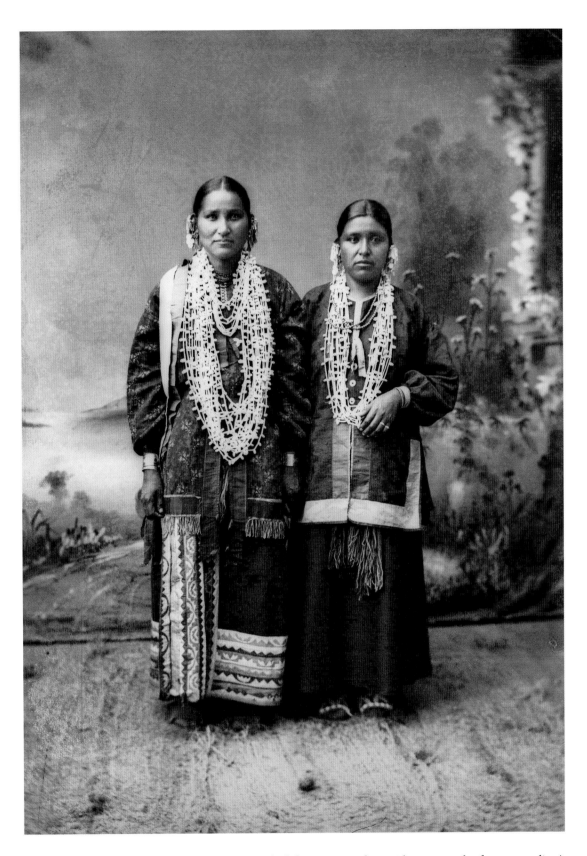

Two unidentified women, ca. 1885. The woman on the left is wearing a dress with many panels of narrow appliqué.

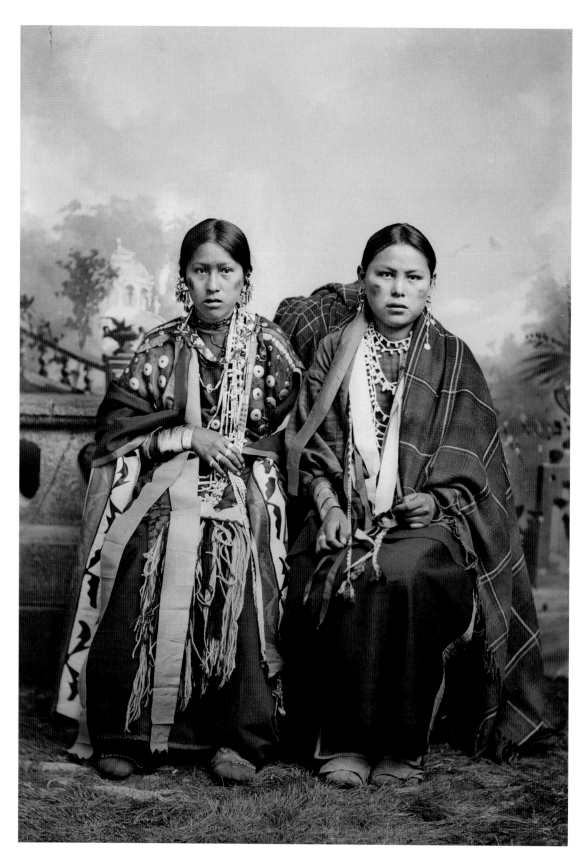

Two unidentified young women with round circles of rouge on their cheeks, ca 1890.

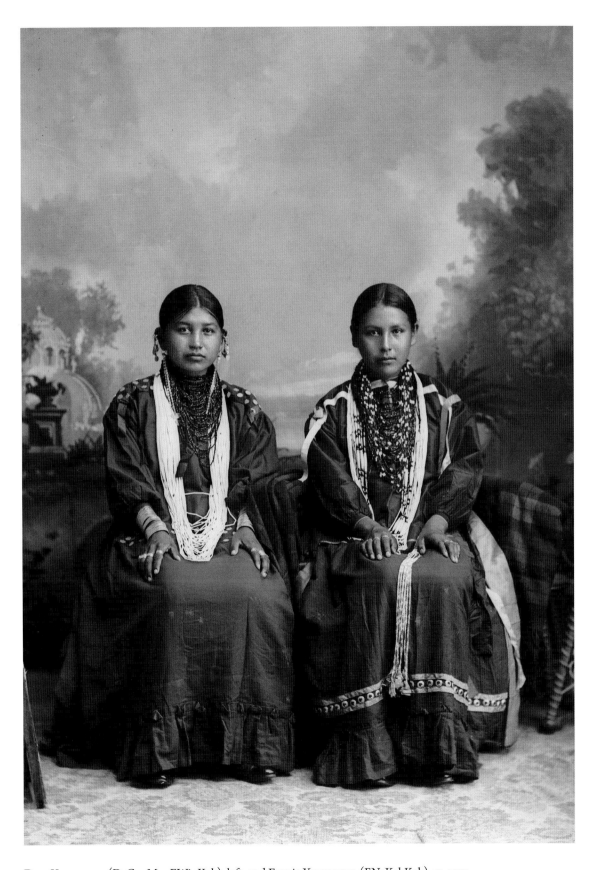

Dora Youngswan (DaCooMonEWinKah), left, and Fannie Youngswan (ENaKahKah), ca. 1902.

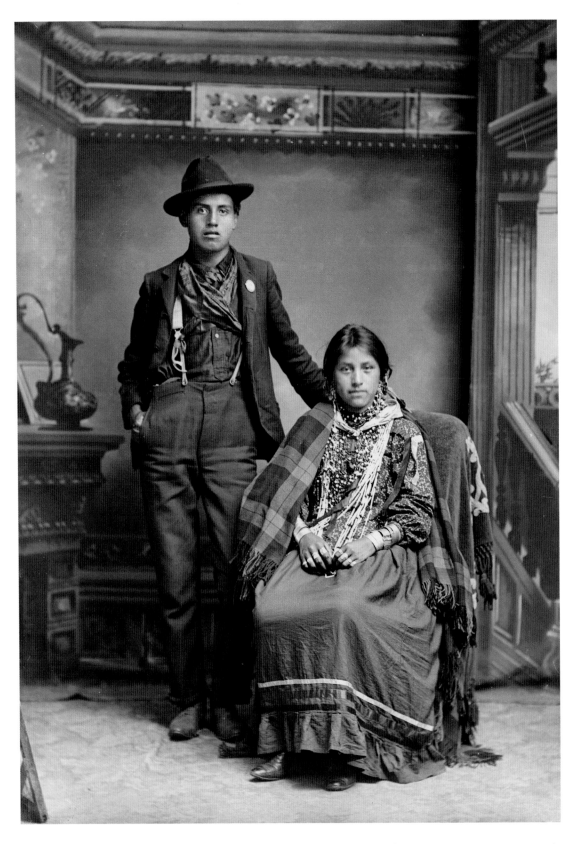

Johnnie Thunder (Little Chief) (HoonkNeeKah) and his wife, Ida Whitespirit (WaukCheHeSkaPeHeTaWinKah), ca. 1905.

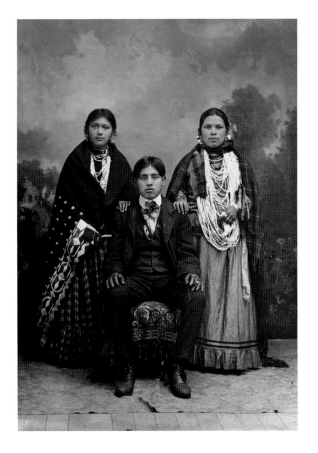

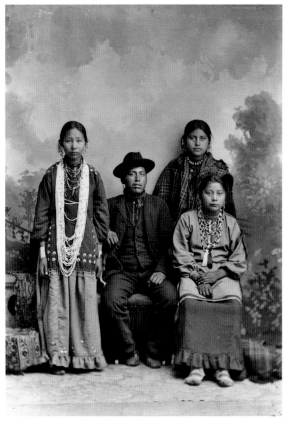

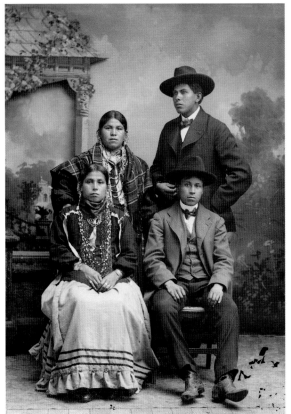

Clockwise from top left:

Fanny C. Whitedog (HoChunTaWinKah), left, and Kate Whitespirit-Dickson Thunder Decorra Baptiste Seymour (NeChooKoontchRaWinKah) stand behind Johnnie Thunder (Little Chief) (HoonkNeeKah), ca. 1905.

Grace Decorra Twocrow Winneshiek Massey (MauHeHut-TaWinKah), seated, and Ida Lizzie Decorah Blowsnake (Real Wampum Woman) (WooRooShiekESkaeWinKah) standing behind her with an unidentified woman and man, ca. 1905.

Albert Henry (HahNahKah) stands with his wife, Martha Henry, behind Martin Green (Snake) (KeeMeeNunkKah) and his wife, Dora Monegar Wallace Green (Snake) (ChePinChayWinKah), ca. 1900.

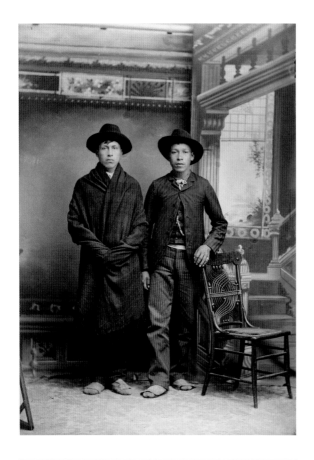

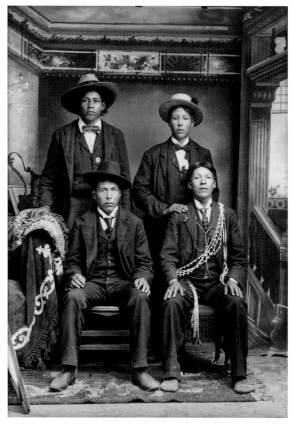

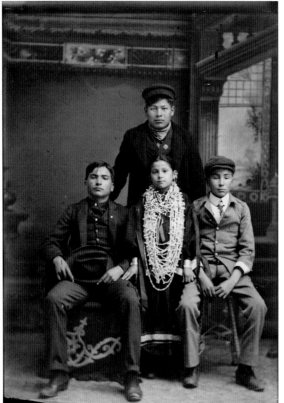

Clockwise from top left:

John Stacy (ChoNeKayHunKah), left, and Henry Green-crow (CooNooZeeKah), ca. 1890. John Stacy has a blanket wrapped around his shoulders, and both men are wearing traditional Ho-Chunk moccasins.

Standing are William Hall (HunkKah), left, and Charlie Greengrass (HoeHumpCheeKayRayHeKah); seated are an unidentified man, left, and Henry Greencrow (Coo-NooZeeKah), ca. 1895. Though the men are dressed in contemporary clothing, Henry Greencrow is wearing Ho-Chunk moccasins and a bone-and-shell bandolier over his shoulder.

Three unidentified young men and a young girl wearing a large wampum necklace, ca. 1900.

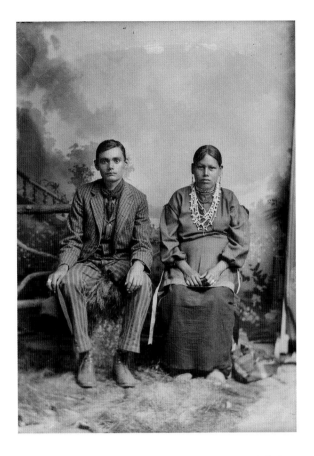

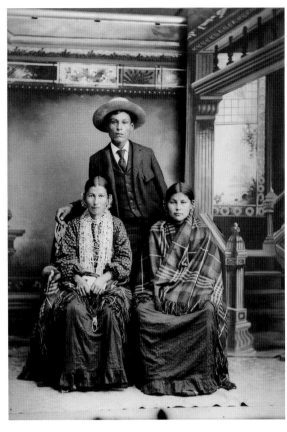

Clockwise from top left:

An unidentified man in a striped suit seated with an unidentified woman in traditional Ho-Chunk attire, ca. 1895.

George Monegar (EwaOnaGinKah) standing behind the sister of John Stacy (ChoNeKayHunKah), left, and the wife of George (Lyons) Lowe (AhHaZheeKah), ca. 1900.

An unidentified man with a woman and young boy, ca. 1915.

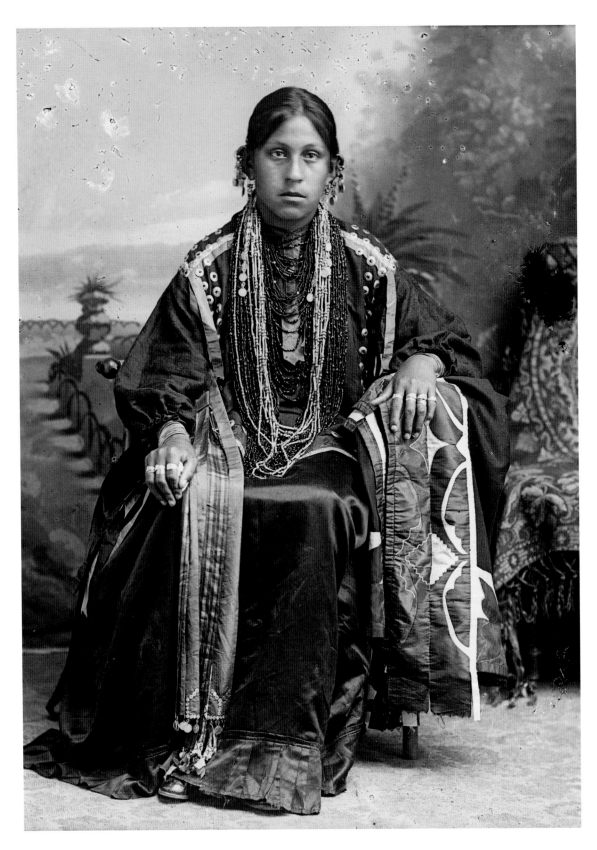

Mabel White Blackhawk St. Cyr is dressed in Ho-Chunk regalia with her left arm resting on a silk appliqué blanket, ca. 1905.

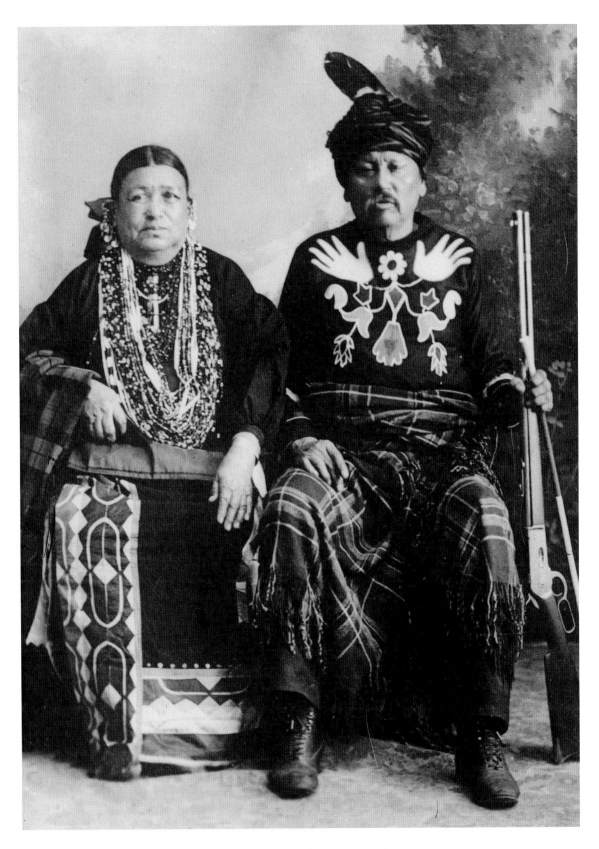

Little Soldier (NoGinKah) and his wife, Bettie Littlesoldier (BayBayBawKah), ca. 1905.

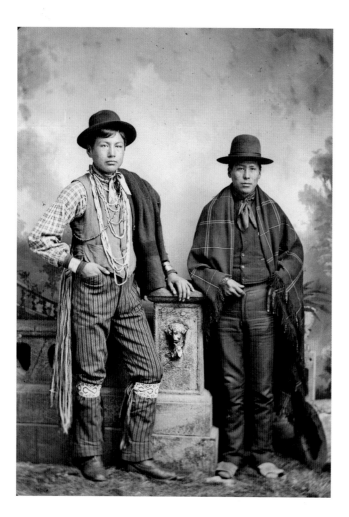

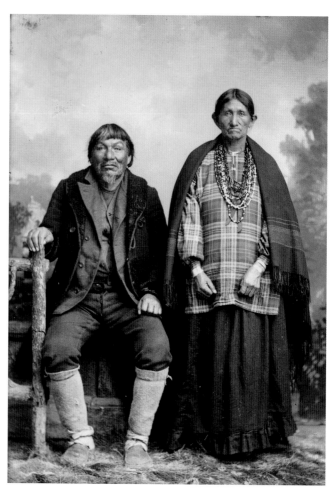

Frank Greencloud-Redcloud (NotchKeTaKah), left, wears loom-beaded garters and has a Hudson's Bay wool blanket on his shoulder. Ed Greengrass (CheWinCheKayRayHeKah), right, wears a blanket and traditional men's moccasins, ca. 1888.

Blackhawk (KaRaChooSepMeKah) is seated next to his wife, Louisa Mike (HumpACooWinKah), ca. 1925.

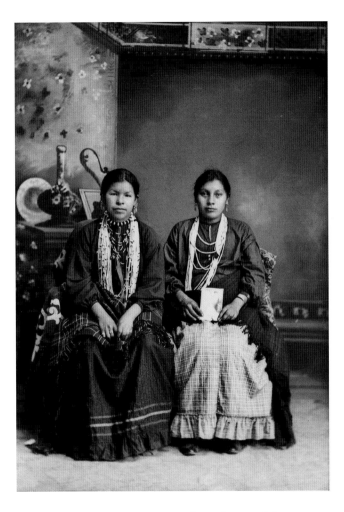

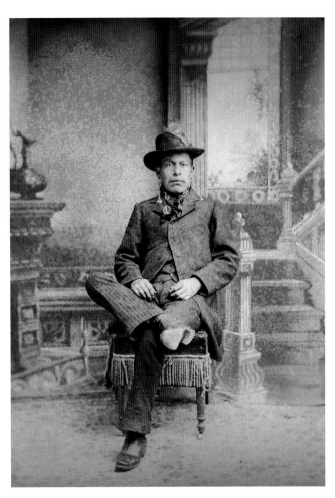

Two unidentified women wearing traditional women's dresses (hįnųkwaje), ca. 1895. The woman on the right holds a Van Schaick cabinet card on her lap.

John Johnson, a Nebraska Winnebago, wears a peacock feather in his hat, ca. 1905.

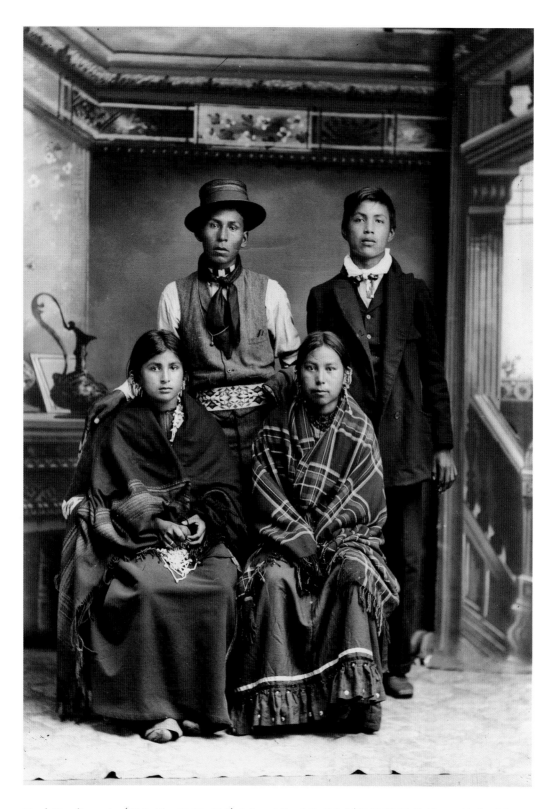

Frank Standingwater (WaTaChayHoNeeKah), left, and Frank Redbird (WakJaHeNoKah) stand behind Lucy
Dot Redbird (WakJaHeWinKah), left, and Jennie Bighawk-Decorra Mallory, ca. 1900. Frank wears a Ho-Chunk
beaded belt with a contemporary shirt, vest, and cravat. Lucy wears traditional Ho-Chunk moccasins, which
are just visible below her traditional woman's dress (hįnųkwaje), and Jennie is wrapped in a plaid Racine
Woolen Mills shawl (waį).

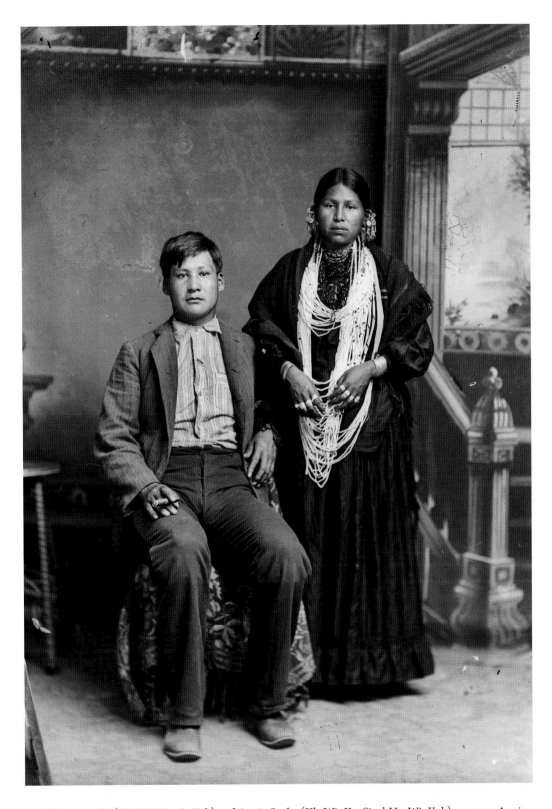

Frank Browneagle (HeWaKaKayReKah) and Annie Snake (KhaWinKeeSinchHayWinKah), ca. 1903. Annie Snake was a member of the Nebraska Winnebago.

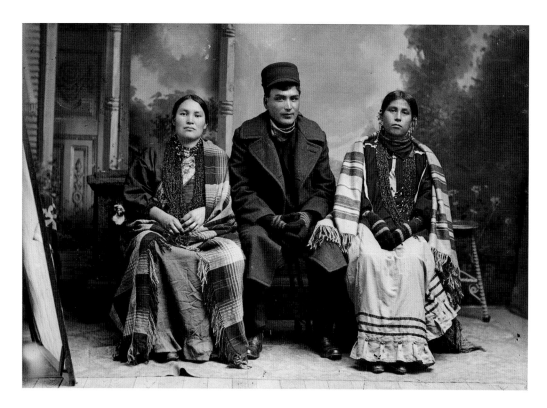

Susie Decorra Thundercloud (UkSeKaHoNoKah) sits to the left of Albert (Robert) Henry (HeKeMeGa) and Dora Monegar Wallace Green (Snake) (ChePinChayWinKah), ca. 1920.

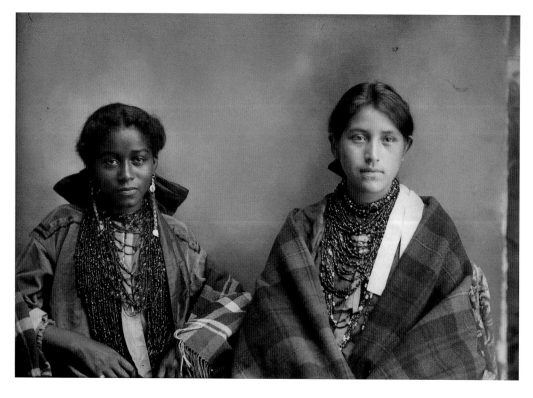

Carrie Elk (ENooKah), daughter of Lucy Elk, left, and an unidentified woman, ca. 1904.

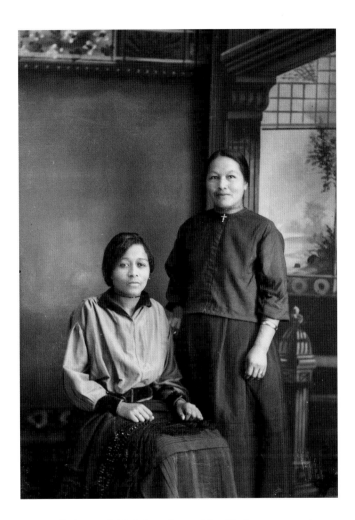

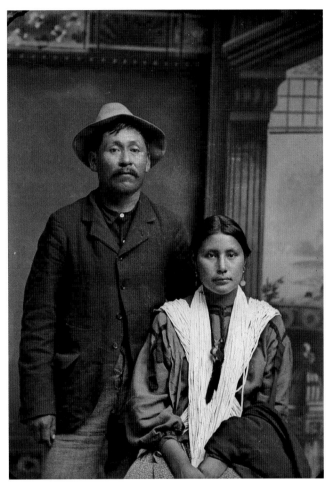

Carrie Elk (ENooKah), left, and an unidentified woman wearing a Christian cross, ca. 1908.

Nebraska Winnebago John Clay (WaCheDaKaw) and Grace Decorra Clay Whitegull (BeekSkaWinKah).

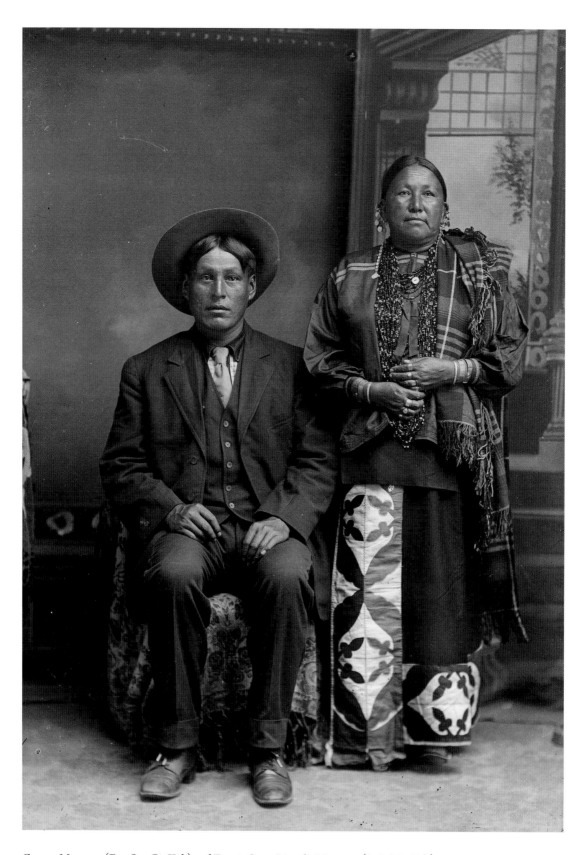

George Monegar (EwaOnaGinKah) and Fannie Stacy Lincoln Monegar (LeBaWinKah), ca. 1920.

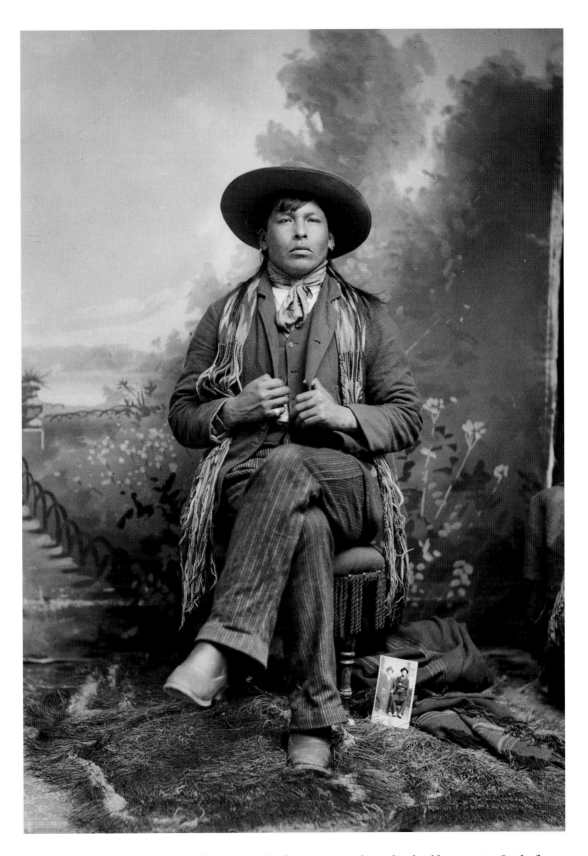

An unidentified man dressed in period clothing with a finger-woven sash over his shoulders, ca. 1893. On the floor propped up by a shawl is a cabinet card from the Van Schaick studio with a picture of two Ho-Chunk men.

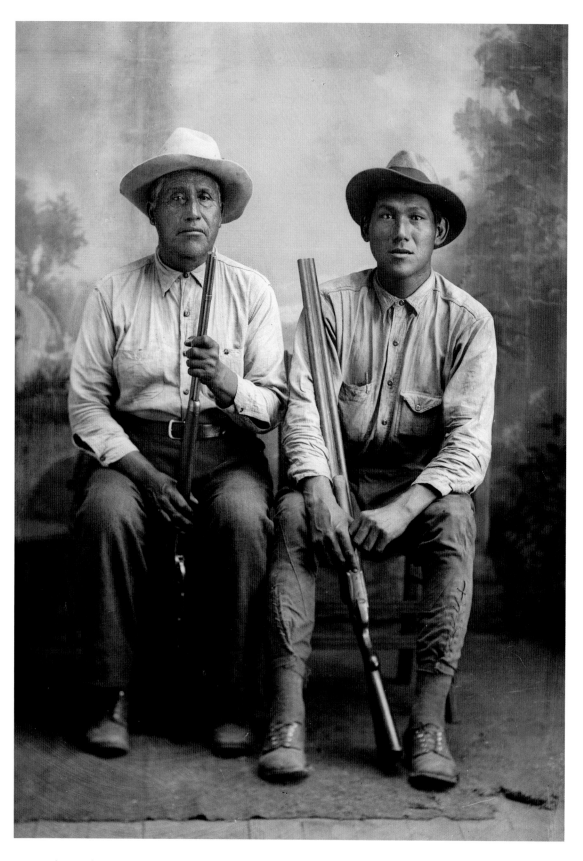

Charles (Charlie) Sine Sr. (HaGaKah), left, and Harry (Henry) Swallow, ca. 1920.

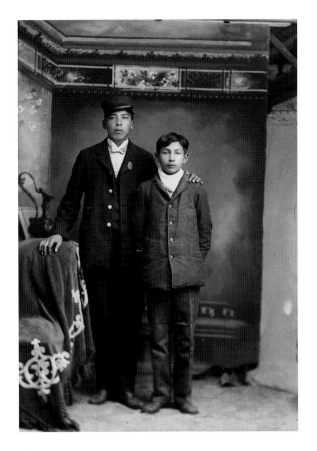

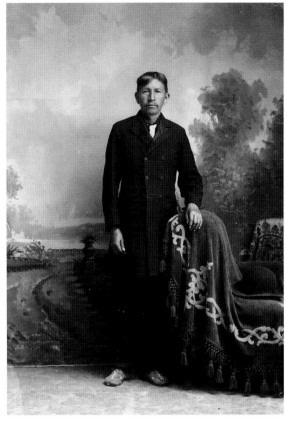

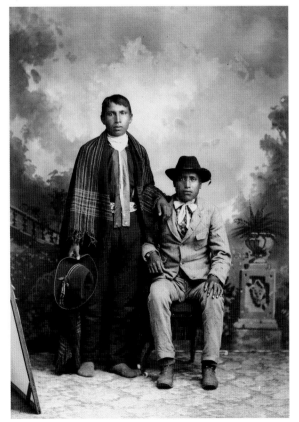

Clockwise from top left:

Robert Sine Jr., left, with an unidentified boy, ca. 1930.

James (Jim) Sine (KahHeHoNoNeeKah), ca. 1900.

Charles (Charlie) Sine Jr. (MoGaReKeeKah), seated, with an unidentified man, ca. 1890. The man on the left wears moccasins and a shirt with two long ribbons hanging down the front. The ribbons have small silver brooches (hiiwapox) attached.

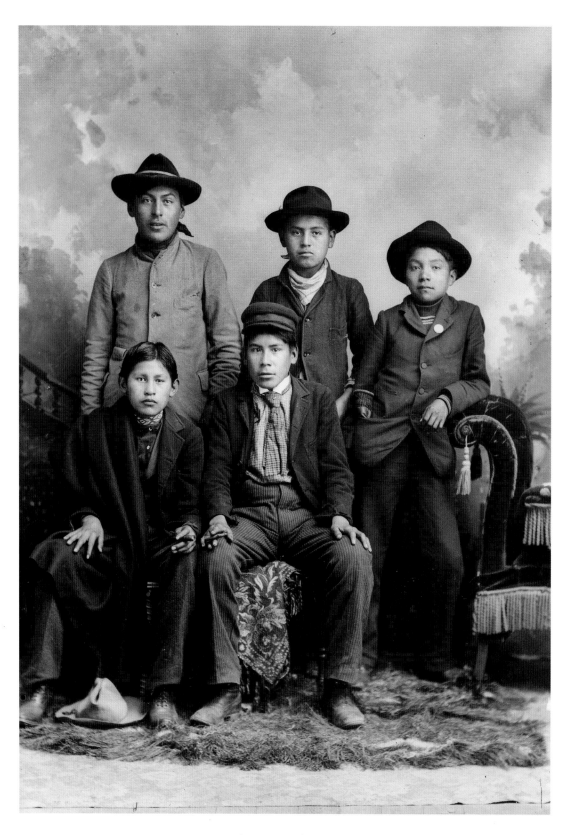

Standing from left to right are George Otter Jr. (HayChoKah), Johnnie Thunder (Little Chief) (HoonkNeeKah), and George Bearchief (HaNaKah); seated are John Rainbow, left, and an unidentified young man, ca. 1900.

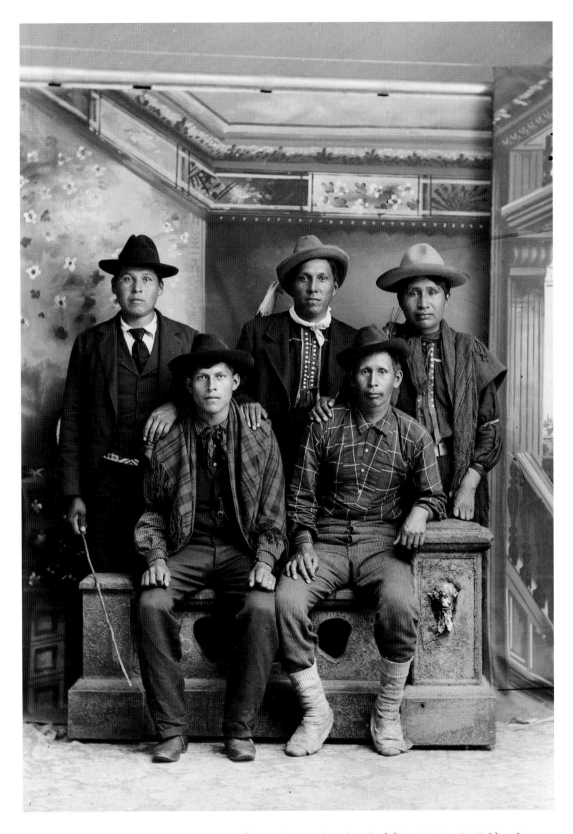

Standing from left to right are Will Blowsnake (One Who Stands and Strikes) (WoeGinNawGinKah) and two unidentified men; seated are Henry Badsoldier Stacy (MonNawPaeSheSheckKaw), left, and Harry Rave, a Nebraska Winnebago.

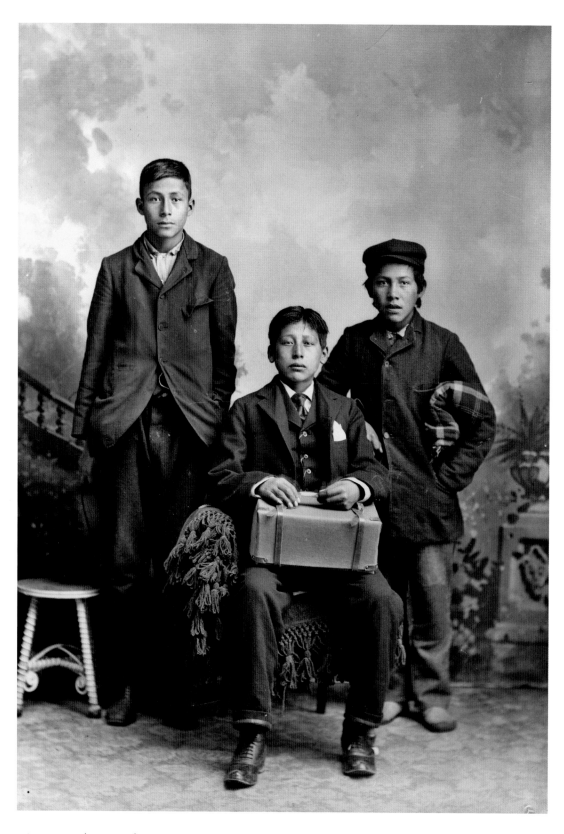

John Stacy Jr. (HaGaKah) stands to the left of two unidentified boys, ca. 1910. The young man in the center holds a package wrapped in paper that likely holds his belongings for boarding school.

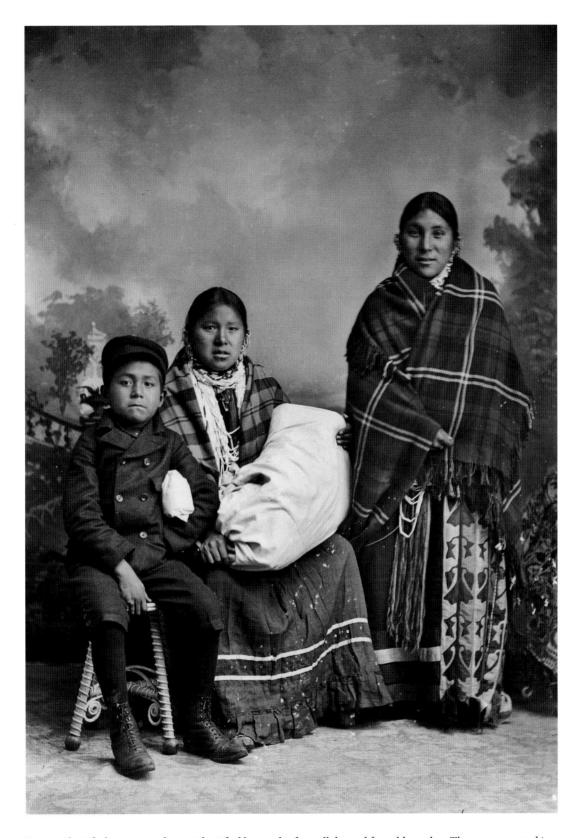

Two unidentified women and an unidentified boy and infant, all dressed for cold weather. The woman seated in the middle holds a cradleboard (hoxjį) wrapped in cloth. Intricate centerfold appliqué and a finger-woven sash can be seen beneath the shawl of the woman on the right.

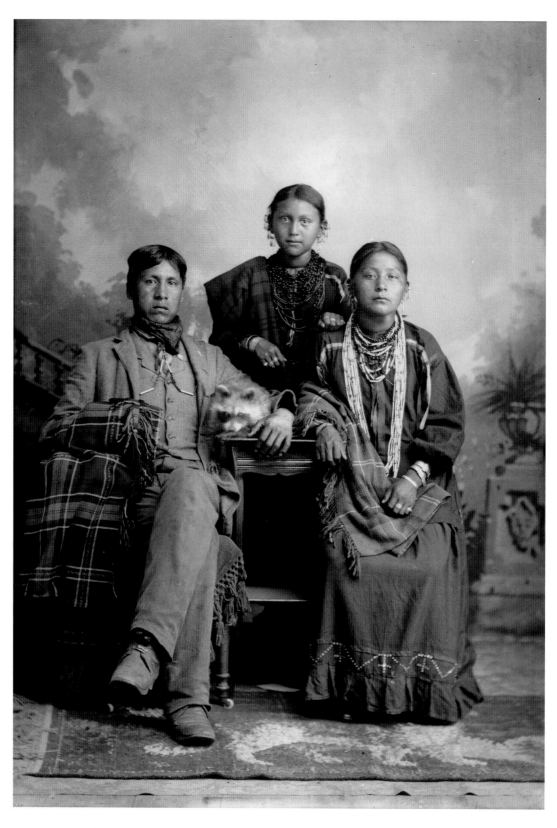

William Massey (ChawRoCooChayKah) is seated next to Grace Decorra Twocrow Winneshiek Massey (MauHeHutTaWinKah) and has his arm around a pet raccoon. The young girl standing behind them is Fanny C. Whitedog (HoChunTaWinKah), ca. 1890.

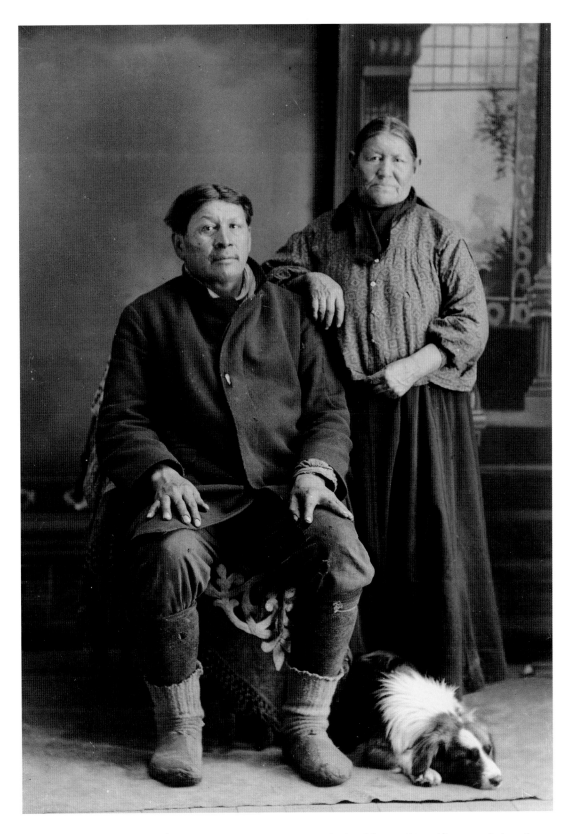

John Buffalohead (ChaPayKay) and Mary Snowball Decorra Buffalohead (PayOokSeKah) pose with their dog lying on the floor between them, ca. 1920.

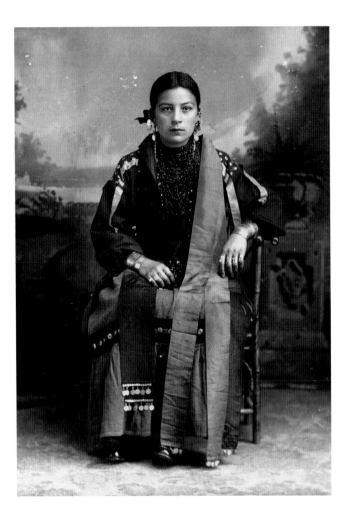

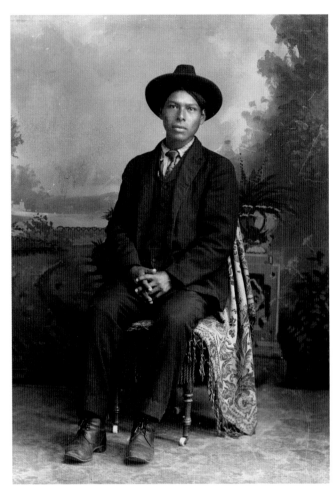

Alice Mary Blackdeer Hopkinah (NautchGePinWinKah), wearing a woman's dress (hįnųkwaje) with long strips of ribbon over her shoulders and silver coins attached to the bottom, ca. 1908.

Charlie Youngthunder (MahAhQuaKah), ca. 1910.

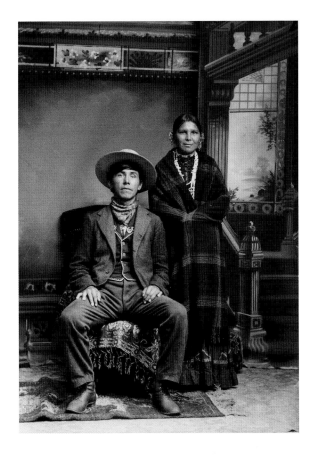

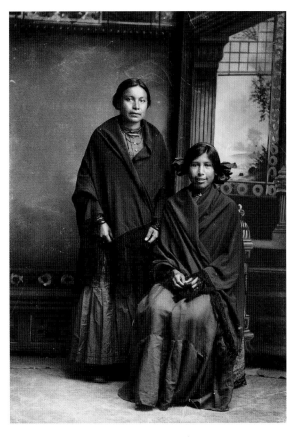

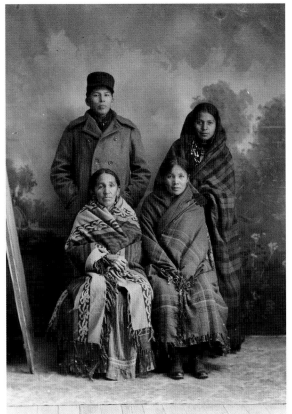

Clockwise from top left:

Amos Wallace (WeeKah), a Ho-Chunk-Menominee, and his Ho-Chunk wife, Annie Bearchief Wallace Bearheart Redbird (MaHaNaKayWinKah), ca. 1900.

Jennie Youngthunder Decorah (PetHatChaCooWinKah), left, and Annie Thunderking Lowe Lincoln (WaNuk-ScotchEWinKah) with fringed shawls pulled over their shoulders, ca. 1910.

Mary Little Littlesoldier (HoUpTchooJayWinKah), left, seated with her daughter Mandy T. Longtail (WaDoHa-WinKah). Behind them are her son David Bow Little-soldier (MauJchayMauNeeKah) and his wife, Emma Thunder Littlesoldier (WePaMaKaRaWinKah), ca. 1910.

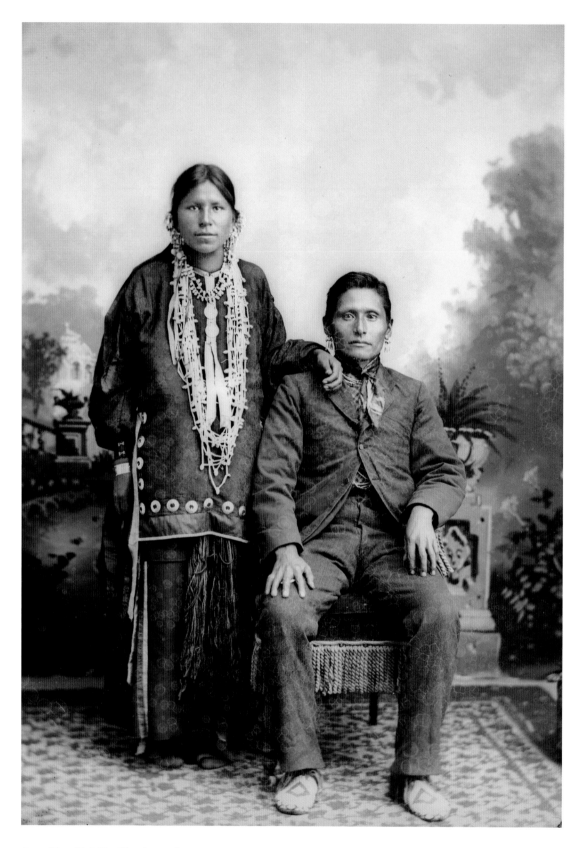

An unidentified Ho-Chunk couple, ca. 1890.

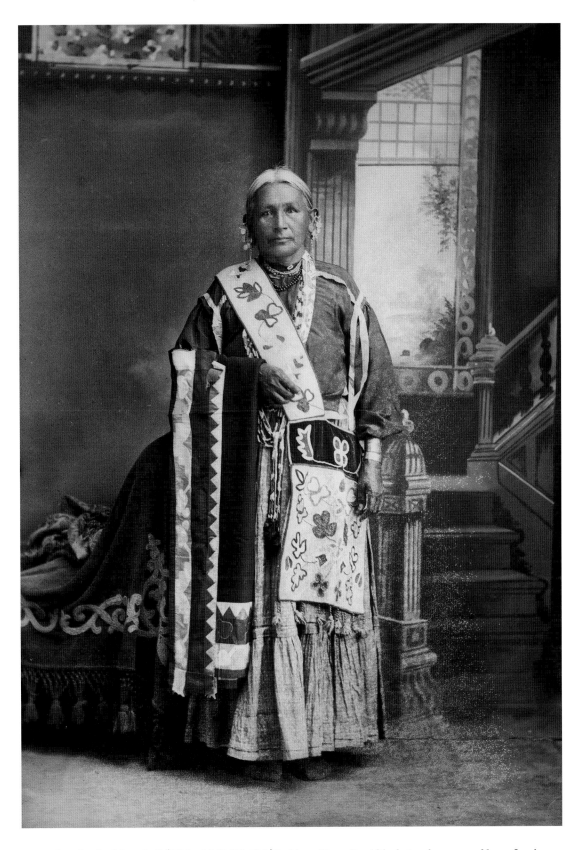

Mary Thunderchief Snowball (WaSayMaKaWinKah) holds a silk appliqué blanket on her arm and has a floral appliqué beaded bandolier bag hanging across her right shoulder, ca. 1920.

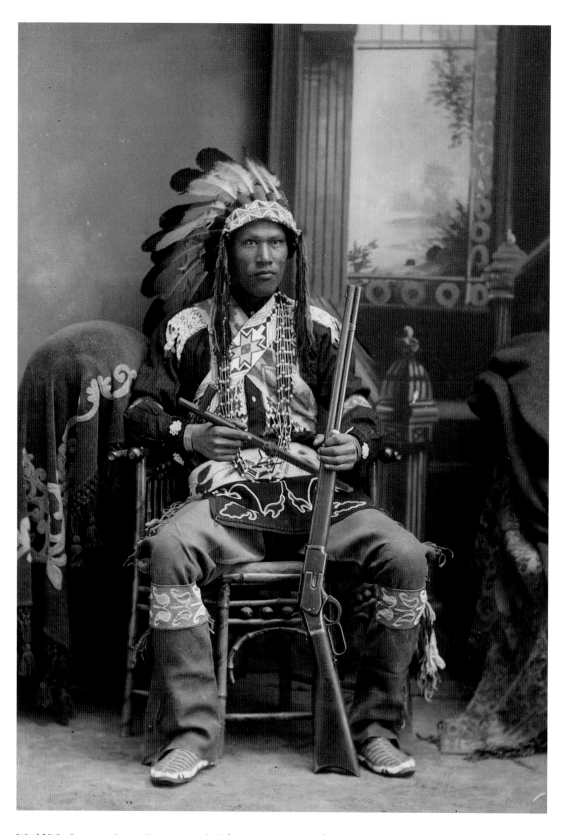

World War I veteran James George Hanakah (PaitchDoAhHeKah), holding a rifle and tomahawk, is dressed in full Ho-Chunk regalia with the exception of Plains-style moccasins, ca. 1910. The eagle feather bonnet was not traditionally Ho-Chunk but was adopted by the late 1800s after Ho-Chunk participated in Wild West shows.

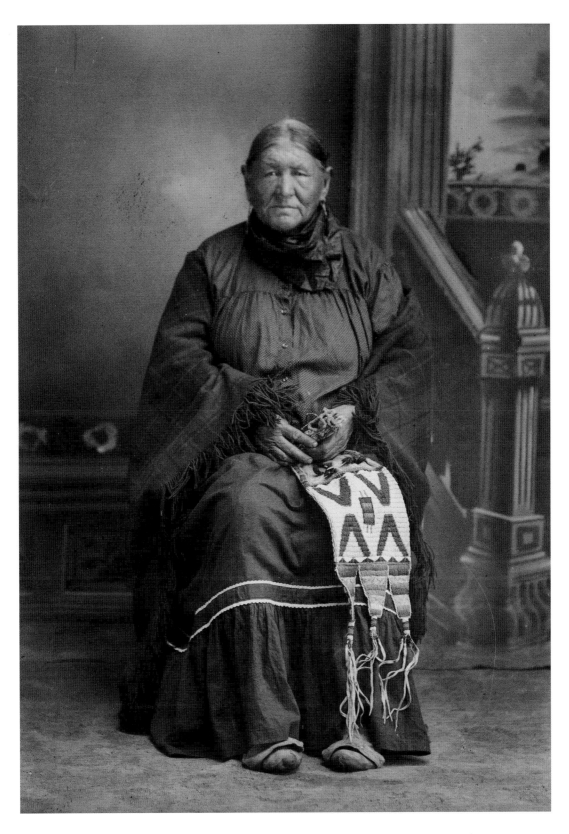

Mary Snowball Decorra Buffalohead (PayOokSeKah) wears a simple woman's dress (hịnųkwaje) and moccasins, ca. 1920. The pipe bag she is holding is not of Ho-Chunk origin.

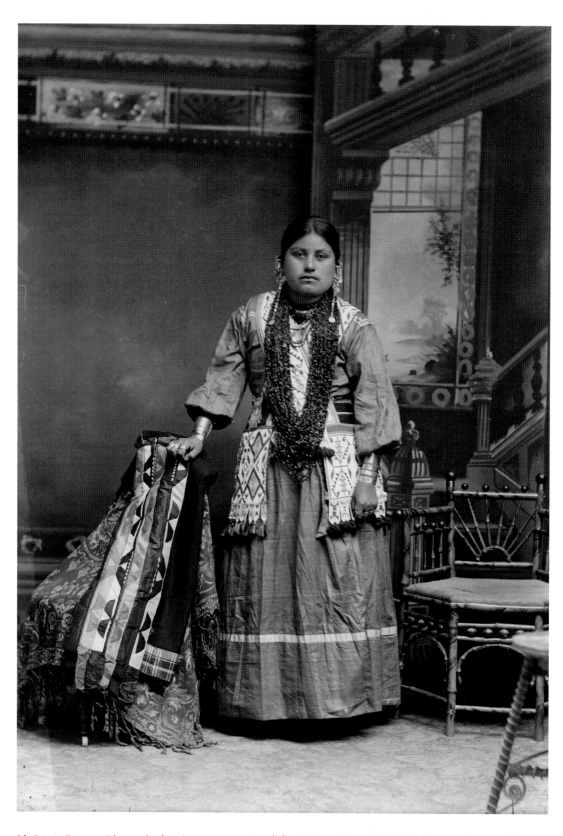

Ida Lizzie Decorra Blowsnake (Real Wampum Woman) (WooRooShiekESkaeWinKah) wears a large necklace made of beads that partially covers the bandolier bags crossed over her shoulders, ca. 1900. Her wrists and fingers are adorned with German silver rings and bracelets. On the chair is a Ho-Chunk appliqué blanket.

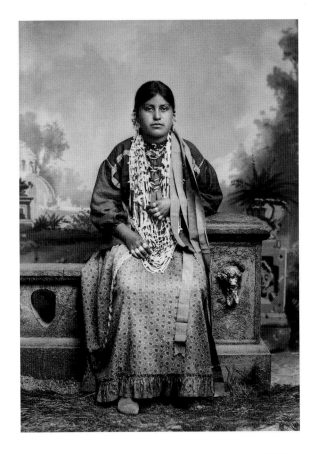

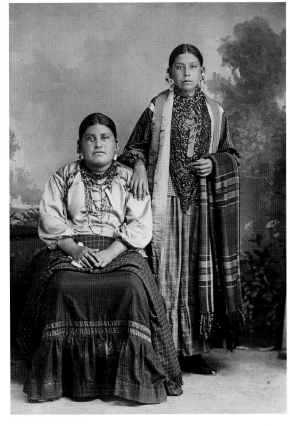

Clockwise from top left:

Ida Lizzie Decorra Blowsnake (Real Wampum Woman) (WooRooShiekESkaeWinKah), seated on a wall in the Van Schaick studio, ca. 1900. She wears a traditional woman's dress (hįnųkwaje) made from a brightly printed fabric. Most Ho-Chunk women's dresses were made from solid-color cloth.

Ida Lizzie Decorra Blowsnake (Real Wampum Woman) (WooRooShiekESkaeWinKah) sits next to her half-sister, Johanna Puss Otter Greendeer Tebo (WaGaChaMeNuk-Kah), ca. 1905. She holds a Racine Woolen Mills shawl and is wearing a plaid print skirt.

Ida Lizzie Decorra Blowsnake (Real Wampum Woman) (WooRooShiekESkaeWinKah), dressed in a plain hįnųkwaje and moccasins, stands next to a chair with a plaid wool shawl, ca. 1920.

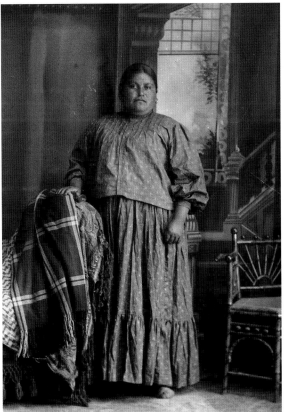

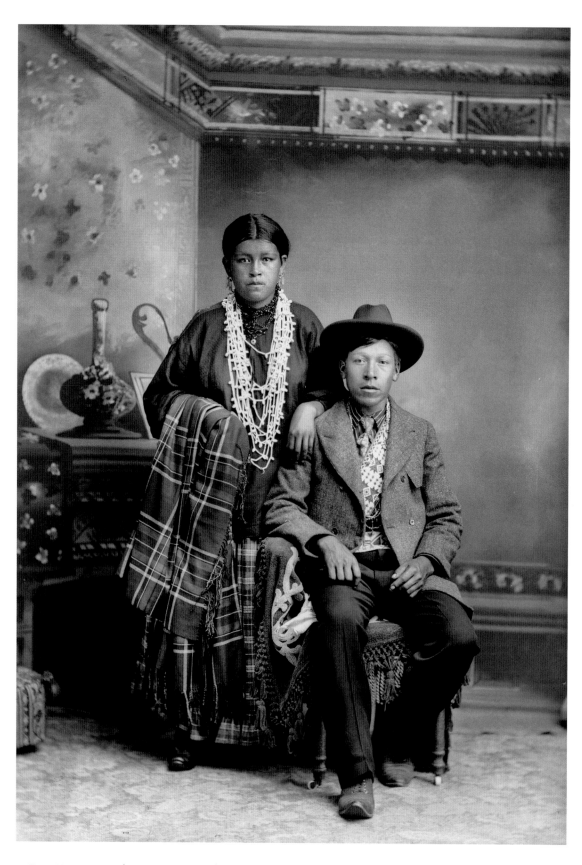

Belle Hall Greencrow (AhHooSkaWinKah) and Henry Greencrow (CooNooZeeKah), ca. 1900.

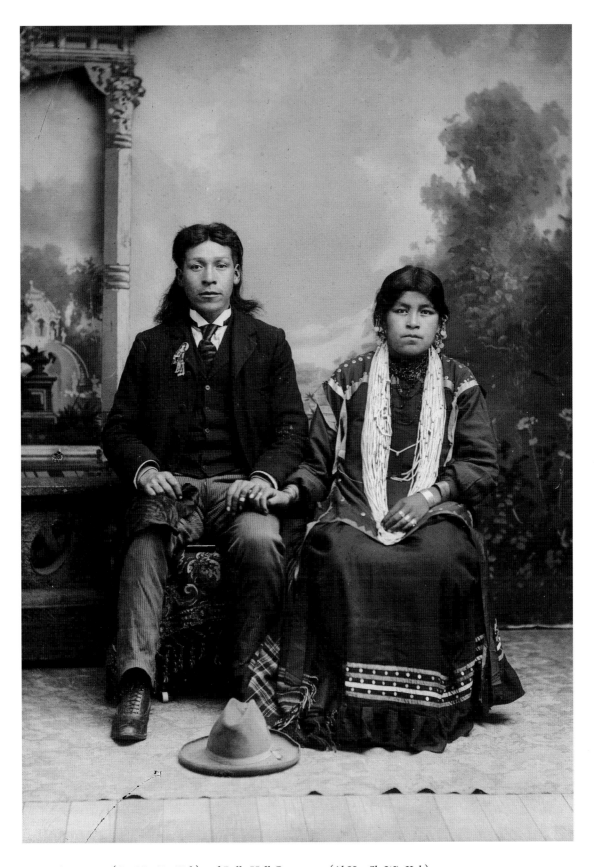

Henry Greencrow (CooNooZeeKah) and Belle Hall Greencrow (AhHooSkaWinKah), ca. 1905.

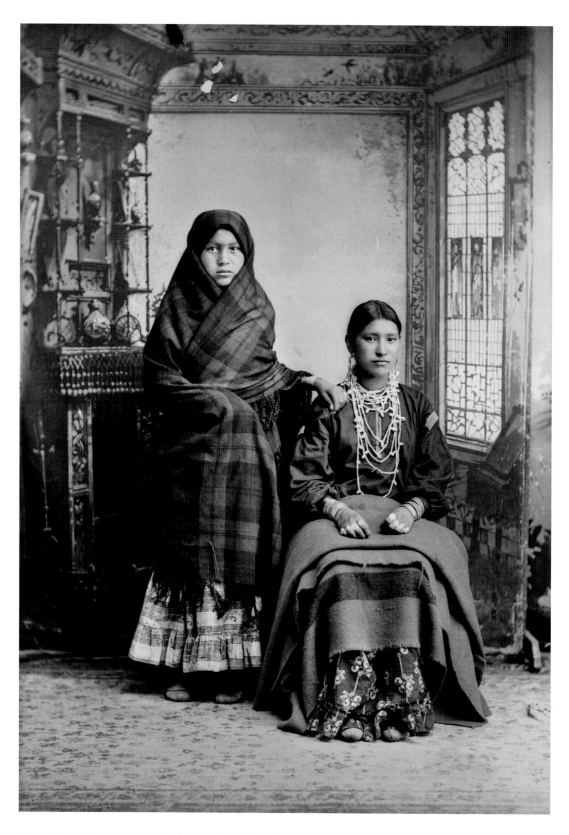

Two unidentified women pose in front of a backdrop that is seen in many of Van Schaick's photographs, ca. 1885. The woman standing on the left is wrapped in a Racine Woolen Mills shawl. The woman seated on the right wears German silver earrings, bracelets, and rings and has a Hudson's Bay trade blanket on her lap.

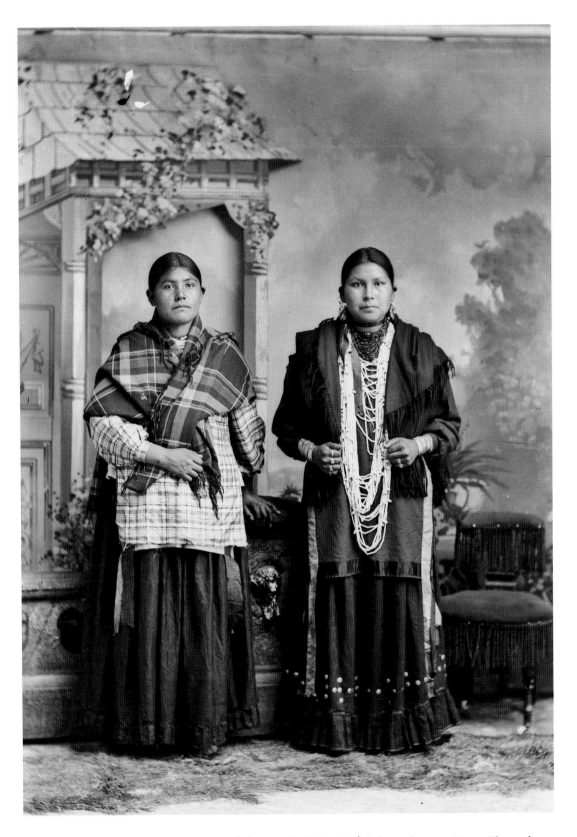

Minnie Pigeon Whiteotter Blowsnake Davis (AhHooKeShelNWinKah), left, stands next to Emma Blowsnake Battise Goodbear Walking Priest Littlejohn Mike (ChakShipEWinKah), ca. 1902.

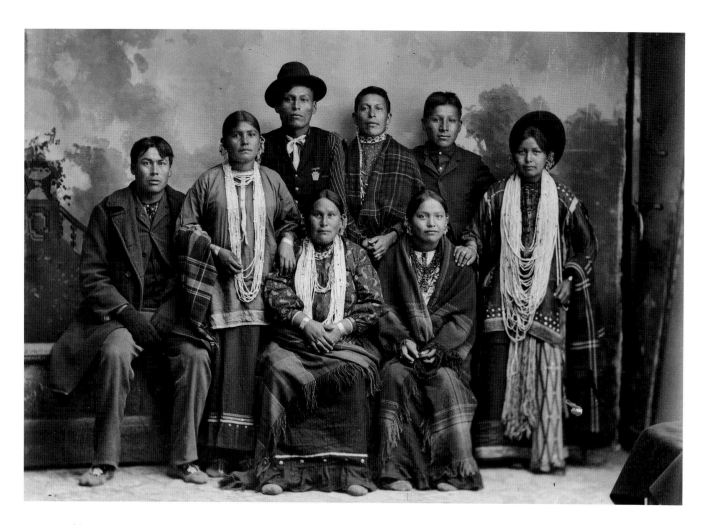

A group of four men and four women lined up in front of a scenic backdrop in Van Schaick's studio, ca. 1895. Standing in back from left to right are Charles George Whiteotter (HoonkHaTaKah), John Lewis (John Johnson) (NoCheKeKah), and Will Stohegah Carriman (WonkShiekStoHeGah). In front from left to right are George Blackhawk (WonkShiekChoNeeKah), Minnie Pigeon Whiteotter Blowsnake Davis (AhHooKeShelNWinKah), Mary Mollie Prophet Thunder (HoWaChoNeWinKah), and an unidentified woman. Standing on the right is Charles Low Cloud's sister Mary L. Decorah (HoChumLaWinKah). George Blackhawk is wearing traditional Ho-Chunk men's moccasins that do not have the top flap.

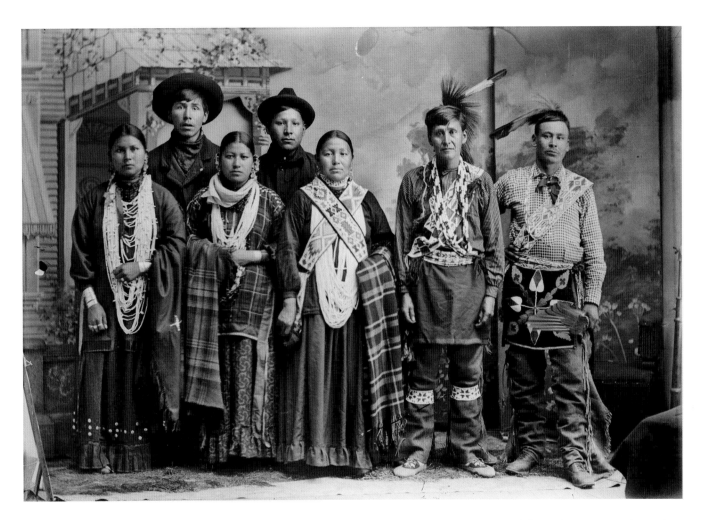

A group stands in front of the porch backdrop used in many of Van Schaick's photographs, ca. 1910. From left to right are Emma Blowsnake Battise Goodbear Walking Priest Littlejohn Mike (ChakShipEWinKah), Amos Wallace (WeeKah), NoKetteKyWinKah, Will Stohegah Carriman (WonkShiekStoHeKah), Mary Goodvillage Hindsley (ChoWasSkaWinKah), William Hindsley (Hensley) (CooNooChoNee-NikKah), and Edward Winneshiek (NaZhooMonEKah).

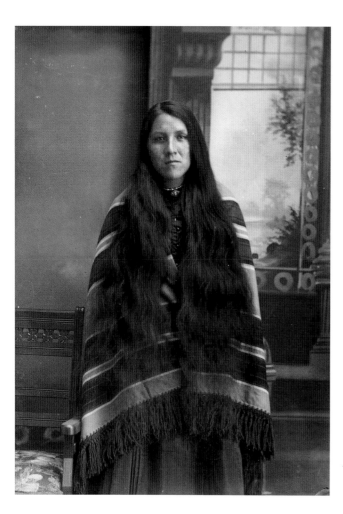

Mamie (Minnie) Bearchief Funmaker (HoHumpCheKaRaWin-Kah) wears a striped wool shawl.

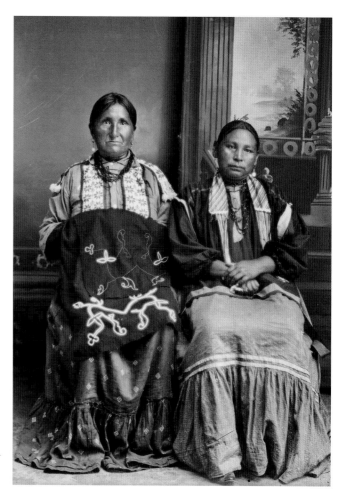

Mamie (Minnie) Bearchief Funmaker (HoHumpCheKaRaWin-Kah), left, and an unidentified woman.

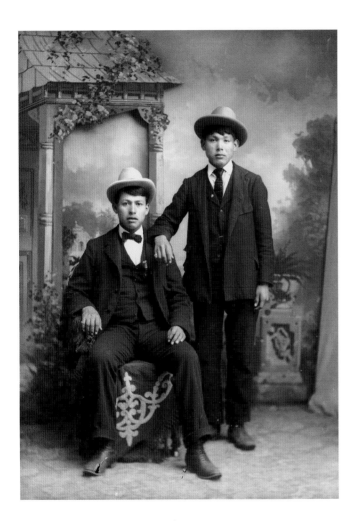

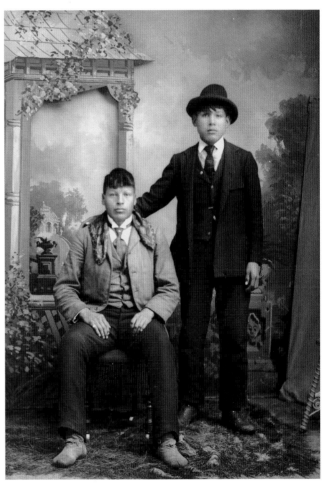

Frank Bigsoldier (KeKahUnGah) stands next to an unidentified man, ca. 1890.

Frank Bigsoldier (KeKahUnGah) stands next to an unidentified man, ca. 1890. The man is wearing Ho-Chunk moccasins with his suit and tie.

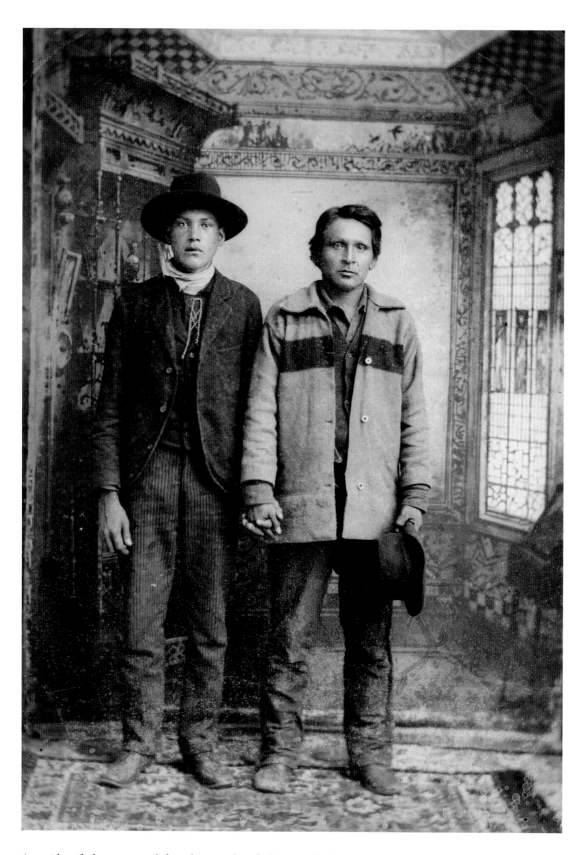

An unidentified young man, left, and a man identified as Fourcloud, ca. 1885. The two are believed to be father and son.

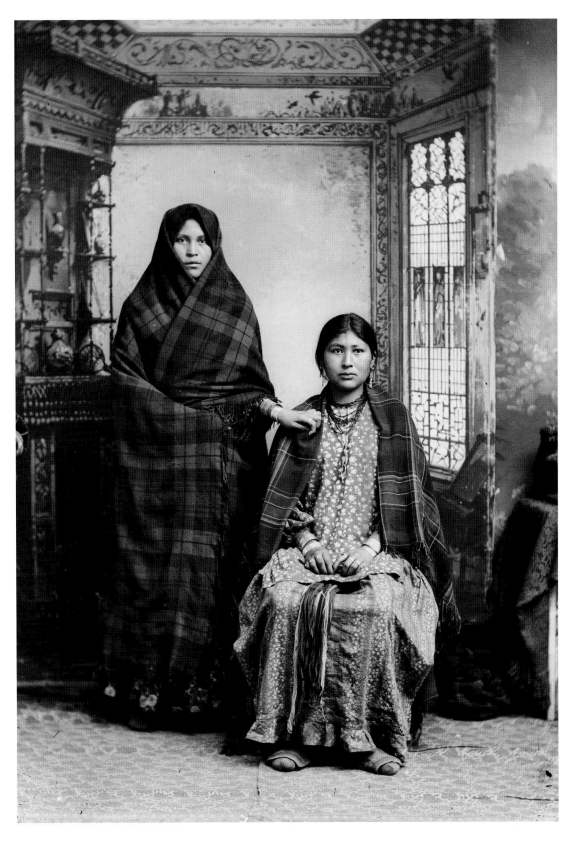

Two unidentified women, ca. 1880. The woman seated in the chair wears a dress (hįnųkwaje) made of fabric with an elaborate print. Most women's dresses used a solid or simple print fabric.

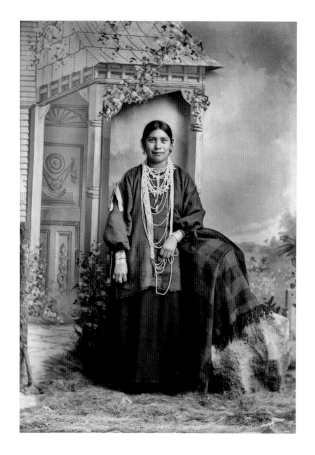

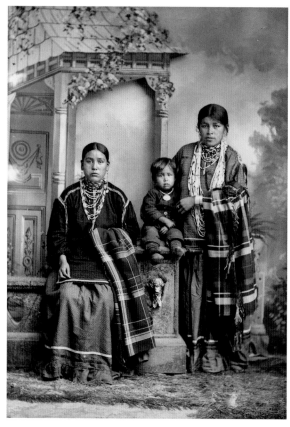

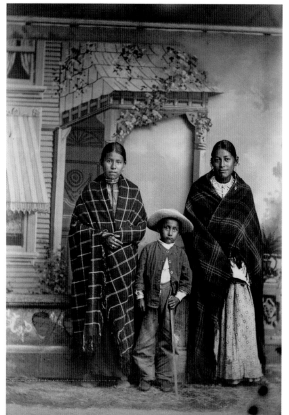

Clockwise from top left:

Mary Alice Johnson Decorra Brown (ENooKah), ca. 1900.

Lucy Decorah (AhHoRaPaNeeWinKah), left, and Belle Hall Greencrow (AhHooSkaWinKah), standing, with a young boy, ca. 1900.

Two unidentified women with an unidentified young boy, ca. 1900.

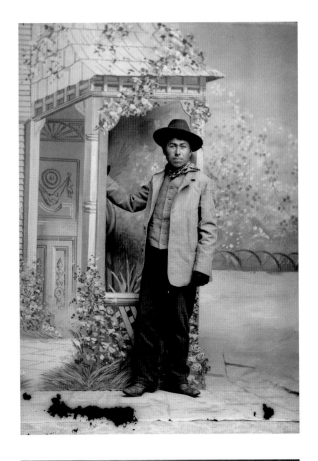

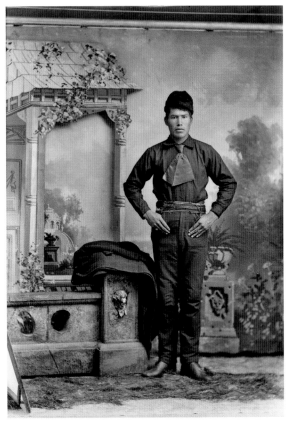

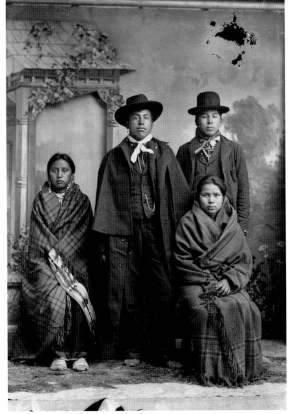

Clockwise from top left:

Charlie Smith (John Beaver) (WySkaInKah), ca. 1895.

An unidentified man dressed in period clothing poses in front of one of Van Schaick's gazebo backdrops, ca. 1895.

Maude Climer Winneshiek (AhHooKeShinNeWinKah), left, David Bow Littlesoldier (MauJchayMauNeeKah), an unidentified man, and Kate Whitespirit-Dickson Thunder Decorra Baptiste Seymour (NeChooKoontchRaWinKah) in front, ca. 1900. Maude is wearing a silk appliqué blanket covered by a Racine Woolen Mills shawl and traditional Ho-Chunk moccasins.

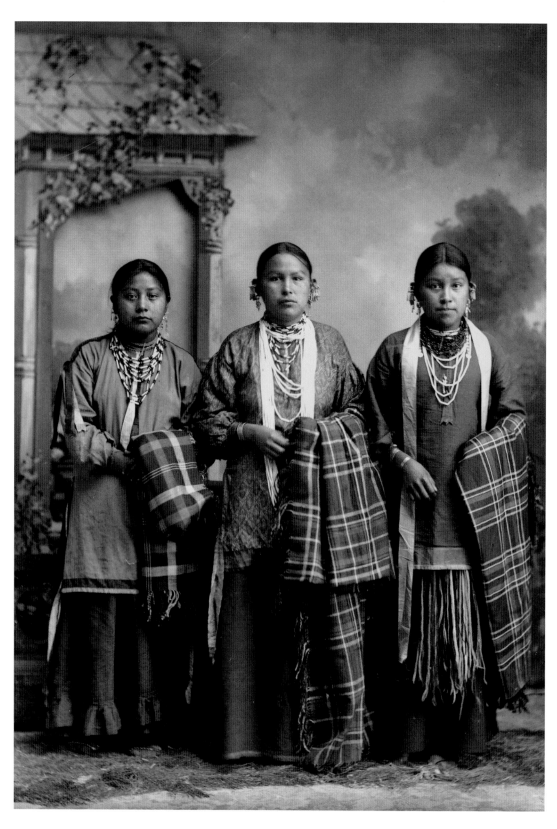

Standing with Racine Woolen Mills shawls are Grace Decorra Twocrow Winneshiek Massey (MauHeHutTaWin-Kah), left, Florence Littlesoldier Wallace Thunder (MauKonNeeWinKah), and Alice Standstraight Blowsnake Littlewolf (HeChoWinKah), ca. 1890.

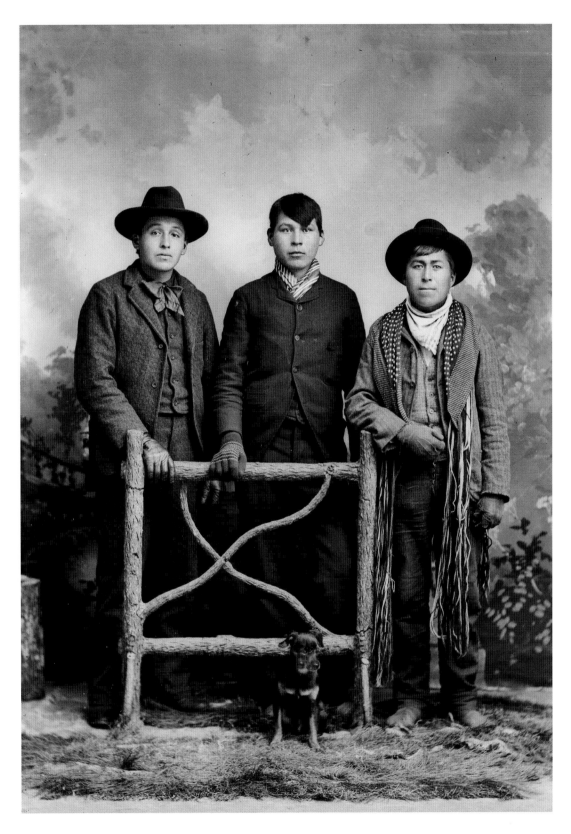

Standing behind a set piece fence with a dog are, left to right, an unidentified young man, Will Blowsnake (One Who Stands and Strikes) (WoeGinNawGinKah), and Charlie Smith (John Beaver) (WySkaInKah), ca. 1890. Charlie Smith has a finger-woven sash over his shoulders.

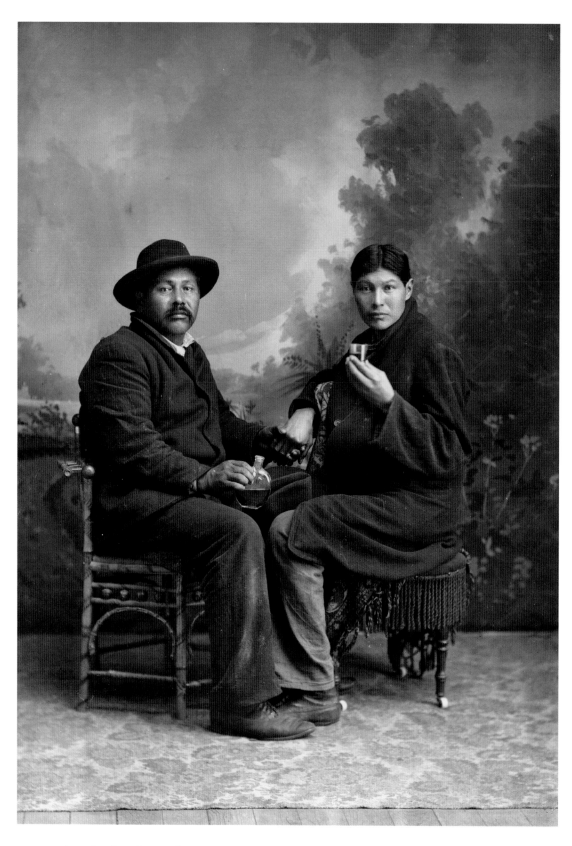

Louis Lookingglass (MaukHeKah), left, and an undidentified man, ca. 1905.

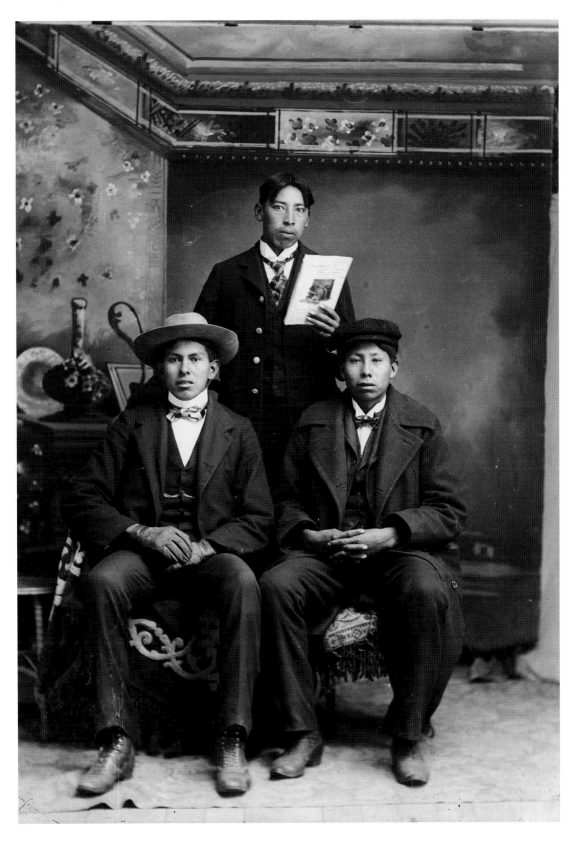

Robert Sine Jr. stands between an unidentified man and David Davis W. Decorra (NeZhooLaChaHeKah), right, ca. 1935.

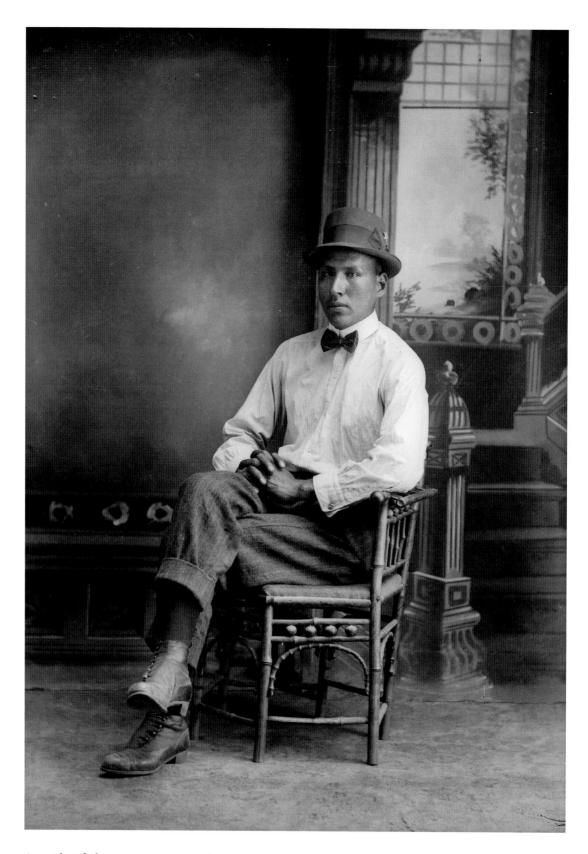

An unidentified man in contemporary dress.

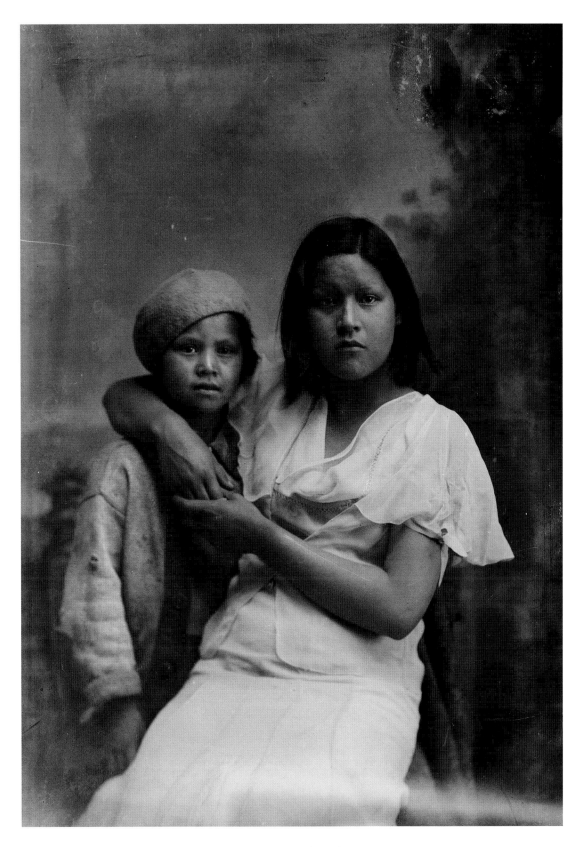

Viola Stacy wraps her arms around her younger sister, Doris (Dolly) Stacy, ca. 1932. Some of the photographs featuring more contemporary dress employ a close-up style. These photos were taken late in Van Schaick's career.

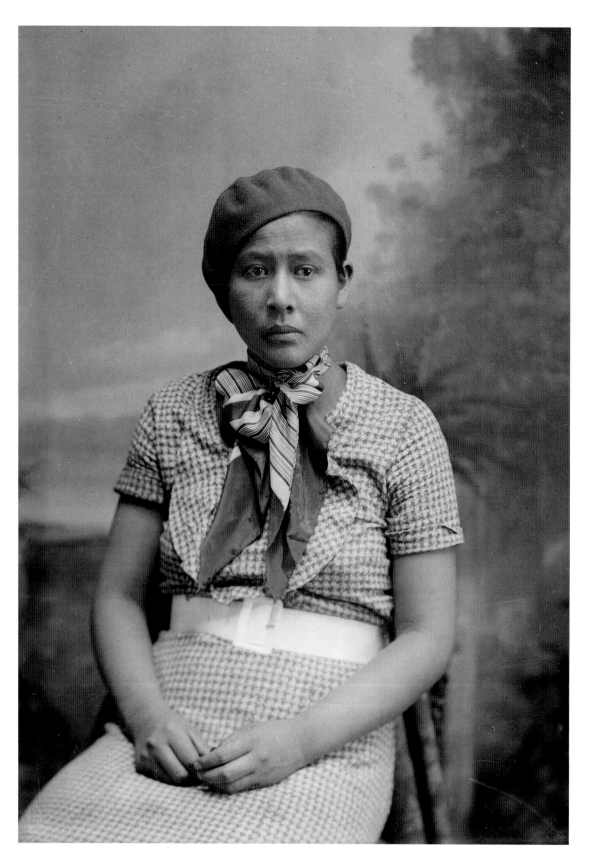

Nancy Davis Funmaker Whitedog (HeNahKahGak), ca. 1930.

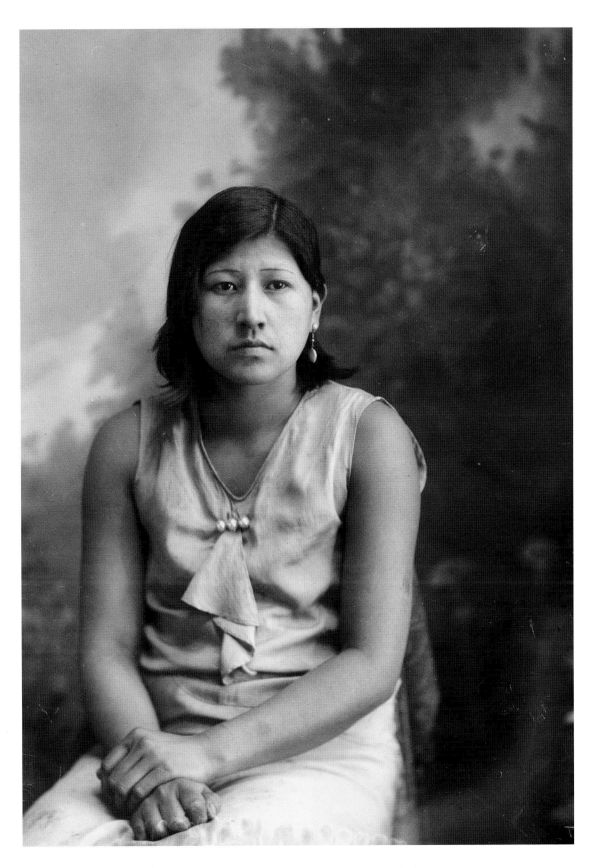

Lavina Davis (UkSuUkKah) was said to be the first Ho-Chunk woman to wear slacks, ca. 1930.

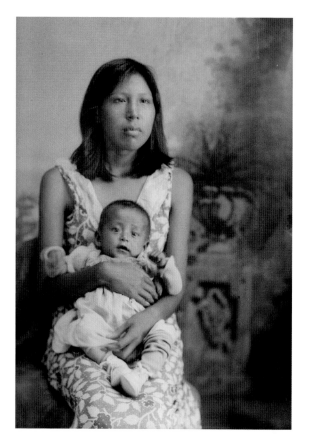

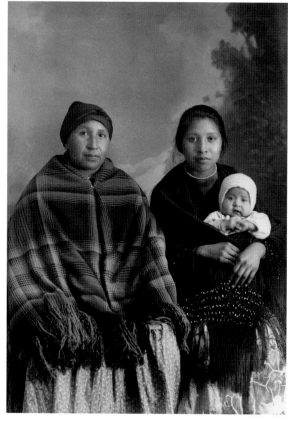

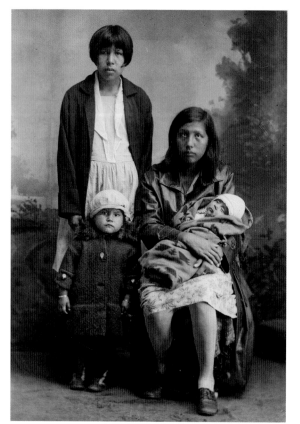

Clockwise from top left:

Marie Bighawk Whitewater holds her son Clyde White-water, ca. 1936.

Mae Mary Smith Whitewater (WaRaKaKaKah), left, with her daughters Mary Whitewater Littlegeorge (HoUpSootchAWinKah) and Berdine Whitewater Tebo Littlejohn sitting on her sister's lap, ca. 1913.

Marie Bighawk Whitewater stands behind her daughter, Betty Walker, and Amanda Bighawk is seated holding her son Calvin Smith-Whitewater, ca. 1930.

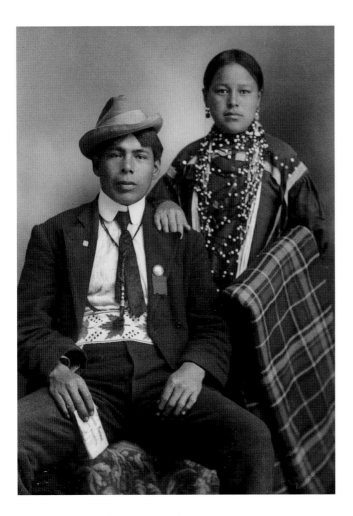

Albert A. Johnson (HunkChoKah) and Annie Bessie Arthur Johnson Standingwater (WeHunKah), ca. 1905. The couple wear a mix of traditional and contemporary clothing.

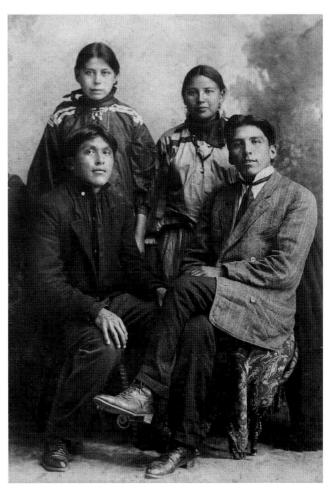

Johanna Puss Otter Greendeer Tebo (WaGaChaMeNukKah), left, and Dora Decorra Winneshiek Greengrass (HoHaWinKah) stand behind John Mann II (NaHeKah), left, and Will Greendeer (ChaWakJaXiGah), ca. 1907.

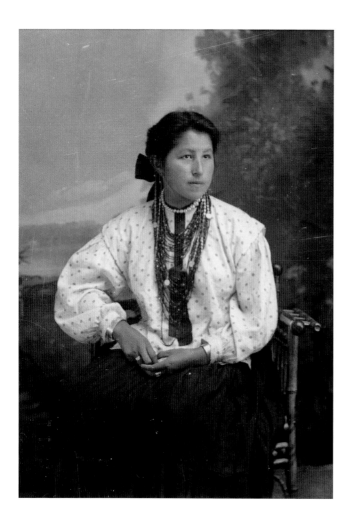

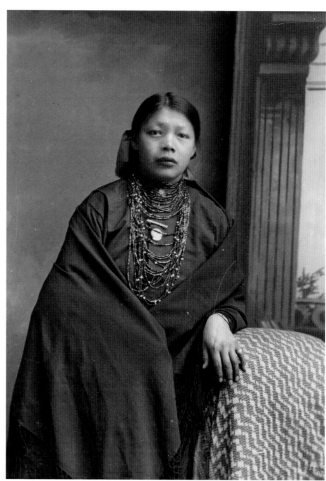

Minnie Sherman Prettyman-Bear Whitebear (AhHooSootch-PaWinKah) wears a contemporary blouse and skirt adorned with a necklace, ca 1905.

Mary Dora White Swan (TaRoKaWinKah), ca. 1910.

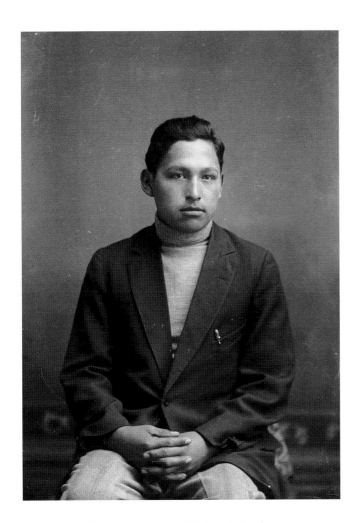

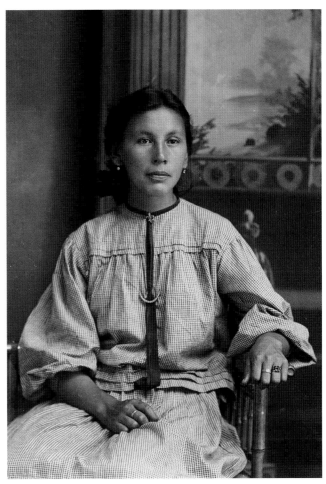

Ernest Howard Whiteagle in a double-breasted jacket, ca. 1930.

Florence White Mann (NaNaZoGaeWinKah) was from Nebraska and married John Mann II, who is listed on the Wisconsin tribal rolls, ca. 1905.

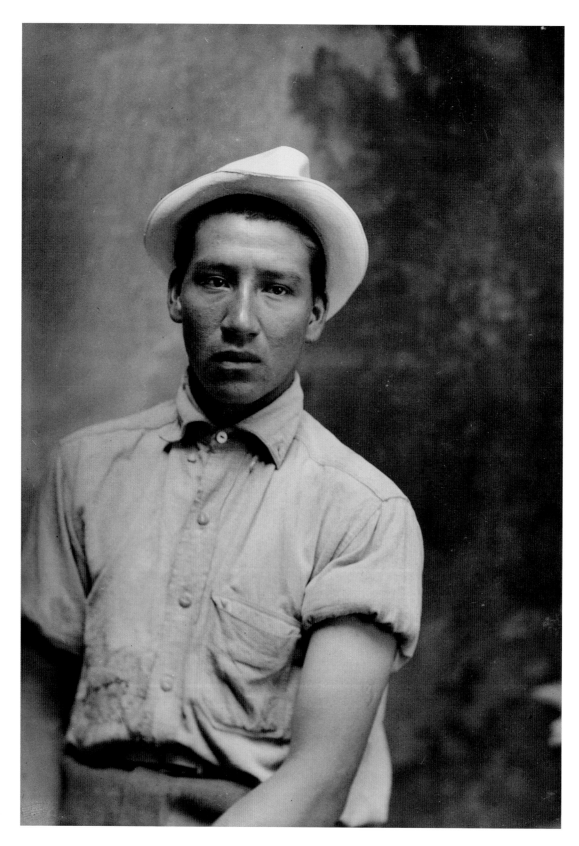

Raymond Pettibone, ca. 1940.

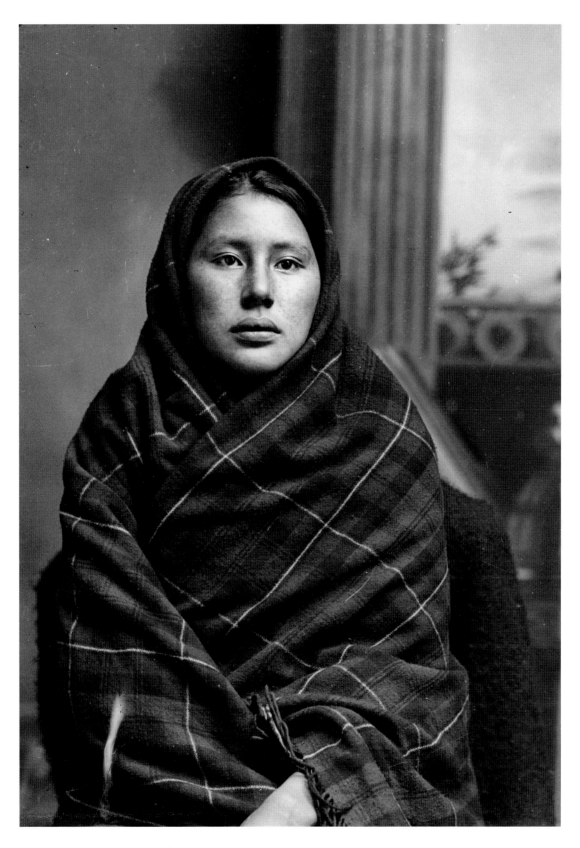

Grace Decorra Clay Whitegull (BeekSkaWinKah) wears a plaid shawl over her head and shoulders, a style seen in a number of Van Schaick's photographs of this period, ca. 1910.

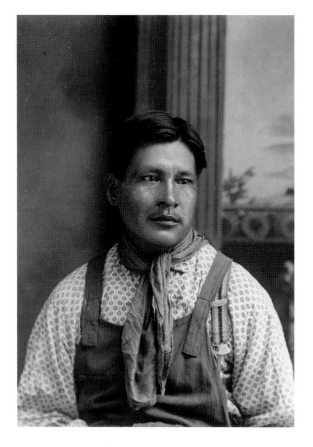

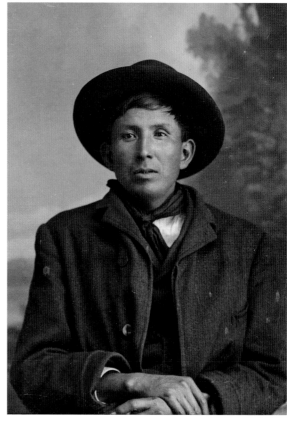

Clockwise from top left:

Henry (Little) Snake (HaRaChoMonEKah), wearing bib overalls, a contemporary print work shirt, and neckerchief, ca. 1915.

Jerome Baptiste (WauKawHunkKaw), a Winnebago from Nebraska, was known as "King of Snakes," ca. 1905.

Stephen Waukon (HumpMeNukKah) sits to the left of an unidentified young man, ca. 1905.

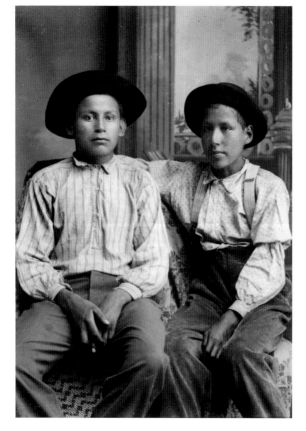

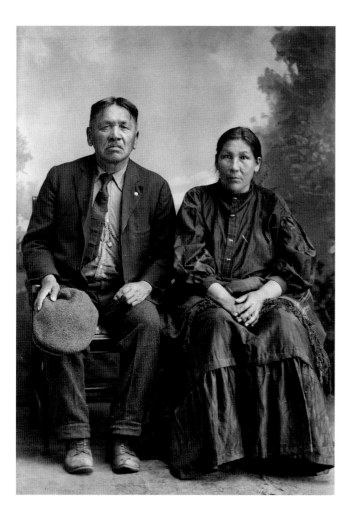

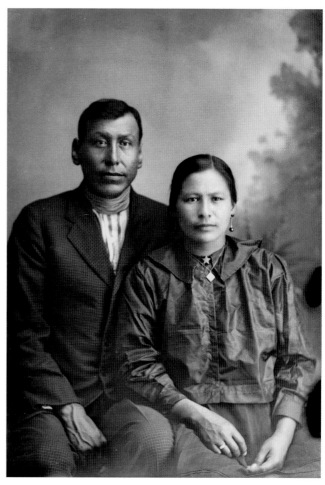

Charles Greencrow, a Nebraska Winnebago, and Belle Blackhawk Monegar Cassiman Greencrow (AwHooSuchRayWinKah), ca. 1930.

Oscar Raisewing, a Nebraska Winnebago, and his wife Louisa (Marie) Johnson Thunder Raisewing, ca. 1930.

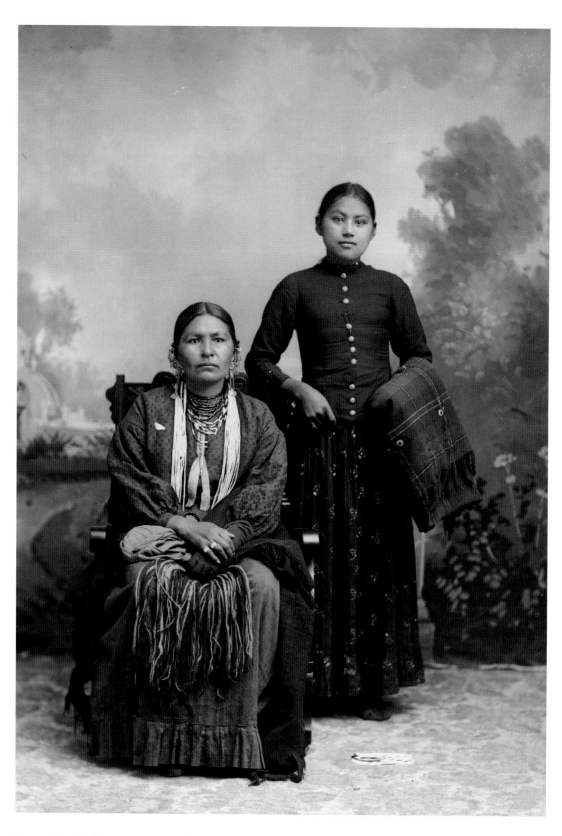

Two unidentified women, ca. 1890. The woman on the right wears a western-style blouse with a long row of buttons and holds a wool shawl embellished with German silver brooches. The woman seated next to her is dressed in traditional clothing.

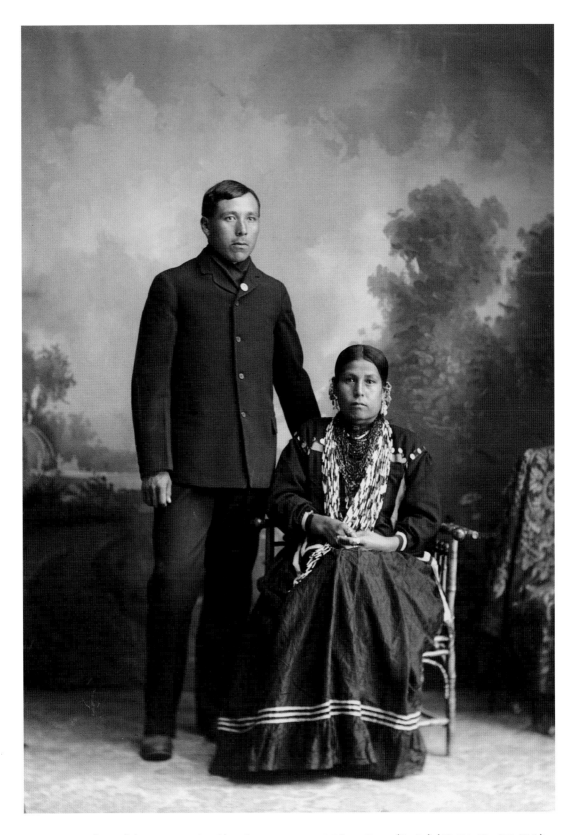

Martin Green (Snake) (KeeMeeNunkKah) and Dora Monegar Wallace Green (Snake) (ChePinChayWinKah), ca. 1905.

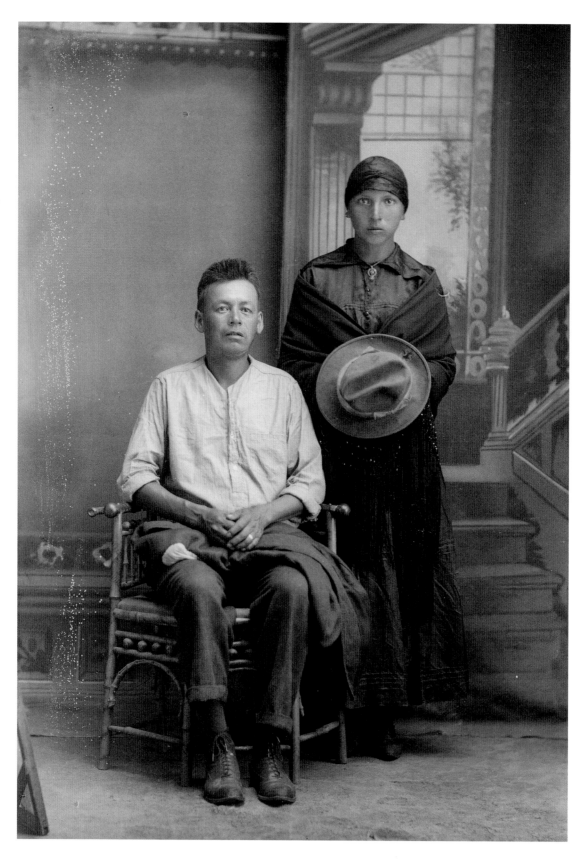

John Dick (DoWjhGeNaNoKah) with his wife, Mary Manly-Mallory Dick (HaJaKeePaNaWinKah), ca. 1915.

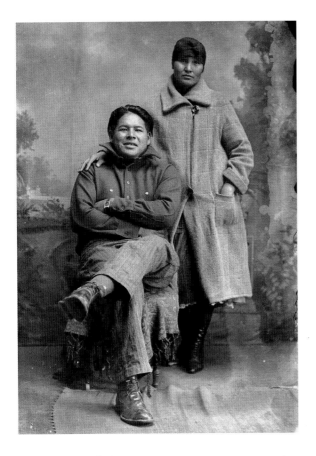

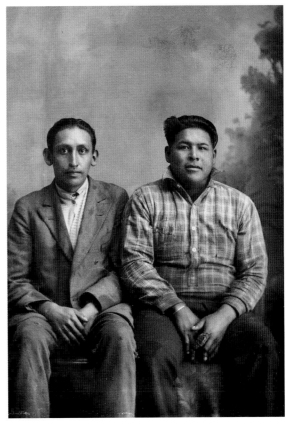

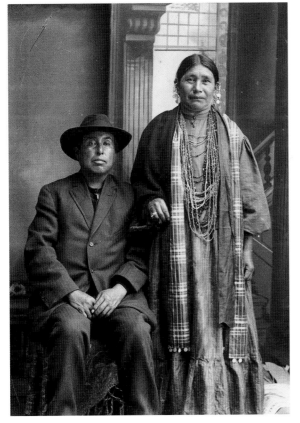

Clockwise from top left:

Louis Johnson (HaNuKaw) and an unidentified woman, ca. 1915.

John Payer, left, and Louis Johnson (HaNuKaw), ca. 1915. John came from Nebraska, while Louis Johnson is listed on the Wisconsin tribal rolls.

Edward Funmaker (WaGeSeNaPeKah) sits next to Mary Johnson (ENooKah), ca. 1935.

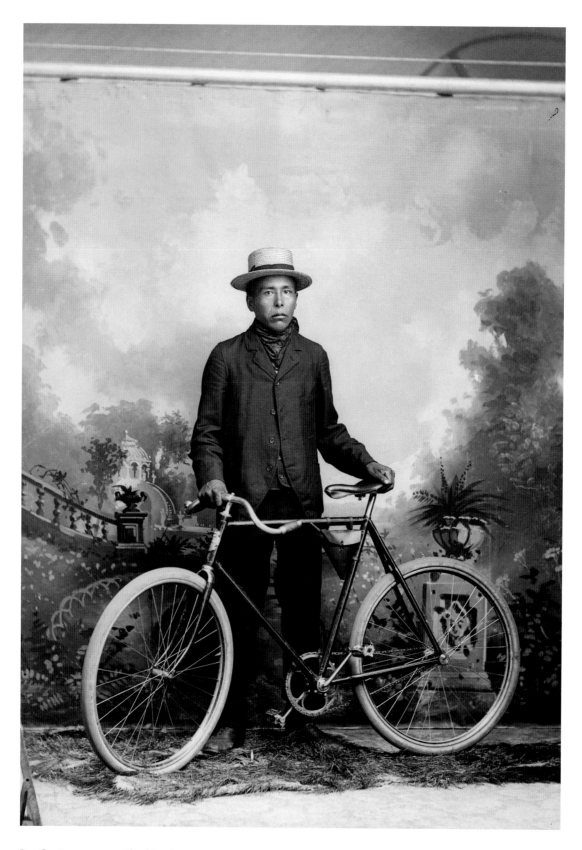

Jim Carriman poses with a bicycle, ca. 1905.

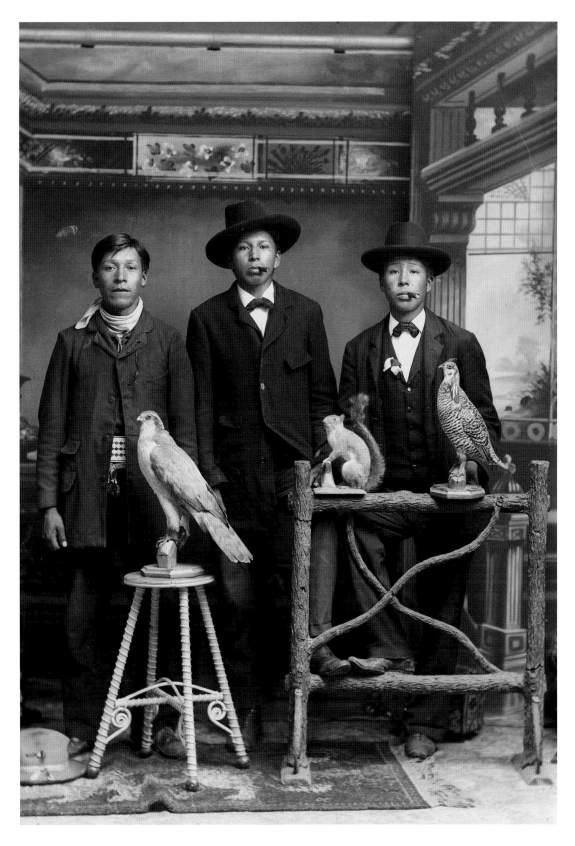

Henry Greencrow (CooNooZeeKah), left, William Hall (HunkKah), and Charlie Greengrass (HoeHumpChee-KayRayHeKah) pose with two stuffed birds and a stuffed squirrel, ca. 1898.

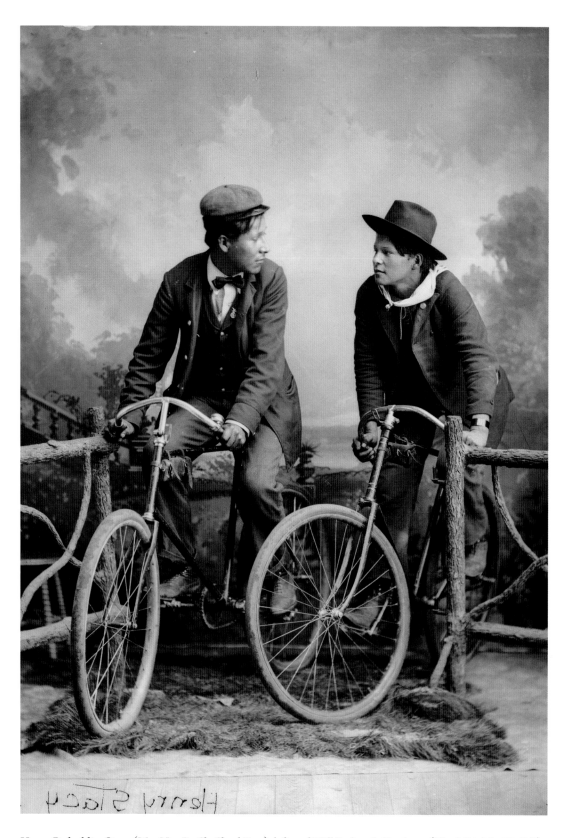

Henry Badsoldier Stacy (MonNawPaeSheSheckKaw), left, and Will Stohegah Carriman (WonkShiekStoHeGah) pose on bicycles in the studio, ca. 1905. Henry's name is etched in the glass plate negative below him in the picture.

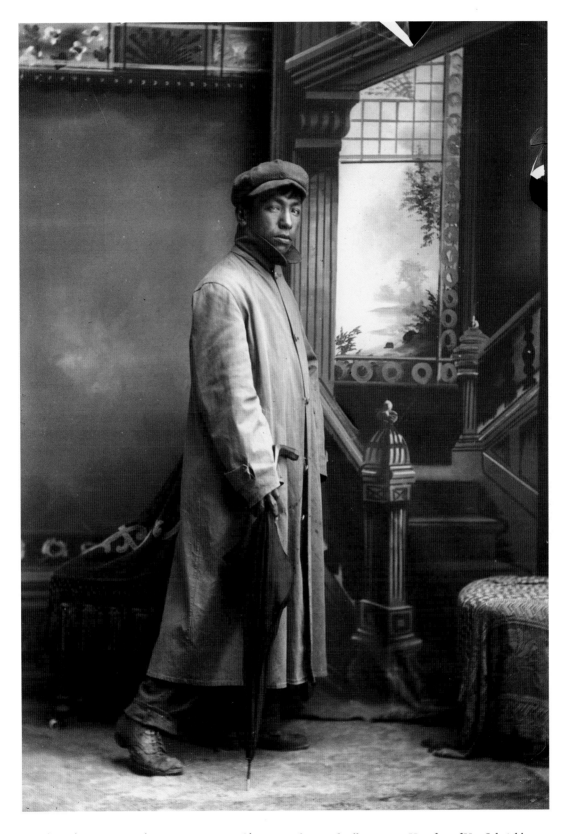

Will (Willy) Goodvillage (MaHayEKeReNaKah) poses with an umbrella, ca. 1910. Very few of Van Schaick's Ho-Chunk images are this animated. Will was blind, and as an old man his uncle, John Swallow (MonKeSaKa-HepKah), who was just a few years older, looked after him and brought him to feasts.

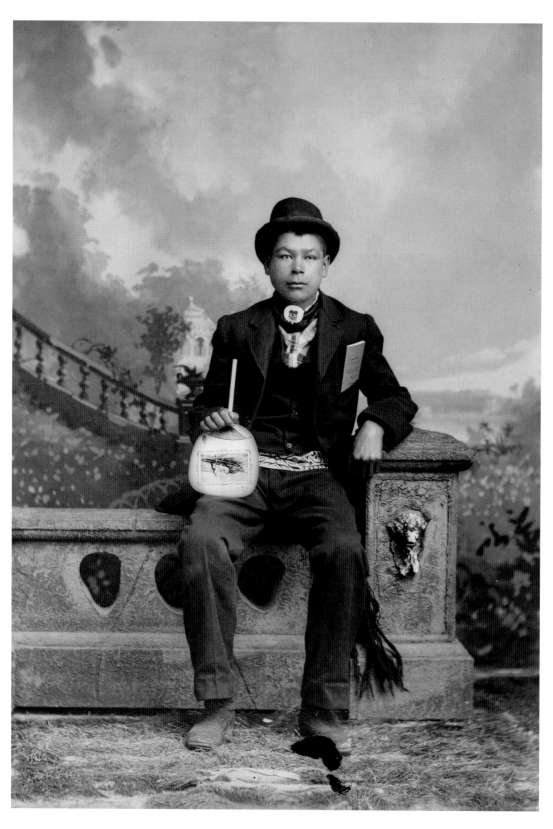

A young Ho-Chunk man sits on a fence in Van Schaick's studio, ca. 1898. He is holding a fan that appears to have come from the 1893 Chicago World's Fair. A large number of Ho-Chunk performed at the fair. In the man's jacket pocket is a savings account book from the bank in Black River Falls.

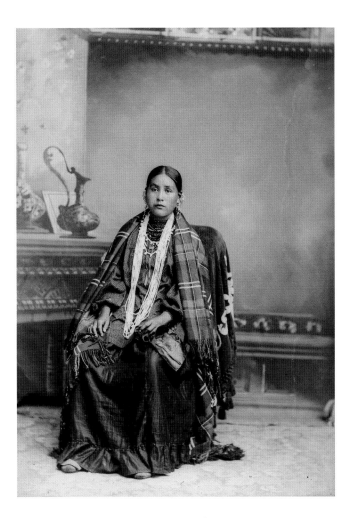

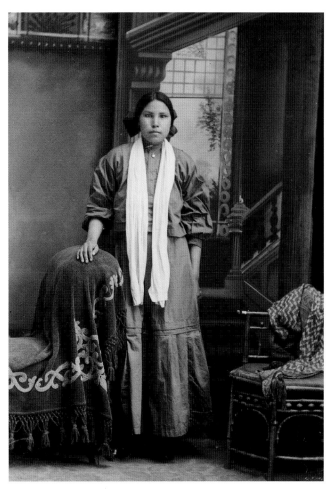

Lucy Decorah (AhHoRaPaNeeWinKah), ca. 1900.

Annie Lizzie Falcon Brown Whitedog Hall (DasChuntAWinKah) rests her hand on an embroidered blanket from Van Schaick's studio, ca. 1920.

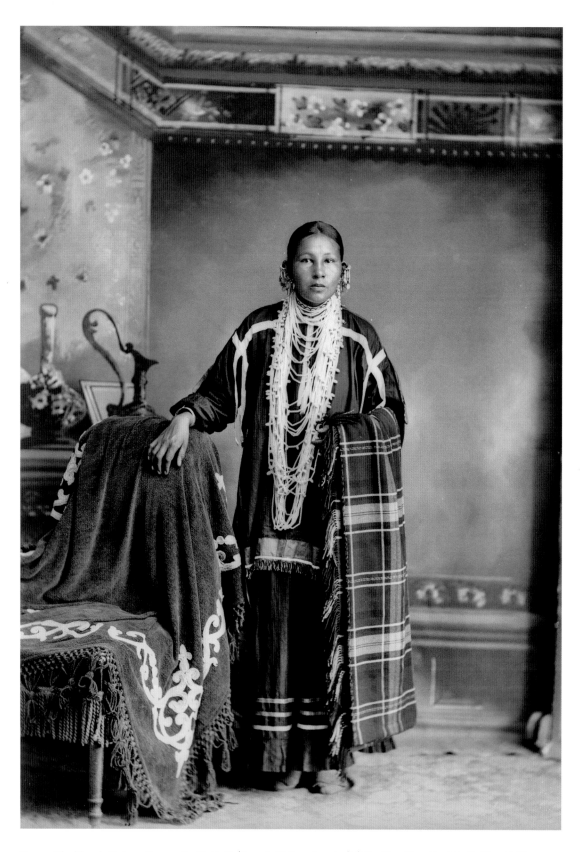

Emma Blackhawk Bigbear Beaver-Smith Holt (Female Yellowthunder) (WauKonChawZeeWinKah) with Van Schaick's studio blanket, ca. 1895.

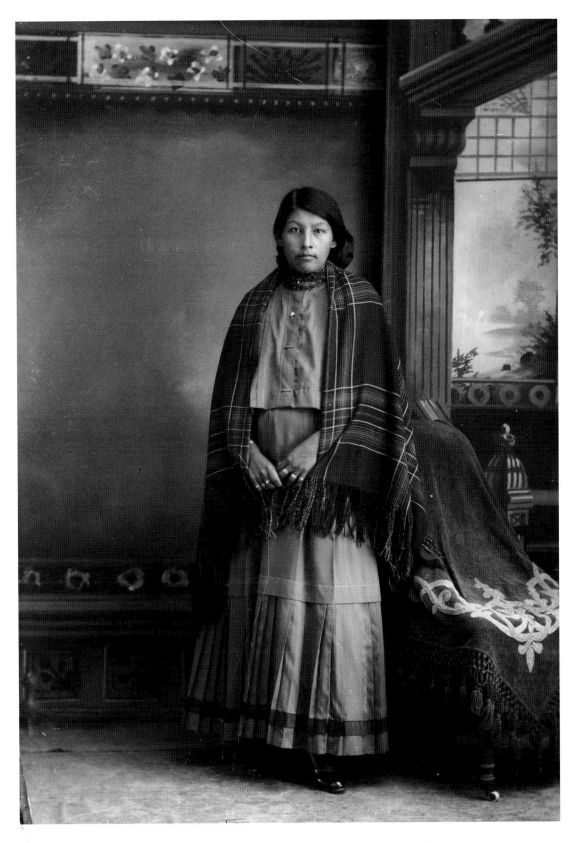

An unidentified woman wearing a plain Ho-Chunk dress with a Racine Woolen Mills shawl draped over her shoulders, ca. 1920.

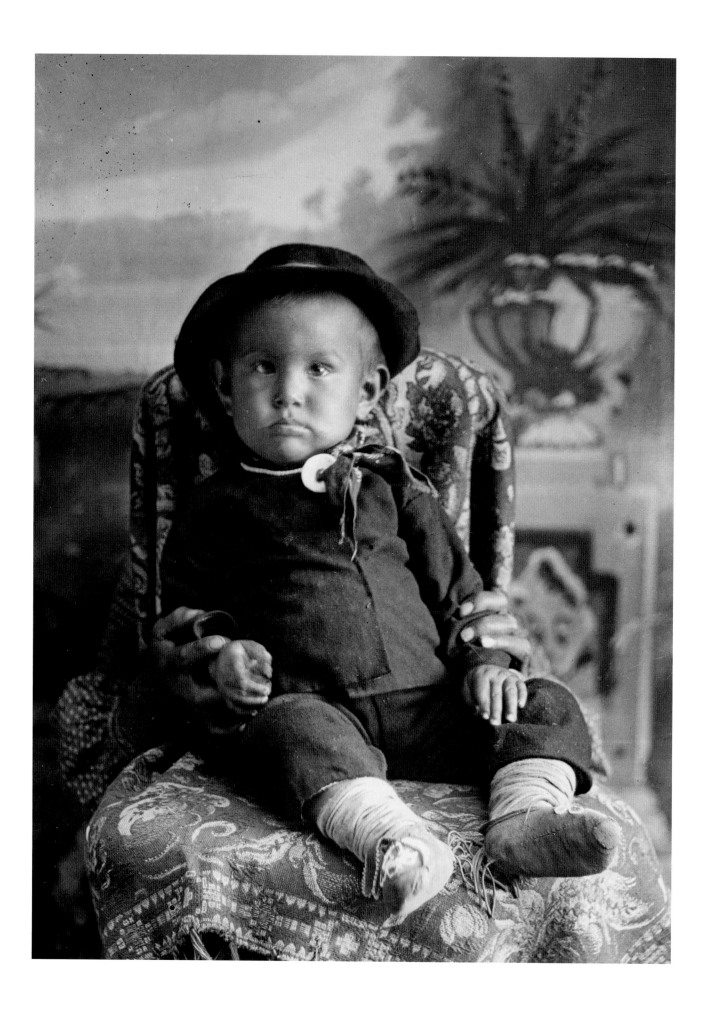

CHILDREN

I N HO-CHUNK CULTURE children hold a very special role. They will be the keepers of the culture, language, and ceremonies for generations to come. Children are shown love by everyone, in particular parents and grandparents. Traditionally, parents rarely scolded or punished, and never hit their children. Instead, discipline was administered by the maternal uncle (Teega) or a male cousin, usually by talking, scolding, or throwing water. In traditional families a child is made to fast when he or she misbehaves.

A child is taught at an early age the Ho-Chunk values of caring and generosity to others, and that everything they do is for the community and not the individual. As the child grows older, they learn they must develop a strong mind, a strong body, and a strong sense of responsibility to their family and clan. With a strong mind they are able to learn from the world around them and become good at solving problems, enabling them to accomplish tasks without being asked.

Traditionally, before a child was born, a male relative would construct a cradleboard for him or her. The cradleboard was decorated with small bells, side-stitch beadwork, and silk or bead appliqué. Today as in the past, when a child is born, they receive a birth-order name such as Kųųnų, which means first son, or Híinų, which means first daughter. Traditionally, when a child was able to walk on the earth, a feast was held and the child was given an Indian name by a clan leader. Even today when a child is given their Indian name, it is a cause for celebration.

Throughout history, many Ho-Chunk children and infants were lost to smallpox, influenza, disease, and complications during childbirth. This made the birth of a child even more significant. With the creation of Indian boarding schools, many children were sent to schools in Wittenberg or Tomah, both in Wisconsin, and as far away as Kansas and Pennsylvania. With children living away from home, it was increasingly difficult for them to continue the language and culture of their ancestors. The Indian schools at Wittenberg and Tomah were some of the only schools in the country that allowed the children to speak their native language outside of the classroom. Despite the United States government's attempts to rid the Ho-Chunk of their language and Indian ways, the Ho-Chunk managed to hold on to their traditions.

Today the Ho-Chunk are teaching the Hoocąk (Ho-Chunk) language to their children. This is the first generation in more than fifty years to become fluent speakers. For some children, Ho-Chunk is their first language, spoken at home and in daycare or school immersion programs. This new generation of native speakers will enable the traditions, culture, ceremonies, and Ho-Chunk way of life to continue.

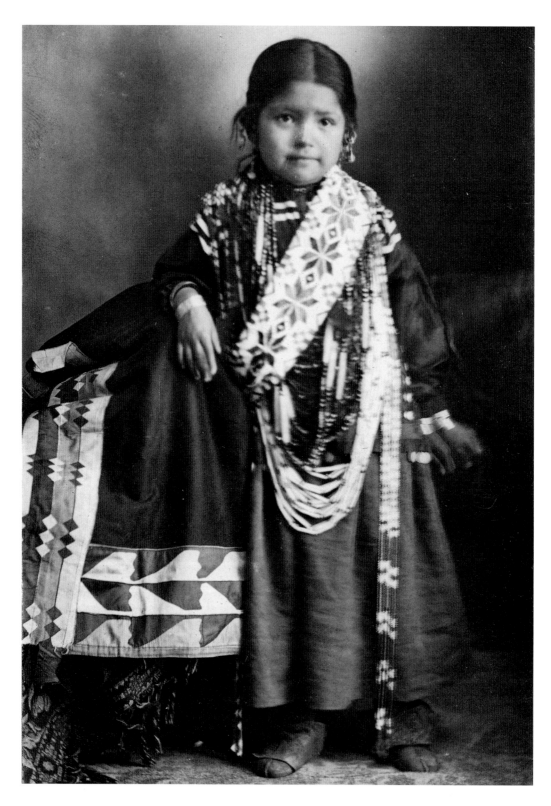

Mabel Mary Lonetree (ENooGah) was the oldest daughter of Alec (Alex) Lonetree (NaENeeKeeKah) and Kate Winneshiek Lonetree (WauKonChawKooWinKah), ca. 1904. Mabel died in 1906 at the age of five from influenza. Her mother had died of the disease four years earlier, as did Mabel's sister Anna in January of 1905 and her brother Howard one month after her. George Lonetree (HoonchXeDaGah) was the only child of Alex and Kate Lonetree to survive the epidemic.

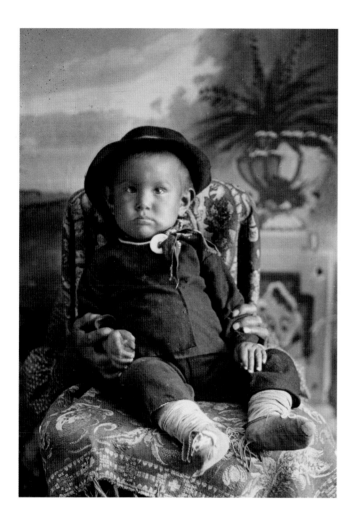

This unidentified child is supported by a woman hiding behind the chair, ca. 1895. Her hands are visible on his arms.

John Stacy Jr. (HaGaKah) is propped up on pillows to keep him steady for the camera, ca. 1901. John Jr. was the son of John Stacy (ChoNeKayHunKah) and Martha Lyons-Lowe Stacy (KaRaCho-WinKah).

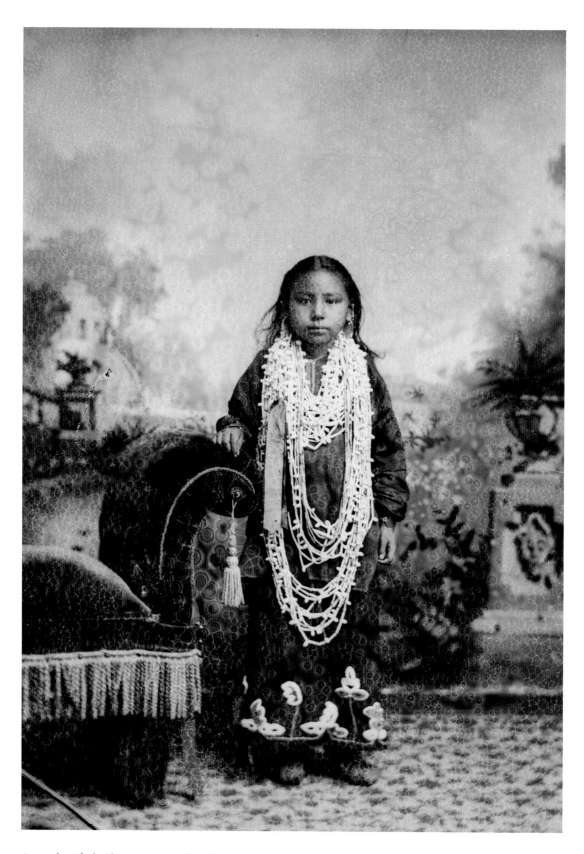

An unidentified girl wearing a rare floral beaded dress and many long strands of wampum, ca. 1885.

Two young girls display their strands of bugle beads, ca. 1885. The girl seated on the floor has a Hudson's Bay trade blanket on her lap.

A young Ho-Chunk girl is wearing a blouse that is completely covered in German silver brooches (hiiwapox) and has silver coins attached to the bottom, ca. 1895.

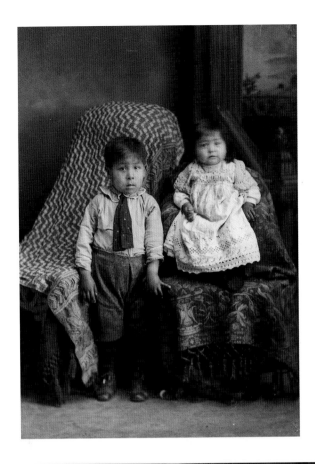

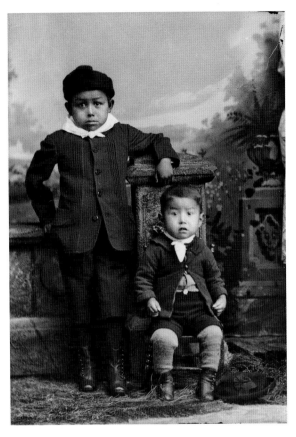

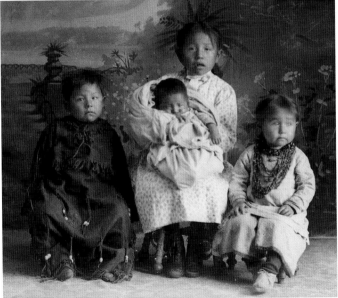

Clockwise from top left:

Daniel Greengrass and Ruth Greengrass Cloud try to hold still for their photograph, ca. 1916.

Two unidentified boys dressed in contemporary clothing, ca. 1910.

The children of Frank Lewis (HaNaCheNa-CooNeeKah) and Addie Littlesoldier Lewis Thunder (WauShinGaSaGah), ca. 1905. George Bryan Lewis (PatchDaHeKah), left, is seated next to Amelia Emma Lewis (PatchKaRa-WinKah), who is holding her brother Harry Ben Lewis (HooNaChaWeKah). To her right is Mary (Pinkah) Lewis (KeSaWinKah).

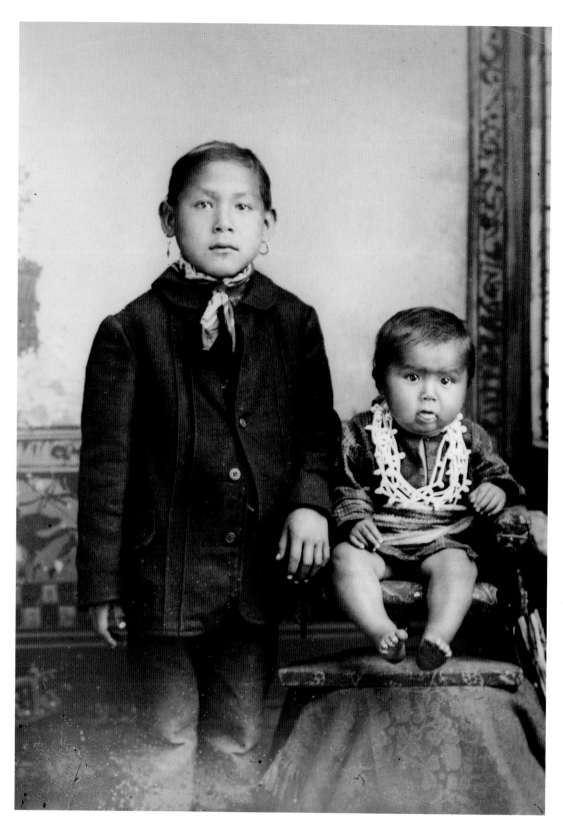

An unidentified boy with German silver earrings stands next to a younger boy who has been draped with a shell necklace, ca. 1890.

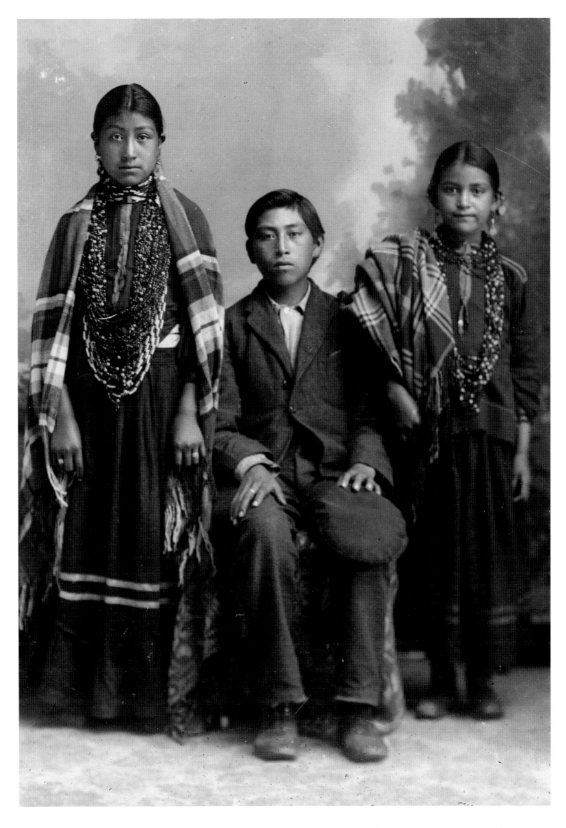

The children of Chief George Winneshiek (WaConChawNeeKah) and Rachel Funmaker Winneshiek (HockJaw-KooWinKah), ca. 1908. From left to right are Ellen Ella Winneshiek (TaCooHayWinKah), Clay Winneshiek (HunkMeNunkKah), and Fannie Winneshiek (HoChunkEHoNoNeekKah).

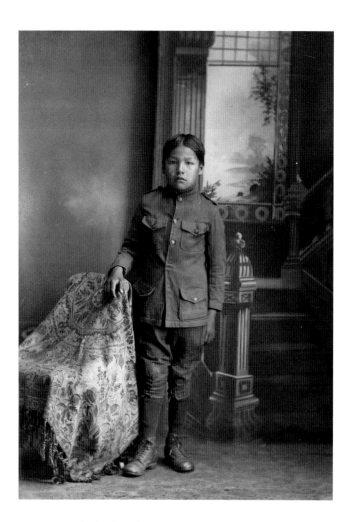

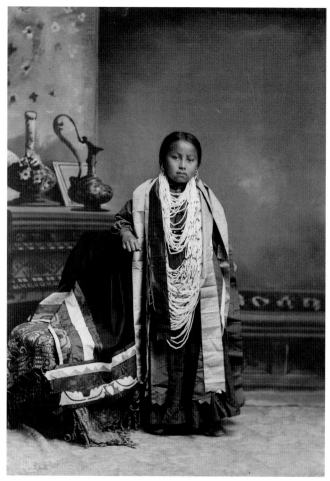

Esau Prescott in his boarding school uniform, ca. 1915.

Martha Waukon (WeHunKah) wears a large wampum necklace and stands next to a chair with a floral appliqué blanket draped over it, ca. 1890.

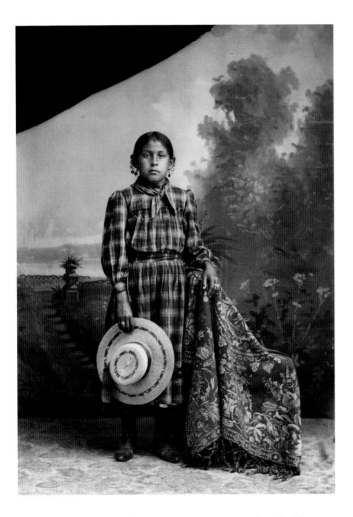

Mabel White Blackhawk St. Cyr in contemporary dress holding a wide-brimmed hat, ca. 1899.

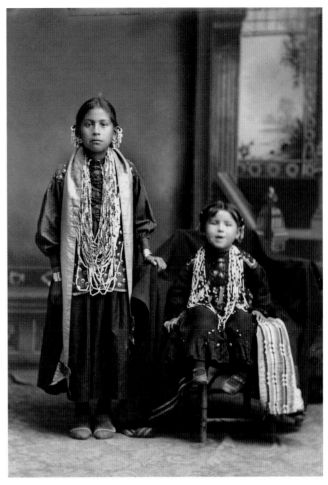

Mabel White Blackhawk St. Cyr stands next to a young girl. The girls are dressed in their finest outfits. The youngest is seated next to a Ho-Chunk blanket with a silk appliqué "beaver tail" design.

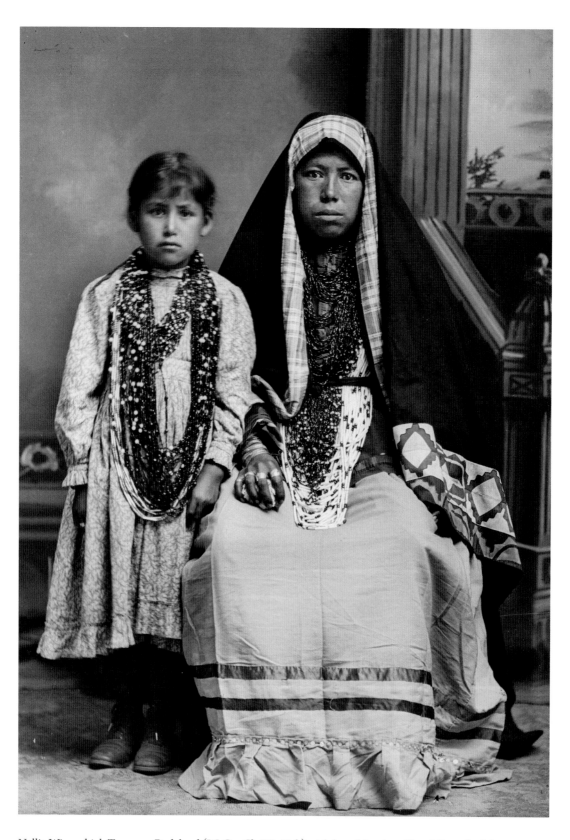

Nellie Winneshiek Twocrow Redcloud (WaConChaWinKah) with her older sister Kate Winneshiek Lonetree (WauKonChawKooWinKah), ca. 1901.

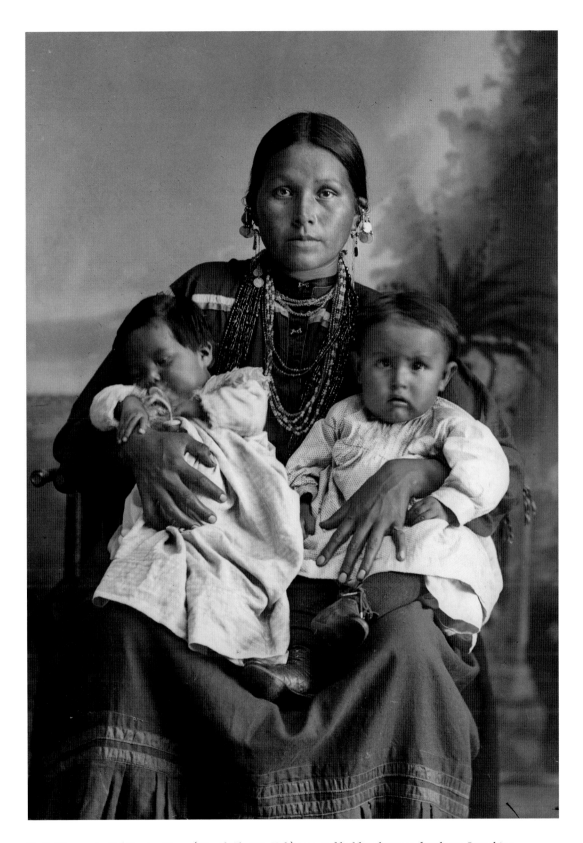

Stella Blowsnake Whitepine Stacy (HayAhChoWinKah) is seated holding her two daughters, Josephine Whitepine Mike (AhHooGeNaWinKah), left, and Lena Whitepine Shegonee (HaCheDayWinKah), ca. 1907. Stella is also known as Mountain Wolf Woman, which is the title of a book written about her by Nancy Lurie.

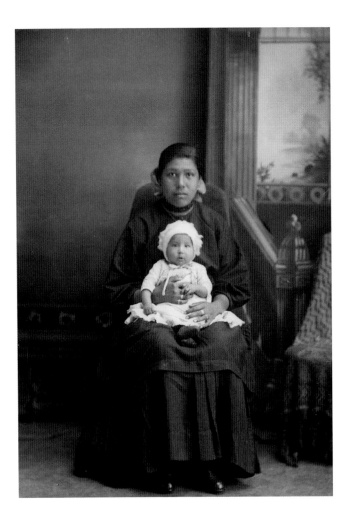

An unidentified young woman and baby.

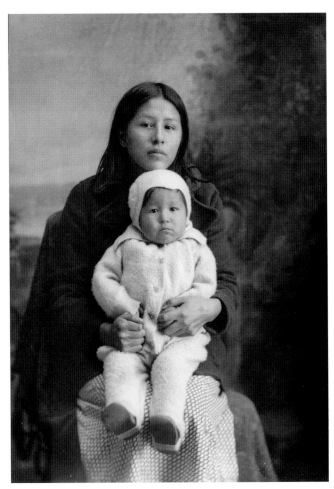

Bertha Greengrass Blackdeer (HaukSeGoHoNoKah) holds her niece, Bernice, the daughter of Ruth Greengrass Cloud, ca. 1933.

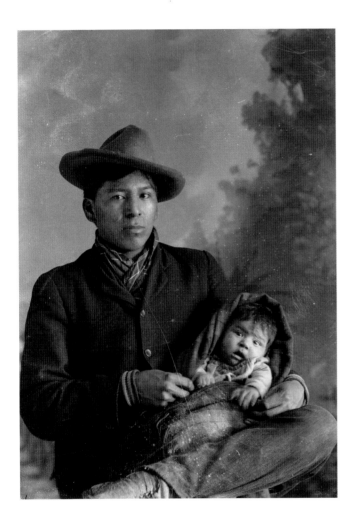

An unidentified man and his son, ca. 1910.

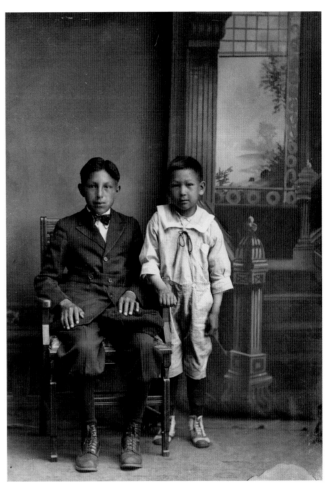

William Crow (HaHiKaw), left, and Francis Cassiman, ca. 1920.

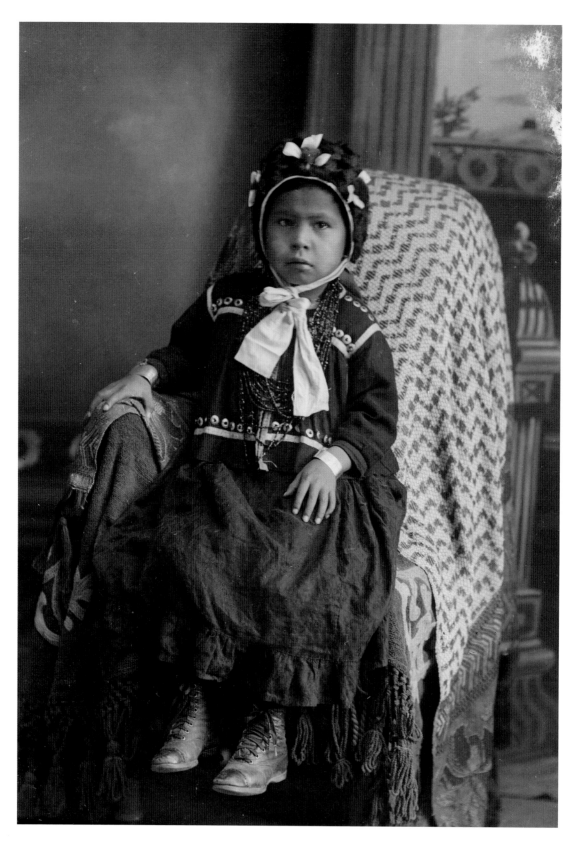

Esther Dora White Yellowbank (HoChunkEWinKah), the daughter of Ulysses White (HoZheWaHeKah) and Queen Redwing-Winneshiek (Fannie Winneshiek) (WarConJarUKee), ca. 1908.

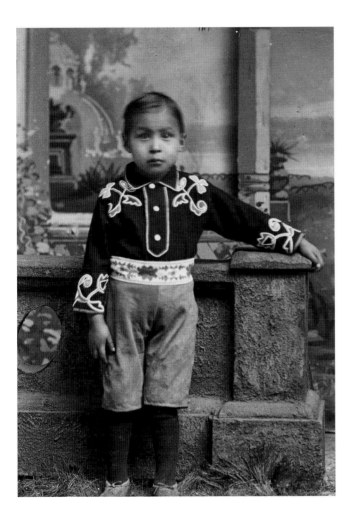

Edwin (Ed Jr.) Greengrass (HoonkSepKah) rests his arm on a wall in Van Schaick's studio while wearing a floral beaded shirt and beaded belt, ca. 1900.

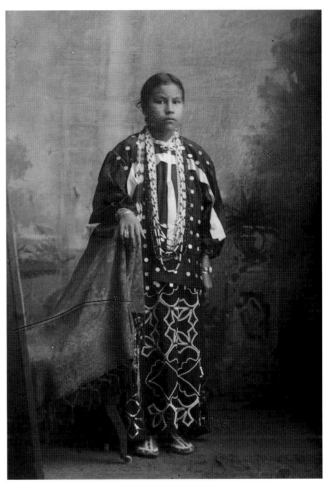

In this photograph taken near the end of Van Schaick's career, Mary Edith Wallace Vasquez wears a Ho-Chunk woman's outfit with a very rare floral beaded skirt, ca. 1940.

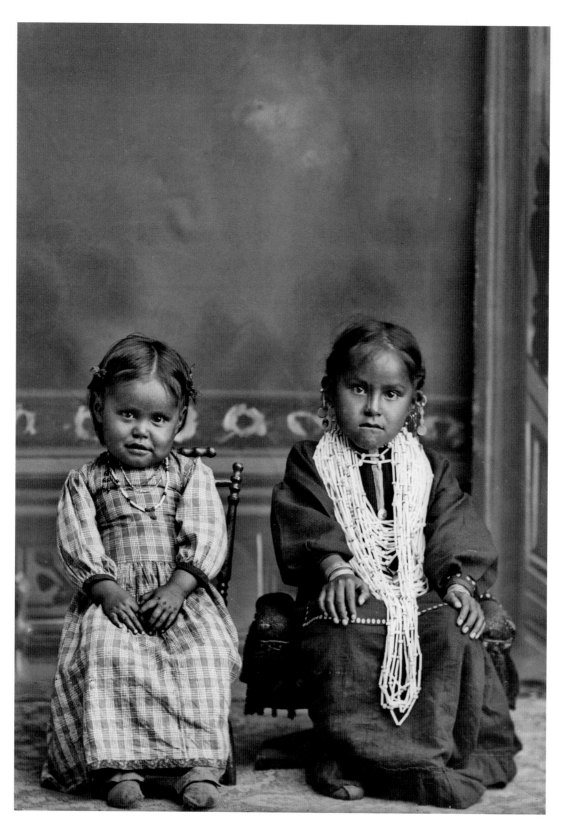

Liola Browneagle (WeHunKah), left, and her younger sister Maude Lookingglass Browneagle (ENooKah), ca. 1903. Liola and Maude were the children of Frank Browneagle (HeWaKaKayReKah) and Annie Snake (KhaWinKeeSinchHayWinKah).

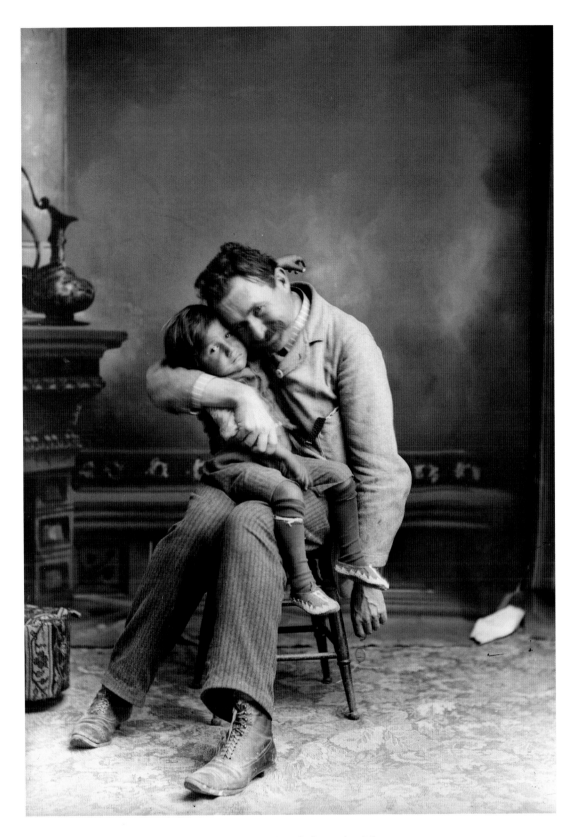

A man identified as Charles Van Schaick with an unidentified Ho-Chunk boy.

AFTERWORD

IT HAS BEEN A GREAT HONOR and pleasure to witness the development of *People of the Big Voice*. With the photographs as the nucleus, the project has been layered with the enthusiastic devotion of the authors. I have been impressed by Charles Van Schaick's story, the visual and cultural interpretations of his work, and the beauty of the collection. Many of the images are breathtaking and will continue to be a source of inspiration for me.

When I first learned of Tom Jones's interest in creating a book of Van Schaick's Ho-Chunk images, I was filled with great anticipation. In the 1980s I saw some of Van Schaick's photographs during a visit to Black River Falls with Frances Perry but not the entire collection. I was thrilled when Tom informed me he planned to collaborate with Amy Lonetree. With the addition of longtime friend of the Ho-Chunk Michael Schmudlach; Matthew Daniel Mason, a young archivist from Yale; and tribal genealogist George Greendeer, I knew this project was destined for success.

I had the honor and privilege of briefly attending one of the first collaborative sessions when Amy, Tom, and Mike began making photographic selections back in 2008. It was a very enjoyable experience, and I found it difficult to return to my daily routines.

Even as a child, I clamored to be a part of the sharing and storytelling that occurred when my relatives gathered around our family photographs. Today, as I view the Van Schaick images, this process continues to feed my soul. My mind drifts to memories of my ancestors and the interconnectedness of life, family, social customs, and language.

As I perused the galleries, I discovered an image of my father, David Neil Lincoln Jr. (WaWaHasKah), with my grandmother, Annie (Lowe) Lincoln (WaNukScotch-EWinKah) (see page 56, top right). What a gift it was to see him as a sweet baby, cradled by my grandmothers. Each time I view that image, I am overcome with gratitude

PEOPLE OF THE BIG VOICE wagaxirera hotoǧocra, pįįxjįhiireže yaare. Hokiwagaxra ee waaehi wa'ųąkra, woorexjį wa'ųąkra, worakra įįcap hižąšąną hanį wa'ųnąąkra, haakja peewįgają, wootoaįxjį.

Tom Jonesga waagax hakiruxara hižą stoohijirera, jaagu wagera, hagiipį. Hokiwagaxra nįoxawanįeja hisge 'ųųirera waaca, Frances Perryga waanįra. Eeja Tomga, Amy Lonetreega hakižu warekjene eera, haipį. Egi žige Michael Schmudlachga, Matthew Daniel Masonga, Yaleija howajira, nąga George Greendeerga, gijirairekjene eera, yaaperešąną, wažą pįįxjį ųirekjenera.

Mąą eegi Amyga here anąga Tomga nąga Mikega hokiwagax gicą mįįnąkirera, hirasa hįgikaraheirera haipįxjį. Hįxųnųxjįkregi woorak hanąąxgųšųnųra, haipįšųnų. Wažą wahaire, hokiwagax horoǧocire anąga woorarak mįįnąkirešųnų. Hąąpte'e Van Schaickga hokiwagaxra waagitoǧocgi, že'e peewį waa'ųaje. Jaasge wąąkšikš'aakra 'ųų hanįhairera peewį anąga s'ii mįįnąkšųnų.

Hokiwagax hotoǧocnąk'ųų, hįąchaara, David Lincolnga yaa'e. Hikoroke haara, Annie Lincolngašge, eja haca. Hįąc haara nįkjąkįk hereregi wą'ųąkšąną. Hikoroke haara nąga hicąk haarašge hija nąąkšąną. Hegų janąhą hokiwagax ze'e hotoǧocgi, hikoroke haara nąga ee hicąk hiira, jaasge hįąc haara xetehiirera, woojnąp hakere.

Hįąc hara wąąkware hižą ere. Nįįkjąkra hakewe xetehi anąga hi'ųnįhaara hoci gi'ųų. Hįąchaara wąąkšikpįįnįhe. Wąąkšikra hanąąc waiš'akšąną. Žeegų xetewįįrawi.

Hokiwagax nąąkre jaasge wotogoc nąkre, žeexgesjį Hoocąkra nišge wajairekjene, yaare. Hacįja hųųwajiwira hiperes ną'įįrekjene.

Hejąga Charles Van Schaickga hokiwagax wanįra haizo hįįworoǧocikjąnawi. Hąąpte'e wążą ceek hį'ųųwi, irokit'e hokiwagax harukos nąąžįįre, anąga žeesge wążą kiiwagax rehire anąga hegų janąha heregi, hokikit'e ruxurukire wa'ųnąąkšąną. Woorakra roohą wa'ųąkra, coowaregi waanąxgų ruxurukirekjene.

for the way my grandmothers influenced my father during his formative years.

I grew up knowing him as a strong and dedicated working man who provided a good home for six children and my mother. He and my mother, Ruby (Littlesam) Lincoln (SoxMiNukGah), worked together to provide us with spiritual guidance, comfort, and security. I watched how he led his life, and how he treated all people with utmost respect.

As I look upon these photographs, I envision this same type of reminiscing for other Ho-Chunk readers who find their relatives in this impressive collection. For young people, it will prompt more questions and create more conversations and intergenerational connections with relatives.

The Ho-Chunk people have made great progress since Charles Van Schaick opened his studio doors to capture the images of my relatives. He was a unique and talented photographer, a man ahead of his time. Through the authors' courage and dedication, this collection takes center stage. At long last, these images have been brought back to life.

There are still many stories to be told and more young Ho-Chunk writers who will take us into the next era. We are now in the digital age where our families are staying in touch by texting, using social networking tools, and sharing information and stories online. Great strides have been made, and there is an abundance of new resources available to our Nation.

We have reached a critical juncture in the lives of the Ho-Chunk people. With our continued dedication to language preservation, I am confident that Ho-Chunk culture will not be lost. We have our elders, our apprentices, and the fortitude to succeed. The challenge is for more young people and our leaders to continue the legacy of our forefathers.

Non-Indian readers who open this book will be forever changed in how they view historical images of Native people. No longer are we invisible or generically labeled as Indian. We have names; we have an identity and a rich cultural heritage to share. This publication is a great artistic and literary accomplishment for viewers who value the history and culture of Indigenous people. It will have a special place in Ho-Chunk homes and on the shelves of collectors and curators.

Hąapte'e Hoocąk hoit'era hį'ųja hąhąkwi. Roohąxjį hikicgaakra, ee hąke Hoocąkra wąągagixawanįkjawi wagi'ųnąąkšąną. Hakogijąra, coowaregi hanįharairekje.

Mąįxetejąąne, waagax hakiruxarara te'e hotoǧocgi, wąąkšik jaasge horoǧoc nįhera, hijąkjene. Kewąąšik kira hįwa'ųnįhaająwi. Waagax hakiruxarara te'e wąžą xetexjį wagi'ųire.

<div align="right">

Janice M. Rice
HiNukHiJaWi (Changing Seasons Woman)
Senior Academic Librarian, University of Wisconsin–Madison

</div>

How This Book Came About

IN LATE 2007, while researching Ho-Chunk silk appliqué (ribbon work) at the Wisconsin Historical Society, I was going through the society's collection of Ho-Chunk photographs. I inquired about any other photographs the society had of the Ho-Chunk. Visual Materials Curator Andy Kraushaar suggested that I look at the glass plate negatives from the Charles Van Schaick Collection. Viewing nearly one thousand Ho-Chunk negative images on a light table, I found it difficult to interpret all of the information they contained. We made the decision to print the images using digital scans made a few years earlier.

Viewing all of the images on contact sheets, I was overwhelmed by their detail and beauty. A week later I attended a Ho-Chunk gathering and talked to photographer and tribal member Tom Jones, suggesting he stop by the Wisconsin Historical Society to familiarize himself with the collection. Tom contacted me a couple of days later, and we discussed the possibility of publishing a book of these photographs. This coincided with a conversation Andy Kraushaar had with Allen Van Schaick, the grandson of Charles Van Schaick, about his desire to make his grandfather's work more publicly available. The Wisconsin Historical Society Press became our willing partner in publishing this book of Charles Van Schaick's Ho-Chunk photographs.

Originally, we proposed a simple coffee-table book using a small portion of these beautiful images. We quickly realized this could be much more, making the book a true educational resource. The decision was made to bring in experts to cover different aspects of the book and tell the story of the Ho-Chunk during the years following the government removals and their return to the Black River Falls area in Wisconsin, a period that coincided with Charles Van Schaick's studio career. Ho-Chunk tribal member Amy Lonetree, an American studies professor at the University of California, Santa Cruz, joined the project with expertise on the representation of Native Americans in American history. Matthew Daniel Mason, an archivist at the Beinecke Rare Book and Manuscript Library at Yale, worked extensively with the photograph collection from 1998 to 2003 and wrote a major portion of his dissertation about the life and work of Charles Van Schaick. Tom Jones, assistant professor of photography at the University of Wisconsin–Madison, brought his voice to the project as a Ho-Chunk artist and photographer. I joined the project to contribute my research skills and knowledge of the Ho-Chunk garnered from over forty years of friendship with members of the tribe.

The four original authors, along with Andy Kraushaar, had the daunting task of deciding which photographs to include in the book. The authors voted on their favorites, and the two hundred photographs with the most votes were chosen. A decision was then made to include all of the families represented in the photographs, expanding the number of photographs to nearly three hundred.

When the Jackson County Historical Society Board of Directors, headed by Donn Holder, made the decision to transfer the remaining glass negatives of the Van Schaick collection to the Wisconsin Historical Society in 1994, some of the images had been partially identified. One of the major goals of the current project has been to identify as many people as possible and complete that work. George Greendeer, tribal genealogist for the Ho-Chunk Nation, joined the project to help with identification of the individuals in the photographs using his knowledge of the Ho-Chunk and

Ho-Chunk families. George Greendeer, Tom Jones, and I met numerous times with Ho-Chunk elders to continue the identifications and to correct misidentifications.

The authors acknowledge a book like this would never have been possible without the dedication of Frances Perry, Black River Falls librarian and friend of the Ho-Chunk. After high school, Perry left her hometown of Black River Falls to teach at a small country school at Sandy Plains in Jackson County, Wisconsin. Across the street from her home was the residence of the widow of Chief Blackhawk and her daughter Sue Eagle (WaKonCheWinKah), Sue Eagle's husband, Charlie Eagle (HoWaHoNoNeeKah), and their children. Three of the youngest children, Eunice (Ethyl) (PatchKaReWinKah), Bernard (NaHeKah), and Adam, attended the Sandy Plains School. Perry spent a great deal of time with the Eagles, sitting on their porch, drinking tea, and socializing.

A relative of the family, WoShipKah (George Garvin Sr.), often came by to visit. WoShipKah was four years older than Perry and had attended the Hampton Normal and Agriculture Institute located in Hampton, Virginia, a school for Blacks that also had Native Americans in its student population. From WoShipKah Perry learned to write Ho-Chunk words using syllabary, a practice taught to the Sac and Fox Indians by Jesuit priests and brought into the tribe by a grandfather of Mitchell Redcloud. On each visit to Sandy Plains, WoShipKah would teach Perry ten new Ho-Chunk words and give her a test on the ten previous words. Perry related that her teacher was tough and that she never received a perfect score.

After teaching school for a year at Sandy Plains, Perry taught school in different areas of Wisconsin, received a college degree from Columbia, married, and had two children. In 1939, following the death of her husband, she returned to Black River Falls, a full twenty-five years after her departure. She had not forgotten her interest in Ho-Chunk culture or her friendship with the tribe. After she "stumbled" into a job as the town's librarian, Perry rekindled her friendship with the Ho-Chunk and "started where she left off," collecting "every bit of information" on Ho-Chunk customs, culture, and language. Eventually, she filled more than eight filing cabinet drawers with information.[1]

In a 1986 interview for Wisconsin Public Radio, Perry reminisced about her part in saving a portion of the Winnebago glass plate negatives from Van Schaick's studio. Perry and her friend Flora Thundercloud Funmaker Bear-

heart (WaNekChaWinKah) spent many years identifying the Ho-Chunk in the photographs. They consulted with tribal members and hosted gatherings at the Mission Church where they showed slides made from the glass plates and recorded names. Assisting Perry with the work on the glass plates were Jo Ann Dougherty; Jo Ann's mother, Kathleen Van Gorden; Mildred Evenson; and Jean Anderson, all volunteers from the Jackson County Historical Society.

This group gathered on Tuesdays to clean, sort, and identify the glass plate negatives. They went through the tedious process of matching the negatives to original photographs and slides made from the negatives. The negatives were then placed in protective sleeves and the information was written onto the sleeves. Curiously, when the glass plates arrived at the Wisconsin Historical Society, a number of the identifications had been inverted laterally, from left to right, on the sleeves. According to Jo Ann Dougherty, the group did not realize that during the slide shows many of the slides had been put into the projector backward, reversing the image. The Ho-Chunk would tease that all of the men had jackets buttoned on the wrong side, like a woman's coat.

The identification of Ho-Chunk photographs continued in 1978 with a project funded by a Wisconsin Humanities Grant. The Winnebago Research Center, headed by Anna Rae Funmaker, collected and identified Ho-Chunk family photographs. This group of photographs covered a period from the late 1800s to the 1970s and featured images from amateur and professional photographers, including Charles Van Schaick.

In 1979, the Winnebago Research Center received an eighteen-month grant from the National Endowment for the Arts to collect photographs and documents pertaining to the Ho-Chunk. Janice Rice and others collected and copied the photographs and documents, returning the originals to the families. Copies of these photographs reside at both the Ho-Chunk Nation's Hoocąk Waaziija Haci Language Division in Mauston, Wisconsin, and the Nation's Cultural Resources Division in Black River Falls. At both of these sites the photographs continue to be identified by elders. In early 2008, using the identifications from the Language Division, the Cultural Resources Division, and the Jackson County Historical Society, the authors of this book arranged the photographs according to family.

When research started on the book, less than one-third

of the photographs had been identified. Tom Jones, George Greendeer, and I continued to visit elders in their homes and at Ho-Chunk gatherings to further the identifications and to verify those already identified. This process continued up to the time the book went to press. We also decided to include the Ho-Chunk or clan name along with the English name for each individual in the photographs. In cases where a birth-order name was available but an Indian name was not, the birth-order name was used. Names were researched by examining census and tribal rolls, and every effort was made to locate records for each individual who appears in the book. Where possible, circas were added, based on the year of birth given for individuals in these registers. Ho-Chunk is an oral language, and during the period when Van Schaick was taking photographs, it had not yet been standardized. As such, there were many different ways to spell Ho-Chunk names. We made the decision to use the spelling as it appears on the Ho-Chunk tribal rolls. The names on the rolls were derived from the first Indian censuses and were not consistent in spelling due to non-Ho-Chunk census takers attempting to record them phonetically. We hope the names will facilitate genealogical research and make it easier for people to trace their family back to early documents that refer only to Ho-Chunk names.

The glass plate negatives were rescanned by the Wisconsin Historical Society's Digital Lab at a higher resolution than was possible ten years earlier when they were first digitized. We decided to keep the photographs true to the existing glass plate negatives, only retouching major imperfections that occurred to the glass plates since the time they were created. In order to remain faithful to the original photographs, duotones were created to match the color of Charles Van Schaick's originals. Cropping of the photographs was kept to a minimum, allowing the viewer to see the complete image as it appeared on the glass plate, even though Van Schaick cropped his photographs to fit the dimensions of his cabinet cards and postcards. These images, as well as all of the images in the Van Schaick Collection, are available through the Wisconsin Historical Images website.

The authors have made every effort to correctly identify the individuals in the photographs but there may be errors or omissions. With any project of this size photograph misidentifications can occur due to many different factors.

If you are able to identify any of the unidentified people or have a correction to any of the identifications, please contact the Wisconsin Historical Society Press and they will forward the corrections to the authors. The authors have made a further commitment to this project by continuing to identify the remaining seven hundred Ho-Chunk photographs by Charles Van Schaick through further research and meeting with elders. Our only regret is that we didn't start this project twenty years ago when more elders would have been able to help.

A BOOK LIKE THIS CANNOT HAPPEN without many hands and many voices. Our contributors are many, and our thanks go to many more than those who appear here. The project was aided first and foremost by the tribal elders who helped with identifications and provided family histories to us during the research process. We are indebted to their wisdom and deep knowledge and love of tribal history. Thanks go to elders Sara Abbott, Flora Bearheart, Delphine Blackcoon, Lila Blackdeer, Wilbur Blackdeer, Judith Buffalo, Nina Cleveland, Dorothy Decorah, Margaret Boyce Decorah, Gertrude Duffy, Alvena Foss, Cecil Garvin, Germaine Green, Conroy Greendeer, Elana Greendeer, Lyle Greendeer Sr., Rebecca Greendeer, John Greengrass, Dorothy Holstein, Irvin Funmaker, James Funmaker, Jo Ann Jones, Bette LaMere, Mary Littlegeorge, Henry Littlesoldier, Ann Littlejohn Lonetree, Connie Lonetree, Puss Lonetree, Samuel Lonetree, Annabelle Lowe, Bertha Lowe, Chloris Lowe Sr., Delia Maisells, Richard Mann, Robert Mann, Leona McKee, Owen Mike, Marian Miner, Mary Payer, Rhoda Rave, Merlin Redcloud Sr., Nellie Redcloud, Lucille Roberts, Cecelia Sine, Ellen Rose Snowball, Delphine Swallow, C. Geraldine Swan, Henry Swan, Bernadine Tallmadge, Myrle Thompson, Andrew Thundercloud Jr., Irvin Eugene Thundercloud, Lillian Thundercloud, Raymond Thundercloud, Gloria Visintin, Joyce Warner, Marion Stacy White, Annie Whitefeather, Cynthia Whitewater, Pam Winneshiek, William Winneshiek, Martin Yellowbank, and Eli Youngthunder.

In addition, the authors would like to thank the Hocąk Wajiza Haci Language Division, which provided assistance with the Ho-Chunk language and with translation, especially Cecil Garvin, Toree Jones, Dianne Low, Andrew Thundercloud Jr., and Shane Yellowthunder; the staff at the Jackson County Historical Society, especially Jo Ann Dougherty, Mildred Everson, and Donn Holder; the staff at the Digital Lab at the Wisconsin Historical Society, headed by Visual Materials Curator Andy Kraushaar; and Grant Arndt and Nancy Lurie for scholarly review of the

text. Thanks also go to the late Allen F. Van Schiack and the Van Schaick family for their financial support and commitment to bringing this project to fruition, and to the Wisconsin Historical Society Press for their careful attention to and development of this project.

Tom Jones would like to thank Shaun Miller and Andrea Brdek for their time and dedication to the research conducted for the book, and Christine DiThomas, Nancy Goldenberg, Jo Ann Jones, Nancy Mithlo, and Judy Natal for reviewing portions of the manuscript. Mike Schmudlach would like to thank Ken Funmaker Sr., Jim and Virginia Smith, Arvina Thayer, and Chief Michael Winneshiek for their mentorship, as well as John Slone of Mills Music Library for research assistance and Kevin Schmudlach for data entry. Matthew Daniel Mason would like to thank Mary I. Woods of the Black River Falls Public Library, former Black River Falls resident Gary Allen Hoonsbeen, and David Benjamin, Visual Materials Curator at the Wisconsin Historical Society. He is also grateful for financial support from the American Historical Association in the form of the Albert J. Beveridge Grant for Research in the History of the Western Hemisphere. Amy Lonetree would like to thank the Lonetree and Littlejohn families; Jon Daehnke, Denise Breton, and Renya Ramirez for writing and editing assistance on her essay; and Don Blackhawk and Loretta Whitman Lonetree for guidance in early research. She is also grateful for faculty research funds granted by the University of California, Santa Cruz, and for a Visiting Scholar Award from the Institute of American Cultures at the University of California, Los Angeles.

Michael Schmudlach for the Authors

APPENDIX

HO-CHUNK NAMING CUSTOMS

THE HO-CHUNK NAMES listed in the captions for the photographs in this collection are taken from the Ho-Chunk tribal rolls and the United States Indian censuses taken from 1885 to 1940.[1] The names are written as they appear in the official documents. Because Ho-Chunk is an oral language, and the names were written down by white officials unfamiliar with Ho-Chunk sounds who tried to spell them phonetically, the spelling of the names is not always consistent. For example, members of the "Hensley" family might be listed as "Hindsley" elsewhere. Birth-order names may also deviate from the spellings listed below.

Most Ho-Chunk have three names: a birth-order name, an English name, and a Ho-Chunk or clan name. In many cases both the English name and the Ho-Chunk name or birth-order name were recorded; in others, only a Ho-Chunk name, birth-order name, or English name was listed. Some of the Ho-Chunk who returned to Wisconsin after 1900 never had an Indian name recorded.

Each Ho-Chunk child is given a name at birth according to birth order and gender. Birth-order names are used from birth through adulthood by immediate family and close friends. Those outside this circle use the Ho-Chunk name. Today, the English name is used most often, but traditional Ho-Chunk will still use Ho-Chunk names. If at a family gathering there were too many men named Kųųnų (first son), a clan name would be added to the birth-order name or the person might be addressed by a nickname to avoid confusion.

ENGLISH EQUIVALENT	CENSUS ROLLS	COMMON SPELLING	CURRENT SPELLING
First son	CooNooKah*	Kunu	Kųųnų
Second son	HaNaKah	Hana	Heeną
Third son	HaGaKah	Haga	Haaga
Fourth son	NaHiKah	Nanxi	Nąąǧi
Fifth son	**	Nanxixonu	Nąąǧixųųnų
Sixth son	**	Nanxixonuninka	Nąąǧixųųninik
First daughter	ENooKah*	Hinu (Henu)	Hiinų
Second daughter	WeHunKah	Wiha (Weha)	Wiihą
Third daughter	UkSeUkKah	Aksi-a (Siga)	Haksiiga (Siiga)
Fourth daughter	HeNaGaKah	Hinunk	Hinąąke (Hinake)
Fifth daughter	AkSeKahHoNoKah	Aksogaxonu	Haksiigaxųnų (Haksiiga)
Sixth daughter	ENooKahHooNooKah	Aksigaxonuninka	Hinąkexųnų (Hinąke)

*In currant usage, the "Kah" at the end of the name is used as a verbal reference but not in direct address, and is no longer written because it is assumed. It also appears as "Gah" and "Kaw" (the Nebraska spelling) in the captions.
**We did not locate instances of fifth or sixth son in the censuses.

258

The Ho-Chunk name or clan name is generally given to a person once he or she is old enough to walk. Traditionally, a father brings a gift of tobacco and food to a clan elder. The elder then considers which clan name from an inventory was most fitting and names the child. A special feast was given for the occasion, or it would be announced at a war bundle feast.

It is difficult to make an accurate translation of a clan name into English because the name has a much fuller meaning than its literal translation. This meaning was explained to the recipient and the family by the elder giving the name.

When the censuses and Indian rolls were created, English names were derived from the translation of Indian names by the early Indian agents and census takers. When the male head of the household went to register his family, the interpreter would ask the person their name and then try to translate it to English. If the translation was "Green Grass," the name would be recorded as such. The other members of his family would then be given a first name, and *Greengrass* would become the family name. These surnames formed the first Indian censuses and tribal rolls and were used to determine allotment payments and tribal registry. The names are still in use today.

NOTES

A Long View
by Matthew Daniel Mason

1. For the professional and personal life of Van Schaick and a history of his collection, I examined decades of issues from Black River Falls newspapers. Publications consulted include the *Badger State Banner* [later *Banner-Journal*] (Black River Falls, Wisconsin), 1873–1974; *The Jackson County Journal* (Black River Falls, Wisconsin), 1886–1926; and the *Black River Falls Wisconsin Independent* (Black River Falls, Wisconsin), 1872–1888. For genealogical information, I consulted a variety of resources, including federal and state censuses and state vital records. For individual sources, as well as a detailed biography of Charles Van Schaick, his immediate family, colleagues, and use of his imagery, see Matthew Daniel Mason, "A Partial Presentation of the Past: A Critical Examination of *Wisconsin Death Trip*" (Ph.D. diss., University of Memphis, 2008).

2. For a discussion of individual schools, see Citizenship and International Committee of the Jackson County Association of the Home and Community Education, *Schools of Yesterday in Jackson County, Wisconsin: A Collection of Memorabilia* (Black River Falls, Wisconsin: Jackson County Association of the Home and Community Education, 1997), esp. 53, 93.

3. For a brief discussion of backdrops, see Avon Neal, "Folk Art Fantasies: Photographer's Backdrops," *Afterimage* (March–April 1997): 12–18.

4. For a contemporary description of Ho-Chunk annuities, see Reuben Gold Thwaites, "The Wisconsin Winnebagoes: An Interview With Moses Paquette, by the Editor," in *Collections of the State Historical Society*, vol. 12, ed. Reuben Gold Thwaites (Madison, Wisconsin: Democratic Printing Company, 1892), 399–433, esp. 420–421. Moses Paquette (born 1828) was a mixed-ancestry member of the Ho-Chunk Nation and a government interpreter.

5. For a discussion of the development of film negatives, see William Welling, *Photography in America: The Formative Years, 1839–1900* (New York: Thomas Y. Crowell Company, 1978), 321–326.

6. For an account of the flood and reminiscences by survivors, see Marie Anne Olson, *Black Friday: The Flood of October 6, 1911 in Black River Falls, Wisconsin* (Black River Falls, Wisconsin: Block Printing, 1987).

7. These photographic prints comprise PH 3469 in the Charles J. Van Schaick Collection, Library—Archives Division, Wisconsin Historical Society, Madison, Wisconsin.

8. Van Schaick had four children. A daughter, Florence Van Schaick (1892–1893), died of consumption (pulmonary tuberculosis) in infancy. His eldest son, Shirley Delaney Van Schaick (1885–1960), worked for the American Railway Express Company in Milwaukee, Wisconsin. His two other sons were medical doctors. Roy Edson Van Schaick (1887–1956) operated an independent medical practice in Marion, Wisconsin, while Harold Dean Van Schaick (1889–1969) was chief surgeon for the Florida East Coast Railway Hospital in Saint Augustine, Florida, as well as a president of the Florida State Board of Medical Examiners.

9. Michael Lesy, *Wisconsin Death Trip* (New York: Pantheon Books, 1973).

10. For a detailed critique of Lesy's work, see Mason, "A Partial Presentation," esp. p. 132 ff.

11. Michael Lesy, "Wisconsin Death Trip," *Quixote* 6, no. 6 (Winter 1971–1972), n.p.

12. For a description of this montage, see Mason, "A Partial Presentation," 450.

13. George Greendeer provided this information about photographic postcards based on a conversation with his maternal grandmother, Puss (White) Lonetree.

14. Steven D. Hoelscher discusses Bennett's images of Ho-Chunk and the marketing of the Wisconsin Dells in *Picturing Indians: Photographic Encounters and Tourist Fantasies in H. H. Bennett's Wisconsin Dells* (Madison: University of Wisconsin Press, 2008). The Denver Public Library purchased the collection of David Barry's original glass negatives in 1937. See Denver Public Library, *David F. Barry Catalog of Photographs* (Denver, Colorado: Denver Public Library, Western History Department, 1961).

15. For a concise overview of photographers of American Indians, see Alfred L. Bush and Lee Clark Mitchell, *The Photograph and the American Indian* (Princeton, New Jersey: Princeton University Press, 1994). For an excellent example of a collection of images depicting a Native group in the greater Midwestern region, see Bruce M. White, *We Are at Home: Pictures of the Ojibwe People* (St. Paul: Minnesota Historical Society Press, 2007), which explores formal and informal portraits of Ojibwe from the advent of photography through 1950.

16. Paul Radin wrote many works on the Ho-Chunk, including "Autobiography of an American Indian," *University of California Publications in Archaeology and Ethnology* 16, no. 7 (April 1920): 381–473, later reprinted and expanded as *Crashing Thunder: The Autobiography of an American Indian*, ed. Paul Radin (New York and London: Appleton and Co., 1926); and "The Winnebago Tribe," in *Annual Report of the Bureau of American Ethnology to the Secretary of the Smithsonian Institution. 1915–1916* (Washington, D.C.: Government Printing Office, 1923), 35–560, and 58 pages of plates.

17. Alan Trachtenberg, "The Group Portrait," in *Multiple Exposure: The Group Portrait in Photography*, eds. Leslie Tonkonow and Alan Trachtenberg (New York: Independent Curators Incorporated, 1995), 17.

18. Roddy had a number of traveling shows featuring members of the Ho-Chunk Nation, and their exploits were often reported in the local newspapers; see "The Winnebagoes at the New York Fair," *Badger State Banner* (June 22, 1893): p. 4, c. 4.

Visualizing Native Survivance

by Amy Lonetree

1. The Charles Van Schaick Collection that I examined in 1993 at the Jackson County Historical Society was moved to the Wisconsin Historical Society (WHS) in 1994. The Jackson County Historical Society Board approved the donation of the negatives to WHS in April 1994, and the move happened in May 1994.

2. The concept of survivance is widely used in the field of Native American Studies, and I feel it is an appropriate term to use when describing Ho-Chunk history. While Gerald Vizenor has offered definitions of the term in various publications, this quote is taken from Vizenor, *Fugitive Poses: Native American Indian Scenes of Absence and Presence* (Lincoln: University of Nebraska Press, 1998), 15.

3. Hulleah Tsinhnahjinnie, "Indigenous and Ethnic Representations in Film" (panel presentation at the Documents of an Encounter: Edward Curtis and the Kwakwaka'wakw First Nation, Getty Museum, Los Angeles, California, June 2, 2010).

4. In 1993, a United Nations Commission defined ethnic cleansing as "the planned deliberate removal from a specific territory, persons of a particular ethnic group, by force or intimidation, in order to render that area ethnically homogenous," as quoted in Cathie Carmichael, *Ethnic Cleansing in the Balkans: Nationalism and the Destruction of Tradition* (London and New York: Routledge, 2002), 2. This definition certainly fits the removal of Native Americans from their homelands that occurred throughout the United States during the nineteenth century. Historian Gary Clayton Anderson also uses the term to describe the history of white–Native relations in the nineteenth century. Though he stops shy of referring to this as genocide, he does feel that the history of Texas fits the definition of ethnic cleansing. He states, "I argue, however, that the situation in Texas fails to rise to the level of genocide, if genocide is defined as the intentional killing of nearly all of a racial, religious, or cultural group. . . . Rather, Texans gradually endorsed (at first locally and eventually statewide) a policy of ethnic cleansing that had as its intention the forced removal of certain culturally identified groups from their lands." Gary Clayton Anderson, *The Conquest of Texas: Ethnic Cleansing in the Promised Land, 1820–1875* (Norman: University of Oklahoma Press, 2005), 7.

5. Jason Tetzloff, "The Diminishing Winnebago Estate in Wisconsin: From White Contact to Removal" (M.A. thesis, University of Wisconsin–Eau Claire, 1991), 1.

6. Thomas Forsyth to William Clark, 10 June 1828, as quoted in Lucy Eldersveld Murphy, "Autonomy and the Economic Roles of Indian Women of the Fox–Wisconsin Riverway Region, 1763–1832," in *Negotiators of Change: Historical Perspectives on Native American Women*, ed. Nancy Shoemaker (New York: Routledge, 1995), 84.

7. Lucy Eldersveld Murphy, *A Gathering of Rivers: Indians, Metis, and Mining in the Western Great Lakes, 1737–1832* (Lincoln: University of Nebraska Press, 2000), 130.

8. Thank you to Grant Arndt for providing clarifying information on Red Bird's acts of resistance during this period. Grant Arndt, email message to author, January 7, 2011.

9. Tetzloff, 59.

10. As quoted in Lucy Eldersveld Murphy, "Autonomy and the Economic Roles of Indian Women of the Fox–Wisconsin Riverway Region, 1763–1832," 86.

11. Nancy Oestreich Lurie, "Winnebago," in *Handbook of North American Indians*, ed. Bruce Trigger (Washington, D.C.: Smithsonian Institution Press, 1978), 698.

12. Nancy Lurie, email message to author, December 14, 2010.

13. Grant Arndt, "No Middle Ground: Ho-Chunk Powwows and the Production of Social Space in Native Wisconsin" (Ph.D. diss., University of Chicago, 2004), 137.

14. As quoted in Mark Diedrich, compiler, *Winnebago Oratory: Great Moments in the Recorded Speech of the Ho-Chungra, 1742–1887* (Rochester, Minnesota: Coyote Books, 1991), 58.

15. Tetzloff, 89.

16. Arndt, 145.

17. This passage is quoted in several sources. See Arndt, 145; Lawrence Onsager, "The Removal of the Winnebago Indians from Wisconsin in 1873–74," (M.A. thesis, Loma Linda University, 1985), 58; and Steven Hoelscher, *Picturing Indians: Photographic Encounters and Tourist Fantasies in H. H. Bennett's Wisconsin Dells* (Madison: University of Wisconsin Press, 2008), 58. Originally quoted in John T. De La Ronde, "Personal Narrative," *Report and Collections of the State Historical Society of Wisconsin* 7 (1876): 345–365.

18. Arndt, 146; De La Ronde, 363; Onsager, 58.

19. As quoted in Diedrich, 69.

20. On the attempts by Ho-Chunk leaders to negotiate for a new reservation and leave the Long Prairie reservation, see Edward J. Pluth, "The Failed Watab Treaty of 1853," *Minnesota History* 57 (Spring 2000): 2–22.

21. As quoted in Diedrich, 73.

22. "The Knights of the Forest: A Chapter of Secret History," *Mankato Daily Review*, April 27, 1886.

23. As quoted in Charles A. Chapman, "Secret Society of the Early Days in Mankato," *Mankato Daily Review*, April 18, 1916.

24. As quoted in Diedrich, 89.

25. The following quote was relayed to Thomas Hughes by John Blackhawk and published in Thomas Hughes, *Indian Chiefs of Southern Minnesota: Containing Sketches of the Prominent Chieftains of the Dakota and Winnebago Tribes from 1825 to 1865* (1927; reprint, Minneapolis: Ross and Haines, Inc., 1969), 179.

26. As quoted in Diedrich, 92.

27. Hoelscher, 58.

28. In Article II, the Ho-Chunk Constitution outlines membership requirements: "(a) All persons of Ho-Chunk blood whose name appears or are entitled to appear on the official census roll prepared pursuant to the Act of January 18, 1881 (21 Stat. 315), or the Wisconsin Winnebago Annuity Payroll for the year one thousand nine hundred and one (1901), or the Act of January 20, 1910 (36 Stat. 873), or the Act of July 1, 1912 (37 Stat. 187); or (b) all descendents of persons listed in Section 1(a), provided, that such persons are of at least one-fourth (¼) Ho-Chunk blood. . . ."

Ho-Chunk Nation Official Government Website, "Constitution of the Ho-Chunk Nation," http://www.ho-chunknation.com/?PageId=180#art_2 (accessed July 10, 2010).

29. This information is provided on the Wisconsin Historical Society website's description of Wisconsin Historic Image 64283, which can be accessed through "Wisconsin Historic Images" at http://www.wisconsinhistory.org/whi/.

30. Frederick E. Hoxie, Peter C. Mancall, and James H. Merrell, "Cultural and Political Transformations, 1900–1950," in *American Nations: Encounters in Indian Country, 1850 to the Present*, ed. Frederick E. Hoxie, Peter C. Mancall, and James H. Merrell (New York: Routledge, 2001), 263.

VETERANS

1. Undated, Henry Roe Cloud writings, Woesha Cloud North files, in possession of Dr. Renya Ramirez.

HOW THIS BOOK CAME ABOUT
by Michael Schmudlach

1. Interview with Frances Perry of Black River Falls, Wisconsin, recorded by Robert Andresen on January 17, 1986, and broadcast on "Northland Hoedown" on April 26, 1986, on Wisconsin Public Radio.

APPENDIX

1. The United States Indian Census, taken from 1885 to 1940, is held at the National Archives in Washington, D.C., and is available on microfilm or online at Ancestry.com. The Ho-Chunk tribal rolls, which are taken from the United States Indian Census, are held by the Ho-Chunk Nation in the Department of Tribal Enrollment. The rolls are used today to determine whether a person can be registered with the Ho-Chunk tribe. Tribal requirements specify that a person must be a minimum of one-quarter Ho-Chunk to be registered, regardless of any other Indian lineage.

ABOUT THE AUTHORS

Tom Jones (ChakShepSkaKah) (White Eagle) is an enrolled member of the Ho-Chunk Nation and an assistant professor of photography at the University of Wisconsin–Madison. He received his MFA in photography and an MA in museum studies from Columbia College in Chicago. Tom has been working on an ongoing photographic essay on the contemporary life of the Ho-Chunk and hopes to give both the tribe and the outside world a perspective from someone who comes from within the Ho-Chunk community. His work continues an ongoing examination of how early photographs of Native Americans taken by people from outside their society have affected the perceptions of Native American culture. Tom's work may be found in the collections of the National Museum of the American Indian, the Polaroid Corporation, the Sprint Corporation, the Chazen Museum of Art, the Nerman Museum, and the Michigan State University Museum.

Michael Schmudlach (WeeMauHaKah) serves on the Wisconsin Historical Society's Board of Curators. He majored in history and construction administration at the University of Wisconsin–Madison and followed in his father's footsteps, becoming a general contractor specializing in custom building and historic preservation. Mike's association with the Ho-Chunk started at the age of twelve, when he became friends with a few Ho-Chunk boys and their families. Starting in his teenage years, he spent his weekends participating in powwows as a dancer and then as a singer with various drum groups. After over forty years of friendship with the Ho-Chunk, one of his favorite activities is learning and listening to traditional Ho-Chunk songs.

Matthew Daniel Mason is an archivist chiefly responsible for processing collections of photographs and other visual resources at the Beinecke Rare Book and Manuscript Library at Yale University. He has also worked in archives at the Wisconsin Historical Society and at Montana State University and received a PhD in history from the University of Memphis and an MA from the University of Wisconsin–Madison School of Library and Information Studies. In addition to his archival work, Matthew teaches courses in history and the history of photography at Quinnipiac University in Hamden, Connecticut, as well as writing reviews of works on photography, art, and architecture for several academic journals and presenting professional papers on the history of photography and photographic archives.

Amy Lonetree (MaHiSkaMonEWinKah) (Walking on White Cloud) is an enrolled citizen of the Ho-Chunk Nation and an assistant professor of American studies at the University of California, Santa Cruz. Her scholarly work focuses on the representation of Native American history and memory in national and tribal museums, and she has published articles in the *Public Historian*, *American Indian Quarterly*, and the *Journal of American History*. She is also coeditor with Amanda J. Cobb of *The National Museum of the American Indian: Critical Conversations* (University of Nebraska Press, 2008). Amy is finishing a manuscript that explores the complexities of the changing historical relationship between Indigenous people and museums, and the potential for museums to serve as sites of decolonization. Her research agenda beyond the museum project includes working on a series of publications focusing on twentieth-century Ho-Chunk history.

George Greendeer (HoXingKah) (Deer Image in the Morning Mist) is an enrolled member of the Ho-Chunk Nation and a graduate of the Institute of American Indian Arts in two- and three-dimensional art. For eighteen years George was employed in different positions in the Office of Tribal Enrollment for the Ho-Chunk Nation. He has been the tribal genealogist from 2000 to the present. During his early years in the Office of Tribal Enrollment, George visited elders for assistance with Indian names, clan affiliations of Indian names, oral family histories, and family relationships.

IMAGE CREDITS

Unless otherwise identified, photographs identified with WHi are from the Charles Van Schaick Collection at the Wisconsin Historical Society. Please address requests to produce these photos to the Visual Materials Archivist at the Wisconsin Historical Society, 816 State Street, Madison, WI 53706, or by visiting www.wisconsinhistory.org/whi/.

A LONG VIEW
by Matthew Daniel Mason

Page 2 Amelia Janes, Earth Illustrated, Inc.; **page 3** WHi 46121; **page 4** WHi 42283; **page 5 (top)** Andy Kraushaar, **(middle)** WHi 48021, **(bottom)** WHi 56299; **page 6** Jackson County Historical Society; **page 8 (left)** WHi 28952, **(right)** WHi 29152; **page 10** Jackson County Historical Society; **page 12** WHi 60777.

VISUALIZING NATIVE SURVIVANCE
by Amy Lonetree

Page 15 Amelia Janes, Earth Illustrated, Inc.; **page 17** Amelia Janes, Earth Illustrated, Inc.; **page 20 (left)** WHi 64283, **(right)** WHi 61278; **Page 21 (left)** WHi 60816, **(right)** WHi 60823.

A HO-CHUNK PHOTOGRAPHER LOOKS AT CHARLES VAN SCHAICK
by Tom Jones

Page 24 WHi 61263; **page 25** WHi 42289; **page 26 (left)** Tom Jones's Collection, **(right)** WHi 60862; **page 28 (top left)** Jackson County Historical Society, **(bottom left)** WHi 63926, **(bottom right)** WHi 63929; **page 29 (top)** WHi 46155, **(bottom)** WHi 10151; **page 30 (left)** WHi 63781, **(right)** WHi 63594; **page 31** WHi 63920.

FAMILIES AND KINSHIP

Page 34 WHi 61207; **page 36** WHi 61113; **page 37** WHi 61326; **page 38** WHi 61170; **page 39** WHi 61167; **page 40 (top left)** WHi 61173, **(top right)** WHi 61341; **(bottom left)** WHi 62297; **page 41** WHi 63246; **page 42** WHi 63591; **page 43** WHi 64256; **page 44** WHi 65692; **page 45** WHi 61088; **page 46 (top left)** WHi 61077,

(top right) WHi 61074, **(bottom left)** WHi 61079; **page 47** WHi 61255; **page 48** WHi 24677; **page 49 (top left)** WHi 61424, **(top right)** WHi 61071, **(bottom left)** WHi 61738; **page 50** WHi 64283; **page 51** WHi 61591; **page 52 (top left)** WHi 62302, **(top right)** WHi 62315, **(bottom left)** WHi 61354; **page 53** WHi 60890; **page 54 (left)** WHi 60881, **(right)** WHi 61318; **page 55 (top)** WHi 64285, **(bottom)** WHi 64259; **page 56 (top left)** WHi 61431, **(top right)** WHi 62330, **(bottom left)** WHi 62321; **page 57** WHi 60938; **page 58 (left)** WHi 61271, **(right)** WHi 60696; **page 59** WHi 60712; **page 60** WHi 60809; **page 61 (top left)** WHi 61269, **(top right)** WHi 60811, **(bottom left)** WHi 61313; **page 62** WHi 62835; **page 63** WHi 60713; **page 64** WHi 60710; **page 65** WHi 60693; **page 66 (left)** WHi 60715, **(right)** WHi 61912; **page 67** WHi 60897; **page 68** WHi 60823; **page 69** WHi 61503; **page 70** WHi 61207; **page 71 (left)** WHi 62202, **(right)** WHi 61429; **page 72** WHi 60862; **page 73** WHi 61496; **page 74** WHi 61333; **page 75** WHi 60816; **page 76 (left)** WHi 60636, **(right)** WHi 60637; **page 77 (top left)** WHi 60613, **(top right)** WHi 61493, **(bottom left)** WHi 61790; **page 78** WHi 61206; **page 79** WHi 62231; **page 80 (top left)** WHi 61264, **(top right)** WHi 63037, **(bottom left)** WHi 61055; **page 81** WHi 61331; **page 82** WHi 60962; **page 83 (top left)** WHi 63042, **(top right)** WHi 61051, **(bottom left)** WHi 60967; **page 84** WHi 63043; **page 85** WHi 64287; **page 86** WHi 63457; **page 87** WHi 63044; **page 88** WHi 63337; **page 89 (left)** WHi 61704, **(right)** WHi 62226; **page 90** WHi 60605; **page 91 (top left)** WHi 61531, **(top right)** WHi 62296, **(bottom left)** WHi 62091.

VETERANS

Page 92 WHi 60910; **page 94** WHi 60634; **page 95 (left)** WHi 60913, **(right)** WHi 60575; **page 96** WHi 60910; **page 97** WHi 62877; **page 98 (top)** WHi 62916, **(bottom)** WHi 63016; **page 99** WHi 62945; **page 100** WHi 61948; **page 101** WHi 64315.

POWWOWS

Page 102 WHi 3692; **page 105** WHi 64073; **page 106 (top)** WHi 3692, **(bottom)** WHi 63901; **page 107 (top)** WHi 64079, **(bottom)** WHi 63899; **page 108 (top)** WHi 63873, **(bottom)** WHi 63708;

page 109 (top) WHi 3696, (bottom) WHi 63867; page 110 (left) WHi 61277, (right) WHi 62834; page 111 (top) WHi 48021, (bottom) WHi 49570; page 112 (top) WHi 3691, (bottom) WHi 64123; page 113 (top) WHi 63895, (bottom) WHi 64325.

Religion and Clans

Page 114 WHi 63759; page 116 (top) WHi 63759, (bottom) WHi 63782; page 117 (top) WHi 63762, (bottom) WHi 62455; page 118 WHi 62187; page 119 WHi 61315.

Housing and Work

Page 120 WHi 64099; page 122 (top) WHi 64168, (bottom) WHi 62829; page 123 (top) WHi 64091, (bottom) WHi 64086; page 124 (top) WHi 64099, (bottom) WHi 64096; page 125 (top) WHi 64093, (bottom) WHi 64092; page 126 (top) WHi 24507, (bottom) WHi 63713; page 127 (top left) WHi 63760, (top right) WHi 64126, (bottom left) WHi 64171; page 128 WHi 62475; page 129 (top) WHi 64130, (bottom) WHi 41991; page 130 (top) WHi 63335, (bottom) WHi 63786; page 131 (top) WHi 63785, (bottom) WHi 63783.

Traditional and Contemporary Dress

Page 132 WHi 65713; page 135 WHi 60905; page 136 WHi 61625; page 137 WHi 61436; page 138 WHi 63697; page 139 WHi 63402; page 140 WHi 62078; page 141 WHi 60782; page 142 WHi 60837; page 143 WHi 61618; page 144 WHi 60603; page 145 WHi 61210; page 146 (left) WHi 62918, (right) WHi 61432; page 147 WHi 60665; page 148 WHi 60607; page 149 (left) WHi 62093, (right) WHi 63375; page 150 (left) WHi 61361, (right) WHi 63050; page 151 (left) WHi 61778, (right) WHi 61599; page 152 WHi 63387; page 153 WHi 63400; page 154 WHi 61437; page 155 WHi 61702; page 156 (left) WHi 62038, (right) WHi 63526; page 157 (left) WHi 27881, (right) WHi 61787; page 158 WHi 63532; page 159 WHi 64317; page 160 WHi 65713; page 161 WHi 61184; page 162 WHi 62303; page 163 (top left) WHi 61619, (top right) WHi 64255, (bottom left) WHi 62271; page 164 (top left) WHi 61324, (top right) WHi 62408, (bottom left) WHi 62299; page 165 (top left) WHi 63644, (top right) WHi 61620, (bottom left) WHi 62092; page 166 WHi 63238; page 167 WHi 60944; page 168 (left) WHi 63541, (right) WHi 60586; page 169 (left) WHi 61594, (right) WHi 62891; page 170 WHi 61513; page 171 WHi 64254; page 172 (top) WHi 60699, (bottom) WHi 60687; page 173 (left) WHi 61703, (right)

WHi 63228; page 174 WHi 2313; page 175 WHi 62081; page 176 WHi 61276; page 177 (top left) WHi 62073, (top right) WHi 60947, (bottom left) WHi 60759; page 178 WHi 61589; page 179 WHi 60606; page 180 WHi 62334; page 181 WHi 62476; page 182 WHi 61247; page 183 WHi 60610; page 184 (left) WHi 63453, (right) WHi 61954; page 185 (top left) WHi 61198, (top right) WHi 60899, (bottom left) WHi 60827; page 186 WHi 62926; page 187 WHi 61068; page 188 WHi 60770; page 189 WHi 60611; page 190 WHi 60655; page 191 (top left) WHi 60659, (top right) WHi 61419, (bottom left) WHi 47463; page 192 WHi 60706; page 193 WHi 60704; page 194 WHi 61358; page 195 WHi 61600; page 196 WHi 62265; page 197 WHi 61616; page 198 (left) WHi 60514, (right) WHi 60516; page 199 (left) WHi 62002, (right) WHi 61272; page 200 WHi 62880; page 201 WHi 61720; page 202 (top left) WHi 60801, (top right) WHi 61647, (bottom left) WHi 61536; page 203 (top left) WHi 60934, (top right) WHi 61997, (bottom left) WHi 61640; page 204 WHi 61434; page 205 WHi 62319; page 206 WHi 60879; page 207 WHi 62335; page 208 WHi 61957; page 209 WHi 61550; page 210 WHi 60646; page 211 WHi 60648; page 212 (top left) WHi 60567, (top right) WHi 61538, (bottom left) WHi 61534; page 213 (left) WHi 47454, (right) Ho-Chunk Nation–Cultural Resources; page 214 (left) WHi 63448, (right) WHi 63021; page 215 (left) WHi 61209, (right) WHi 63240; page 216 WHi 60901; page 217 WHi 63243; page 218 (top left) WHi 47457, (top right) WHi 63223, (bottom left) WHi 63232; page 219 (left) WHi 60769, (right) WHi 60904; page 220 WHi 61642; page 221 WHi 64261; page 222 WHi 60663; page 223 (top left) WHi 62307, (top right) WHi 61267, (bottom left) WHi 60788; page 224 WHi 60614; page 225 WHi 60142; page 226 WHi 61314; page 227 WHi 60766; page 228 WHi 62080; page 229 (left) WHi 60661, (right) WHi 61788; page 230 WHi 60604; page 231 WHi 61791.

Children

Page 232 WHi 63979; page 234 WHi 76694; page 235 (left) WHi 63979, (right) WHi 63976; page 236 WHi 64066; page 237 WHi 63984; page 238 WHi 64065; page 239 (top left) WHi 60579, (top right) WHi 63952, (bottom left) WHi 64144; page 240 WHi 63988; page 241 WHi 63637; page 242 (left) WHi 62478, (right) WHi 61202; page 243 (left) WHi 61781, (right) WHi 60911; page 244 WHi 63048; page 245 WHi 9385; page 246 (left) WHi 62162, (right) WHi 60714; page 247 (left) WHi 62172, (right) WHi 61546; page 248 WHi 63242; page 249 (left) WHi 63986, (right) WHi 61191; page 250 WHi 62828; page 251 WHi 57003.

NAME INDEX

Dandy, 17

Davis, Ellen (AhHooChoWinKah), 69

Davis, John (KaRoJoSepSkaKah), 29, *29*, *112*

Davis, Lavina (UkSuUkKah), *211*

Davis, Minnie Pigeon Whiteotter Blowsnake (AhHooKeShelNWinKah), *195*, *196*

De La Ronde, John T., 18

Decorah, David, 115

Decorah, Dora Whitefeather (HoHaWinKah), 66

Decorah, Jennie Youngthunder (PetHakCha-CooWinKah), *56*, *185*

Decorah, Lucy (AhHoRaPaNeeWinKah), *150*, *202*, *229*

Decorah, Mary L. (HoChumLaWinKah), *196*

Decorah, Nellie Windblow (HaWePinWin-Kah), 47

Decorah, Spoon, 16

Decorra, David Davis W. (NeZhooLaChaHe-Kah), *54*, *207*

Decorra, Jim, 103

Deer, Mary May Thundercloud (WaNeekPi-WinKah), *49*

Dick, John (DoWjhGeNaNoKah), *222*

Dick, Mary Manly-Mallory (HaJaKeePaNa-WinKah), *222*

Dougherty, Jo Ann, 256

Eagle, Adam, 256

Eagle, Agnes (HaHumpAWinKah), 78

Eagle, Bernard (NaHeKah), 256

Eagle, Charlie (HoWaHoNoNeeKah), 256

Eagle, Eunice (Ethyl) (PatchKaReWinKah), 256

Eagle, George (WaNaKeeScotchKah), *106*

Eagle, Kate (WoJayWinKah), *147*

Eagle, Mary (ChaUkShePaRooEWinKah), *95*

Eagle, Minnie (Edna) (DaScootchWinKah), *147*

Eagle, Sue (WaKonCheWinKah), 256

Elk, Carrie (ENooKah), 11, *172*, *173*

Elk, Lucy, 172

Evenson, Mildred, 256

Fairbanks, Mary Littlejohn (WeHunKah), 21, *21*, *75*

Falcon, John (NaHeKah), *79*

Forsyth, Thomas, 16

Fourcloud, *200*

French, Sarah (Ellen Davis) (AhHooCho-WinKah), *69*

Funmaker, Anna Rae, 256

Funmaker, Edward (WaGeSeNaPeKah), 58, 59, 61, *223*

Funmaker, George Jr. (HoonkMeNukKah), 28

Funmaker, George Sr. (WojhTchawHeRay-Kah), 24–25, *24*, 28, *28*

Funmaker, Harry (HaGaChaCooKah), 52

Funmaker, Hilda Alice Stacy (HoWaCho-NeWinKah), 89

Funmaker, Jim (HaHayMonEKah), 24, 27–28, *28*

Funmaker, Kenneth Sr., 104

Funmaker, Mamie (Minnie) Bearchief (HoHumpCheKaRaWinKah), 56, 58, *198*

Garvin, George Sr. (WoShipKah), *127*, 256

Goodbear, Flora Miner (WaNikPeWinKah), *149*

Goodvillage, David (WauHeTonChoEKah), 30, *31*, *112*

Goodvillage, Will (Willy) (MaHayEKeRe-NaKah), *227*

Green (Snake), Dora Monegar Wallace (ChePinChayWinKah), *163*, *172*, *221*

Green (Snake), Martin (KeeMeeNunkKah), 5, 11, *111*, *163*, *221*

Green, Nina Thunder Decorah (AhHooGe-NaWinKah), *118*

Green Grass (HaWinChoKah), *63*, *66*, *158*

Greencloud, John "Green Thunder" (WauKonChawChoKah), 93, *98*

Greencloud, Kate, 83

Greencloud-Redcloud, Frank (NotchKeTa-Kah), *168*

Greencrow, Belle Blackhawk Monegar Cassiman (AwHooSuchRayWinKah), *219*

Greencrow, Belle Hall (AhHooSkaWinKah), *192*, *193*, *202*

Greencrow, Charles, *219*

Greencrow, Henry (CooNooZeeKah), *110*, *112*, *164*, *192*, *193*, *225*

Greendeer, George, 253, 255–256, 257

Greendeer, Will (ChaWakJaXiGah), *213*

Greengrass, Charlie (HoeHumpChee-KayRayHeKah), *81*, *143*, *164*, *225*

Greengrass, Daniel, 239

Greengrass, Dora Decorra (HoHaWinKah), *213*

Greengrass, Dorothy, 66, 77

Greengrass, Ed (CheWinCheKayRayHeKah), *62*, *80*, *168*

Greengrass, Edwin (Ed Jr.) (HoonkSepKah), *249*

Greengrass, Emma Lookingglass (ChayHe-HooNooKah), 10, *64*, *65*

Greengrass, George (WauKeCooPeRayHe-Kah), *64*, *65*, *112*

Greengrass, Robert (HoNutchNaCooMee-Kah), 20, 66

Greenly, Hiram B., 2

Grizzlybear, Edna, *56*

Gull, 18

Hall, Annie Lizzie Falcon Brown Whitedog (DasChuntAWinKah), *229*

Hall, William (HunkKah), *112*, *164*, *225*

Hanakah, James George (PaitchDoAhHe-Kah), *188*

Hanson, William (HoonchHoNoNikKah), *112*

Hauser, Jacob, 115

Henry, Albert (HahNahKah), *163*

Henry, Albert (Robert) (HeKeMeGa), *172*

Henry, Elias, 74

Henry, Mark, 74

Henry, Martha, *163*

Hicks, E. R., 28

Highsnake, John (NaukSheNeeKah), *112*

Hill, Henry Rice (SanJanMonEKah), *96*

Hill, John Hazen (XeTeNiShaRaKah), *51*, 93, 97, 103, *112*

Hill, Mary, 20

Hindsley (Hensley), William (CooNooCho-NeeNikKah), *112*, *141*, *197*

Hindsley, George (AhoShipKah), 12

Hindsley, Henry (MaHePeWinKah), *136*

Hindsley, Mary Goodvillage (ChoWasSka-WinKah), *136*, *197*

Holder, Donn, 13, 255

Holt, Emma Blackhawk Bigbear Beaver-Smith (Female Yellowthunder) (WauKonChawZeeWinKah), *230*

Hopkinah, Alice Mary Blackdeer (Nautch-GePinWinKah), *184*

Hunker, Thomas (WaConChaKeeKah), *111*

Johnson, Albert A. (HunkChoKah), *213*

Johnson, John, 31, *100*, *169*

John Johnson (John Lewis) (NoCheKeKah), *196*

Johnson, Louis (HaNuKaw), 10, *223*

SUBJECT INDEX